AMBRA |V

Edition Angewandte

Book Series of the
University of Applied Arts Vienna

Edited by Gerald Bast, Rector

edition: 'ʌngewʌndtə

Georg Glaeser

Nature and Numbers
a mathematical photo shooting

AMBRA |V

Georg Glaeser
Institute for Art and Technology
University of Applied Arts Vienna, Austria

Enlarged translation from German language edition:
Wie aus der Zahl ein Zebra wird by Georg Glaeser
Copyright © Spektrum Akademischer Verlag Heidelberg 2011
Spektrum Akademischer Verlag Heidelberg is a part of Springer Science+Business Media
All rights reserved.

© 2013 AMBRA | V
AMBRA | V is spart of Medecco Holding GmbH, Vienna
Printed in Austria

Photographs: See p. 360
Translation: Peter Calvache
Graphic Design: Peter Calvache
Image Editing: Peter Calvache
Print Layout & Production: Peter Calvache
Printing: Ueberreuter Print GmbH, Korneuburg, Austria

Printed on acid-free and chlorine-free bleached paper.

With 757 coloured figures.

ISSN 1866-248X
ISBN 978-3-99043-615-8

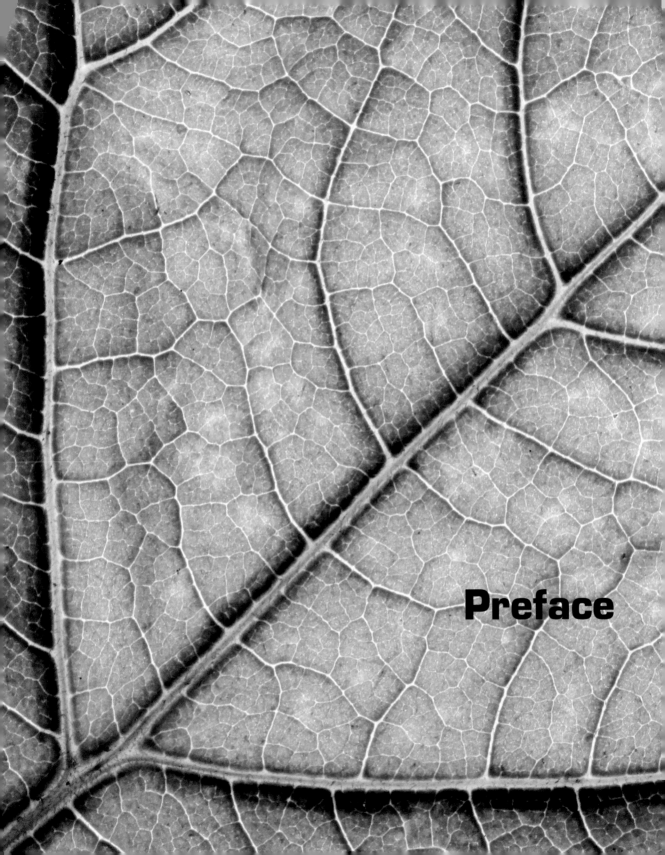

Preface

Preface

Like many books before it, *Nature and Numbers* has had a peculiar developmental history. After many years of research and teaching, and after writing several volumes on the topics of mathematics, geometry, computer graphics, and photography, I was supposed to write and produce this book relatively quickly. It seemed, at first, that there was a lot of photographic and textual material to choose from, which would "only" have to be put into the appropriate context. As usual, it turned out to be a much bigger project than anticipated.

My team, consisting of Franz Gruber and Peter Calvache, helped me far beyond what I could reasonably demand from them. Without Franz' sophisticated computer simulations, created using our in-house software Open Geometry, and without Peter's remarkable sense for graphics design and layout, the book would simply not have attained its current level of quality. The book was translated into English by Peter and proofread by Elisabeth Halmer, Johnny Ragland and Eugenie Maria Theuer. Rudolf Waltl provided several mostly technical photographs to this book and conducted research concerning physics. I also have to thank the physicist Georg Fuchs and the biologists Axel Schmid and Hannes Paulus for fruitful comments and suggestions. Since this book is an English translation of a prior German version called "Wie aus der Zahl ein Zebra wird", I also need to thank Andreas Rüdinger and Bianca Alton from Springer Spektrum Heidelberg for their feedback on the original. For the extended English version, I have to thank Anja Seipenbusch and Angela Fössl for their patient help during the final phase.

In the months leading up to the completion of this book, a remarkable momentum emerged among our team, as vast quantities of gathered material and insights underwent a steady process of recombination and refinement – a positive spiral, so to speak. Since spiral motion is also covered in this book, it seems appropriate to display an object which is essentially composed of two screw-like bodies (the outer one is left-handed, and the inner one right-handed). Such objects are ideal for mixing and kneading – an appropriate metaphor for how this book

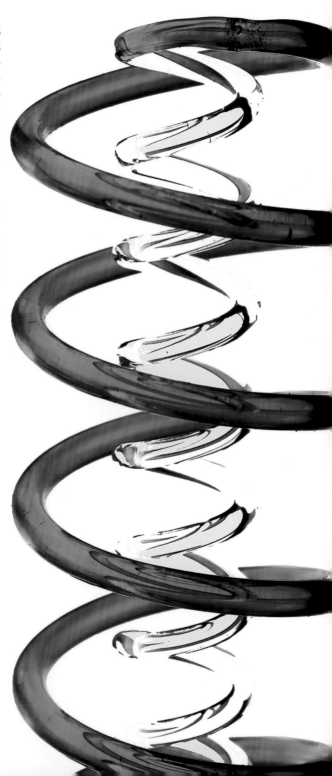

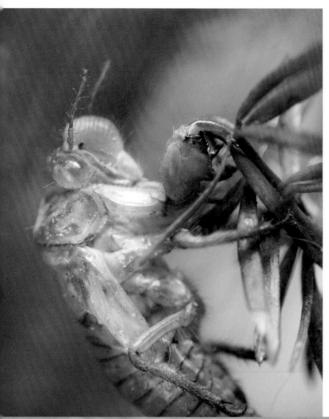

came into existence. The emergence of an adult insect from a larva or pupa may also be a good analogy for this final phase of production. The images above show the abandoned chitin shell of a cicada, on which all details of the emerging insect can already be discerned. The final imago stage is pictured on the left. Much of an insect's life takes place beneath the surface – hidden from our view, often over the course of many years. The imago stage is one of several stages, and most essential for the reproduction of that species. Nature abounds in processes that have a mathematical basis. In writing this book, I tried to follow the principle of explaining each concept on a single page spread. You are, thus, invited to approach each new idea in „easily digestible bits". Since I only wanted to dedicate a single spread to each concept, I often provide literature references or web links that delve deeper into the respective subjects.

For now, however, I would like to wish you much reading pleasure!

Vienna, November 2013
Georg Glaeser

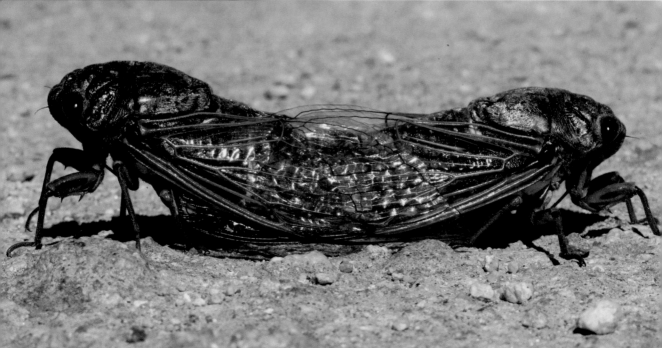

Maths and nature photography

I am a mathematician specializing in computer geometry and a passionate nature photographer. But are these disciplines actually related, or do I have to strain credulity in uniting them? Only a study of this book can convey the reasons behind my answer to this question: Mathematical relationships abound in nature, and photography can aid us in recognizing that fact!

Mathematicians tend to model natural shapes which can be put into a certain unambiguous category. The crystal structure of a diamond, for instance, is perfectly tetrahedral. However, this is only hard to prove photographically. On the other hand, there exist plenty of less perfect crystals, and insofar as their crystalline structure is visible to the naked eye, it is hardly perfect (the photo shows Calcite crystals with four-sided double pyramids at their base). In my lectures, I have sometimes noted that nature is never perfect, for otherwise, human beings would not exist as they do today. My comment, which was often taken as a joke by my students, relates to the imperfect reality of biological evolution.

Nature is a pragmatic mechanism and accepts many supposedly imperfect solutions, which emerge by means of selection or random chance, insofar as they improve an organism's reproductive success. If they are advantageous or more optimal, new forms are always ready to be accepted. This holds equally true for the development of life as for the emergence of shapes and patterns.

The digital age has provided mathematicians with unprecedented possibilities, allowing them to visualize ideas which used to be unreachable. It is especially

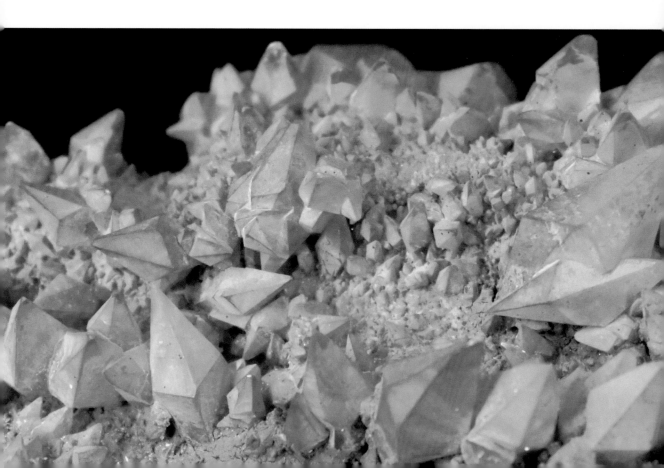

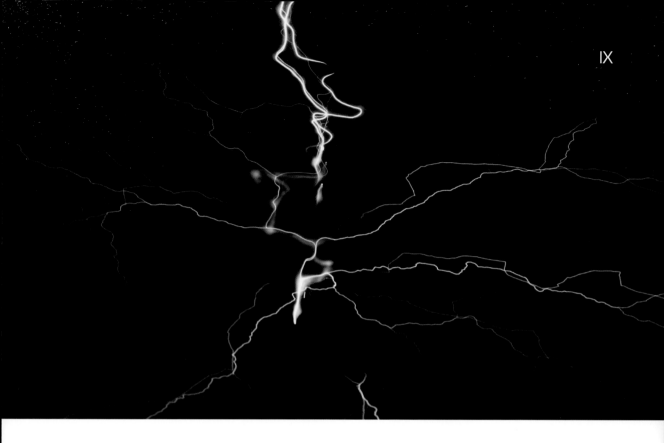

practical for the simulation of natural processes. Here, computer-aided mathematics allows for a free experimentation with parameters – a legitimate and indispensable method in order to achieve results more efficiently.

Solving a problem in this way might entail a comprehension of how the various mechanisms of nature proceed on their own and intertwine among each other. It is remarkable to recognize that many such processes are very simple, but only if considered locally. The complexity of the mechanism as a whole often escapes immediate explanation.

This principle may lie at the heart of using mathematics to understand nature successfully. After all, infinitesimal calculus uses a similar approach, focusing on increasingly tiny localities in which certain properties hold true. In-

tegration is then used to ascertain the big picture. In the modelling of dynamic processes, the smallest change can affect the whole result, and yet, nobody will deny that weather forecasts today are many times more accurate than a few decades ago. Still, there are so many parameters at play that certain degrees of inaccuracy are unavoidable.

It would seem that the lightning bolt has more degrees of freedom in branching out, compared to the fields of clouds through which it passes. And yet, as unfathomable as it may appear, modern sciences is dedicated to finding out how this phenomenon works. An essential prerequisite is the ability to capture a lightning bolt's structure – hence the necessity of high-speed photography!

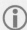
WIKIPEDIA **Diamond cubic** http://en.wikipedia.org/wiki/Diamond_cubic
WIKIPEDIA **Lightning** http://en.wikipedia.org/wiki/Lightning

Table of contents

This photo of the Anthaxia nitidula beetle – bare-ly a quarter of an inch long – suits many topics at once: „Colour pigments or iridescence?" (p. 188), „Blurry decisions" (p. 300), „Com-pound eyes" (p. 58), „Decimal powers among animals" (p. 280). Consider the tiny white mite within the red circle, whose length measures 1/300 of an inch. It is roughly 50 times smaller in comparison to the beetle, and weighs only 1/100 000 as much!

Preface .. V

This book contains a photographic and mathematical journey into the kingdom of nature – with its myriad of phenomena at the end of a long process of biological evolution. We will attempt to draw conclusions and derive understanding about them, without the need for higher mathematics, by employing a sharpened common sense and a wholly imaginative approach to the subject matter. The introductions to each chapter can be found below. The image to the left shows cellular structures in a leaf which are well suited for mathematical modelling.

1 Mathematical interplay .. 1

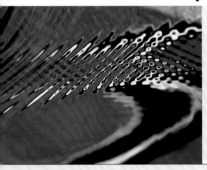

Mathematics is more than mere calculation. It is an artificial construct created by humans, employing a strict set of rules that draws an absolute distinction between "black and white" or "true and false". It would seem that nature is different from such absolute approaches, and yet, more than any other discipline, mathematics is capable of modelling natural processes and providing deeper insights into its underlying mechanisms. The title image shows a standing wave at the drainage of a pond. The wave interferences are barely moving. If just a few parameters were known, the picture would be reproducible in a computer.

2 The mathematical point of view 29

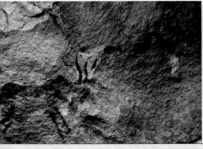

This cave painting might well be many thousands of years old. It was created by the San (the indigenous people of southern Africa) and illustrates hunting techniques with bow and arrow. The parabolic trajectories of their arrows have, from time immemorial, been intuitively calculated by the San people with astonishing precision without a single mathematical calculation. This chapter concerns mechanisms or approaches ubiquitous in nature that give pause to a mathematical mind – for instance, supposed or explicable similarities.

3 Stereopsis or spatial vision ... 53

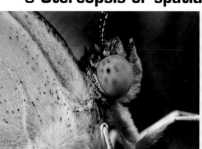

This close-up photo of a beautiful butterfly shows dark spots on the compound eyes (so-called pseudopupils), which are generated by the crystalline prisms contained within each compound. The animal's depth perception is excellent at close range. This chapter seeks to explain why that is so, how stereoscopic vision functions in the first place, and what rules of perspective and three-dimensional analysis apply. It is especially interesting to consider how easily our visual perception can be confused if certain conditions are met.

4 Astronomical vision ... 79

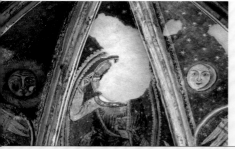

To glimpse ever deeper into the vast infinity of space has always been a fascination of humankind. In this chapter, we will restrict ourselves to our sun, our moon, and one or the other prominent constellation. Many phenomena related to stars arouse interest in mathematically minded people. For instance, a rather simple geometric theorem concerning right angles gives us an answer to the non-trivial question of the precise beginning of spring and the supposedly false inclination of the moon. The latter is immortalized in the medieval fresco from the Church of St. Lawrence in Požega (Croatia), our image for this chapter.

5 Helical and spiral motion ... 105

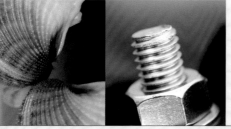

Before we attempt to analyze different types of curves and surfaces, we will take a closer look at screwlike and spiral motion. The former has many key applications in technology (the screw thread, including its nut, serves as a symbol for this chapter). Spiral motion is omnipresent – not only in art, but also in nature, where snail shells, seashells and animal horns employ its principles to great visual effect. Here, exponential or linear growth is combined with rotation.

6 Special curves ... 125

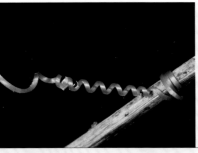

Curves like the catenary may lie on a plane or be "genuinely spatial curves" like the pictured sprout of a climbing plant, which – quite unusually for our naive understanding of plants – tries to capture its spatial surroundings and attach itself to a solid object by rotating and wiggling. Conic sections are among the most famous curves for a good reason: They abound in nature. Planetary paths are ellipses, the trajectories of thrown objects are parabolic, and shadows (including the perspective images of circles) are often hyperbolic.

7 Special surfaces ... 139

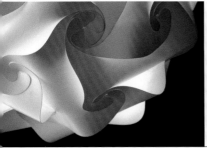

The variety of curved surfaces is even greater than that of the underlying curves themselves. The sphere, in particular, is a constant source of fascination for us due to its infinite symmetry. Its surface is doubly curved, and it is, therefore, impossible to spread it into a plane without deforming it. The parts of the pictured lamp which approximate a sphere are created by bending planar, rhombus-shaped strips and are, thus, only singly curved. Surfaces which exhibit an equilibrium of tension are called minimal surfaces and are always doubly curved.

8 Reflection and refraction 161

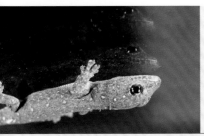

Reflection and refraction are closely related. If, for instance, the sun is reflected in a water surface, then the light rays partially enter the water itself, though the degree to which this happens depends on the angle of incident. The inversion of this principle is not as self-evident as this: Light which hits the water surface from below at a flat angle is reflected completely. The tiny gecko on the plane of glass appears doubly reflected: Once at the upper side of the plane, and once more at the back side. The double refraction in between cancels itself out.

9 Distribution problems 199

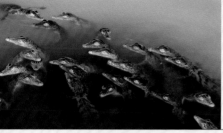

A frequent problem in nature concerns the distribution of a maximum number of elements in a limited space. The young crocodiles from the Nile that frolic in the chapter image visualize this problem quite well. In nature, however, distribution problems arise in very diverse areas: There is, for instance, the supposedly easy question of distributing a given number of points on the surface of a sphere. Here, mathematical-physical algorithms can be employed that solve the problem by simulating a repulsive force between the individual points.

10 Simple physical phenomena 221

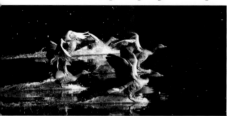

Mathematics and physics overlap frequently. One may, for instance, pose the question of how a ski jumper could achieve the greatest possible distance, or at what angle a motorcyclist should be inclined when passing a hairpin curve. Issues of a more physical nature are invoked when investigating the reasons behind animal flight (or the flight of human contraptions such as airplanes), or the peculiar complexities of wave formation as a function of sources of turbulence.

11 Cell arrangements 257

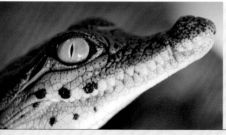

A mathematician finds it hard to glance at a reptile's scales (a Nile crocodile is pictured), and not interpret them as some form of a so-called Voronoi diagram. This chapter deals with the question of how useful such associations actually are, whether or not a simple connection to mathematical theory exists at all, and whether or not we may find similarities in the wings of dragonflies, the leaves of plants or even the cracks in dry mud. Other relationships are explored, such as the supposed spiral patterns on daisies, sunflowers, and pine cones.

12 The difference between big and small .. 279

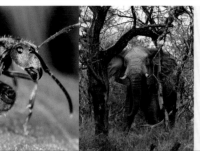

This chapter concerns the thrilling question of why the world of the very small is so different from the world of the very large. The juxtaposition of elephant and ant in the chapter image should hint at the chasms of scale that separate these different physical situations. For instance, gravity seems to be of little importance to insects, as most of them are very strong in relation to their size, and many of them can fly. This tendency can be explained mathematically: The ratio between surface and volume is dependent on the absolute size of the animal observed.

13 Tree structures and fractals .. 315

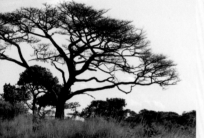

The branching structures that we can observe in trees (as in the pictured Israeli babool) or rivers are also ubiquitous at much smaller scales, such as in corals or in the roots of small plants. In many cases, the objects are so far away from having a clear and sharp silhouette that it is more useful to consider them as fractals. Fields of clouds, ferns, and the contour lines of landscapes (the contours of islands in particular) are typical examples. Since tree structures and recursive algorithms are commonplace in computer graphics, we can discuss substantial and beautiful overlaps to the structures of nature.

14 Directed motion .. 339

How is it possible that the tiny caterpillars in the chapter image can move into the perfect position on a leaf for the purpose of efficient collaborative digestion? Does a monkey have any control over the flight path whilst in mid-air, jumping from one part of the canopy to the other? Such questions can be beautifully explained in the context of kinematics – the geometry of motion – which serves as the topic of the final chapter.

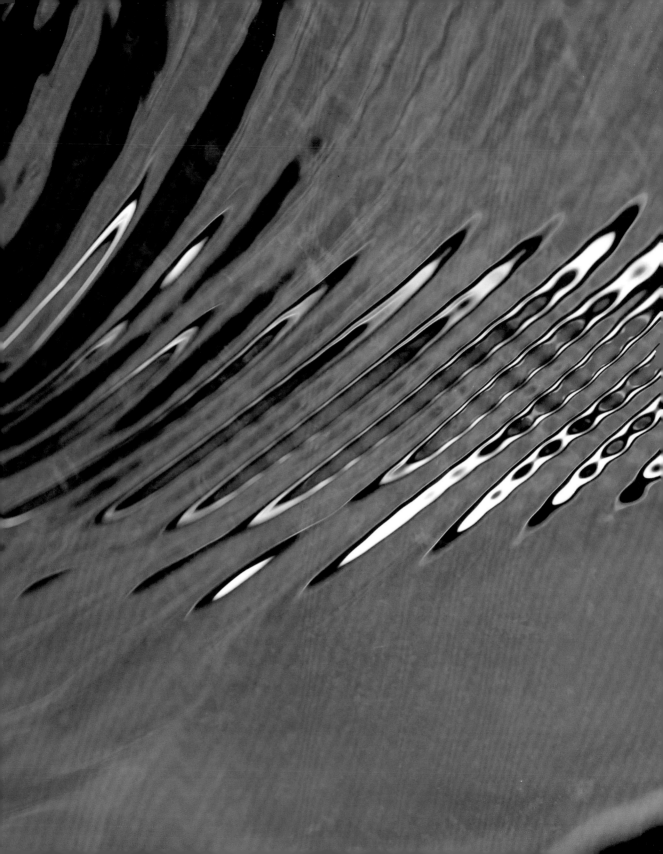

1 Mathematical interplay

Zebra stripes and index

Mathematics is a very strict discipline – probably the only one which draws such a strong distinction between "true or false", ""1 or 0", or (to use a popular phrase) "black or white". If the statement "all panthers are black" is false, then it only follows that "not all panthers are black", but not that "all panthers are white". Upon closer inspection, panthers tend to be spotted anyway, and only exhibit their dark coat as a "background color". According to biologists, the zebra has its stripes for a number of reasons: Camouflage, the confusion of the tsetse fly, improved thermal regulation, and the discernment of fellow members of the same species.

A serious naturalist has no choice but to derive a series of reproducible tests, in order to prove statistically that large predators or tsetse flies are, indeed, confused by the zebra's patterns, or that the surface temperature of a non-striped animal is higher when exposed to strong sunlight. Such proofs have a further positive effect for the discipline of bionics, which seeks to develop new technologies based on the techniques of nature. All natural sciences employ mathematical methods with great success. In most cases, it is "applied mathematics" or statistics in particular, as many statements can only be proven statistically. The radio-carbon-dating of a mummy is a typical case in point: For a mathematician, it is the classical example of exponential decline of a "y-Value" combined with the "law of large numbers". It is impossible to say when exactly a certain ^{14}C-atom decays, but with billions of such candidates to choose from, one quickly reaches the conclusion that the speed of decay is proportional to the number of existing atoms.

A strict mathematician is forced to consider statistical proofs with skepticism. It has never been disproven that a rock, if dropped from a height close to the Earth's surface, will fall towards its centre of mass. However, it has never been strictly proven either, or at least not in a way that would satisfy a mathematician's standards for proof. On the other hand, a number theorist finds it easy to explain why a cicada's developmental cycle, which lasts for several years, is advantageous to the species if this number of years is a prime number (in fact, in many species, it is 17 years). Potential predators with shorter lifespans find it difficult to adapt to the

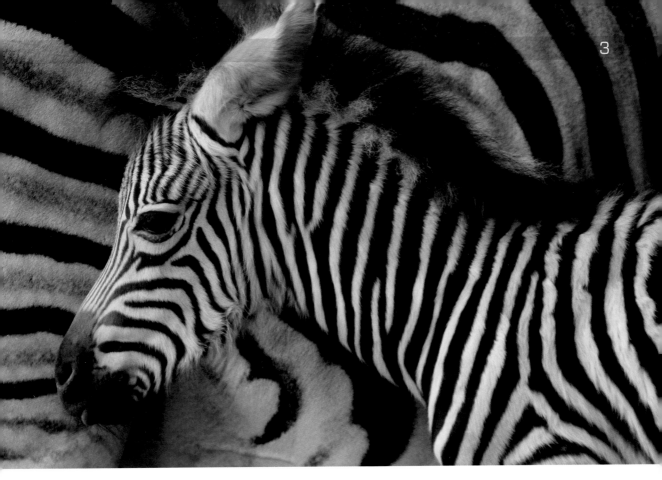

abundance of food when the cicadas emerge from the ground *en masse*. Usually, many generations of predators come and go before the predators and the cicadas meet again. The pattern on each zebra is unique, and its sequences of black stripes on a white background have been well researched by mathematicians. Retail products in a store are labelled using similar patterns, which encode a 13-digit number through a so-called EAN barcode. Each digit corresponds to a standardized pattern, which makes it possible to express a virtually infinite number of combinations. The code is being read by a laser scanner.

What is remarkable is that a day-old zebra foal is able to recognize its mother not only by smell, but – and this has been proven statistically – by the unique pattern on the parent coat. Hence, mathematics and nature are much closer than one may think, even though it has usually not been the intention of mathematicians to be guided by the principles of the biosphere! No wonder that a mathematician should like to take pictures of natural phenomena, hoping to explain them mathematically, even though the solution may take a considerable effort to be reached.

Such approaches are repeated hundredfold in this book, with the intention to illuminate the continuous interplay between natural sciences and mathematics – in other words, between nature and numbers.

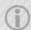

WIKIPEDIA **European Article Number** http://en.wikipedia.org/wiki/European_Article_Number
WIKIPEDIA **Cicada** http://en.wikipedia.org/wiki/Cicada
J. D. MURRAY **Mathematical Biology** www.ift.unesp.br/users/mmenezes/mathbio.pdf

How a number becomes a zebra

We shall now consider the following mathematical model: Let us assume a grid of 500x500 white points and paint a random number of pixels black ("pixel" stands for picture element, or a single elemental square in the grid). Now, let us travel from pixel to pixel – from top to bottom, and from left to right – one by one (in the right image, such a "test pixel" is marked red). We can now imagine two elliptical or circular rings around the test pixel, where the outer ring (orange) is roughly double the size of the inner ring (green). As a next step, we can apply a simple counting procedure: We count the black pixels – at first within the outer elliptical or circular ring, and then only within the inner one. If the condition $n > 3 \cdot m$ is met, then the test pixel in question is painted black. After all pixels have undergone this procedure, the grid pattern has changed to some degree. By repeating this entire procedure several times, we get a new picture every time.

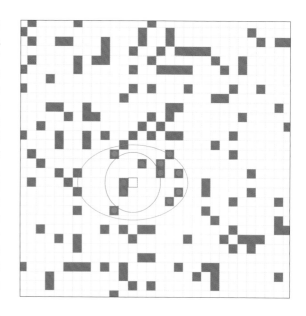

After only 5 or 10 iterations, however, the image appears to converge upon a fixed and final pattern. The weighting (multiplication) by a factor of 3 in the condition follows from the fact that there may be, at most, thrice as many orange pixels ("inhibitors") as green pixels ("activators"). If the weighted activators outweigh the inhibitors in any locality, then the test pixel turns black. The four zebra patterns on the right side were generated by this very procedure. Surprisingly enough, the form of the pattern is not determined by the number or the position of the initial black points, but by the shape of both rings. A zebra pattern can be generated by picking ellipses as in the sketch in the top left corner: The main axes are rotated by 90°.

The large photo on the right shows two zebras fighting for domination. If the patterns on their heads are similar, it is due to their genetic proximity. Similar patterns can be found not only on the coats or skins of animals (tiger, tiger shark) but also on the sand dunes in flat water, as illustrated by the left photo.

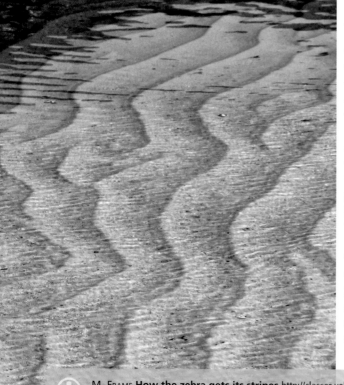

M. FRAME **How the zebra gets its stripes** http://classes.yale.edu/fractals/Panorama/Biology/Leopard/Leopard.html

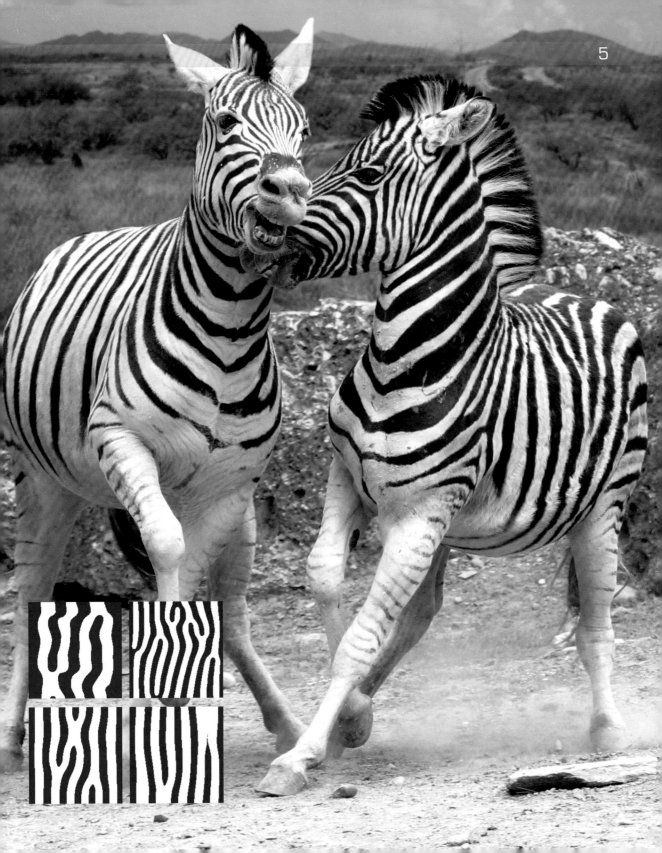

The question of which came first – the chicken or the egg – seems like an appropriate metaphor for many day-to-day problems. From a mathematical point of view, a chicken-egg-problem arises whenever relationships cannot be "topologically sorted". In evolution, there might never have been a "first chicken" or a "first egg". Aside from the philosophical implications, chickens and eggs pose several different questions of mathematical, physical, and biological nature:

Why are chicken eggs solids of revolution, but not spheres or at least symmetrical ellipsoids? The answer is simple: The more symmetrical they are, the more likely they are to roll away from their mother's nest and become lost. All the better if they keep rolling around in circles on the spot, as chicken eggs tend to do. For this reason, the eggs of many bird species which hatch on cliff faces (such as the Icelandic murre) are not even solids of revolution anymore.

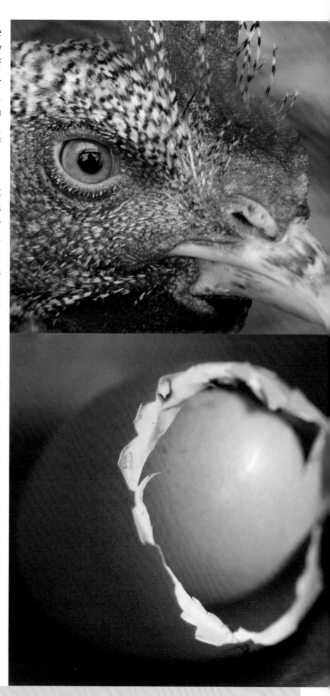

Why is it impossible to cook a breakfast egg at the highest mountain peaks? Due to low air pressure, water starts to boil at much lower temperatures, which may be inadequate to harden the egg white on the inside.

Why do larger eggs require greater heat during incubation, and why do they take longer to cook? Because larger eggs have a smaller surface as a proportion of their volume, and thus, heat takes a longer time to act.

The question of which species was first capable of opening eggs skilfully (the chick or the human) can be answered unambiguously. The egg in the bottom right image was opened by one of the chicks in the picture. There are about twice as many chickens as there are people worldwide, and that excludes domesticated animals. Domestication has changed the distribution of our planet's biomass completely – just for comparison, there are about 1,3 billion specimen of domesticated cattle alive at any given moment.

 WIKIPEDIA **Chicken or the egg** http://en.wikipedia.org/wiki/Chicken_or_the_egg
M. GLEICH, D. MAXEINER, M. MIERSCH **Life Counts. Cataloguing Life on Earth.** Atlantic Monthly Press, 2002

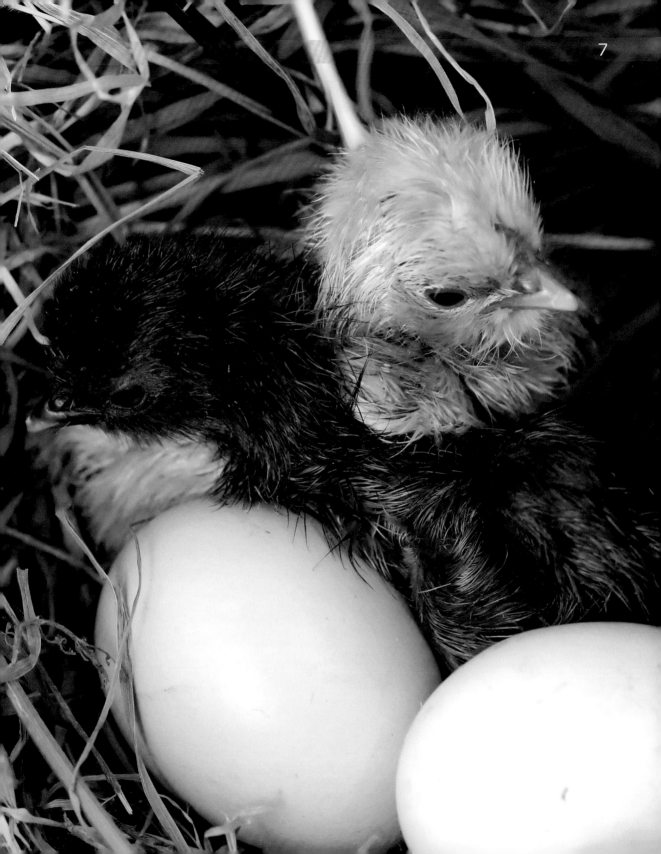

The tortoise in the picture is able to crawl at a speed of roughly one body length per second – that's about 7 inches. The Greek hero Achilles would have been about ten times bigger, and probably marched ten times faster in full armor. And yet, according to Zeno of Elea, a Greek philosopher from 500 B.C., he would never be able to catch up to the much slower animal, even if it only had a head start of 10 m.

For when the invincible hero reached the spot that the tortoise had occupied at the start, the reptile would already have moved on by a further 1 metre, and after crossing that metre, the tortoise would still be ahead by 10 cm. It would seem that this could be continued ad infinitum: A further advance of 10 cm by Achilles still places the tortoise about 1 cm ahead. Something must be wrong with this analysis, but what exactly?

What this process of incremental advance actually describes – infinitely tediously, it would seem – is merely the well-defined time interval required by Achilles to reach the tortoise's position. Zeno's paradox is justly famous for its apparent contradiction of common sense – even a layman must conclude that some kind of error is being committed.

N. Huggett **Zeno's paradoxes** http://plato.stanford.edu/entries/paradox-zeno
E. Barbeau **The Problem of the Car and Goats** CMJ 24:2 (Mar 1993), p. 149
University of California, San Diego **The Monty Hall Page** http://math.ucsd.edu/~crypto/Monty/monty.html

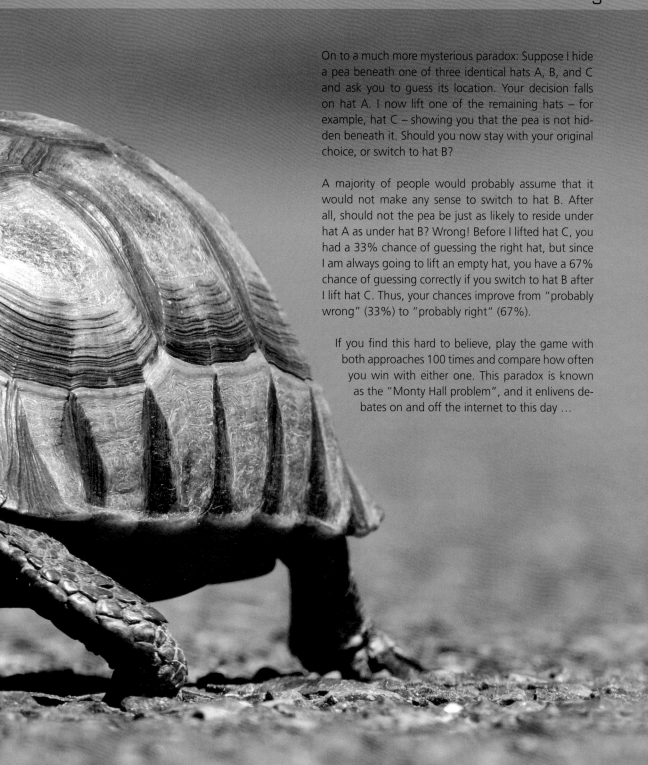

On to a much more mysterious paradox: Suppose I hide a pea beneath one of three identical hats A, B, and C and ask you to guess its location. Your decision falls on hat A. I now lift one of the remaining hats – for example, hat C – showing you that the pea is not hidden beneath it. Should you now stay with your original choice, or switch to hat B?

A majority of people would probably assume that it would not make any sense to switch to hat B. After all, should not the pea be just as likely to reside under hat A as under hat B? Wrong! Before I lifted hat C, you had a 33% chance of guessing the right hat, but since I am always going to lift an empty hat, you have a 67% chance of guessing correctly if you switch to hat B after I lift hat C. Thus, your chances improve from "probably wrong" (33%) to "probably right" (67%).

If you find this hard to believe, play the game with both approaches 100 times and compare how often you win with either one. This paradox is known as the "Monty Hall problem", and it enlivens debates on and off the internet to this day …

For better or worse, photographs dominate our world. Thousands upon thousands of books are filled with them, and ever since the dawn of social networking, more photos are being taken and uploaded every day than can practically be comprehended. And yet, people are keen to "prove" all manner of absurdities using just photos – a fact made worse by widely accessible techniques of image manipulation.

From a geometrical standpoint, it is possible to debunk many forgeries, especially if the person manipulating the picture possesses little mathematical and geometrical knowledge. However, in cases when a photograph can be trusted (for instance, if it was taken personally), and when some basic photographic information is available (such as the focal length), it is certainly possible to gain new insights from it.

A simple example: Suppose we would not yet be able to journey to the moon. It would still be possible to come to many conclusions based on photos taken with a telescopic lens. Could it be proven, for instance, that the moon is spherical? For one, the contour of the moon in the telescopic image is clearly circular, just like the contour of a sphere undergoing normal or central projection if the projection is directed towards the centre of the sphere. What is more, the self-shadow boundary of the moon, when being lit from a side by the sun, clearly resembles the same ellipses that appear on a lit sphere.

From the weak definition of the shadows on the moon's surface, it is possible to conclude that it is mountainous, but not strongly so in relation to its radius. However, one would also have to recognize that, since the back side of the moon cannot be seen from the Earth, we are unable to draw conclusions about its shape or texture.

Therefore, in theory, it could be possible that the side of the moon facing us is an egg-shaped ellipsoid of revolution (this would produce the kind of self-shadow

The moon is spherical – a photographic proof

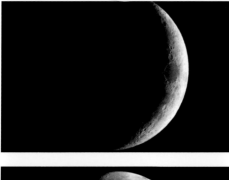

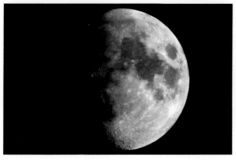

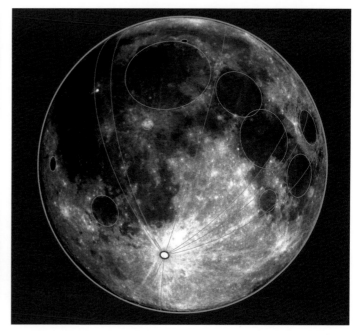

boundary we are able to observe from Earth), and that the side of the moon facing away from us looks completely different in every respect. The surface that we can see is covered in roughly circular craters which were produced by impacting meteors. Such circular shapes are shown in the overlaid computer image on the right, and it is notable how well they seem to fit the moon photo in the background. What's more, such circular shapes appear only on spheres, but not on ellipsoids. If we know the size of the moon, we can use computer simulation to determine the diameters of the craters. It is further possible to see several bright strips (many hundreds of miles long) emanating from the crater that is marked red in the southern hemisphere. Evidently, these strips are shaped like great-circles on a sphere. Other craters also exhibit these "markings", which suggest the tremendous influence that impacting meteors have on the structure of the moon's surface.

The moon is not always equidistant in relation to Earth. The minimum and maximum distances are more than 5% smaller or larger than the average distance of 238 600 miles. If a sphere's diameter is 1.1 times larger in relation to another sphere, then its volume is much bigger still – 1.1^3 times, in fact, which is equivalent to an increase of about 33% (compare both images on the left side). Therefore, the colloquial statement that the "moon appears to be especially large today" is not even an illusion. The true illusion would be to state that the rising or setting moon actually has a greater diameter. The double image on the lower left shows a non-modified photo of the sun setting above the Viennese Kahlenberg. The very tall television tower makes the sun appear much larger in the telescopic photo.

The right photo has been manipulated to show the full moon instead of the sun, appearing just as large behind the television tower. In theory, such an image would be possible, since sun and moon appear with nearly equal diameters on the firmament.

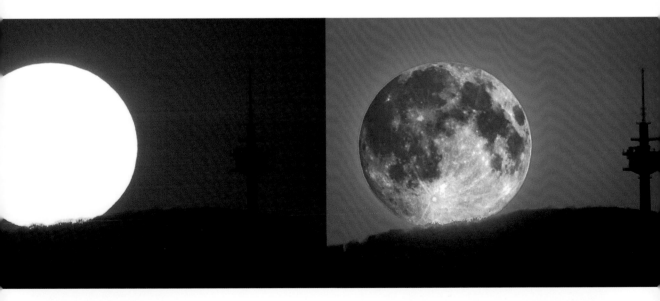

Repeatability of experiments

One of the fundamental tenets of natural science is the demand that experiments, from which conclusions are drawn, should be repeatable. What also follows from this requirement is that the initial conditions of an experiment must be as fully and as exactly described as its results or conclusions. The single photographs of a dripping faucet on the left are not stroboscopic, and thus, do not depict the same drop of water at different times, but rather a different series of drops. Notice how the sequence of drops appear to be separated by nearly equal distances (a single drop would, if captured at constant time intervals, produce larger and larger distances as time progressed). Apparently, partial drops detach themselves during their fall and lag slightly behind the bigger drop from which they originated. The situation depicted can be repeated as often as one wishes, with virtually identical results.

The photo of a water droplet detaching itself from a sunflower has a certain aesthetical appeal. Here, one might ask the question of how exactly the distorted pictures come into being (p. 299) ...

 WIKIPEDIA **Plateau–Rayleigh instability** http://en.wikipedia.org/wiki/Plateau%E2%80%93Rayleigh_instability

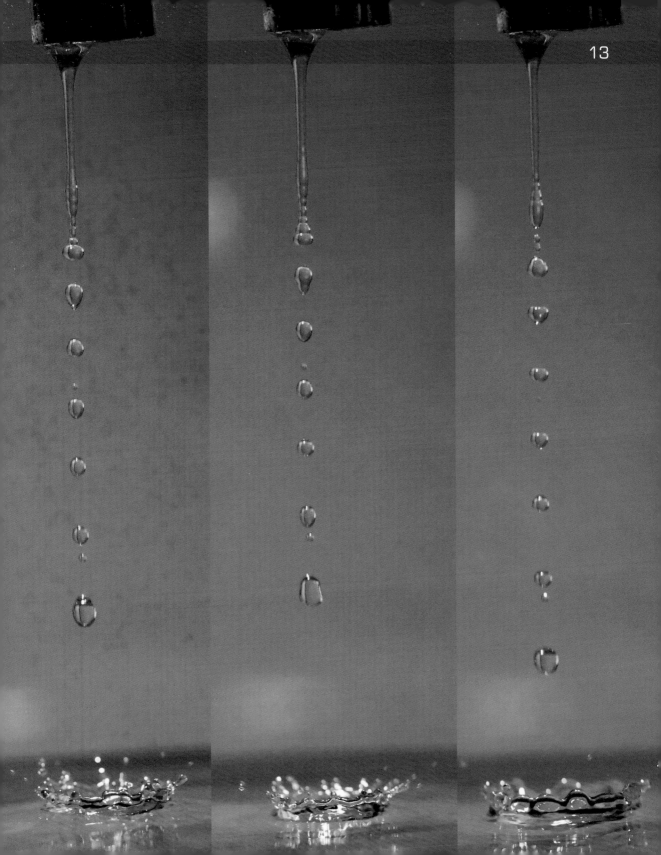

The following situation implies an exponential equation: Water lilies, which grow in a pond, increasingly spread on its surface. The area that they occupy grows by 10% every day, and it only takes 30 days until the entire pond is covered. How large was the initial area, and when exactly was half of the pond covered?

Let S be the surface area covered by the water lilies on their first day, and A the surface of the entire pond. On the second day, the sea lilies would cover an area of $1,1 \cdot S$, and on the n-th day, they would cover an area of $1,1^n \cdot S$. From $1,1^{30} \cdot S = A$ it follows that $S = A / 17,5$. This means that at the start, the pond was covered by less than 6%. Now we have to calculate the value of n from $1,1^n \cdot S = 0,5\ A$: $1,1^n \cdot S = 0,5 \cdot 1,1^{30} \cdot S \rightarrow 1,1^{n-30} = 0,5 \rightarrow n = 30 + \log 0,5 / \log 1,1 = 22,73$.

It would seem that the pond was covered exactly halfway on the 23rd day. The problem of the water lilies is exemplary of exponential growth phenomena in general, which in nature are exhibited most dramatically in the reproduction of bacteria. Such growth is forced to collapse eventually in one form or the other, due to a limited number of resources being available. In the case of the pond, it is especially easy to see why, as it makes no sense to cover it by water lilies more than once. The photo below shows a near-closed area of reeds on the *Neusieldlersee*.

In casinos, the so-called martingale betting strategy, which takes advantage of exponential growth, can have disastrous consequences: A player bets a certain amount of money on red. If the next ball lands on a red color, an immediate profit G is made. If, however, the ball lands on black, the player needs to double the stake ($4G$) and bet on red once more. If the round goes well, the player makes a net profit G, recouping all losses up to this point, but if the round goes wrong, the stake needs to be doubled again.

There is a catch, however: The net profit can only be G. At some point, a doubled stake would exceed the maximum amount allowed, and the bank would refuse to accept it. The player would then be left with no probable method of recouping the accumulated losses.

MATH IS FUN **Exponents and Logarithms** www.mathsisfun.com/algebra/exponents-logarithms.html

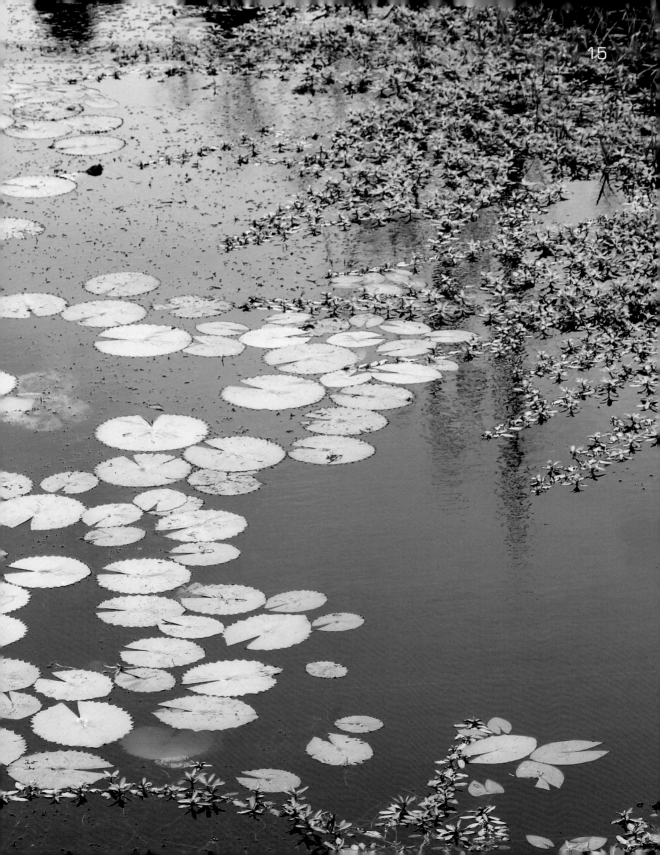

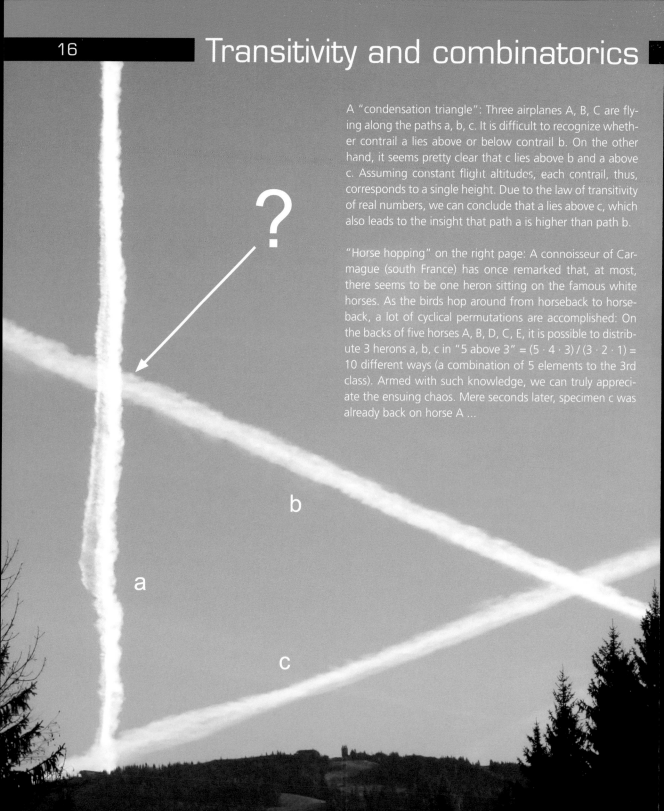

Transitivity and combinatorics

A "condensation triangle": Three airplanes A, B, C are flying along the paths a, b, c. It is difficult to recognize whether contrail a lies above or below contrail b. On the other hand, it seems pretty clear that c lies above b and a above c. Assuming constant flight altitudes, each contrail, thus, corresponds to a single height. Due to the law of transitivity of real numbers, we can conclude that a lies above c, which also leads to the insight that path a is higher than path b.

"Horse hopping" on the right page: A connoisseur of Carmague (south France) has once remarked that, at most, there seems to be one heron sitting on the famous white horses. As the birds hop around from horseback to horseback, a lot of cyclical permutations are accomplished: On the backs of five horses A, B, D, C, E, it is possible to distribute 3 herons a, b, c in "5 above 3" = $(5 \cdot 4 \cdot 3)/(3 \cdot 2 \cdot 1)$ = 10 different ways (a combination of 5 elements to the 3rd class). Armed with such knowledge, we can truly appreciate the ensuing chaos. Mere seconds later, specimen c was already back on horse A ...

?

b

a

c

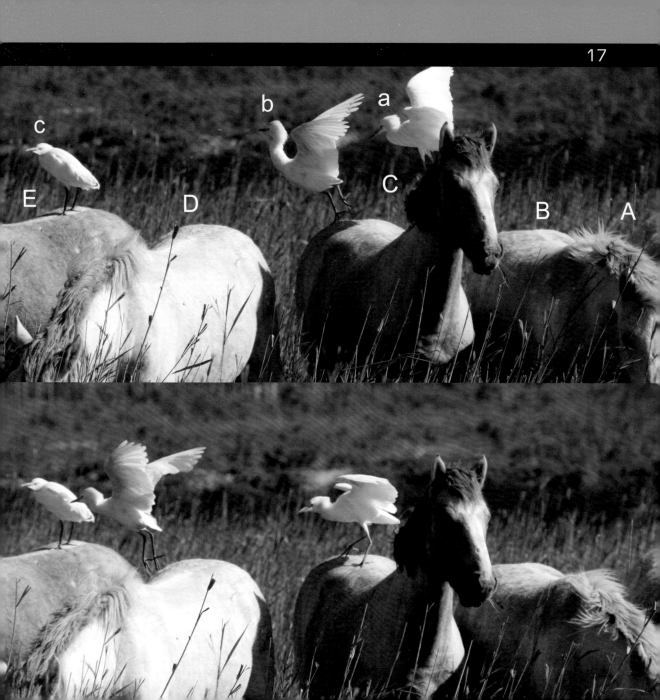

Cameras and hand luggage

This book is replete with images that were not taken under studio conditions. If one wishes to capture rare or original phenomena which cannot be replicated in the studio, one would be well advised to always carry a camera. A compact digital camera may fit in every pocket, but might not be sufficient for the ambitious photographer -- especially under poor light conditions. For this reason, I have made it a point to always carry one or two DSLRs during travels. Presenting these devices for inspections at airports has long become a frustrating but harmless routine. During X-ray scanning, the inner life of the camera becomes visible. Although the relatively

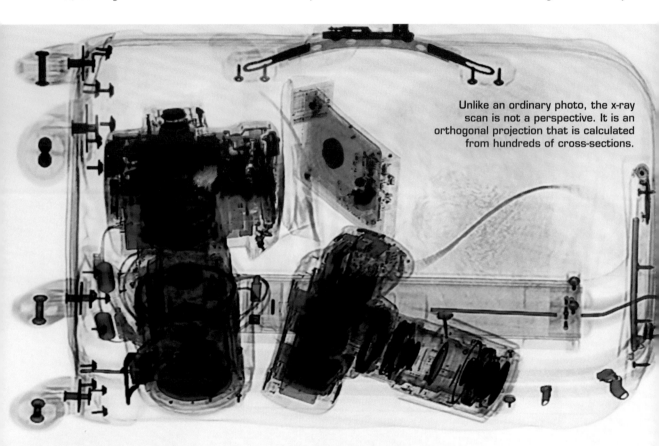

Unlike an ordinary photo, the x-ray scan is not a perspective. It is an orthogonal projection that is calculated from hundreds of cross-sections.

large weight of good cameras and lenses is sometimes a problem for hand luggage restrictions, taking them into the passenger cabin has one clear advantage: The risk of airport crews losing or damaging the suitcase is simply too high. Even renowned airlines tend to lose about 1% of all luggage. This allows us to formulate the following prediction based on converse probability: The likelihood of reclaiming your suitcase after a single flight is $p(1) = 0,99$. After two flights, it is $p(2) = 0,99^2$, and after n flights, it is $p(n) = 0,99^n$. This begs the question: After how many flights should one expect to lose a suitcase? From $p(n) > 0,5$, or $0,99^n > 0,5$, it follows

from logarithmic algebra that n > log 0,5 / log 0,99, or n > 69. If the airline is less reliable (given a probability of p(1) = 0,98), we are likely to lose a suitcase after n > 38 flights. What better reason could one give for carrying expensive equipment within hand luggage? The photo of the African red-winged starling would have been hard to take, if not for the technical advantage of a heavy camera. By the way: At the time this picture was taken, the larger suitcase, which had gone through regular baggage claims and contained a laptop, was reported to be lost by the airline, and the starling photo was only a bittersweet consolation.

 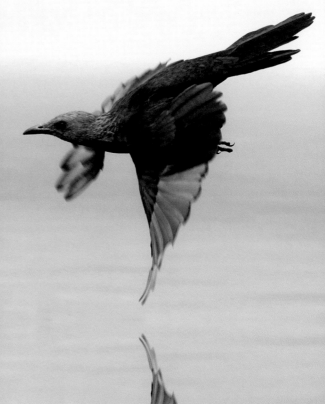

The X-ray image of the small suitcase deserves a closer geometrical explanation: Since all projection rays (X-rays) are parallel and do not pass through a single centre, the image does not constitute a photograph in the classical sense. Instead, the X-rays proceed in parallel across the passing suitcase, producing a normal projection instead of a perspective.

WIKIPEDIA **Lost luggage** http://en.wikipedia.org/wiki/Lost_luggage

On this spread you can see atomic models of complex protein molecules. The corresponding molecular weights range from about 12 000 Dalton (one carbon atom is 12 Dalton) to over 150 000 Dalton. The pure target protein has to be crystallised (similar to the crystallisation of table salt or sugar). X-ray diffraction and 3D Fourier transforms then reveal the relative positions of all atoms of the target protein (molecular structure). Structure visualization was carried out using the programs COOT and PyMol.

The 3D structures are determined by using a method called X-ray-crystallography. Once the exact 3D arrangement of all the atoms in a complex protein (or DNA) molecule is known, chemistry can be used to understand the mechanism of action (or function) of a given protein molecule. When the structure of a medically relevant protein molecule is determined, that knowledge can also be utilized to discover and design potent and specific inhibitors which can then be developed into therapeutic drugs.

A small portion of a very large protein (yellow chain across) is binding into a groove on the surface of a protein complex involved in cancer which is composed of four molecules (red/blue/gray surface).

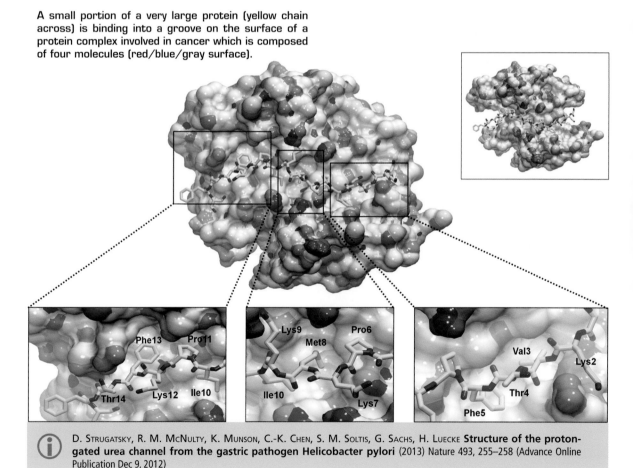

ⓘ D. STRUGATSKY, R. M. McNULTY, K. MUNSON, C.-K. CHEN, S. M. SOLTIS, G. SACHS, H. LUECKE **Structure of the proton-gated urea channel from the gastric pathogen Helicobacter pylori** (2013) Nature 493, 255–258 (Advance Online Publication Dec 9, 2012)
G. OZOROWSKI, S. MILTON, H. LUECKE **Crystal structure of a C-terminal AHNAK peptide in a 1:2:2 complex with S100A10 and an acetylated N-terminal peptide of annexin A2** (2013) Acta Cryst. D 69, 92-104.

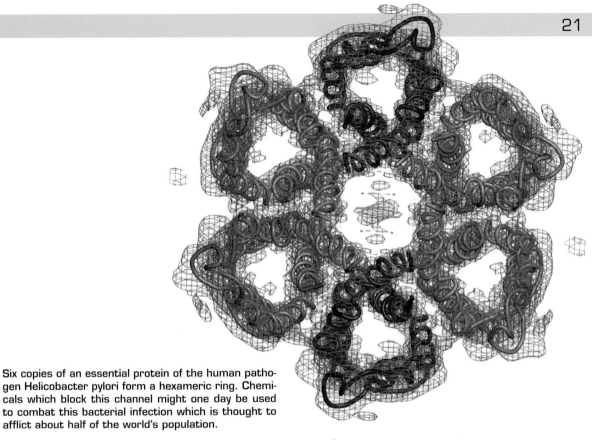

Six copies of an essential protein of the human patho-
gen Helicobacter pylori form a hexameric ring. Chemi-
cals which block this channel might one day be used
to combat this bacterial infection which is thought to
afflict about half of the world's population.

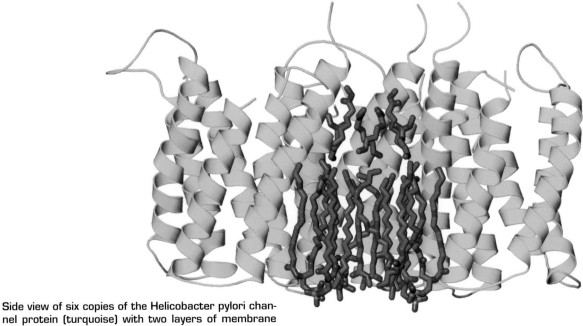

Side view of six copies of the Helicobacter pylori chan-
nel protein (turquoise) with two layers of membrane
lipids in the centre (magenta).

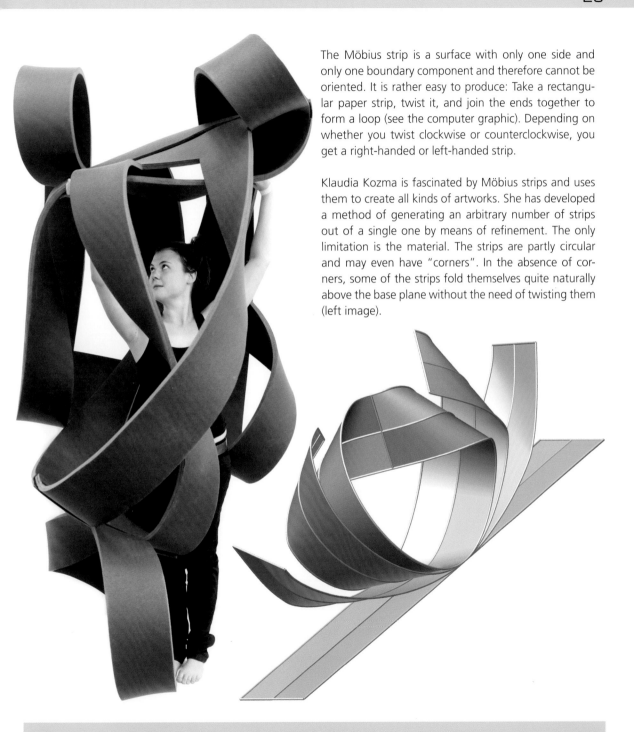

The Möbius strip is a surface with only one side and only one boundary component and therefore cannot be oriented. It is rather easy to produce: Take a rectangular paper strip, twist it, and join the ends together to form a loop (see the computer graphic). Depending on whether you twist clockwise or counterclockwise, you get a right-handed or left-handed strip.

Klaudia Kozma is fascinated by Möbius strips and uses them to create all kinds of artworks. She has developed a method of generating an arbitrary number of strips out of a single one by means of refinement. The only limitation is the material. The strips are partly circular and may even have "corners". In the absence of corners, some of the strips fold themselves quite naturally above the base plane without the need of twisting them (left image).

E. L. STAROSTIN, G. H. M. VAN DER HEIJDEN **The shape of a Möbius strip** www.ucl.ac.uk/~ucesest/moebius.html

Mathematical crochet work

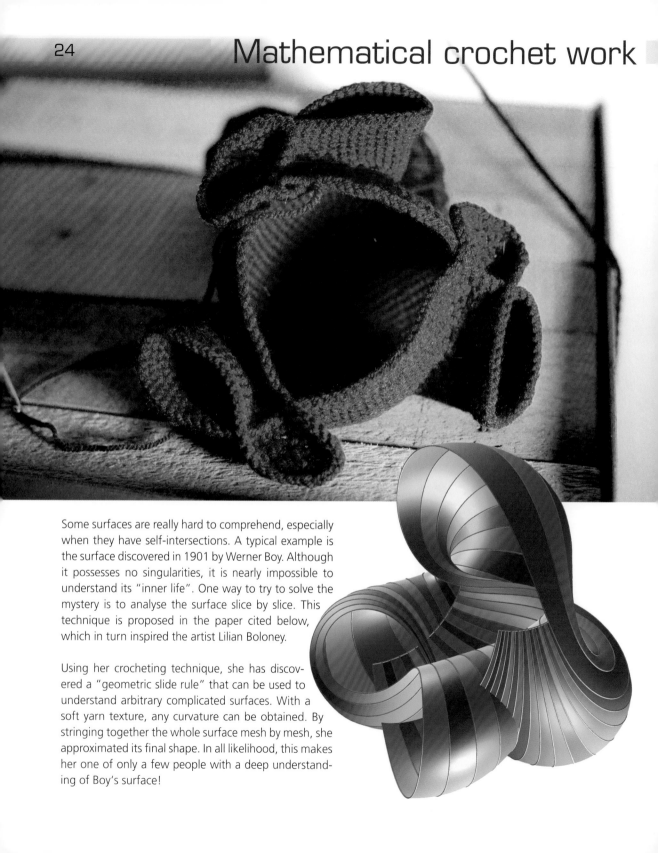

Some surfaces are really hard to comprehend, especially when they have self-intersections. A typical example is the surface discovered in 1901 by Werner Boy. Although it possesses no singularities, it is nearly impossible to understand its "inner life". One way to try to solve the mystery is to analyse the surface slice by slice. This technique is proposed in the paper cited below, which in turn inspired the artist Lilian Boloney.

Using her crocheting technique, she has discovered a "geometric slide rule" that can be used to understand arbitrary complicated surfaces. With a soft yarn texture, any curvature can be obtained. By stringing together the whole surface mesh by mesh, she approximated its final shape. In all likelihood, this makes her one of only a few people with a deep understanding of Boy's surface!

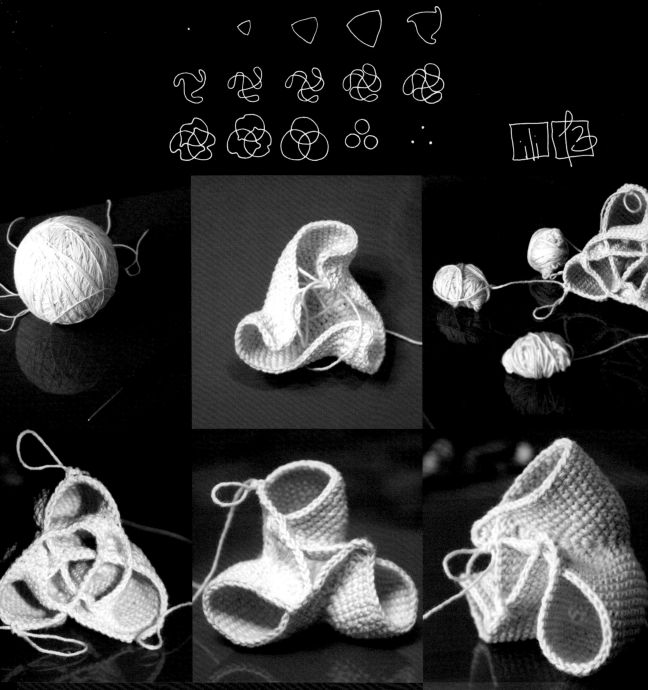

O. Karpenko, W. Li, N. J. Mitra, M. Agrawala **Exploded View Diagrams of Mathematical Surfaces**
IEEE Transactions on Visualization and Computer Graphics archive, Volume 16 Issue 6, November 2010, Pages 1311-1318
(http://vis.berkeley.edu/papers/methexpview/math_exploded_view_small.pdf)

Pacific Sea Nettles (Chrysaora fuscescens) swim using jet propulsion by squeezing their bell and pushing water behind them. Most of the time, however, they prefer to simply float. They feed on a wide variety of zooplankton, crustaceans, salps, other jellyfish, etc.

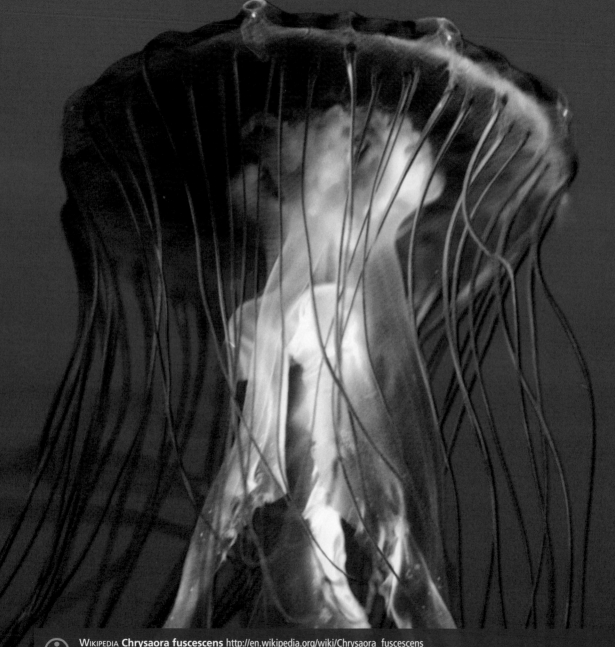

WIKIPEDIA **Chrysaora fuscescens** http://en.wikipedia.org/wiki/Chrysaora_fuscescens
G. GLAESER **Geometry and its Applications in Arts, Nature and Technology** Springer Wien New York 2012

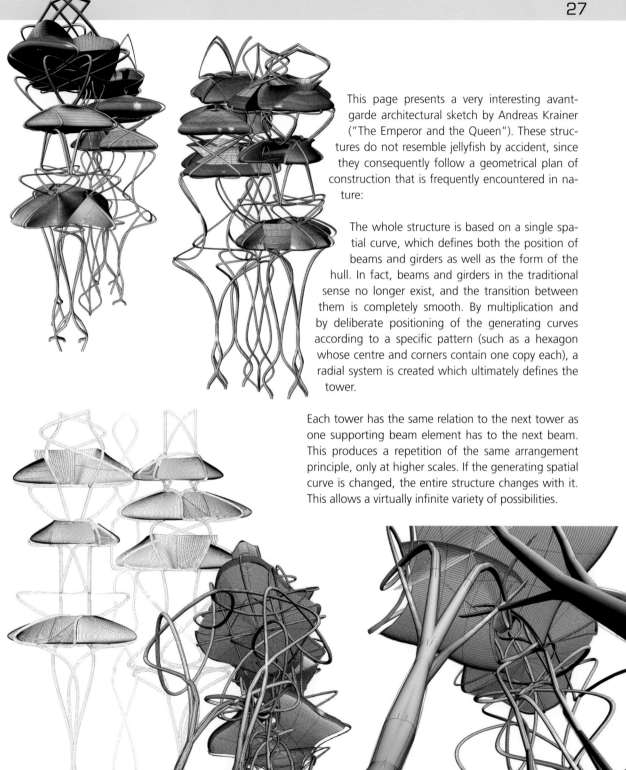

This page presents a very interesting avant-garde architectural sketch by Andreas Krainer ("The Emperor and the Queen"). These structures do not resemble jellyfish by accident, since they consequently follow a geometrical plan of construction that is frequently encountered in nature:

The whole structure is based on a single spatial curve, which defines both the position of beams and girders as well as the form of the hull. In fact, beams and girders in the traditional sense no longer exist, and the transition between them is completely smooth. By multiplication and by deliberate positioning of the generating curves according to a specific pattern (such as a hexagon whose centre and corners contain one copy each), a radial system is created which ultimately defines the tower.

Each tower has the same relation to the next tower as one supporting beam element has to the next beam. This produces a repetition of the same arrangement principle, only at higher scales. If the generating spatial curve is changed, the entire structure changes with it. This allows a virtually infinite variety of possibilities.

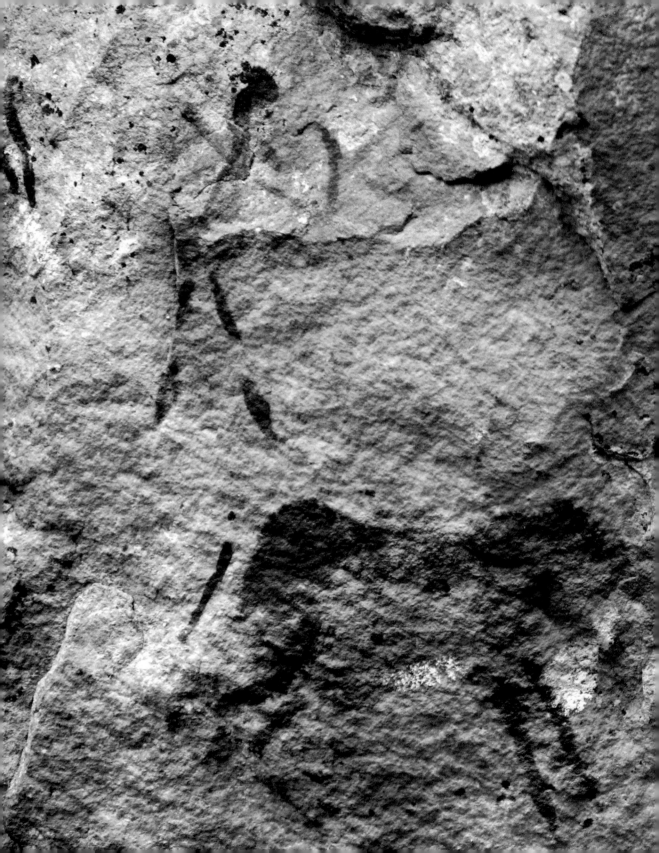

2 The mathematical point of view

Remarkably similar

The shapes of nature are often highly geometrical, but rarely perfect. This may be due to the fact that a large number of "interference factors" exist, which, for instance, prohibit a perfectly uniform growth from taking place.

Still: A clear relationship with ideal shapes allows a careful mind to formulate a certain amount of educated interpretations. The computer graphic on the right shows part of a so-called Enneper surface – a frequently cited example of an algebraic minimal surface.

The photo below shows a "Peacock's tail" alga underwater, which, as mathematicians love to point out, bears a strong resemblance to the Enneper surface. This association is not as far-fetched as it may first appear: It may, in fact, be the guiding principle behind the plant's structure to minimize its surface tension.

The photo on the right side shows a Monkey Ladder (a lignified tropical vine), along with a pretty good attempt at simulating its shape in a computer. The procedure started from a parallel pencil of straight lines, which were distorted depending on the distance of the symmetry plane through the middle normal. It seems clear that sine and exponential functions must play a role in this. In fact, both functions are frequently employed in natural processes.

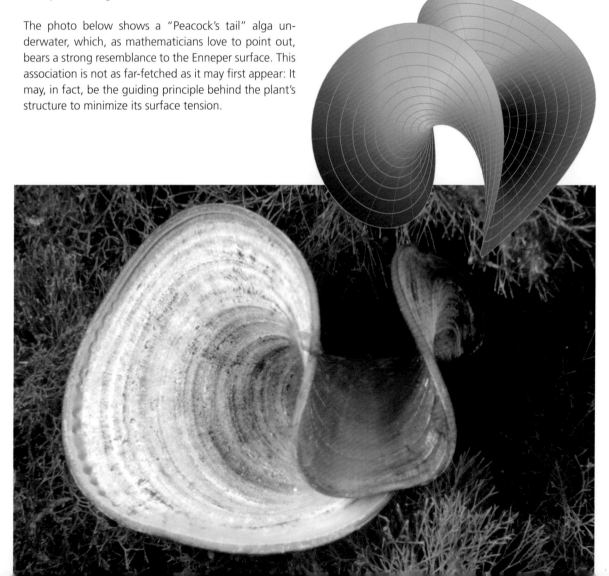

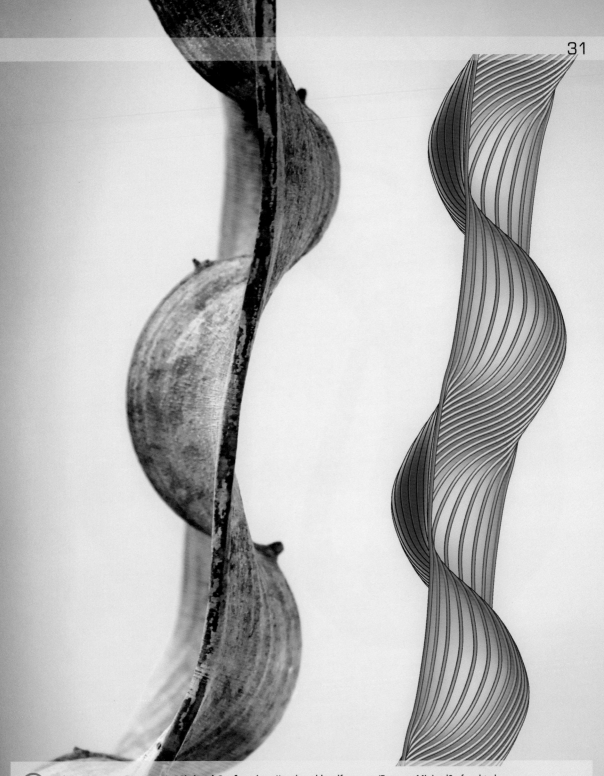

E. W. WEISSTEIN **Enneper's Minimal Surface** http://mathworld.wolfram.com/EnnepersMinimalSurface.html
S. DICKSON **The Klein Bottle** www.ifp.illinois.edu/~sdickson/Klein/Klein.html

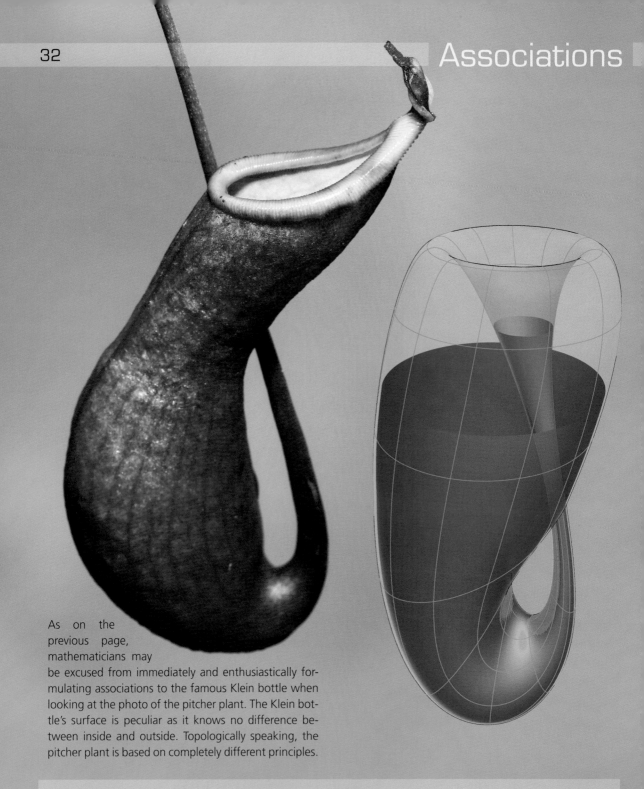

As on the previous page, mathematicians may be excused from immediately and enthusiastically formulating associations to the famous Klein bottle when looking at the photo of the pitcher plant. The Klein bottle's surface is peculiar as it knows no difference between inside and outside. Topologically speaking, the pitcher plant is based on completely different principles.

S. DICKSON **The Klein Bottle** www.ifp.illinois.edu/~sdickson/Klein/Klein.html

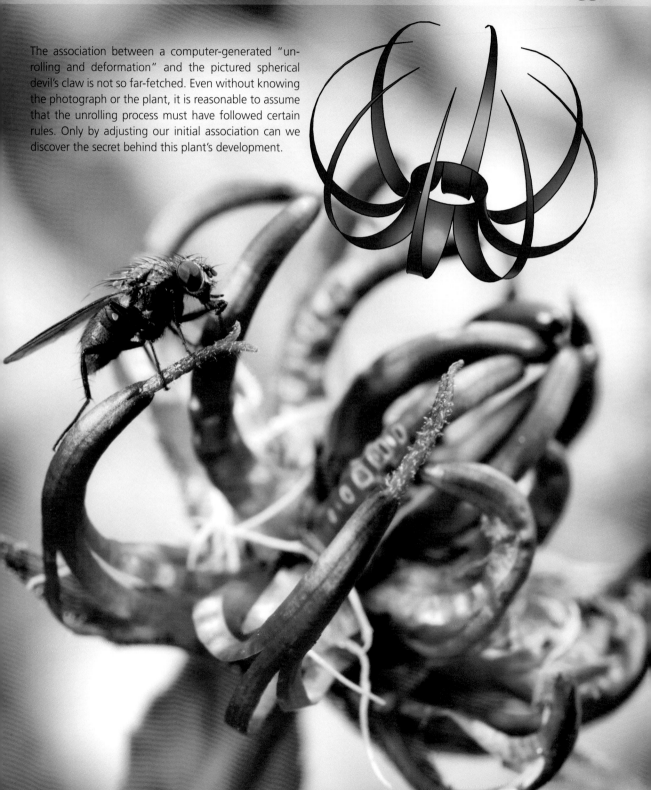

The association between a computer-generated "un-rolling and deformation" and the pictured spherical devil's claw is not so far-fetched. Even without knowing the photograph or the plant, it is reasonable to assume that the unrolling process must have followed certain rules. Only by adjusting our initial association can we discover the secret behind this plant's development.

Similar, but not by accident

One occasionally stumbles upon supposedly coinciden-
tal similarities between computer graphics and natural
phenomena. Let us consider the computer-generated
image to the right, which shows the equipotential lines
or field lines (orthogonal trajectories) of an electrical
field consisting of three symmetrically aligned linear
charges.

Let us now consider a rather special cross-section of a
tree (shown below), where two trunks appear to have
joined together. The tree rings (and their orthogonal im-
ages) appear to follow along the transversal medullary
rays. Even though the computer graphic was never in-
tended to look like the cross-section of a tree trunk, the
similarities are, nevertheless, remarkable.

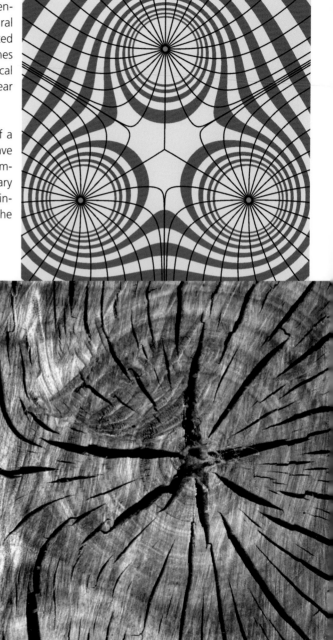

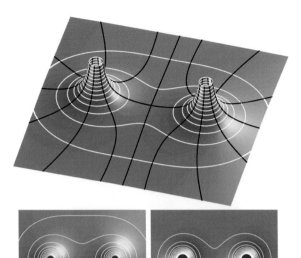

The similarity of equipotential lines to candles with multiple flames (pictured below) is much easier to explain. Instead of electrical charges, a pillar of heat surrounding each flame melts away the wax and produces a distinct shape.

The equipotential lines of electrical charges are curves of degree 4 (see small computer graphic on the bottom left). For such curves, the sum of the reciprocal of the squared distances from the fixed points is constant (see small computer graphic on the bottom right).

Such relationships are conceptually similar to the loci where the sum of the reciprocal distance squares from the two fixed points remains constant (as in the small computer graphic on the bottom right).

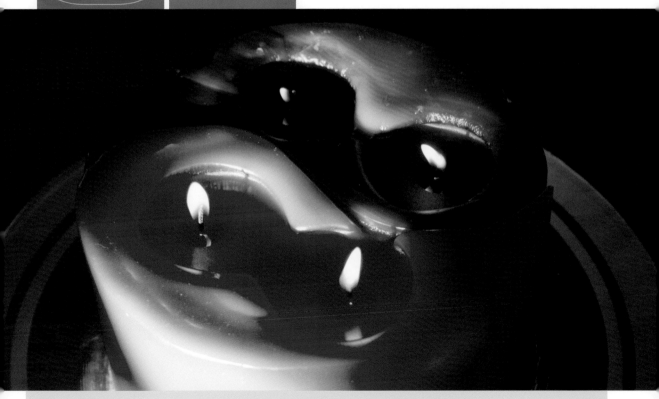

P. SMITH **Electricity – Force Lines and Equipotential Surfaces** www.astarmathsandphysics.com/
a_level_physics_notes/electricity/a_level_physics_notes_force_lines_and_equipotential_surfaces.html

Iterative shape approximation

As previously explained, nature rarely exhibits perfectly geometrical forms. In order to simulate such forms in a computer, there are several standard approaches to choose from: First of all, one may attempt to recreate the objects in a simplified way – for instance, by representing branches through approximated cylinders. One may then employ CAD software to bend the models into shape by using free-form surfaces, achieving a closer visual approximation of the natural form. A different approach is based on scanning the reference objects in three dimensions – ideally, this process would also capture the appropriate textures, so that a very realistic visual simulation may be achieved. The methods described hitherto may be very useful, but they entail a significant disadvantage: They do not provide any deeper insight into the causes behind the natural form, or how it may have grown or developed. This makes computer simulations that generate shapes or patterns from physical

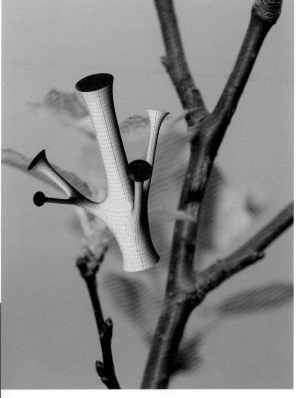

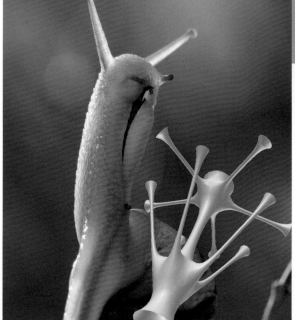

properties all the more fascinating. Several such techniques are presented in the book (for example on p. 4, p. 210 and p. 332), though this listing is by no means exhaustive. Insofar as the algorithms utilized produce workable results, it is sometimes possible to verify, that some of the approaches used during simulation actually correspond to the natural mechanisms themselves. To give just one concrete example: By connecting regular cylinders like branches and then demanding that the surface of the connecting patches be minimized step by step, we can achieve highly organic forms that closely resemble the smooth transitions between natural branching structures of various kinds.

F. Gruber, G. Glaeser **Magnetism and minimal surfaces – a different tool for surface design**
Computational Aesthetics in Graphics, Visualization, and Imaging (2007), pp. 81-88
F. Gruber **Vom Magnetismus zur Minimalfläche** http://sodwana.uni-ak.ac.at/geom/mitarbeiter/files/flaechendesign.ppt

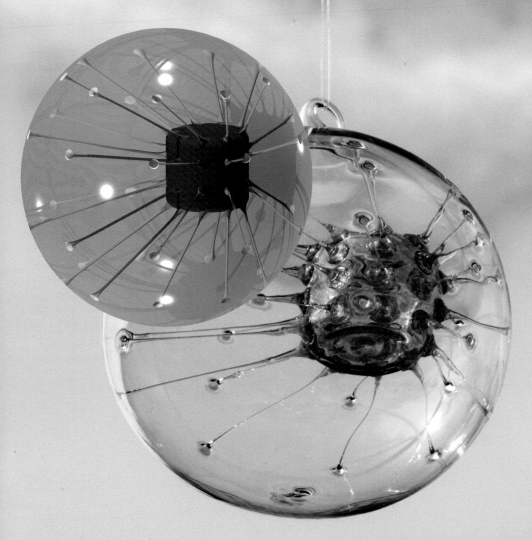

The image on the left page in the top right corner illustrates that natural branches may very well adhere to such principles of surface minimization. In the case of the image in the bottom left corner, the artist never attempted to model an exact snail – mollusks tend to continuously change their shape anyway, much like amoeba. However, it is hard to deny that the smooth transitions at the extrusions of the computer simulation exhibit snail-like characteristics. One may try to simulate other types of real objects to benchmark the effective-

ness of such an algorithmic approach. Here, a rather original glass sphere was simulated, into which a cylinder was imprinted at very high temperatures.

Gravity, and the forces of contraction that arise during cooling, produced a rather bizarre but remarkably organic figure. The result of our simulation fits its template very well, which suggests that the simulated forces may actually have contributed to giving the real object its form.

Rhombic zones

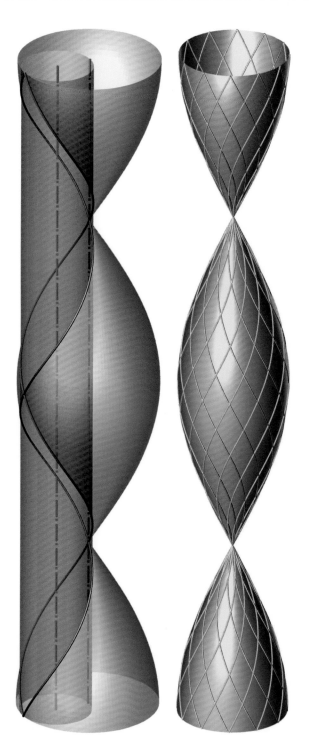

Let us consider a surface of revolution that arises from the rotation of a Sine curve (amplitude a, blue). By intersecting it with a cylinder of revolution (orange) with a diameter of a, which includes the vertices and touches the surface at the points furthest away from the axis, we get – quite surprisingly – two opposing helices (red and gray).

One can produce any desired number of helical lines by rotating the cylinder. They form a net on the surface, which, due to its inherent aesthetics, was employed by the architect Norman Foster in the design of his famous London skyscraper.

Let us now choose an even number n of helices and inscribe $n + 1$ equidistant points on it – from tip to tip. These points form a polyhedron whose faces are rhombuses with a given constant side length. In top view, the rhombic shapes also form an equilateral rhombic grid due to the constant inclination of the helical lines. In the images below, the special cases of $n = 6$ and $n = 12$ are pictured as examples. The differences in height of the separate points also stay constant, owing to the properties of the helical line, which in turn justifies their zonohedric designation.

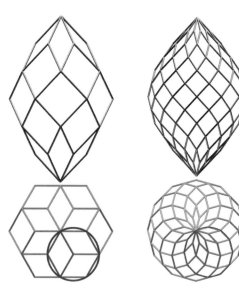

A conifer is pictured producing new sprouts, and even though it may not be strictly related to zonohedra, it, nevertheless, shows a certain resemblance. Notice the bottom sprout's view in particular, from which the circular image of a cylinder of revolution can clearly be discerned. The pine cones of conifers also resemble zonohedrons.

N. Foster **Great Buildings** www.greatbuildings.com/buildings/30_St_Mary_Axe.html
G. W. Hart **Zonohedra** www.georgehart.com/virtual-polyhedra/zonohedra-info.html

Nets of skew rhombuses

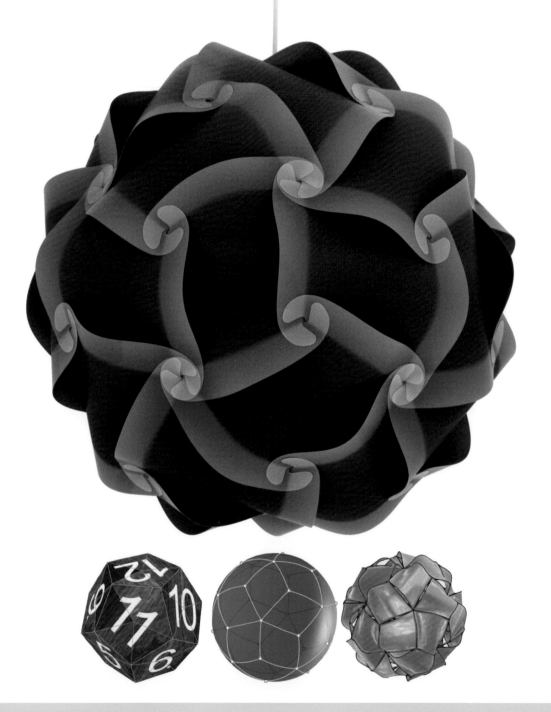

 G. GLAESER **Geometry and its Applications in Arts, Nature and Technology** Springer Wien New York 2012

A rhombus is a planar polygon. If we link together rigid rhombic plates, we get a special class of polyhedrons – so called zonohedrons (p. 38). In nature, it is impossible to tile doubly curved surfaces (such as the sphere) with exact rhombuses. However, if we distribute 32 points evenly on the surface of a sphere, they will form a net of 30 "spherical rhombuses" which are congruent with relation to each other (left page, bottom center). Thus, if we manufacture flexible plates, we can approximate a sphere relatively well. It would also be possible to tie a net from 60 ropes of equal length, and to enmesh a sphere in this way.

Another type of net fits a so-called pseudosphere, where each point is the intersection of only four ropes, made from a square net. Fishermen worldwide employ nets of this kind (big picture). The small photo below pictures a model constructed from flexible metal plates.

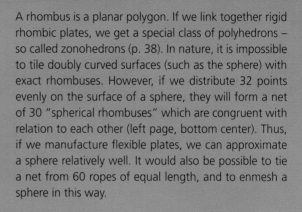

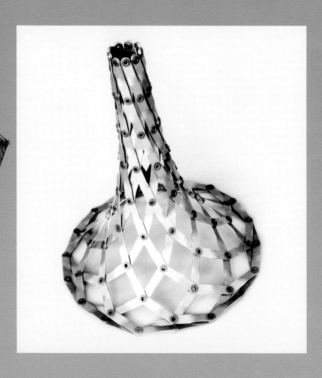

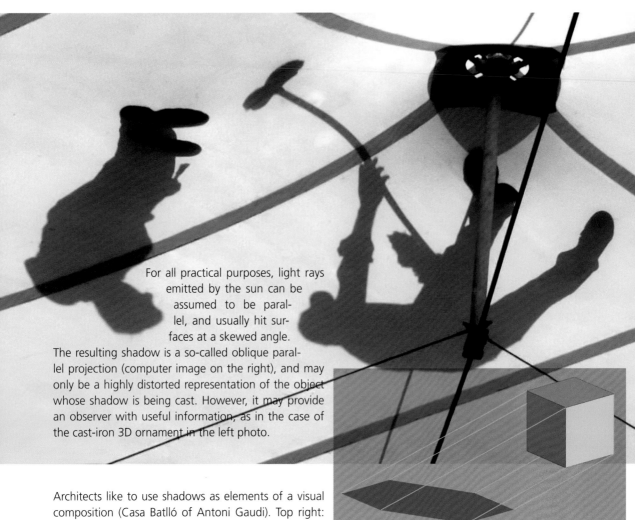

For all practical purposes, light rays emitted by the sun can be assumed to be parallel, and usually hit surfaces at a skewed angle. The resulting shadow is a so-called oblique parallel projection (computer image on the right), and may only be a highly distorted representation of the object whose shadow is being cast. However, it may provide an observer with useful information, as in the case of the cast-iron 3D ornament in the left photo.

Architects like to use shadows as elements of a visual composition (Casa Batlló of Antoni Gaudí). Top right: Within just half an hour, the "zebra patterns" mutate completely. Bottom right: The further apart the spatial point and the shadow point, the less sharp the shadow of the handrail appears. This is due to the fact that the sun on the firmament has a diameter of 0.5°, producing a very sharp light cone (with an aperture angle of 0.5°) at every point.

The diminishing sharpness of the shadow is evident in the photo (especially in the encircled part). In both photos, the incident light (orange) appears to be parallel, which implies that the light rays incide orthogonally with respect to the optical axis.

ⓘ WIKIPEDIA **Oblique projection** http://en.wikipedia.org/wiki/Oblique_projection

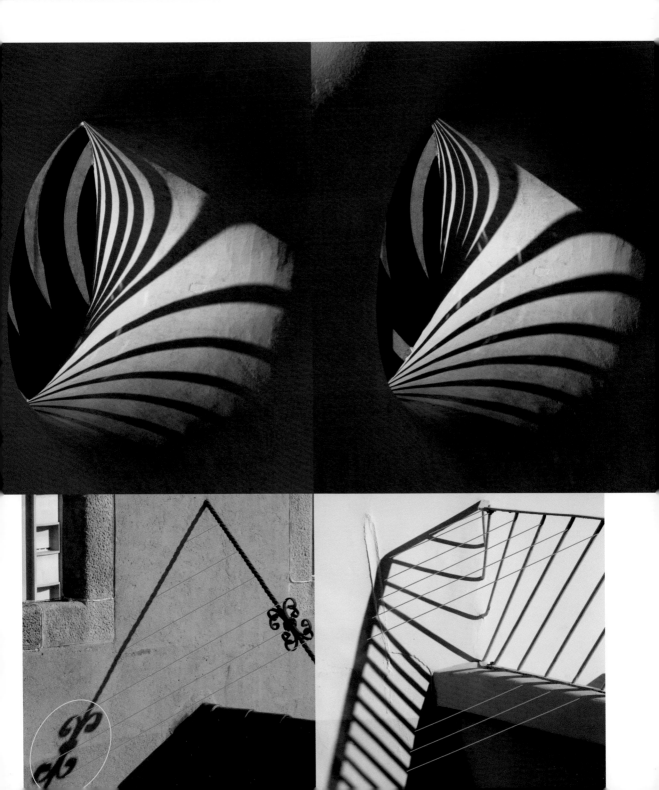

Fibonacci and growth

Leonardo da Pisa – commonly known as Fibonacci – was one of the most significant European mathematicians of the middle ages. He was the first to conceptualize the so-called Fibonacci sequence of numbers 1, 1, 2, 3, 5, 8, 13, 21, 34, etc., which can be expressed recursively through $F(0)=F(1)=1$, $F(i+1)=F(i)+F(i-1)$. Thus, a sequence number is the sum of the previous two numbers. One might also say that the n-th element in the sequence is smaller than the sum of the first $n-2$ elements. It can be shown that the quotient $F(n)/F(n-1)$ quickly converges towards $\Phi = (1 + \sqrt{5})/2 = 1,618\cdots$ and that large Fibonacci numbers can be relatively accurately represented through the formula $F(n) = c\,\Phi^n$ (with $c = \Phi/\sqrt{5} \approx 0,7236067$).

Fibonacci numbers are closely related to the exponential function. The coordinate system below shows the first 27 Fibonacci numbers, although the ordinate is shrunk by 10000 due to $F(27) = 317\ 811$. Fibonacci himself used an easily comprehensible example from nature to explain his sequence: A young pair of rabbits (image on the left side) takes a month to reach fertility and can thus produce further specimen every other month. The offspring themselves take one month to reach their reproductive maturity.

This evidently leads to exponential growth, which proceeds so quickly, that the death of the older generations bears little significance on the survival of the group. Such an approach to reproduction or subdivision occurs very frequently in nature, even though its inherent mechanisms are not so mathematically simplified: The distribution of genders, for one, is never exactly 1:1 – for rather complex reasons which have nothing to do with the Fibonacci sequence.

The close relationship between the whole-number Fibonacci sequence and exponential growth is often evident when observing the development of blossoms. Some claim to be able to discern spirals proceeding in two separate directions, with their quantity being equal to two subsequent Fibonacci numbers (p. 258). The number of flower petals frequently corresponds to a Fibonacci number as well.

$n = 0$ 1 2 3 4 5

$F(n) = 1$ 1 2 3 5 8

$F(n)$

n

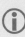

The fern on the left exhibits remarkable similarities to the right image of tire tracks in the snow. But where do the actual similarities lie? There is a middle line, from which two sets of branches extrude at roughly constant angles. The similarity is further improved by the extreme perspective of the photo on the right, as the distances between the branches appear to shrink in the direction of the tip.

The fern had to be photographed from the front in order to appear sharp in the picture. If we now compare the branching distances, we will come to the conclusion that they follow an arithmetic series. By and large, each distance follows from the previous one by the addition of a constant, and after a finite number of points, this distance converges towards zero.

The tire tracks display a typical projective scale. The angle and composition is comparable to a picture of train tracks running towards the horizon. This means that in theory, an infinite number of branching points would fit in the image.

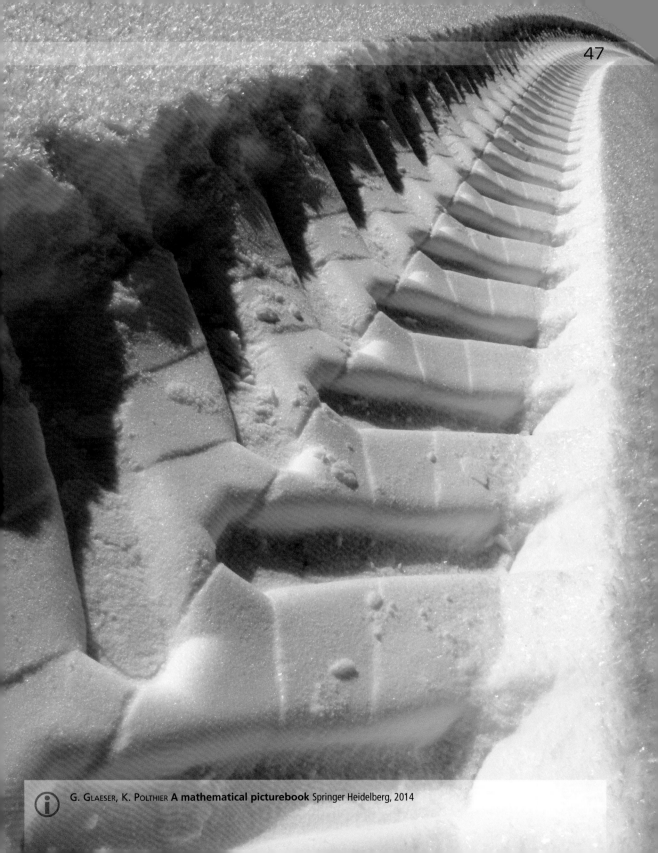

G. GLAESER, K. POLTHIER **A mathematical picturebook** Springer Heidelberg, 2014

The volume of a wine barrel

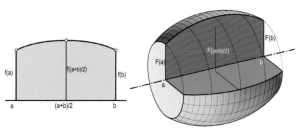

The volumes of solids of revolution are usually calculated through integration, where the meridian has to be expressed as a function graph $y=f(x)$. Insofar as the integral is given explicitly, we are able to immediately derive a correct formula. In practice, $f(x)$ may not be given, or the volume integral may only be solvable in an approximated manner.

Kepler managed to describe a very useful formula for the estimation of barrel-shaped volumes. His approximation works better, the more the meridian resembles a parabolic arc. The volume of the solid of revolution can be calculated by an average of the cross-sections at the beginning, at the end, and at the center (which counts four times).

$$V = \frac{b-a}{6} \left[F(a) + 4\,F(\frac{a+b}{2}) + F(b) \right]$$

Let us use Kepler's insight to quickly estimate the length of the gigantic wine barrel at the Croatian winery of Kutjevo. We need not estimate its volume, since it is given on the barrel itself: 53 520 liters, or about 54 cubic meters. The ladies in front of the barrel are roughly 165 cm tall, and because the front diameter of the barrel is about twice their size, we can estimate a cross-section surface of about 8-9 m². The diameter at the center should be approximately equal to 10-11 m². These figures would indicate the following approximation (we need not calculate this very precisely, since our mathematical chain is only as strong as its weakest link):

$$54\,\mathrm{m}^3 = \frac{b-a}{6}\,[8{,}5 + 4 \cdot 10{,}5 + 8{,}5]\mathrm{m}^2$$
$$\Rightarrow b - a \approx 5{,}4\,\mathrm{m}$$

The largest wine barrel in the world is located in Heidelberg (Germany), and holds roughly four times the volume of its Croatian counterpart. The length scales would here have to be multiplied by $\sqrt[3]{4} \approx 1{,}6$. Let us now attempt an unorthodox segue into a completely different world: A mosquito attached itself to my left hand (such experiments should only be attempted in

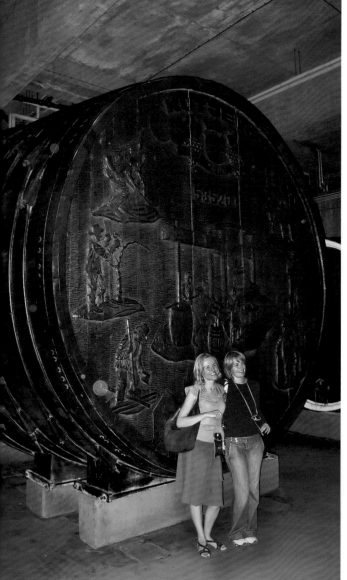

malaria-free regions). How much blood did it manage to extract?

The shape of the insect's blood container seems well suited for Kepler's formula. If we assume the shape of the insect's body to be a symmetrical spindle, we may further assume the boundary cross-sections to have an area of zero. The length of the spindle corresponds to roughly 10 mm, and the middle cross-section to 7 mm², or a diameter of roughly 3 mm. It follows that

$$V = \frac{10\,\text{mm}}{6}\,[0 + 4 \cdot 7 + 0]\,\text{mm}^2 \approx 46\,\text{mm}^3$$

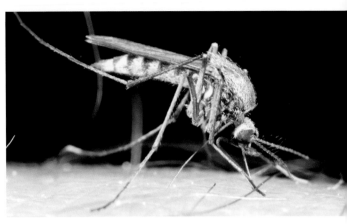

20 mosquito stings would, thus, extract a volume of 1 cm³ (1 milliliter). From the picture on the right, it is apparent that this volume is wholly composed of blood. The loss of blood is, thus, largely irrelevant in our annoyance at these pests. The anti-coagulant liquids that they inject, and the myriads of diseases that they transmit, appear to be far more significant.

Mosquito stings are distressing and dangerous to both humans and animals: Over 1.5 million people die of malaria every year. Due to climate change, mosquitos in the Earth's tundra regions manage to reproduce much sooner during the final phases of winter than just a few years ago. This drives herds of caribou into the inhospitable mountains, where food is relatively scarce.

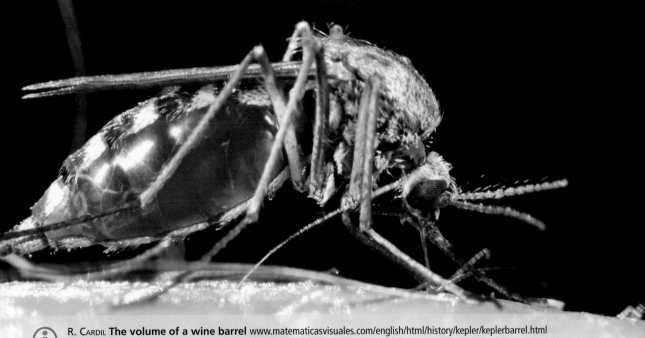

R. Cardil **The volume of a wine barrel** www.matematicasvisuales.com/english/html/history/kepler/keplerbarrel.html
Wikipedia **Heidelberg Tun** http://en.wikipedia.org/wiki/Heidelberg_Tun

At times, shoaling fish or flocking birds seem to „dance" in the water or in the sky. One might be excused to think that there is a complicated and deliberate choreography behind it.

Animals often gather or travel together in large numbers. In many cases, this swarming behavior takes place in defense against predation.

But how can we explain the complex and intriguing movements of swarms, as these collections of animals change directions within a fraction of a second, split up into groups and then reunite? One might assume the existence of an "alpha specimen" that determines the movement of the swarm. But how is it possible that this individual always stays at the front of the pack?

In fact, there is no such leader of the pack. All members of the swarm are equal during motion and merely follow three very simple rules:

1. Move in a common direction.
2. Always keep a certain distance to your neighbours.
3. If a predator is approaching, escape.

In moments of danger, the distances between neighbours increase due to reaction time. The swarm becomes wider and may even „tear apart", but as soon as the predator has left the scene, the remaining group usually reunites.

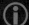

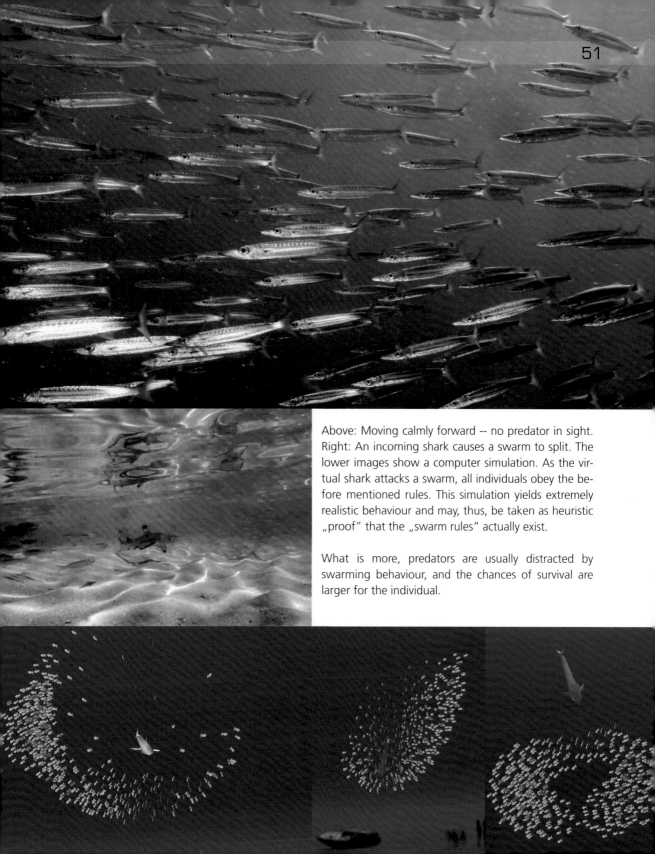

Above: Moving calmly forward -- no predator in sight. Right: An incoming shark causes a swarm to split. The lower images show a computer simulation. As the virtual shark attacks a swarm, all individuals obey the before mentioned rules. This simulation yields extremely realistic behaviour and may, thus, be taken as heuristic „proof" that the „swarm rules" actually exist.

What is more, predators are usually distracted by swarming behaviour, and the chances of survival are larger for the individual.

3 Stereopsis or spatial vision

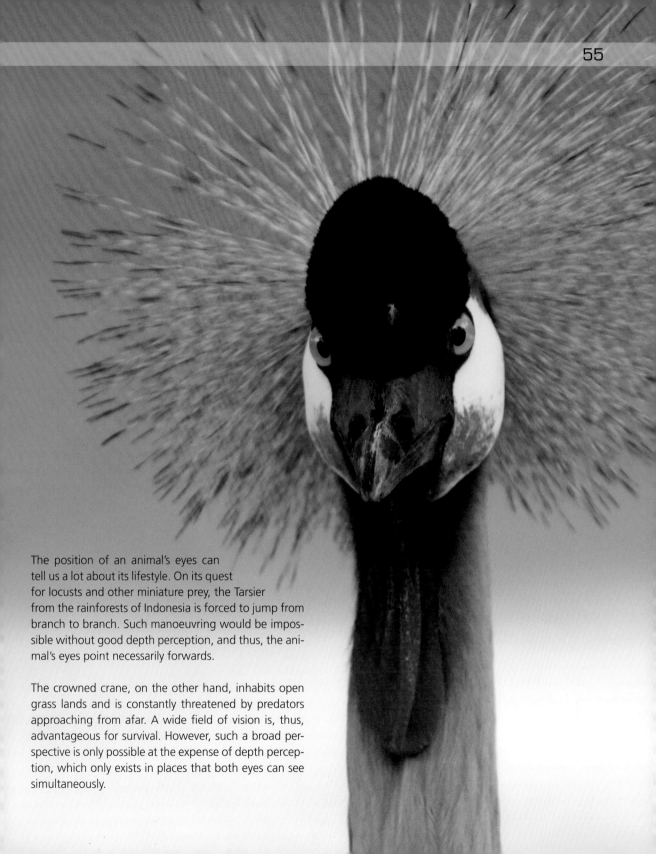

The position of an animal's eyes can tell us a lot about its lifestyle. On its quest for locusts and other miniature prey, the Tarsier from the rainforests of Indonesia is forced to jump from branch to branch. Such manoeuvring would be impossible without good depth perception, and thus, the animal's eyes point necessarily forwards.

The crowned crane, on the other hand, inhabits open grass lands and is constantly threatened by predators approaching from afar. A wide field of vision is, thus, advantageous for survival. However, such a broad perspective is only possible at the expense of depth perception, which only exists in places that both eyes can see simultaneously.

Two projections in one image

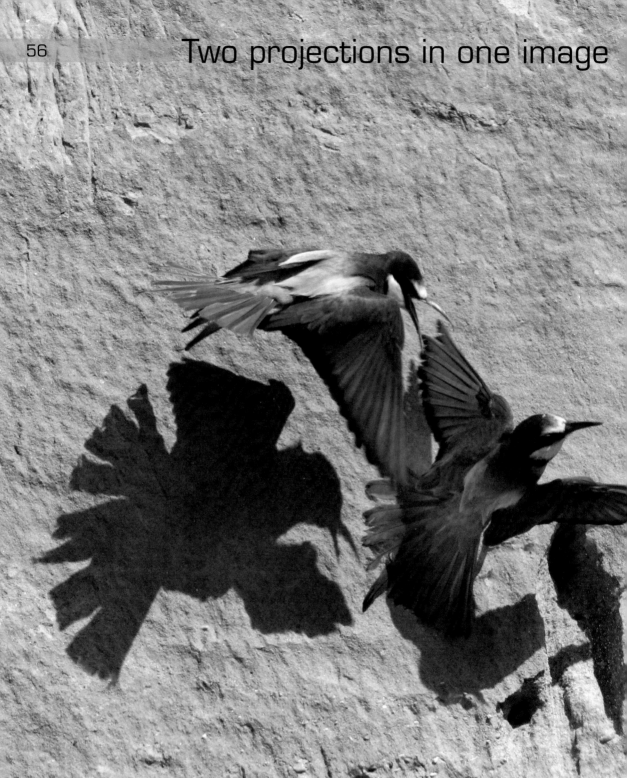

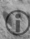 N. Bouglouan **European Bee-eater** www.oiseaux-birds.com/card-european-bee-eater.html

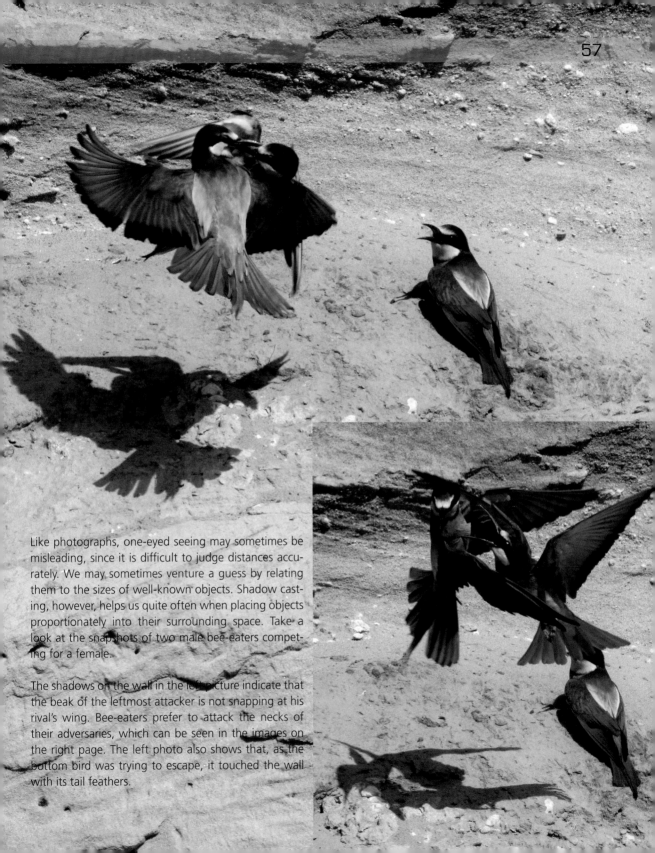

Like photographs, one-eyed seeing may sometimes be misleading, since it is difficult to judge distances accurately. We may sometimes venture a guess by relating them to the sizes of well-known objects. Shadow casting, however, helps us quite often when placing objects proportionately into their surrounding space. Take a look at the snapshots of two male bee-eaters competing for a female.

The shadows on the wall in the left picture indicate that the beak of the leftmost attacker is not snapping at his rival's wing. Bee-eaters prefer to attack the necks of their adversaries, which can be seen in the images on the right page. The left photo also shows that, as the bottom bird was trying to escape, it touched the wall with its tail feathers.

Compound eyes

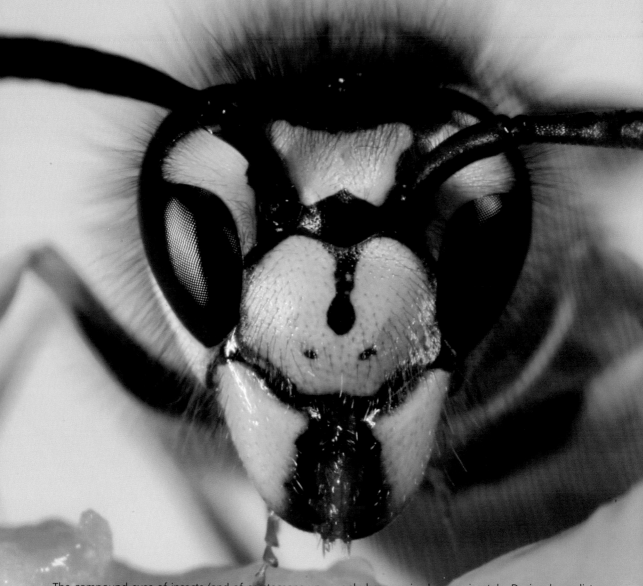

The compound eyes of insects (and of crustaceans underwater) deserve closer examination, as their visual function is often misunderstood. In larger animals, the area of view extends from about 30 cm to infinity. But anything that is more than 30 cm away from a fly is largely irrelevant to its decision-making and must only be perceived approximately. During long-distance flights, bees and wasps rely mainly on their three so-called simple eyes on the upper part of their heads (see the wasp head above). More information about the geometry of compound eyes can be found on the next spread.

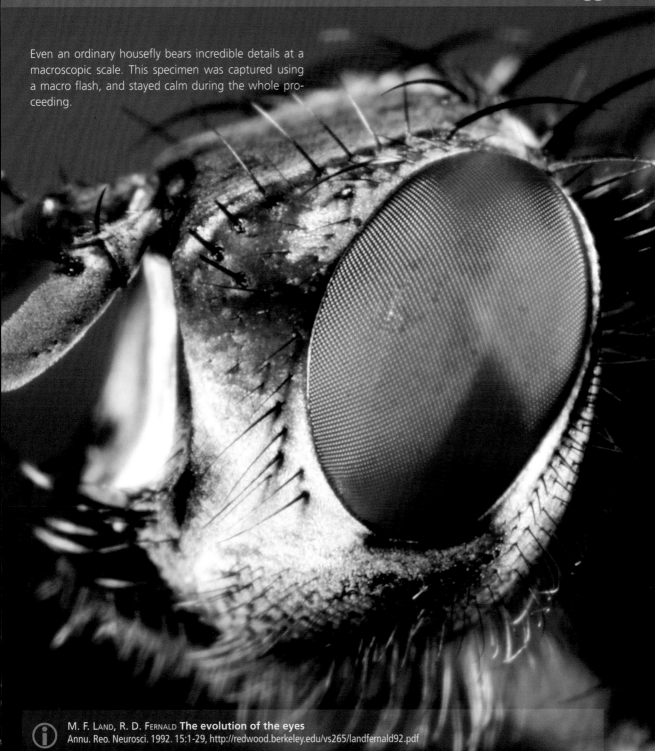

Even an ordinary housefly bears incredible details at a macroscopic scale. This specimen was captured using a macro flash, and stayed calm during the whole proceeding.

M. F. Land, R. D. Fernald **The evolution of the eyes**
Annu. Reo. Neurosci. 1992. 15:1-29, http://redwood.berkeley.edu/vs265/landfernald92.pdf

Distance tables

The less compounds there are in a compound eye, the less visual acuity is available to the animal. However, even simple eyes possess an astonishing feature:

Since the eyes of insects are immobile, each compound possesses a well-defined and constant axis of vision. Astonishingly enough, insects are able to use this to their advantage when measuring distances. Certain pairs of compounds – one compound on the left and another on the right eye (see the computer graphic) – are aligned such that their axes of vision intersect at fixed points. Thus, if the same point in space is detected by both compounds of such a pair, then its distance is instantly known to the animal. This technique is accurate to the millimetre, as even the slightest change at the observed point completely alters the visual image that is detected by the compound pair. This makes the insect capable of detecting slight movements without knowing anything about the structure of the physical object. Compound eyes have other advantages, such as their ability to de-

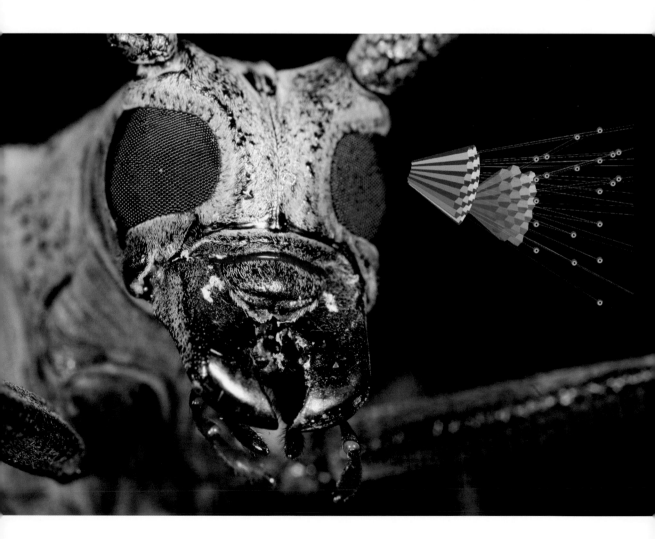

tect approximately 250 frames a second, which permits an extremely rapid reaction time. What is more, insects and crustaceans have the widest field of vision of any known life form.

Picture below: A frog's eyes, despite being lens-based, share a particular feature with compound eyes: Their orientation is fixed, which has an important effect on how the frog perceives its surroundings. Experiments with human participants have determined that, if the pictures perceived by both eyes remain completely constant, then the observer's brain stops recognizing any details within them. Within several minutes, any features or textures which could previously be seen deteriorate into blurry greyness. However, any motion which then occurs in the field of view is perceived especially vividly. Frogs put this effect to good use when detecting the faint motion of their prey. The pictured frog, however, appears to be on the lookout for a mate …

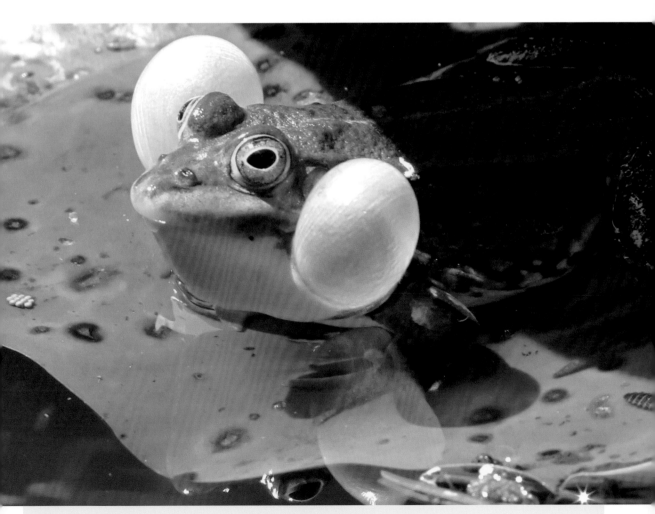

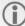 G. GLAESER, H. PAULUS **Die Evolution des Auges** Springer Spektrum, 2014

Lens eyes

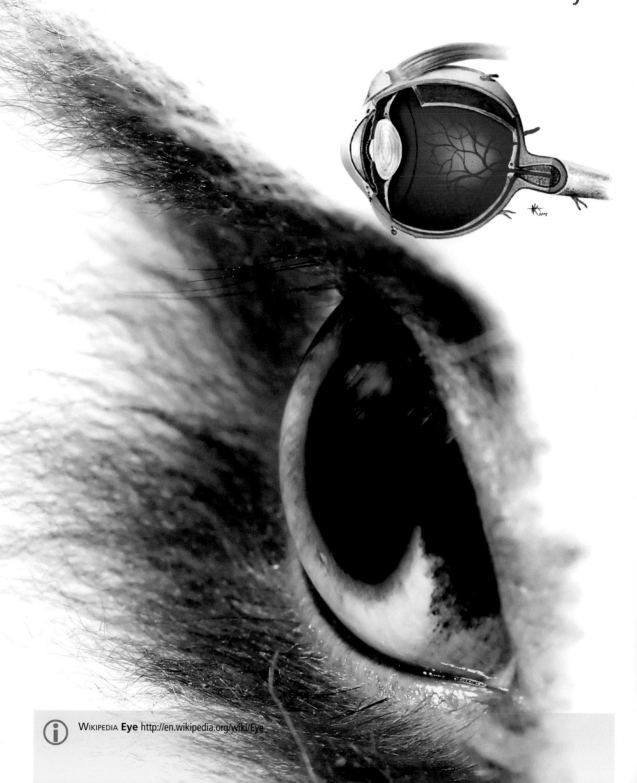

Evolution has constructed different eyes on the basis of different principles, each with their own advantages and disadvantages. The complex eyes of articulate animals may permit fast reaction times, but they require better light conditions and are unable to focus.

Both weaknesses can be compensated by a lens that resides within a liquid and whose curvature can be affected by contractions of muscles (the convex converging lens focuses light on the retina).

In relation to its own body, the tarsier (p. 54) possesses the largest eyes of all mammals. However, it is unable to move them, as the necessary muscles would require too much space. The animal instead rotates its head in the manner of an owl.

Aside from humans, many other vertebrates, insects, crustaceans, and squids are able to see colours. Cats have limited colour vision, though their eyes are much more sensitive to light. The left page shows a schematic diagram of a human and a rabbit eye. The right side shows a cat's eye for comparison.

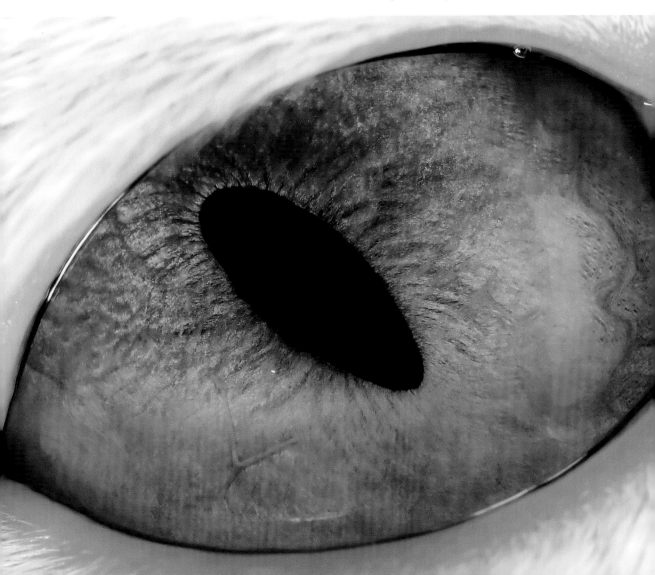

Eyes with mirror optics

Nearly all animals with lens eyes bundle light on their retina by means of refracting lenses. Some crayfish and shrimps, however, manage this trick by using compound eyes and reflection. The underlying principle is purely geometrical: What happens to a light ray if it enters a hollow quadratic prism with reflecting faces? The light ray either passes through without a reflection, or bounces around between faces until it exits the prism.

An interesting case occurs when the light bounces around between two subsequent -- and thus perpendicular -- faces: As one can see in the top view (upper right), the incoming ray is parallel to the outgoing one in this projection, i.e., the first two components of the directional vector are swapped. However, the third component (the z-value) is not affected.

We now arrange thousands of tiny prisms on a sphere (lower image), and investigate what happens to light rays that arrive from a certain radial direction. We consider all prisms whose axes are at a constant angle in relation to the incoming light. Their axes are distributed on a cone of revolution through the sphere's centre.

We now consider the intersection circle of this cone with the sphere. If the prism's diameter is very small, one might estimate that the ray exits the prism if it has been reflected in a

Reflection in an edge

Top view

single plane through the axis of the prism perpendicular to the projection of the incoming ray in direction of the axis.

All light rays that hit the sphere within this circle and are also reflected in an edge of the tiny corresponding prism share an equal angle with relation to the prim's axis (a generating line of the cone).

 M. F. Land **Eyes with mirror optics** 2000, J. Opt. A: Pure Appl. Opt. 2 R44
Wikipedia **Pseudopupil** http://en.wikipedia.org/wiki/Pseudopupil

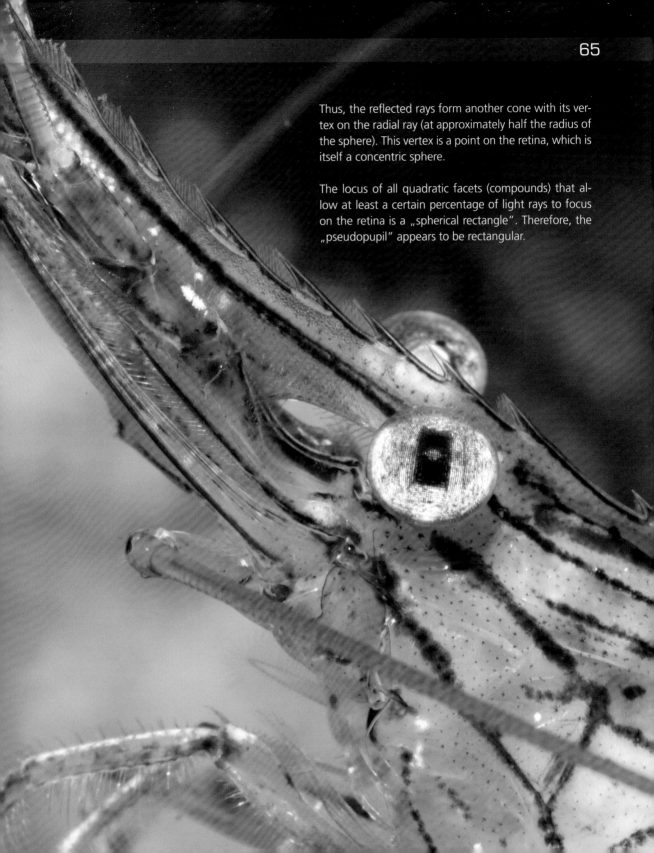

Thus, the reflected rays form another cone with its vertex on the radial ray (at approximately half the radius of the sphere). This vertex is a point on the retina, which is itself a concentric sphere.

The locus of all quadratic facets (compounds) that allow at least a certain percentage of light rays to focus on the retina is a „spherical rectangle". Therefore, the „pseudopupil" appears to be rectangular.

Using antennae for accuracy

In addition to their nostrils, through which they are able to detect smells reasonably well, snakes also possess long, dichotomous tongues. Its tips are used to propel odorant molecules towards the vomeronasal organ inside the mouth. This procedure is so precise that it allows snakes to detect the direction from which certain smells originate – scents of prey or sexual partners, for instance.

Snake eyes are covered by a transparent scale as they do not possess eyelids. They are especially adept at detecting moving objects. Spitting cobras excel at estimating distances by moving their heads from side to side and thus inducing a so-called "motion parallax".

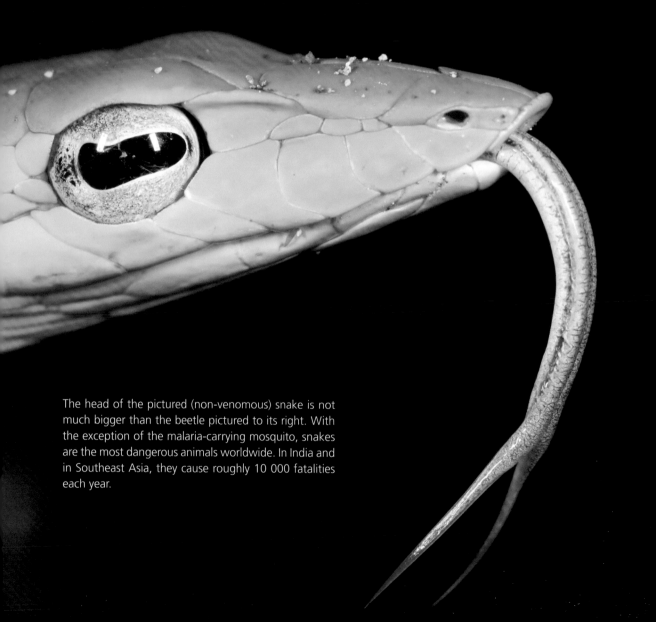

The head of the pictured (non-venomous) snake is not much bigger than the beetle pictured to its right. With the exception of the malaria-carrying mosquito, snakes are the most dangerous animals worldwide. In India and in Southeast Asia, they cause roughly 10 000 fatalities each year.

The male cockchafer is also a master at detecting the subtle scents of female pheromones. By spreading out its antennae, through which it makes contact with odorant molecules, it increases its sensory surface several times over. The little hairs which can be seen on the antennae serve as the actual receptors.

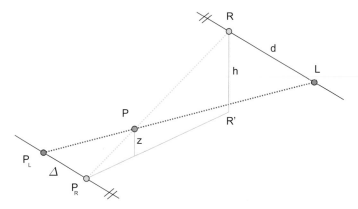

3D images continue to fascinate us, especially as 3D TV screens are gaining an ever stronger foothold in everyday households. Two images from two different spatial positions are required to create a three-dimensional illusion (see sketch). Geometrically speaking, two axes of vision must be intersected at the respective points P_L and P_R in the image. The only requirement is that LR be parallel to $P_L P_R$.

Let us calculate the height z of a virtual point P within the scene given the distances d, Δ and an eye level h. According to the theorem of intersecting lines, it follows that $(h - z) / h = RP / RP_R = d / (d + \Delta)$, which in turn leads to $z = h \Delta / (d + \Delta)$. The height of the point z is, thus,

merely dependent on the distance of the image points, regardless of their location. A change in eye level only causes an extension or a compression in the direction of the z-axis, and thus does not substantially affect the image.

Thus, in principle, the procedure seems to be rather uncomplicated. If one attempts to bend over a stereoscopically captured image of an eye, one will, with some squinting, be able to see it in three dimensions. A mirror can be used to avoid squinting (see the right page). The left image is reflected at its vertical edge and assumes its position as indicated. This method is surprisingly effective!

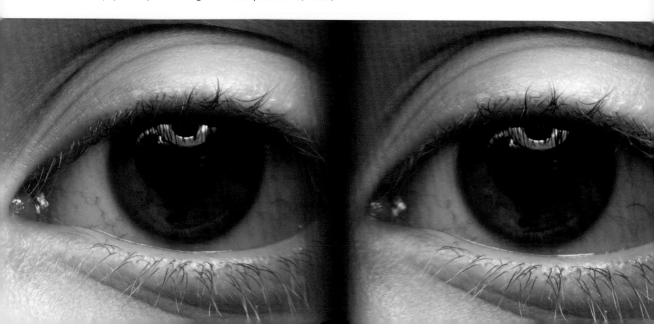

W. WUNDERLICH **Darstellende Geometrie II** BMI-Hochschultaschenbücher Bd. 133/133a, Mannheim 1967

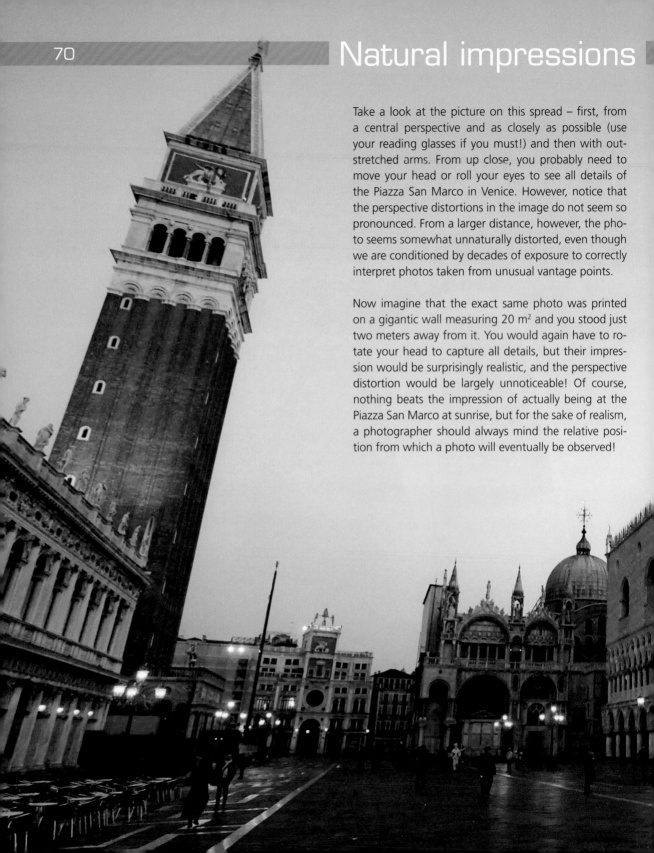

Natural impressions

Take a look at the picture on this spread – first, from a central perspective and as closely as possible (use your reading glasses if you must!) and then with outstretched arms. From up close, you probably need to move your head or roll your eyes to see all details of the Piazza San Marco in Venice. However, notice that the perspective distortions in the image do not seem so pronounced. From a larger distance, however, the photo seems somewhat unnaturally distorted, even though we are conditioned by decades of exposure to correctly interpret photos taken from unusual vantage points.

Now imagine that the exact same photo was printed on a gigantic wall measuring 20 m² and you stood just two meters away from it. You would again have to rotate your head to capture all details, but their impression would be surprisingly realistic, and the perspective distortion would be largely unnoticeable! Of course, nothing beats the impression of actually being at the Piazza San Marco at sunrise, but for the sake of realism, a photographer should always mind the relative position from which a photo will eventually be observed!

G. Glaeser **Extreme and Subjective Perspectives** http://sodwana.uni-ak.ac.at/dld/extreme.pdf

Photo stitching

A careful photographer may sometimes manage to create a panoramic composite from a series of adjacent photos, although this is not always possible. In the case of the ski jumper, this task was rather easy to accomplish due to the relative uniformity of the background. The red marking (at the height of the K-point, where the ramp is already very flat, see also p. 241) proved to be a very useful reference for this purpose. The upper edge of the guarding rail was captured as a straight line (yellow), due to the fact that it passes very closely through the lens centre, minimizing the effects of barrel distortion. Even during the computer-aided creation of panoramic pictures, straight lines tend to appear curved.

At the time when the three photographs were taken, the projection centre appeared constant (1/10 of a second apart). One might, therefore, conclude that the perspective was roughly equal. However, the whole camera -- including the sensor plane -- was also moved along with the jumper. At very small focal lengths, this would have had a significant effect, since, at increasing distances from the image center, an enlargement of the image takes place. However, due to the relatively large focal length (190 mm), this effect can barely be noticed.

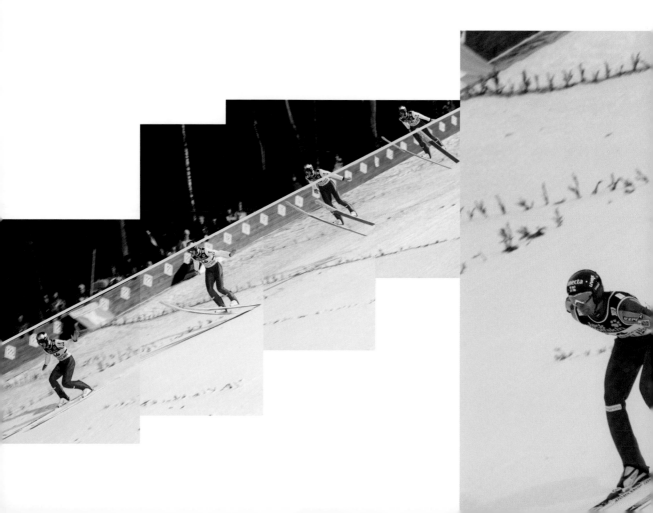

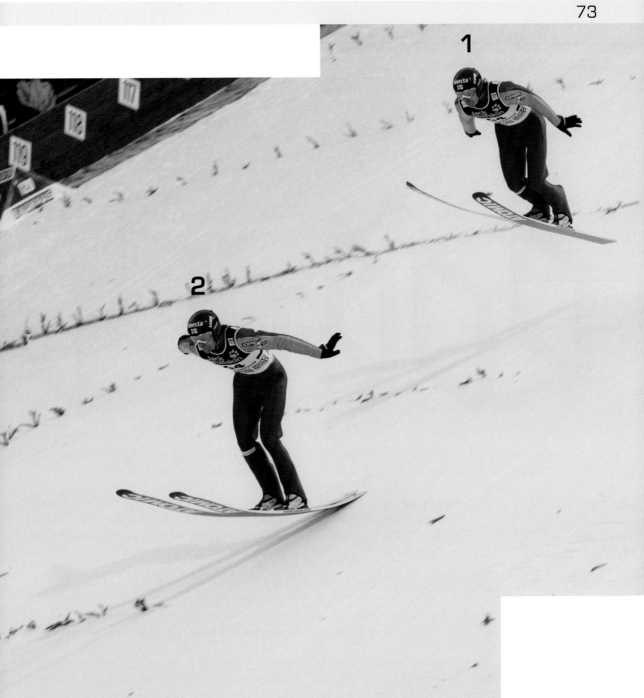

Impossibles

An "impossible" is an object which implies an apparent contradiction with regard to the visibility of its constituent parts. A classic example can be seen in the left image. The second image shows how such an object could actually be constructed, exhibiting the illusion of impossibility only from a certain well-defined perspective. This illusion can be improved by illuminating the scene diffusely – that is, without any noticeable shadows.

The question is whether such an object could be photographed in such a way that the "error" would be impossible to detect. We have to be aware of the fact that a geometrically perfect normal projection cannot, so far, be simulated by a photo camera. By employing an extremely telescopic lens (with a focal length exceeding 1000 mm), we can approach a normal projection relatively well.

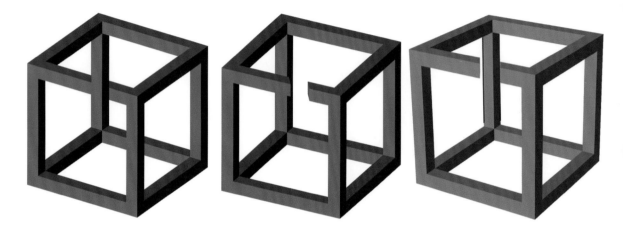

The image on the right shows the treacherous effect of perspective distortion on our seemingly impossible object. The front cuboids appear larger than the ones in the background. If we manipulate the photo such that the planes appear to be truncated by the red edges of the furthermost cuboid, then the resulting effect will be relatively seamless.

The differences in size, however, are impossible to eliminate without actually deforming the cuboid, which would make the deception much more noticeable to the inquisitive sceptic. Page 76 hints at the kind of deformation which would yield the desired effect – a so-called "elation", which plays an important role in photography. Any sharp transitions in the photograph would quickly dispel the illusion. The same is true for

our second example (see the web link), to which we shall now draw our attention.

Let us look at a cube from such a perspective that its diagonal converges in a single point. During normal projections, this produces a very regular shape (the projections of the edges form an equilateral hexagon).

Let us now group additional cubes around three of the original cube's edges (as in the upper left image), so that they form three square rods, which together produce a sort of skewed triangle. If we now omit the upper cube and one half of the next cube (bottom left), the entire structure will appear to be closed in normal projection. This is confusing, as it upsets our expectations about the visibility of the object (bottom left image).

ⓘ WIKIPEDIA **M. C. Escher** http://en.wikipedia.org/wiki/M._C._Escher
M. O. ILLUSIONS **Impossible aus Spielwürfeln** www.moillusions.com/2007/05/impossible-dices-triangle-illusion.html

The contradiction is resolved, however, if we move our vantage point away from the diagonal. In the picture, this situation was recreated with dices and an extremely telescopic lens with a focal length of about 1000 mm.

Upon closer inspection, it is possible to notice that the upper half-dice is slightly larger than the farthest one, as not even a focal length of 1000 mm is enough to exactly recreate a normal projection.

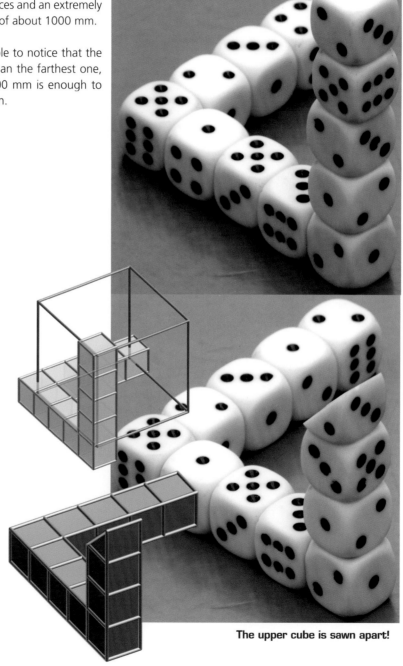

The upper cube is sawn apart!

Cuboid or truncated pyramid?

Pedestrian areas often attract talented street painters who excel at producing confusing perspectives on the pavement. If they are then photographed alongside actual three-dimensional objects or people, it can result in bizarre spatial relationships.

The large image on the left side shows a similar trick: A truck appears to transport a risky piece of cargo, and yet, things are not as they seem to be. If the pictured object was actually real, would not the cargo area protrude at a skewed angle, or at least be shaped like a pyramid? The desired effect seems to appear only if one drives exactly behind the truck.

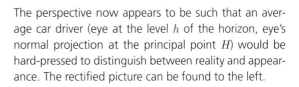

The perspective now appears to be such that an average car driver (eye at the level h of the horizon, eye's normal projection at the principal point H) would be hard-pressed to distinguish between reality and appearance. The rectified picture can be found to the left.

The top left computer simulation shows that it would, indeed, be possible to see a distorted cargo area as in the picture, which would have to assume the shape of a truncated pyramid. The image below shows the position of the lens centre Z which led to the above perspective.

In other words: From the mere position Z, an observer is unable to assess whether the pictured object is merely a flat illusion or a three-dimensional cargo area shaped like a truncated pyramid.

Such pseudo-spaces shaped like truncated pyramids have important applications in set design: Theatre and opera sets often depict spaces of seemingly infinite length that could never fit on the actual stage. By shaping these spaces as truncated pyramids, a realistic illusion can be created for at least some members of the audience.

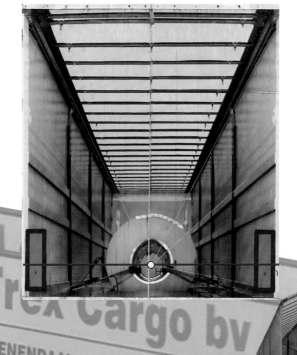

ⓘ WIKIPEDIA **Julian Beever** http://en.wikipedia.org/wiki/Julian_Beever
VOLKSAPOTHEKE SCHAFFHAUSEN **Trompe-l'oeil** http://www.volksapothekeschaffhausen.ch/Kunst%20Trompe%20l%20oeil.html

4 Astronomical vision

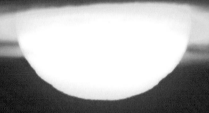

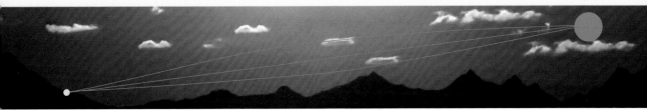

Sunrises and sunsets retain a unique fascination, despite being very familiar sights to the inhabitants of plains and coastal areas. But at what moment can it truly be said that the sun has "set"? Apparently, as soon as the last part of the solar disk has disappeared beyond the horizon. And yet, the warm glow of the sun exudes its influence on the evening sky for many minutes after that!

The last minute (series in the middle) is especially interesting: The circular disk becomes an oval, though not necessarily a symmetrical one. The changes in colour are sometimes dramatic, as in the seldom occurring "green flash". In any case, an observer with a clear view of the horizon can see the sun from "around the bend" every single day, long after it should already have disap-

peared, due to the refraction of light rays in the Earth's atmosphere, which splits up the sunrays that incide at a flat angle into spectral colours. Blue is refracted to the strongest degree – however, due to its shorter wave length, it scatters more easily and is, thus, somewhat lost in the sky.

Red and yellow tones are more likely to reach an observer, even though there are an increasing number of obstacles in the way: At such an extreme angle of incidence, the probability of being obscured by very distant clouds grows in a "tangential relationship" (see the sketch above). It thus becomes likely that the light has to pass through several layers of air of differing temperature and humidity, which leads to increasingly pronounced refractive effects (large image on the left).

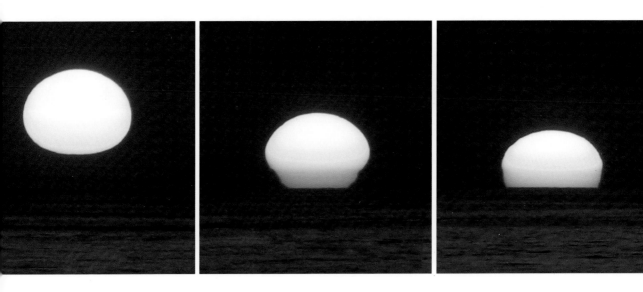

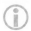 A. T. YOUNG **Explaining Green Flashes** http://mintaka.sdsu.edu/GF/explain/explain.html

Solar eclipse

5:31

5:19

5:09

Partial solar eclipse on May 31st 2003 in Vienna

The fact that the silhouettes of sun and moon in the sky are roughly equal in size frequently leads to partial and sometimes even total eclipses. Every 9 years, the moon's orbital plane matches that of the earth around the sun, and the probability of an eclipse is then at its highest. However, this does not mean that total eclipses are impossible in the intermediate years. In fact, the only requirement for an eclipse is that the intersecting straight line between the carrier planes of the earth and the moon passes through the sun. An analysis of the series of images shot on May 31st 2003 (with a then very expensive 5-mega-pixel-camera) turned out to be interesting: The first images (05:09AM to 05:19AM) were nearly useless due to the obscuring skyscraper and the clouds of smog on the horizon. From 05:22AM onwards, the sunlight was already so strong that it caused artefacts when being picked up by the imaging chip. The three photos on the next page, however, were perfectly usable. Their comparison yielded the following insights:

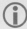 TIMEANDDATE.COM **Solar and Lunar Eclipses Worldwide – Next 10 years** www.timeanddate.com/eclipse/list.html

| 5:20:26 | 5:22:13 | 5:26:56 |

1. All three silhouettes were in fact elliptically flattened due to refraction (see page 294), and could only be bent into a spherical shape by a stretching of the whole image.

2. On that particular day, the diameter of the moon on the firmament was noticeably smaller than that of the sun (about 90%). Consequently, its distance to the Earth must have been greater than the average distance of 384400km – but even if it had been as large in the sky as the sun, it would not have caused a total eclipse on that particular day.

3. In a manner of minutes, the sun rose much higher than the moon. This was to be expected, as the relative rotation of the moon around the earth is slower than the relative (inverted) motion of sun and stars around the earth's axis.

4. During the time that this series of photographs was shot, the moon drifted to the left, which means that its path on the firmament was, on that day, more inclined than that of the sun. This relationship, which depends on numerous factors (such as the incli-

nation of the carrier plane of the moon's orbit to the earth's ecliptic), is not at all trivial and could easily have been reversed (especially in the summer half-year).

The lower image shows an interesting effect which occurs during solar eclipses: The light which passes through the leaves produces crescent-shaped patterns on the pavement (the asphalt of the Viennese Ring Street during the eclipse of August 11th 1999 at 12:55AM). The tiny holes in the leaf roof obviously acted like pinhole cameras.

When the sun is very low

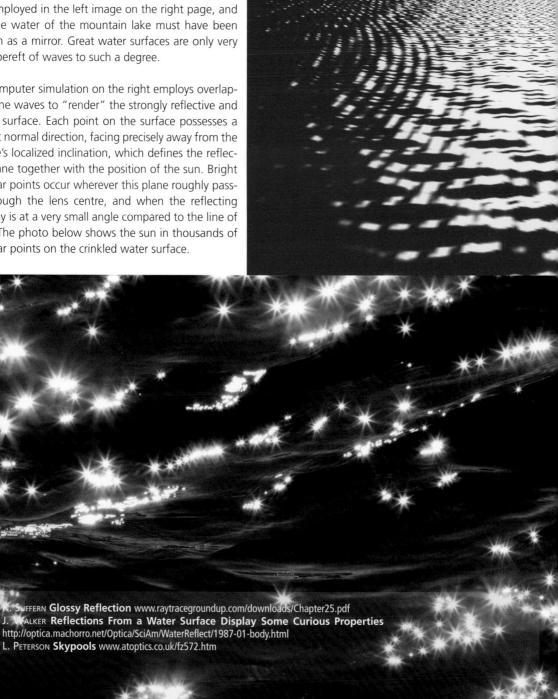

Let us consider both images on the right side: What a difference in the way that the sun is reflected! A photographer is right to conclude that a polarisation filter was employed in the left image on the right page, and that the water of the mountain lake must have been smooth as a mirror. Great water surfaces are only very rarely bereft of waves to such a degree.

The computer simulation on the right employs overlapping sine waves to "render" the strongly reflective and backlit surface. Each point on the surface possesses a distinct normal direction, facing precisely away from the surface's localized inclination, which defines the reflective plane together with the position of the sun. Bright specular points occur wherever this plane roughly passes through the lens centre, and when the reflecting light ray is at a very small angle compared to the line of sight. The photo below shows the sun in thousands of specular points on the crinkled water surface.

K. SUFFERN **Glossy Reflection** www.raytracegroundup.com/downloads/Chapter25.pdf
J. WALKER **Reflections From a Water Surface Display Some Curious Properties**
http://optica.machorro.net/Optica/SciAm/WaterReflect/1987-01-body.html
L. PETERSON **Skypools** www.atoptics.co.uk/fz572.htm

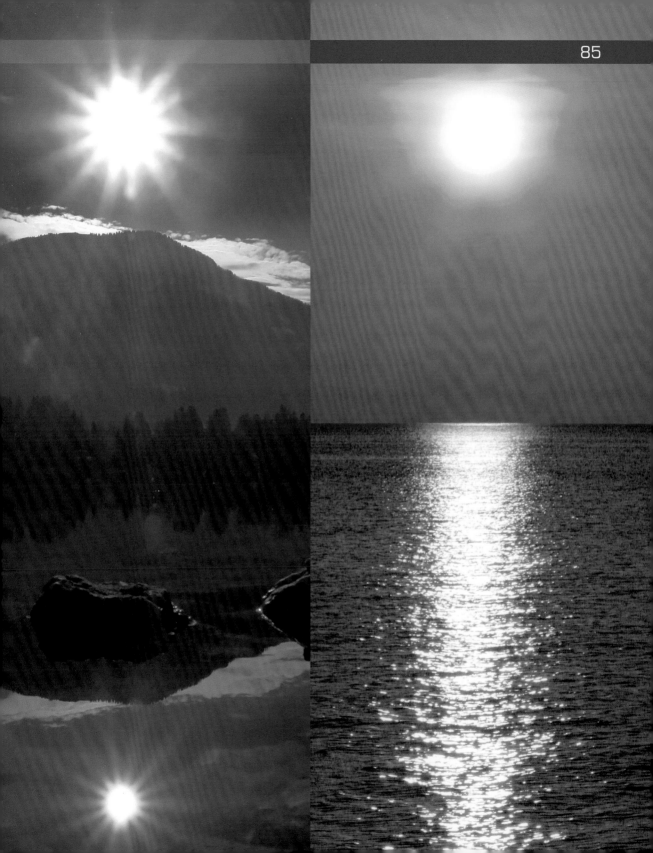

Fata Morgana

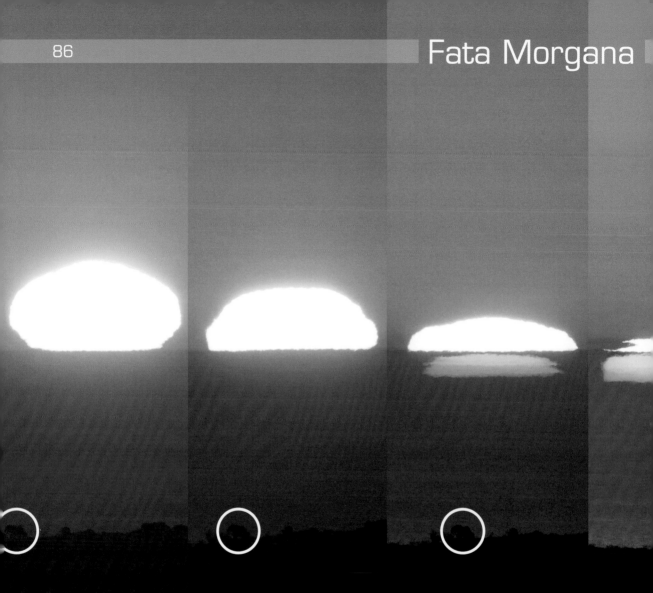

Sunsets at sea are always a special occasion, and this particular event deserved a spread of its own. Both left images are relatively familiar. From the third image onward however, something like a reflection appears to emerge, which is then increasingly distorted in the subsequent images, even though the sun has already disappeared completely. A Fata Morgana is an optical illusion caused by the refraction of light in layers of air of differing temperature and humidity. Geometrically speaking, the sun should already have disappeared from sight

several minutes before the picture was taken. Due to the low angle of incidence, the short-wavelength blue components of light were already fully absorbed by the atmosphere, while the red components still managed to be refracted around the curvature of earth. But what caused the strange reflection?

The specular points are not infinitely far away but are instead located on the water surface. In fact, due to the curvature of the earth, they can be much closer than

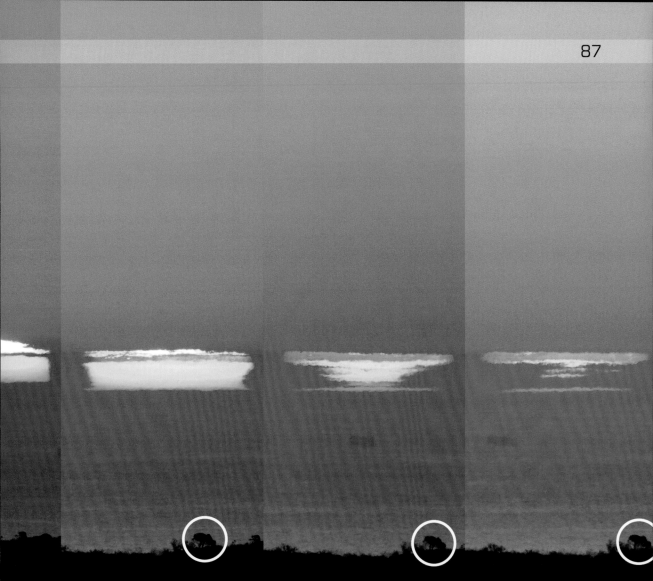

one might expect. Depending on one's height above water level, it is possible to see anywhere from several to 100 kilometres ahead, though the latter distance is only possible during clear atmospheric conditions.

The images on the right were taken a few seconds after the sun had disappeared completely. The fisherman at sea, however, would still have been able to see it. The sunrays which hit the water surface at the fisherman's position could have been detected by us, although they might have been slightly refracted, owing to the different atmospheric conditions of temperature and humidity. The series of photos was taken on the Cape of Good Hope at the end of February. On the northern hemisphere, at the same latitude, the sun sets clockwise in west-north-west direction. On the same day on the southern hemisphere, the sun sets in anti-clockwise direction towards the west-south-west. Notice the encircled tree, which appears to move one sun diameter to the right within a span of 3.5 minutes.

WIKIPEDIA **Fata Morgana** http://en.wikipedia.org/wiki/Fata_Morgana_(mirage)

The scarab and the sun

Takeoff backed by sunlight. Notice both the reflection in and the symmetrical shadow on the roof of the silver-gray car (see also the right photo on the right page).

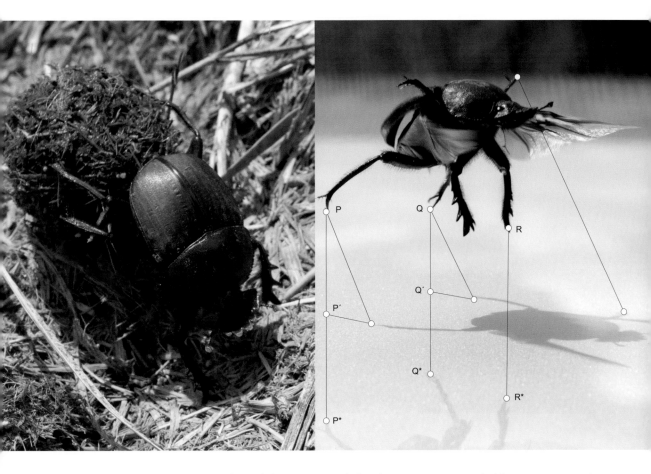

The ball-roller scarab beetle constructs spherical shapes out of dung and then rolls these masterpieces towards the sun (image on the left). This directional preference was statistically proven. The balls themselves serve as food for its larvae. In ancient Egypt, the beetle's preference of movement was correlated to the path of the sun on the firmament, which must have been the reason why these animals were deified.

Scarab beetles are, at once, veritable strongmen and efficient flyers and, like the rose chafer, employ their wings without opening their elytra. Despite all that, the photos were actually rather simple to take: Regardless of the direction in which the beetle was placed, it always turned its back on the sun and took off at the same angle. The animal was clearly using the sun for orientation, just as many other species of insects (like ants and bees) do.

WIKIPEDIA **Khepri** http://en.wikipedia.org/wiki/Khepri

Cranes consist of a large horizontal rail, which rests on a perpendicular pillar. In the strongly perspectivic image of the Sagrada Familia (Barcelona), the right angle never appears in its true size – but in the telescopic image, it does! Which conditions must be met, so that a right angle is actually perceptible as such in a photograph?

To put it in a different way: Let us assume that two rods or edges appear at a planimetric right angle in a photo. At which conditions would we be able to conclude that a physical right angle was captured?

 G. GLAESER **Geometry and its Applications in Arts, Nature and Technology** Springer Wien New York 2012, p. 65

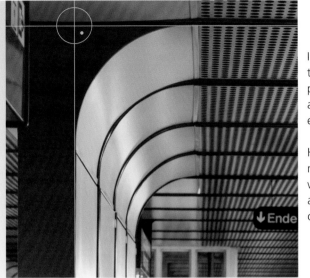

In the general case, the answer is unsatisfying: Even if the right angle in a frontal plane is parallel to the image plane (as in the top left photo), it is impossible, in the absence of additional information, to assume anything else about the angle in a general perspective.

However, it is a plain sailing if our photo depicts a normal projection instead of a perspective. In that case, we can apply the law of right angles: "A physical right-angle appears as a right-angle in an image if at least one of its legs is parallel to the image plane".

 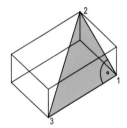

The sketch depicts three parallel projections of cuboids, along with a right-angled triangle 123 which, in a non-trivial way, also appears right-angled in the image, due to its leg 12 being parallel to the image plane.

In photography, normal projections can be approximated by using telescopic lenses (see the bottom left image), and the law of right angles can be applied approximately in such photos. We can estimate that the helicopter blades appear orthogonally whenever one of the blades is parallel to the sensor plane. This position can be found by estimating the trajectory ellipses and their axes. According to the law of right angles, the auxiliary axis is also the image of the rotor axis.

The beginning of spring

The spring snowflake (Leucojum vernum) is one of the earliest harbingers of spring and tends to blossom pretty closely to its beginning. However, this manner of date determination is much too imprecise. Mathematically speaking, the onsets of spring and autumn occur at the equinoxes.

In the year 2007, spring (and autumn on the southern hemisphere) began on March 21st at 1:07 CET. In the years 2012 to 2020, this event takes place on March 20th, but how is it possible to determine its precise time up to the minute?

The carrier plane of our earth's equator intersects the carrier plane of our earth's orbit (ecliptic) in a straight line, which, in general, does not include the sun. The first time such an event takes place in March, the intersecting straight line produced is called the Vernal equinox line. This moment is determined with minute precision. At noon on this particular day, the sun stands precisely vertically above the equator, and the earth's self-shadow boundary passes precisely through both poles. All across our planet, the day is exactly 12 hours long! Another geometrical definition is shorter: Spring or autumn begin at the moment when the sun rays are at a right angle relative to the earth's axis. This allows for an easy construction of the onset of spring: According to the right-angle theorem (see page 91), the relevant right angle appears on the ecliptic in its true size during normal projection. In the image below, the associated construction is schematically sketched, although it must be noted that the elliptical path of the earth is strongly exaggerated for the purpose of clarity.

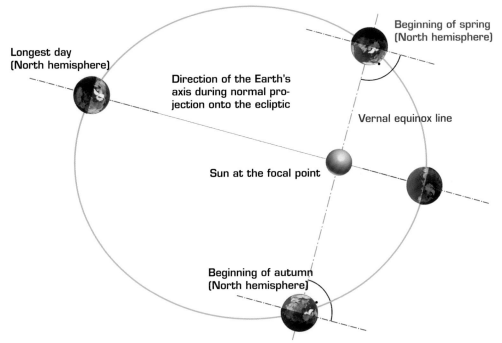

Beginning of spring
(North hemisphere)

Longest day
(North hemisphere)

Direction of the Earth's
axis during normal pro-
jection onto the ecliptic

Vernal equinox line

Sun at the focal point

Beginning of autumn
(North hemisphere)

If the perpendicular passes through the centre of the sun during normal projection of the earth's axis direction, then both equinox points can be constructed on the path ellipse. The onset of spring tends to vary slightly, due to the fact that a year measures 365.24 days. Every 25800 years, the earth's axis completes a full revolution about the normal of its ecliptic. During the same interval, the Vernal equinox line completes a full revolution about the sun.

By traditional pagan definition, Easter falls on the first Sunday following the first full moon of spring. Due to a full moon phase measuring 29.53 days, 12.37 moon phases occur each a year, and for this reason, the dates of Easter vary as much as they do.

WIKIPEDIA **Equinox** http://en.wikipedia.org/wiki/Equinox

In the photo, the axis of symmetry of the moon's crescent points obliquely upwards, even though the sun is already nearly at the horizon. Were the light rays simply refracted along it? This phenomenon tends to puzzle a lot of people, and has caused many heated discussions on internet forums. Close-ups of the moon, being necessarily telescopic, are roughly comparable to a normal projection. From the right-angle theorem (see p. 91) it follows that the crescent's axis of symmetry points towards the normal projection of the light rays.

The schematic sketch illustrates this fact: The sunray s undergoes normal projection onto the image plane (sensor plane) (s^n). Although s is assumed to be horizontal (as it would be during sunset), s^n points obliquely upwards. The same inclination of the crescent's symmetry axis occurs for every direction of the sun that lies within the plane defined by s and s^n.

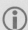 G. Glaeser, K. H. Schott **Geom. considerations about the seemingly wrong tilt of the crescent moon**
KOG13, 19-26, 2009

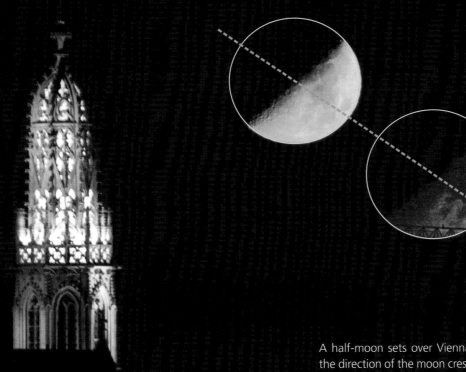

A half-moon sets over Vienna. As we can plainly see, the direction of the moon crescent's symmetry axis does not correspond to the moon's trajectory tangent (the paths of sun and moon are differently inclined at all times except when a new moon occurs). The moon's silhouette is already slightly elliptically distorted. During sundown, the red colour components tend to increase from minute to minute.

Relatively speaking, the moon moves slightly slower around the earth than the rest of the heavenly bodies. Due to its four-week period of revolution, it loses roughly 50 minutes every day. This would imply an angular velocity of 0,24° per minute, assuming a diameter in the sky of 0.5°. From this, we can conclude that the joined pictures were taken roughly 2 minutes apart.

The lower photo was taken only a day later. The moon may be far above the *Church Maria am Gestade*, but it is set to disappear half an hour later behind the city hall.

It is a common misconception that on the equator, the sun reaches the zenith every day. In fact, this only happens at the equinoxes (around March 21st and September 23rd). Within the tropics (geographical latitude $\varphi = \pm 23.44°$), the sun reaches the zenith twice a year. At the northern tropics – in Aswan (Egypt), Cuba, and Taiwan – and the southern tropics (in Rio de Janeiro), this event occurs exactly once a year.

The computer drawing on the right illustrates the locus of all possible sun positions during the course of a year for a location at the northern latitude of $\varphi = 20°$. Whenever the sunrays and the earth's axis (marked red) form a right angle along with φ, the sun can be said to reside at the zenith. The image on the right was taken on the island of Bunaken (North Sulawesi, Indonesia, 1.5° n. lat. and 125° e. lng., see Google Earth image below) on September 20th at 11:40AM. Due to the fact that the local time is measured in relation to the 120th longitudinal degree, the sun was at its absolute highest point – three days before the equinox – and the condition $\varphi + \sigma = 90°$ was thus met.

The girl was well aware of the situation and kept experimenting with the rod's shadow length. Despite the fact that shadows are at their absolute minimum when the sun is at its highest, such a light situation is actually inconvenient to a photographer.

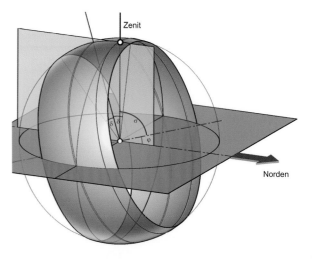

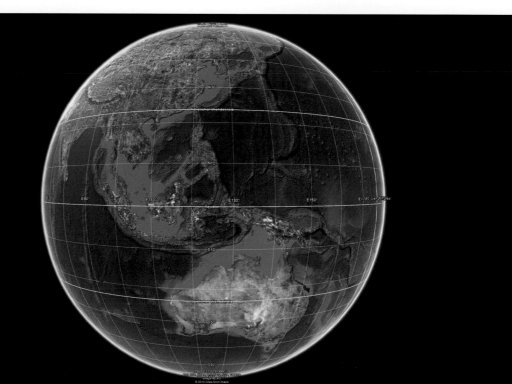

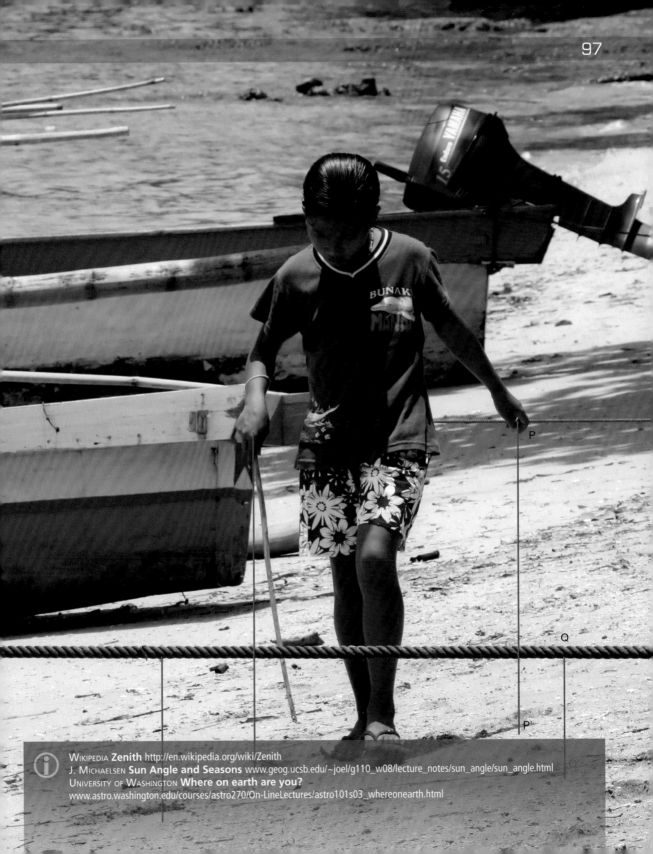

WIKIPEDIA **Zenith** http://en.wikipedia.org/wiki/Zenith
J. MICHAELSEN **Sun Angle and Seasons** www.geog.ucsb.edu/~joel/g110_w08/lecture_notes/sun_angle/sun_angle.html
UNIVERSITY OF WASHINGTON **Where on earth are you?**
www.astro.washington.edu/courses/astro270/On-LineLectures/astro101s03_whereonearth.html

Central american pyramids

Astronomy has always been a typical field of application for geometric theory. Monumental structures like Stonehenge and the Egyptian or Central American pyramids served as giant observatories for the evidently strange motions in the sky. The alignments of those structures were not only influenced by sun positions, but might also have been arranged with other aspects in mind, such as the puzzlingly extreme moon positions (one might think of lunar standstills) and the special positions of the Pleiades.

Some special constellations allowed ancient societies on three different continents to precisely determine long periods of time with nothing more than Stone Age methods -- for instance, the length of a year or the time in between lunar standstills. Coincidentally, a Venus year is almost exactly 5/8 of the sidereal year. Therefore, when the Mesoamerican astronomers observed the "August-13-phenomenon" (Pleiades at the zenith during sunrise), they also realized that in every eighth year Venus was at the same relative position in the sky.

Some temples and platforms in Chichen Itza precisely indicate important sunset directions (Google Earth image)

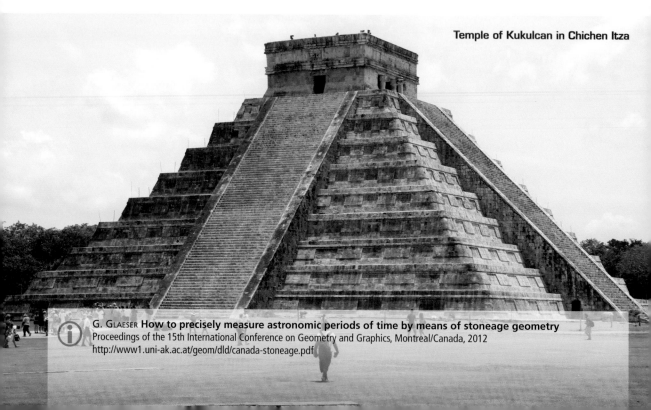

Temple of Kukulcan in Chichen Itza

G. GLAESER **How to precisely measure astronomic periods of time by means of stoneage geometry**
Proceedings of the 15th International Conference on Geometry and Graphics, Montreal/Canada, 2012
http://www1.uni-ak.ac.at/geom/dld/canada-stoneage.pdf

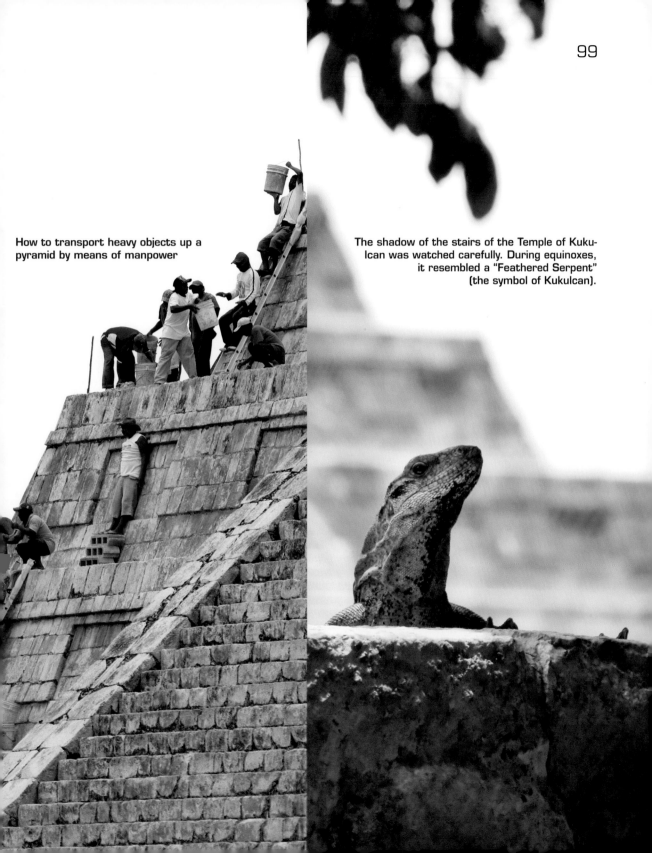

How to transport heavy objects up a pyramid by means of manpower

The shadow of the stairs of the Temple of Kuku-lcan was watched carefully. During equinoxes, it resembled a "Feathered Serpent" (the symbol of Kukulcan).

The arctic circle

At the present day, the tilt ε of Earth's axis, which is responsible for the change of seasons, measures approximately 23,44°. Several hundred years ago, it used to be 23,5°, as it oscillates "harmonically" within a rough range of 22,4° and 24,2°. This does not seem like much, but it exerts a large influence on our planet's climate.

The arctic circle is defined as the small circle on the Earth's surface where there is exactly one day on which the sun does not set.

On the Northern Hemisphere, the day of the summer solstice is exactly 24 hours long, and on the Southern Hemisphere, the same situation is repeated half a year later. This occurs at a latitude of $90° - \varepsilon = 66,55°$.

Grimsey is a small island in the North of Iceland located 40 km off the main island. The marked point of interest in the photo above is not static. Due to the continuous change in axial tilt, it is currently shifting northwards at a speed of about 1m per 70 years. The photos on the right page show polar foxes and the penguin-like but airworthy puffins which inhabit these areas. The mammals mainly pray on other mammals and on birds, which in turn feed on fish.

fall equinox

summer solstice

winter solstice

spring equinox

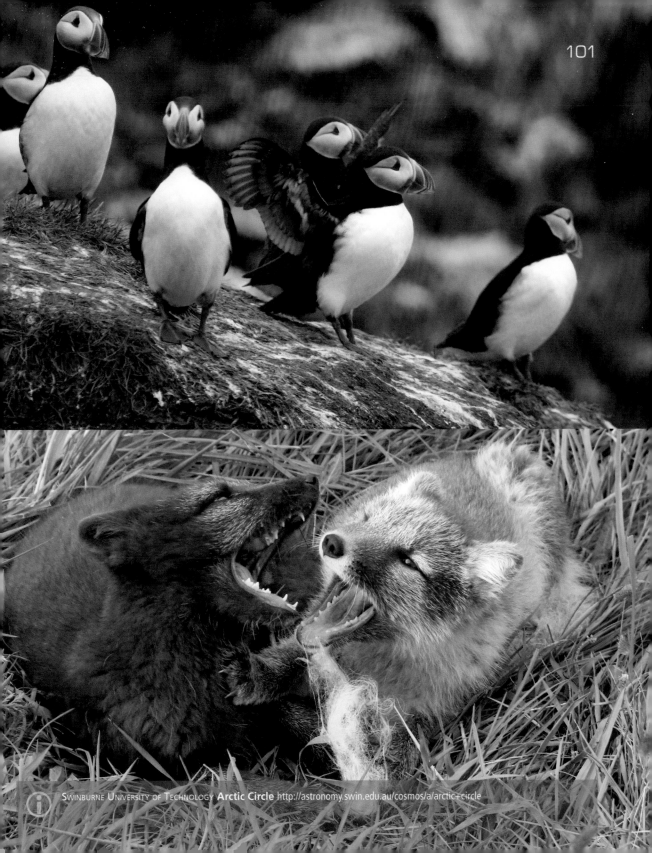

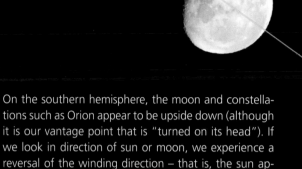

On the southern hemisphere, the moon and constellations such as Orion appear to be upside down (although it is our vantage point that is "turned on its head"). If we look in direction of sun or moon, we experience a reversal of the winding direction – that is, the sun appears to move in an anti-clockwise direction. As is the case anywhere else, however, our star tends to rise in the east and set towards the west. Strictly speaking, it only rises in the precise east and only sets in the precise west during both equinoxes.

This photo was taken in Simon's Town at the southern cape. The pictured moon was waning (!) and rises towards the upper left as the sun set roughly 1.5 hours before behind the observer.

Here you can see two further night photographs taken at the Cape of Good Hope (at a southern latitude of $\varphi = 34°$). The southern sky can be found at an elevation angle of φ. The Southern Cross is especially noticeable as it points towards a fixed location in its four- or five-fold extension (as does to the extension of Ursa Major's front axis on the northern hemisphere). If one looks at the southern celestial pole, then the sky appears to rotate anti-clockwise as usual. The Southern Cross is pictured on the flags of many southern nations (the Australian flag being a very prominent example). Both pictures were taken with a 22mm wide-angle lens. In the left image, the Southern Cross is close to the centre and can, thus, be assumed to be barely distorted. In the right image, due to its far position towards the edge of the picture, it is stretched out owing to perspective distortion. Such an extension at a predefined factor must, therefore, proceed very carefully. The position from which the pictures were taken is roughly the same. The relative rotation of the Milky Way galaxy, in which the Southern Cross is embedded, is especially noticeable.

20:48

03:27

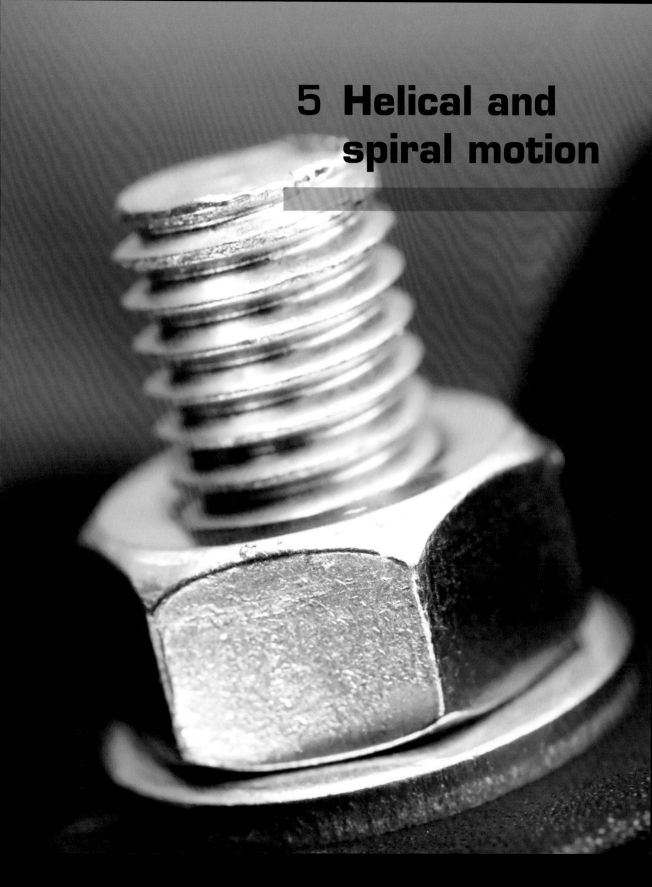

5 Helical and spiral motion

Helicoid

A helicoid can be derived by moving a straight line that intersects the screw axis at a right angle in helical motion. This spread shows several practical applications of the surface. The famous water spiral dates back to Archimedes.

 WIKIPEDIA **Helicoid** http://en.wikipedia.org/wiki/Helicoid

Thrust or lift?

Employing insights from mathematics and geometry, modern technology allows us to move relatively freely within the two fluids that are omnipresent on our planet. In water, which possesses 1000 times the density of air, movements are necessarily slower. However, this makes turbulences and differences in pressure much easier to notice.

Forward and reverse movement requires helical motion, which is defined as the relationship between a rotation about an axis and the simultaneous proportional translation along the same axis.

Mathematical methods make it possible not only to determine the optimal shape of the blade wheel, but also to simulate the emerging turbulences.

In helicopters (image above) and ships, rotation is translated into thrust or lift. In an entirely opposite process, turbines (image below) and windmills translate thrust back into rotation, which is, in turn, converted into an alternating current.

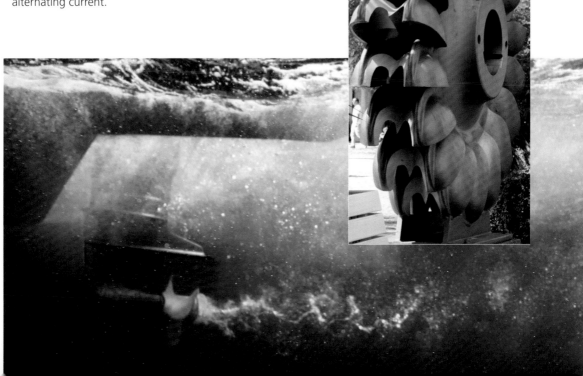

WIKIPEDIA **Kaplan turbine** http://en.wikipedia.org/wiki/Kaplan_turbine
W. JOHNSON **Helicopter Theory** Dover Books, 1980
T. VON KÁRMÁN **Aerodynamics** McGraw-Hill Education 1963

The logarithmic spiral counts among the most beautiful offerings of nature and mathematics. Despite or perhaps because of its aesthetic value, its polar equation could not be any simpler:

$$r = a^\varphi$$

This means, that the distance from the centre is exponentially related to the rotation angle. The constant a decides the speed at which the change takes place ($a = 1$ defines a circle). Antoni Gaudi was so enchanted by logarithmic spirals that he used them to encircle the ceiling light at the Casa Batlló.

The spiral's course angle φ on the right page is constant in relation to the radial rays. For the purpose of flying straight, butterflies and other airborne insects use their compound eyes to assume a constant course angle in relation to sun- or moonlight. Artificial light sources, however, are not part of their cognitive faculties. Once such insects fixate their attention on a sufficiently bright lantern, they will fly towards it on a spiral path.

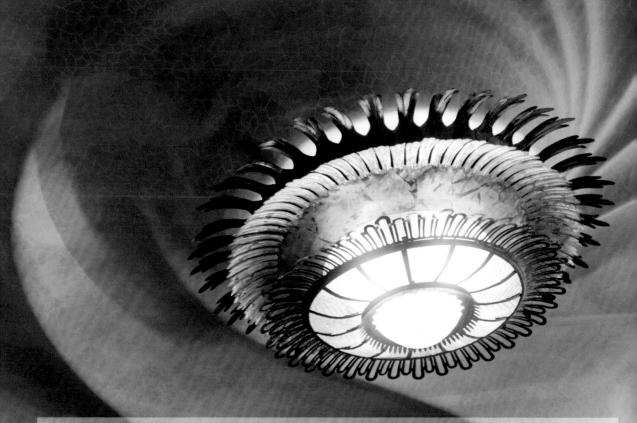

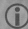
A. Gaudi **Casa Batllo** www.casabatllo.es
How Stuff Works **Why are moths attracted to light?** http://animals.howstuffworks.com/insects/question675.htm

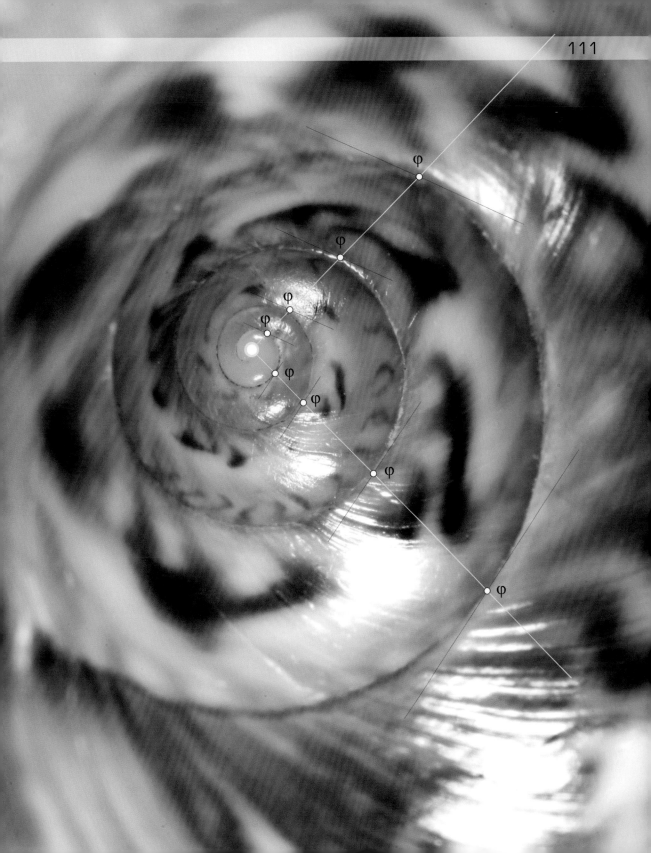

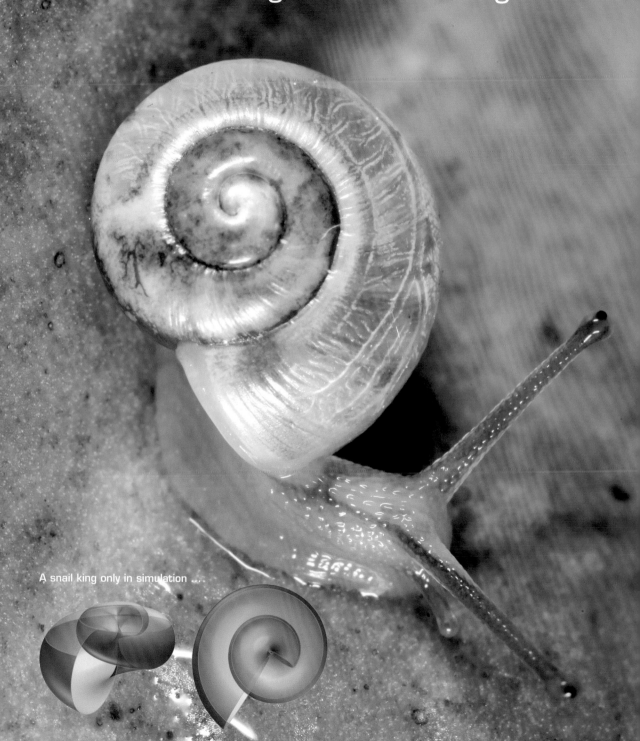

A snail king only in simulation ...

If observed from above, snail shells usually wind themselves anti-clockwise (in a positive mathematical direction), with their generating spiral growing ever smaller until its central point of origin. However, in a small number of snails (up to 1 in a million), this winding direction is reversed. The proud finders of such unusual individuals sometimes refer to their specimen as "king snails".

Snail shells can be easily simulated in a computer, as their growth proceeds exponentially in relation to the angle of rotation. Mathematically inquisitive readers will find the parameterized form of the path curve below. u denotes the angle of rotation, a is a measure for scale and b specifies the opening of the circumscribed cone.

$$x = a^u \cdot \cos u, \ \ y = a^u \cdot \sin u, \ \ z = b \cdot a^u$$

Let us now consider the "Christmas trees" below. In fact, these strange organisms are part of the species Spirobranchus giganteus of the genus Lamellibrachia, which live on coral colonies. The computer simulation below demonstrates that these tree-like bodies resemble a spiral surface very accurately. The left worm, however, is mirror-symmetric compared to its neighbour – a "king worm", as one might say!

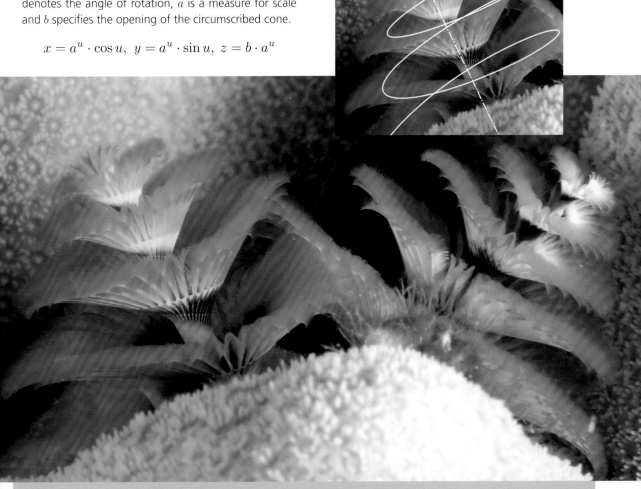

WIKIPEDIA **Spirobranchus giganteus** http://en.wikipedia.org/wiki/Spirobranchus_giganteus

Snail shells (images to the right) and clam shells (images to the left) grow exponentially. By some mechanism, the animals seem to know when this growth has to stop -- if they didn't, their size would "explode"!

When finding such houses on sandy beaches, as in the picture below, you might often wonder as to their origin. These particular specimen are the shells of Spirula spirula, a deep water mollusc, sometimes also called the "Little Posthorn-Squid". The drawing of the whole animal is by Ewald Rübsamen (1910).

We have noted earlier that snail shells tend to have the same "winding direction", but this is only true if there is no symmetry plane. Since a Spirula's shell does not have such a plane, we cannot determine whether it winds clockwise or counterclockwise. Similar situations arise in the shells of clams, which are also often symmetrical.

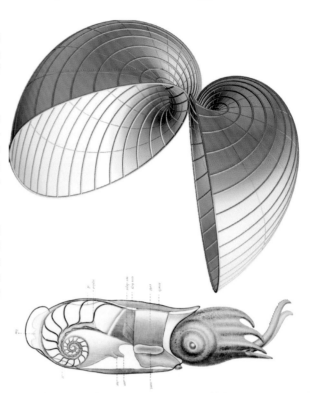

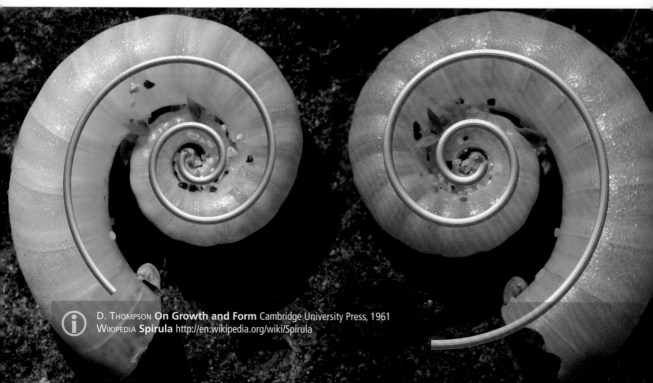

D. THOMPSON **On Growth and Form** Cambridge University Press, 1961
WIKIPEDIA **Spirula** http://en.wikipedia.org/wiki/Spirula

The interior
of a snail shell
can be quite
complicated

Sweet water snails mating

Helispirals

What do the three photos on this spread have in common? The snail shape on the cello and the moufflon's and the markhor's horns follow the same geometrical procedure: "Wind yourself about an axis and keep growing in proportion to the angle of rotation".

An object based on such a transformation is called a helispiral, which combines helical and classical spiral motion. For this reason, all three structures can easily be simulated in a computer.

G. GLAESER, H. STACHEL **Open Geometry – OpenGL and Advanced Geometry** Springer New York, 1999

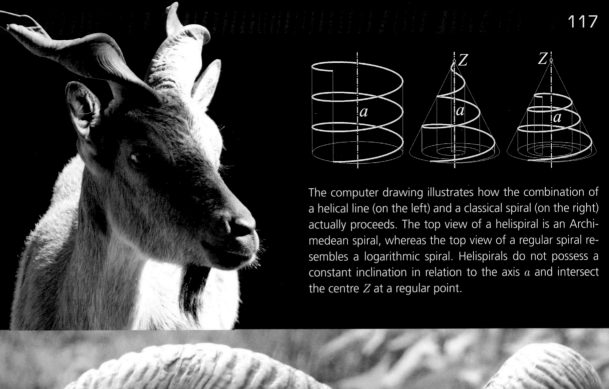

The computer drawing illustrates how the combination of a helical line (on the left) and a classical spiral (on the right) actually proceeds. The top view of a helispiral is an Archimedean spiral, whereas the top view of a regular spiral resembles a logarithmic spiral. Helispirals do not possess a constant inclination in relation to the axis a and intersect the centre Z at a regular point.

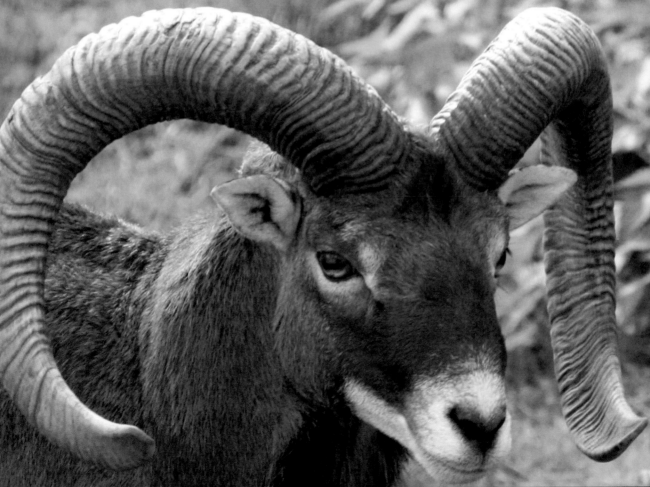

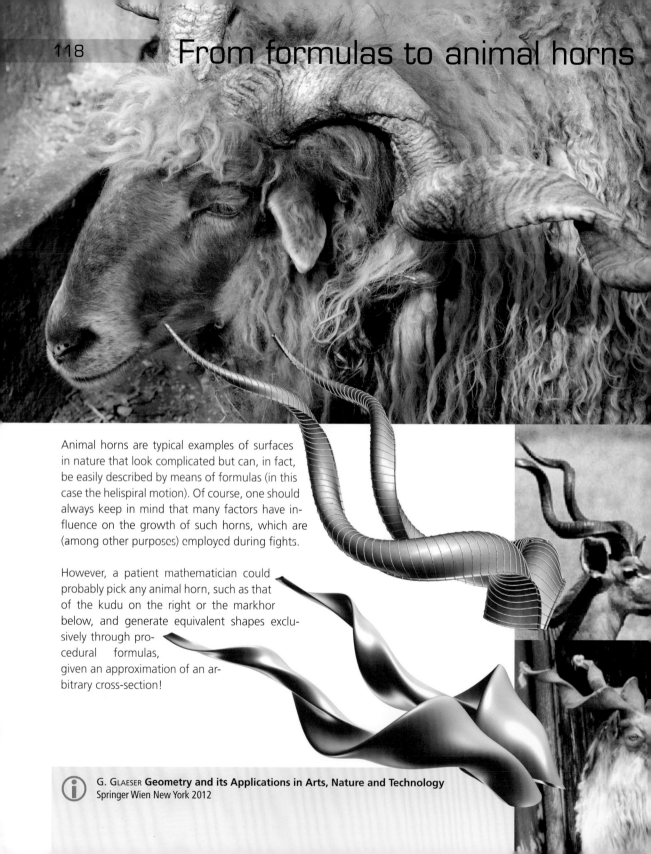

Animal horns are typical examples of surfaces in nature that look complicated but can, in fact, be easily described by means of formulas (in this case the helispiral motion). Of course, one should always keep in mind that many factors have influence on the growth of such horns, which are (among other purposes) employed during fights.

However, a patient mathematician could probably pick any animal horn, such as that of the kudu on the right or the markhor below, and generate equivalent shapes exclusively through procedural formulas, given an approximation of an arbitrary cross-section!

ⓘ G. GLAESER **Geometry and its Applications in Arts, Nature and Technology**
Springer Wien New York 2012

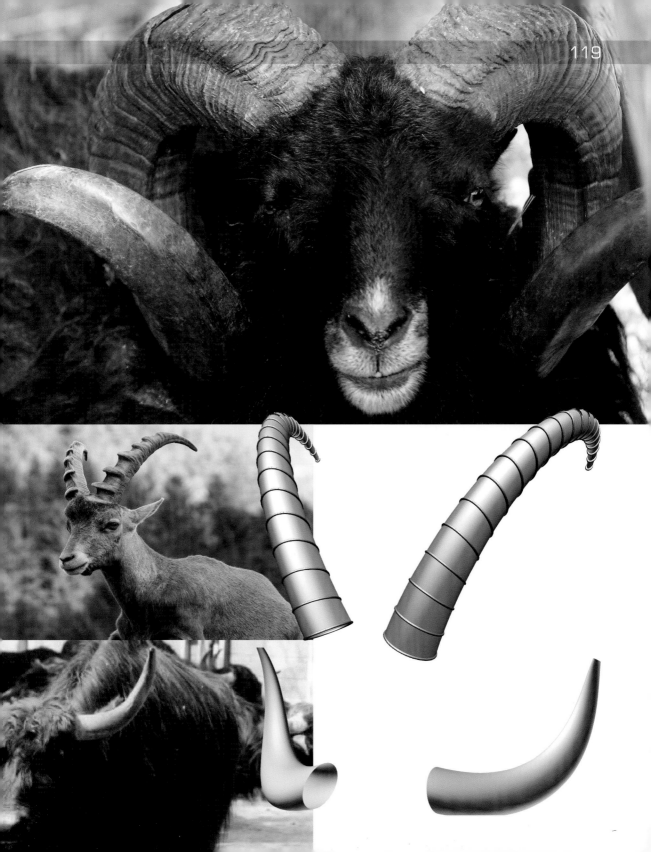

Millipedes and pipe surfaces

By moving a sphere along a generating line, it sweeps up a so-called pipe surface (or a tubular surface), which comes close to the shape of a millipede -- no matter if it is curled up or not.

Despite the name, no known millipede has anywhere close to 1.000 legs. In fact, it has two pairs of legs on each segment, so it is probably easier to count the segments and multiply this number by four.

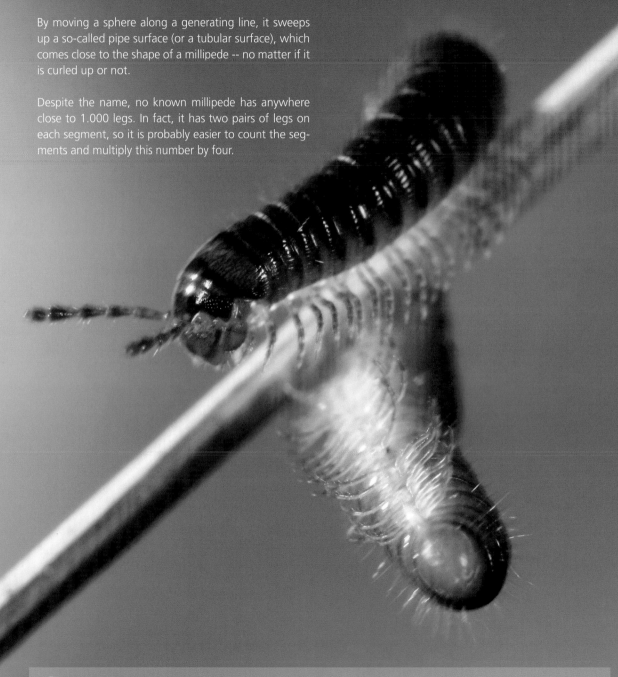

O. Karpenko, W. Li, N. J. Mitra, M. Agrawala **Exploded View Diagrams of Mathematical Surfaces**
IEEE Transactions on Visualization and Computer Graphics archive, Volume 16 Issue 6, November 2010, Pages 1311-1318
(http://vis.berkeley.edu/papers/methexpview/math_exploded_view_small.pdf)

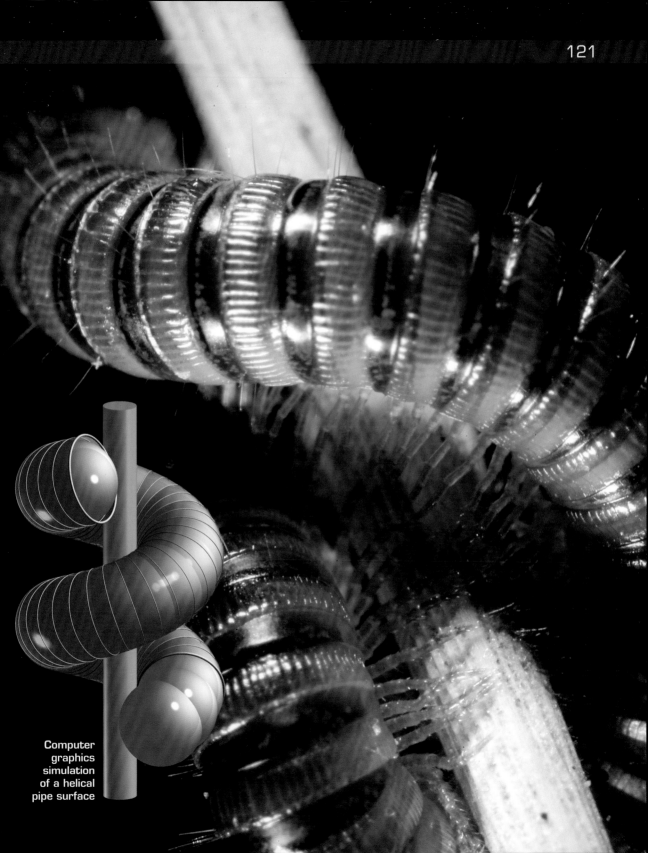

Computer
graphics
simulation
of a helical
pipe surface

While cephalopod intelligence remains controversial, it has already been proven that octopuses are able to learn by observation. For instance, they have been known to open bottles with the aid of a screw plug. In fact, screwing off a cap or a cork seems to be common behaviour: I was filming the octopus on this page with a tiny underwater camera attached to a stick. The animal was already used to my presence, having lost all of its shyness within several minutes.

It understandably became interested in the camera and it did not take long before it grasped the object. Within seconds, the camera was unscrewed, and the cephalopod almost managed to escape with it. Luckily, I had another camera with me to immortalise the event ...

Besides their powerful brain, octopuses have additional processors (quasi-brains) in each of their eight arms. They are masters of camouflage and can very quickly adapt to the colour of their background.

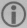

WIKIPEDIA **Cephalopod intelligence** http://en.wikipedia.org/wiki/Cephalopod_intelligence

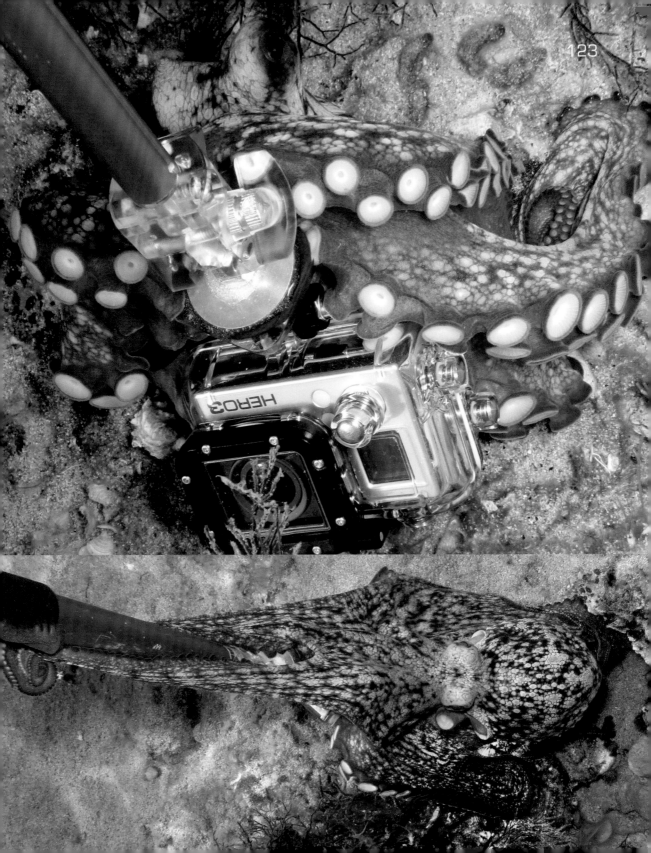

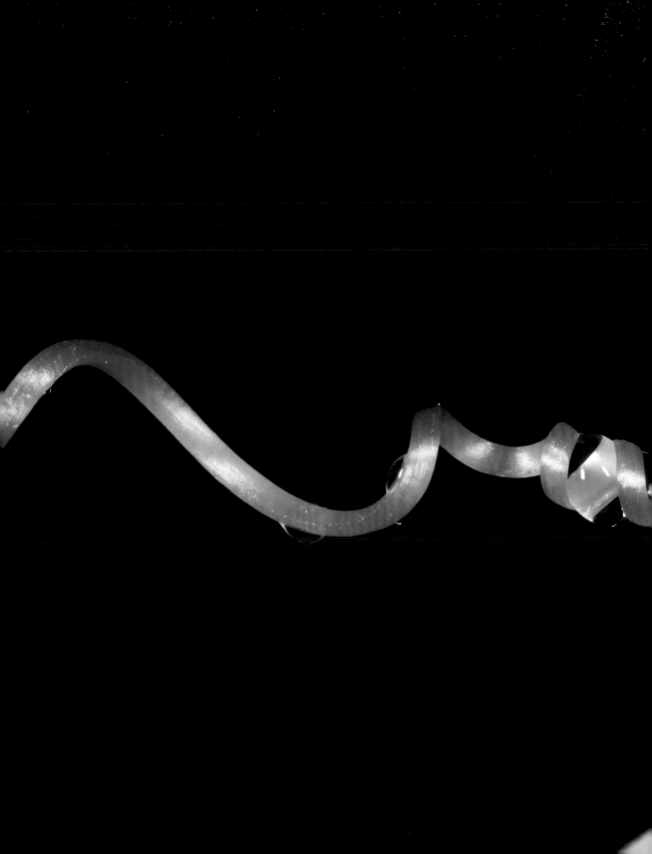

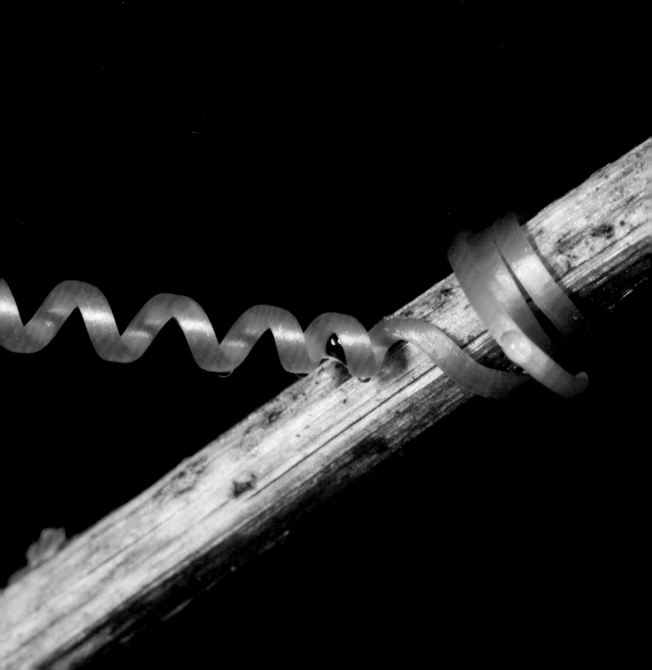

6 Special curves

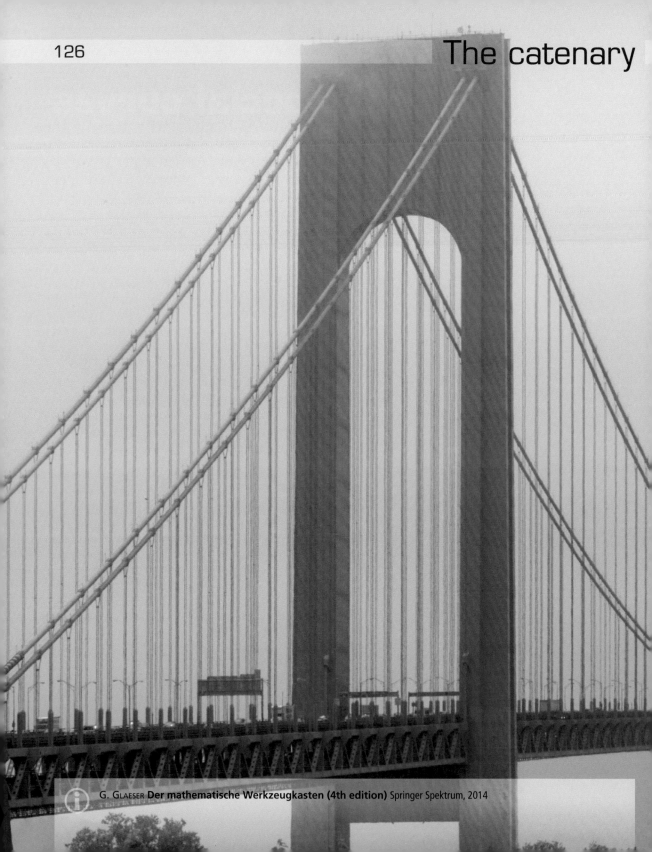

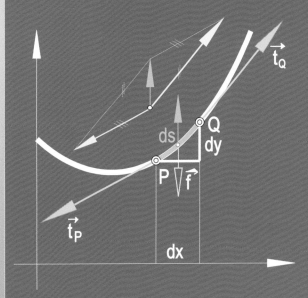

If a curve of homogenous density (such as a regular rope) is exposed to gravity, it assumes the well-defined shape of a catenary. Like a parabola, with which it shares certain visual similarities, it can be constructed by scaling a single prototype with the following equation:

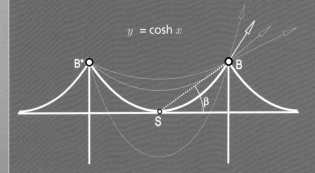

$$y = \cosh x$$

The prototype segment that assumes the above shape at $\beta = 34°$ is optimal for hanging bridges, for it minimizes the tension of the rope.

Verrazano-Bridge, New York

A photograph is a central projection of a space from the centre of the lens system onto the sensor plane (see the computer graphic on the next page).

Despite the pincushion distortion caused by less expensive lenses, straight lines in physical space keep their straight character after central projection. Curved lines, however, undergo perspective distortion, except in rare instances where they reside in planes which are normal in relation to the optical axis, or parallel to the sensor plane. Insofar as the original curve possesses special metric properties, they are usually lost in the projected image.

In general, a picture of a catenary doesn't count as a catenary anymore, and the same is true for parabolas. It is thus impossible to judge, from mere photographs, whether Antoni Gaudi employed actual inverted catenaries (with their optimal properties for structural engineering) or whether he actually used a parabola for his supporting arches (see photo below). Given some basic information, such as the position and inclination of the camera, it would be possible to rectify such planar curves. For both photos on the right, however, this would be a very challenging undertaking.

Parabolas, nevertheless, have a distinct geometrical advantage over catenaries: They are conic sections, and they are the only curves that retain this characteristic even after a central projection onto an arbitrary plane. During this process, ellipses (including circles, as in the computer graphic) sometimes become hyperbolas or parabolas – and vice versa.

Thus, if the stadium below is elliptically or circularly shaped, the photograph should be positively teeming with parts of ellipses and hyperbolas. We are less likely to encounter parabolas, but this would not be impossible: Such a situation would occur if a spatial circle (or an ellipse) touched a normal plane of the optical axis which passes through the lens centre.

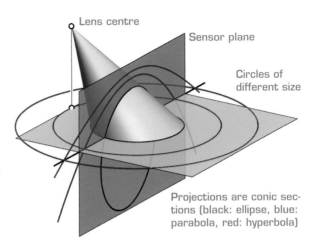

Lens centre

Sensor plane

Circles of different size

Projections are conic sections (black: ellipse, blue: parabola, red: hyperbola)

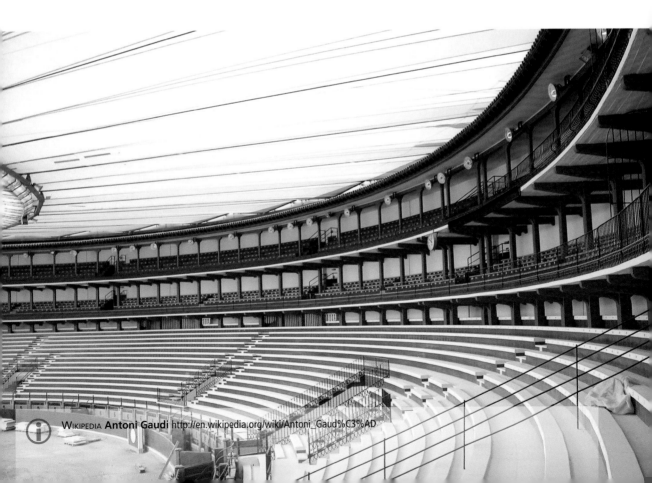

WIKIPEDIA **Antoni Gaudi** http://en.wikipedia.org/wiki/Antoni_Gaud%C3%AD

An arbitrary intersection of a cone of revolution with a plane usually yields either an ellipse or a hyperbola. Two very specific intersections produce exceptional cases: Intersections perpendicular to the axis yield circular sections and intersections parallel to one of the cone's generatrices yield parabolic sections (see the bottom left image on the right page).

A photograph of a conic section is, thus, usually a conic section as well. There are only two instances in which the photographer can be sure to capture an exact circle or an exact parabola: By capturing either object from a frontal perspective. The bridge pictured above was photographed from the front, and we could overlay a parabola to prove that the arc follows a perfectly parabolic shape. The same approach was used for the bridge below, with the same result.

Here, the bridge was photographed twice at an oblique angle. The orientation in the right image was arbitrary, which led to the parabolic arc appearing as an ellipse. In the left image, the optical axis was kept horizontal on purpose, and it can be shown that the photographic projection yielded a hyperbola whose left asymptote is perpendicular.

Bottom right picture: An artistic model of a conic section by Oliver Niewiadomski. A parabola can be found between the series of elliptical and hyperbolic sections. In the adjacent computer graphic, hyperbolic sections are marked green, elliptical ones are marked blue, and parabolic ones are marked red.

As is the case with circles, parabolas are always similar to one another. Thus, it is possible to construct any parabola by the scaling up or scaling down of a "unit parabola". Upper right image: The larger the focal length of the lens, the closer a projection approximates a normal projection, which preserves the type of a conic section. The normal projection of a parabola is always a parabola. It thus makes sense that we are able to approximate the bridge arcs closely in the telescopic photograph on the right by means of simulated parabolas.

W. Wunderlich **Darstellende Geometrie II** B.I. Hochschultaschenbücher 113/113a, 1967, S.141

Knots

Knot theory forms part of the study of topology. It attempts to analyse the equivalence of knots – in other words, the question of when two given knots can be made to resemble one another by means of a steady motion (though this movement may never split the rope into pieces).

As easy as sailor's knots seem to appear, getting them right requires a certain measure of training. The grape vine at the centre of the page is even more elaborately entangled. The pictured carving from Ghana was made from a single piece and is thus inseparable. In the case of the strangely distorted tree below, the third picture demonstrates that the knot is less complicated than one might expect.

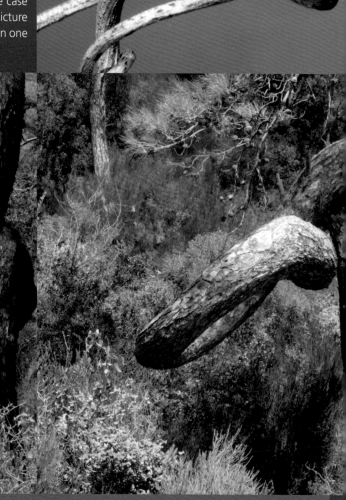

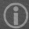
G. De Santi **An Introduction to the Theory of Knots** http://graphics.stanford.edu/courses/cs468-02-fall/projects/desanti.pdf

A point K on a surface is part of the surface's contour, if the tangential plane in K contains the eye position E (see image below). The projection of the contour onto the image plane is called the silhouette or the contour line. The silhouette of the blossom is marked red and exhibits several cusps. The right page describes the circumstances at which such cusps occur.

G. GLAESER **Geometry and its Applications in Arts, Nature and Technology** Springer Wien New York 2012
MOLABS **Space Curve and Projections, with Cusp**
www.shapeways.com/model/672136/space-curve-and-projections-with-cusp.html

It is easy to imagine a ring torus – just think of the inflated inner tube of a car tire, as in the large image. If this torus is seen from a flat angle, it often exhibits cusps, despite the fact that the actual threedimensional object is round at e v e r y point.

The computer image on the left visualizes this principle. The adjacent graphic shows, that the corresponding contour line resembles a "harmless" surface curve, if observed from another perspective.

As (by definition) the tangential plane passes through the eye point E in each point of the contour line, it often happens that the curve's tangent contains the point E. Such points appear as cusps on the silhouette.

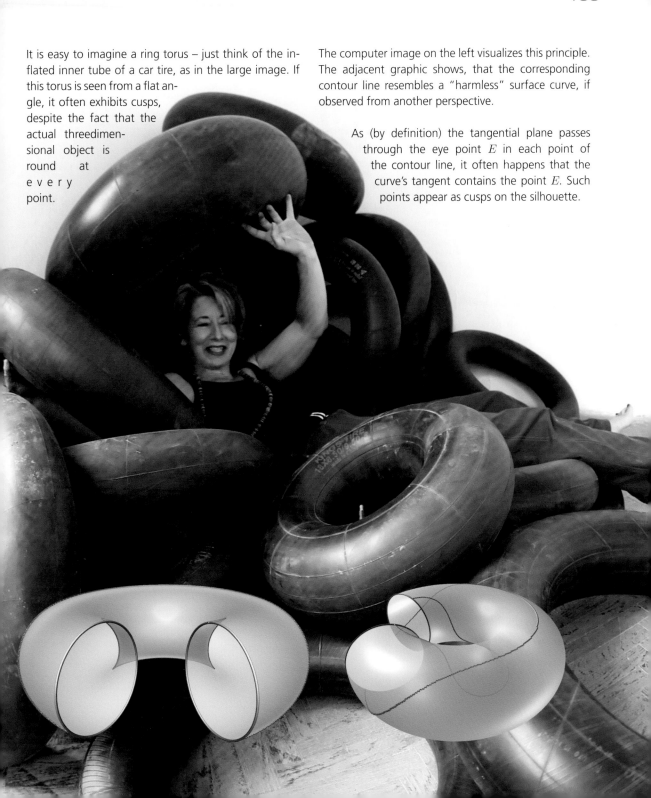

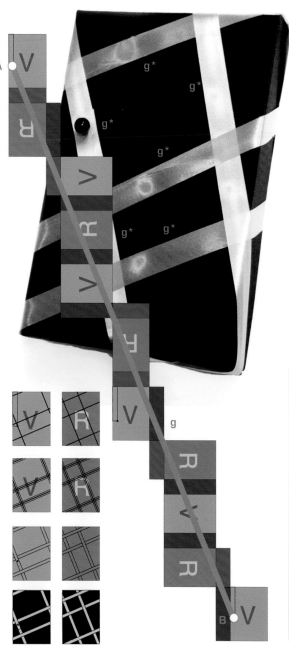

Assume that you want to embellish a cuboid packaging with a ribbon in such a way that it forms a closed and unfolded line (large image on the left). This challenge can be solved as follows:

Imagine the cuboid spread out into the plane (as pictured), with its side surfaces overlapping when necessary. Now draw a straight line g from A to B onto this "extended net" before reconstituting the spatial cuboid (straight line included). g thus becomes a multiply angular g^* on the surface of the cuboid.

A curve which becomes a straight line after development is called a geodesic curve and represents the shortest connection between two points. If A and B become identical and if the connecting straight line g^* finishes pointing in the same direction in which it started, then g^* is called a "closed geodesic".

We can use the following technique to wrap a tetrahedron: After circumnavigating the tip S_1, the geodesic

g^* returns to the starting position, pointing in the opposite direction. Only after another tip S_2 is surrounded by the ribbon it become possible to close the path and to secure the ribbon with a knot at the double point D.

The top view on the right shows the construction of a tetrahedron, whose angle sum σ in the adjacent faces S_1 and S_2 is identical. The edges become parallel after envelopment – in fact, they become equal to S_1S_2. D can be translated along the edge S_1S_2 without changing the length of the loop. A closer inspection of these principles can be found following the link below. It is further possible to generalize the described wrapping strategy for arbitrary surfaces (like the foot shape on the bottom left).

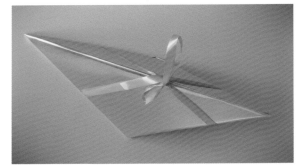

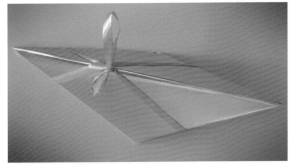

G. Glaeser, K. Polthier **A Mathematical Picturebook** Springer, 2014

7 Special surfaces

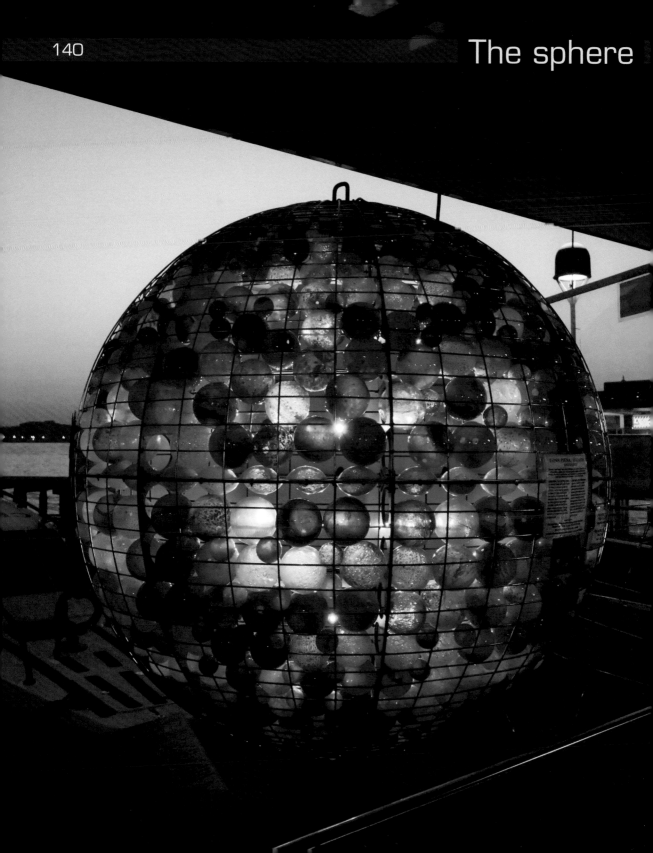

Spheres, the generalizations of planar circles, are omnipresent in nature and art (the left image shows a sculpture in Venice). A sphere's surface is mathematically defined as the locus of all points equidistant from a fixed centre. For this reason, wave fronts of fixed sources spread out in a spherical pattern. A sphere can also be described as the locus of all points that receive an equal measure of light or heat from a fixed source of energy, or as the surface generated by a circle that rotates around one of its diameters. In such cases, the path curves of the circle points may be considered as the layers of circles from which the entire sphere is composed (see the photo on the right page). It is thus obvious that every planar section of the sphere is a circle.

If two intersecting circles are made to rotate about the straight line that connects their centres, then the intersection between the two emerging spheres also takes the form of a circle (see also page 159 on the right). The cosmos is the ultimate domain of the spheres: All celestial objects with a diameter larger than 500km, given sufficient density and sufficient heat to allow for deformation, tend to assume a highly spherical shape. The constant π plays a huge part in the calculation of spheres and their properties: The surface of a sphere is four times larger than the area of the largest possible section circle, and the volume can be derived by multiplying the surface by a third of the radius.

In order to determine the silhouette of a sphere, let us position a cone of revolution that intersects the image or sensor plane such that its tip is placed at the eye position and that its body touches the sphere. It follows that the emerging silhouette must be a conic section. In most cases, it will be elliptical, as it is not so easy to produce a hyperbola. For this special case to occur, the image plane that is translated through the projection centre would have to intersect the sphere itself. One would have to position a camera close to the sphere's surface and point the optical axis more or less tangentially. The computer simulation on the right page features two spheres. The grey one exhibits a usual elliptical silhouette, while the blue one produces a clearly hyperbolic contour, whose asymptotes are inscribed in the image. Our choice of sphere colours has been deliberate, in order to suggest that such occurrences may indeed take place, if we photograph objects on the horizon, such as the rising and setting moon. The photo below appears to simulate what we know to be true: that the Earth is spherical, and that it therefore exhibits a curved silhouette. However, the image was taken with a fish-eye lens (the original photo is pictured in a smaller version). The visible and pronounced distortion is thus a simple optical effect, which appears only when the horizon does not pass through the centre of the image. Nevertheless, we are often quite convinced to observe the curvature of the earth if, for instance, we take pictures through the window of an airplane. Although, given ideal atmospheric conditions, we are indeed able to see our planet's curvature (even from sea level), we do so to a much smaller degree than we would intuitively think. First, we should actually expect the silhouette to be part of a hyperbola. Secondly, in order to capture any curvature at all, we would need to employ a wide-angle lens. Such lenses tend to produce pincushion distortions that may be mistaken for actual curvature of the observed physical objects – the same is true for fish-eye lenses, where this distortion is especially dramatic. If we wish to minimize pincushion distortion and to utilize the wide-angle lens to its fullest capabilities, we have to position the horizon across the precise diagonal of the image. However, we might then be rather disappointed by the result, as any actual curvature of our planet would be very hard to detect in the picture.

Low altitude. The deceptively prominent distortion is largely due to the pincushion effect of the camera lens.

Regular flight altitude of 10 km. The pincushion effect is neutralized by orientating the horizon along the diagonal. Despite the 28 mm wide-angle lens, the Earth's curvature is barely discernable.

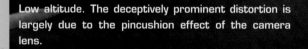

A. T. Young **Distance to the Horizon** http://mintaka.sdsu.edu/GF/explain/atmos_refr/horizon.html

Except for very simple and special circumstances (cylinders and cones), surfaces of revolution (such as spheres) cannot be created from planar parts. This makes it necessary to use a particular trick: As in the case of the dome of Florence Cathedral, the curved surface is approximated by means of congruent, cylindrical strips, which are joined together in the shape of a flower's closed blossom. In fact, the eight "petals" are much closer to a so-called spindle torus than to a hemisphere (see the computer graphic).

Originally, the leaf surfaces on the right page were merely simply curved – that is, they could be developed into the plane without significant distortion. However, dehydration led to the shrivelling up of the surface, which made development no longer possible. This can be glimpsed from the fact that the contours (of which certain parts have been marked red) are no longer straight.

Flexible and versatile

The hulls of ships are, in part, doubly curved (though only "harmlessly" so). How, then, is it possible to construct them from planar wooden planks?

A remark concerning underwater photography: The bow of the ship was merely 50 cm away from the camera, as an ultra-wide-angle lens was employed to capture the whole scene. Using a flashlight to illuminate the bow meant that the light had to travel a total distance of 1m. Since colour distortion is only noticeable at larger distances, we were thus able to depict the bow in its realistic colours.

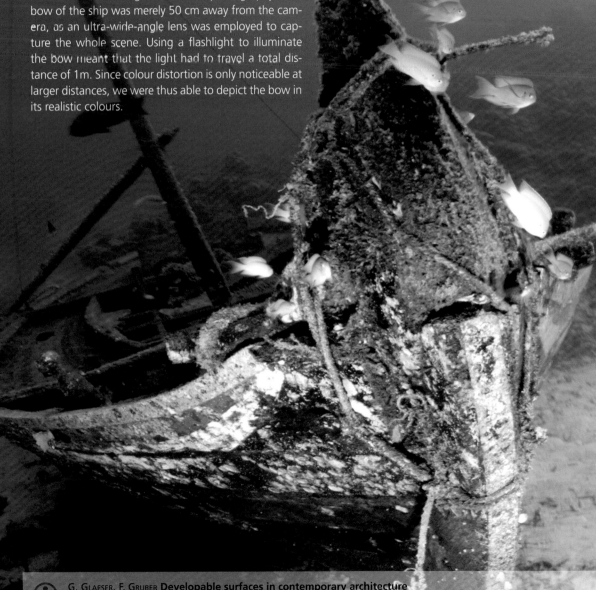

G. GLAESER, F. GRUBER **Developable surfaces in contemporary architecture**
Mathematics and the Arts Vol. 1, No. 1, March 2007, pp. 59-71

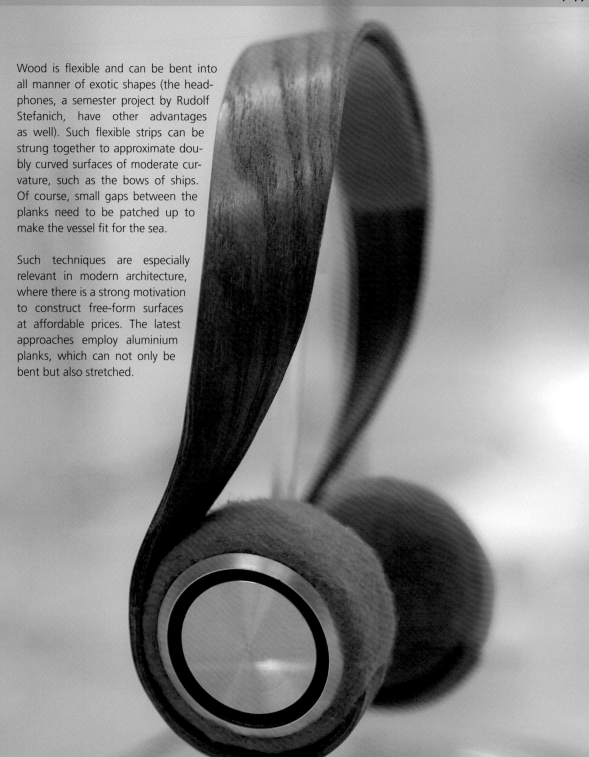

Wood is flexible and can be bent into all manner of exotic shapes (the headphones, a semester project by Rudolf Stefanich, have other advantages as well). Such flexible strips can be strung together to approximate doubly curved surfaces of moderate curvature, such as the bows of ships. Of course, small gaps between the planks need to be patched up to make the vessel fit for the sea.

Such techniques are especially relevant in modern architecture, where there is a strong motivation to construct free-form surfaces at affordable prices. The latest approaches employ aluminium planks, which can not only be bent but also stretched.

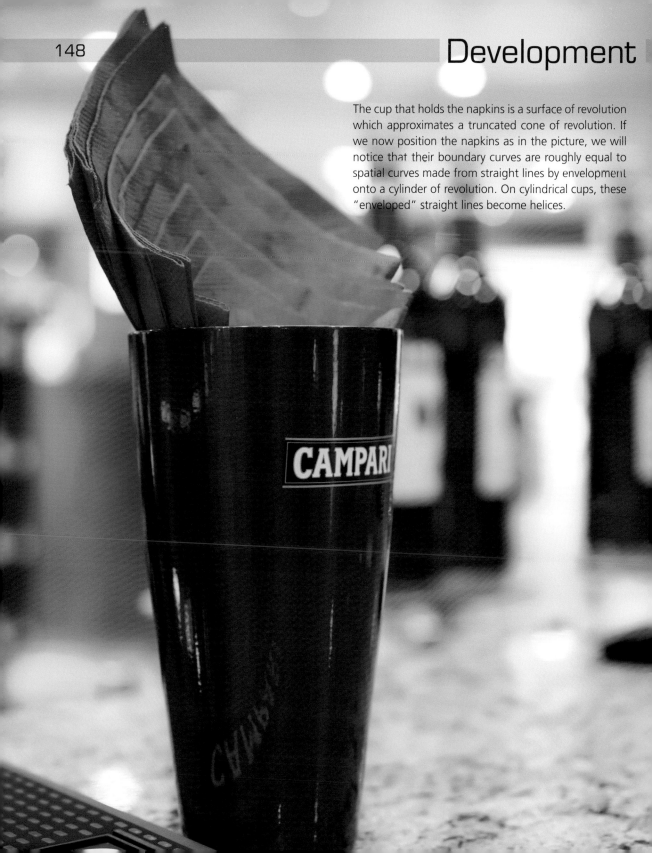

Development

The cup that holds the napkins is a surface of revolution which approximates a truncated cone of revolution. If we now position the napkins as in the picture, we will notice that their boundary curves are roughly equal to spatial curves made from straight lines by envelopment onto a cylinder of revolution. On cylindrical cups, these "enveloped" straight lines become helices.

If we now develop the cone of revolution into the plane, as in the computer graphic, it will roll around its own tip, and if we simultaneously observe the imprint of a circle that passes through the tip, we will be able to construct the pictured spatial curves. By analogy, if we envelop a circular waffle onto a cone of revolution, we will get a shape that exhibits precisely these spatial curves.

G. GLAESER **Geometry and its Applications in Arts, Nature and Technology** Springer Vienna Architecture (2013)

Puristic beauty

The 22 m Louvre pyramid of glass and metal (designed by the Architect I. M. Pei) is surrounded by three smaller ones, and is quite obviously supposed to remind the observer of the „classical pyramids" in Giza (its four faces have the same angle of inclination). Like the classic pyramids, this structure seems to be inspired by many numerological "secret codes". The Pyramid of Chephren (Khufu) was originally 146,5 m high, or exactly 6,7 times higher. This makes its volume approx. 300 times larger ($6,7^3$)! If you visit the point that is south of the southern base edge of the Cheops pyramid by a distance equal to its height h, and if you look towards the vertex of the pyramid, you will look exactly in the direction to the North Celestial Pole, enabling you to observe the rotation of the sky.

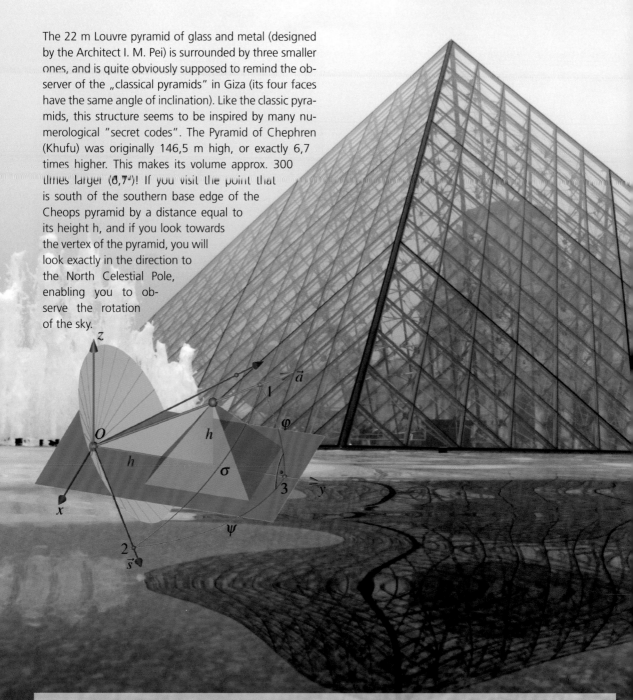

G. GLAESER **Geometry and its Applications in Arts, Nature and Technology** Springer Wien New York 2012
WIKIPEDIA **Louvre Pyramid** http://en.wikipedia.org/wiki/Louvre_Pyramid

The correspoing pyramid below
repeats the „classical ratios".

Stable and simple construction

The one-sheet hyperboloid of revolution can either be constructed by the rotation of a hyperbola about its auxiliary axis, or by the rotation of a straight line by an oblique axis – an insight we owe to Sir Christopher Wren. He also noticed that the straight line may be inclined in two symmetrical directions, so that the surface carries two different pencils of straight lines.

The same is true only for the hyperbolic paraboloid, which makes it possible to quickly construct its scaffolding using meshes of straight lines. This makes the surface surprisingly stable. A so-called "asymptotic cone" fits well into the hyperboloid (see the photo of Barcelona's airport tower and its adjacent computer graphic on the right).

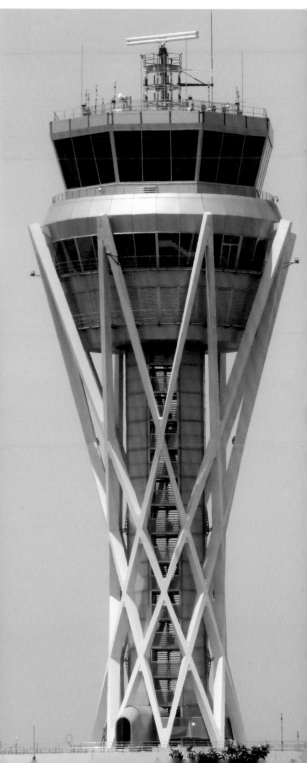

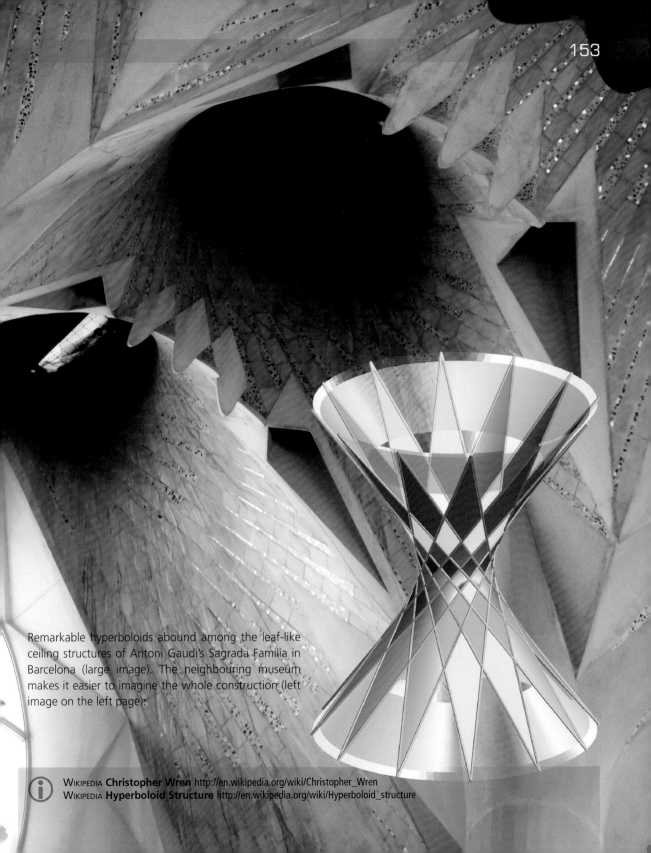

Remarkable hyperboloids abound among the leaf-like ceiling structures of Antoni Gaudi's Sagrada Familia in Barcelona (large image). The neighbouring museum makes it easier to imagine the whole construction (left image on the left page).

WIKIPEDIA **Christopher Wren** http://en.wikipedia.org/wiki/Christopher_Wren
WIKIPEDIA **Hyperboloid Structure** http://en.wikipedia.org/wiki/Hyperboloid_structure

Minimal surfaces are defined as having an average curvature of zero. Broadly speaking, this means that the surface passes through its tangential plane in every point, with the mutually orthogonal main curvatures having the same absolute value. Physically speaking, this allows for a perfect equilibrium with regard to surface tension.

A cube-shaped wire model (left page) was submerged in soapy water and photographed before the bubbles could burst. The result is dependent on many parameters and is thus not always the same. Aside from the subtle fluctuations of air, the emergent and short-lived surface is largely dominated by surface tension. If the wire model takes the form of helical lines, then the result is a helicoid (see page 106). Given a model like the one on the bottom left (parallel circles), we may observe the emergence of catenoids (see page 294), or even part of a so-called Scherkian chessboard surface (see page 157) on the bottom right.

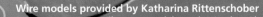
Wire models provided by Katharina Rittenschober
J. T. JACOBSEN **Soap Film** www.math.hmc.edu/~jacobsen/demolab/soapfilm.html
M. WEBER **Soap films** www.indiana.edu/~minimal/maze/intro.html

Minimal surfaces

H. KARCHER, K. POLTHIER **Palast der Seifenhäute** http://page.mi.fu-berlin.de/polthier/video/Touching/Preface_ger.html
WIKIPEDIA **Minimal surface** http://en.wikipedia.org/wiki/Minimal_surface

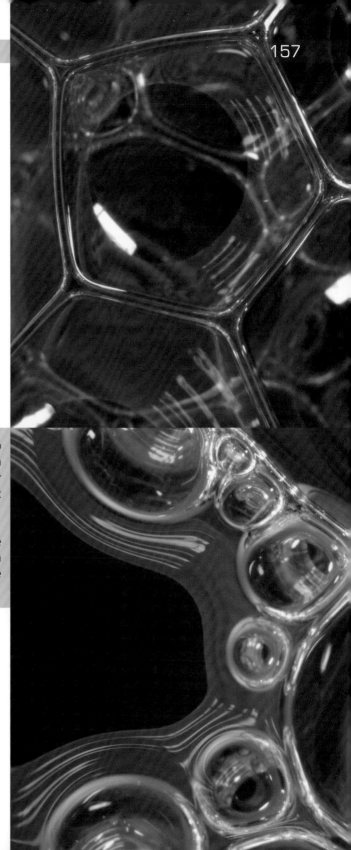

As their name implies, minimal surfaces attempt to minimize their surface area. This principle can be seen in action by submerging a wire model into soapy water (the image above is a computer simulation). The right side depicts the formation of bubbles in liquids.

Sabine Duschnig has incorporated tires and square models into elastic fabric. The inherent surface tension produces works of art that are as aesthetic as they are fragile (left page).

Soap bubbles

The soap bubbles that envelop wire models are minimal surfaces with an average curvature of zero. If these bubbles are blown into the air by the force of human breath, they will quickly change shape to encompass a maximal volume with a minimum surface. In other words, they will become spheres, which are the only surfaces with constant, positive curvature in every direction. Due to the fact that breathing air is usually warmer than most other air in a person's environment, the bubbles will tend to rise upwards. Very large bubbles (image below) react differently, however, as they are more strongly affected by the downwards pull of gravity. Only after some unnecessary ballast is thrown off (surplus drops, for instance) does the overall shape start to resemble a sphere. If the bubble is made to burst before that, the results can be very interesting. Both images were taken one tenth of a second apart.

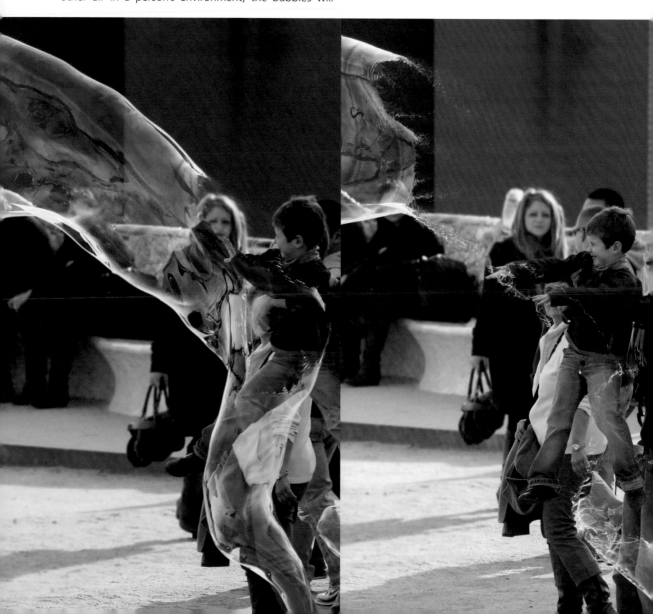

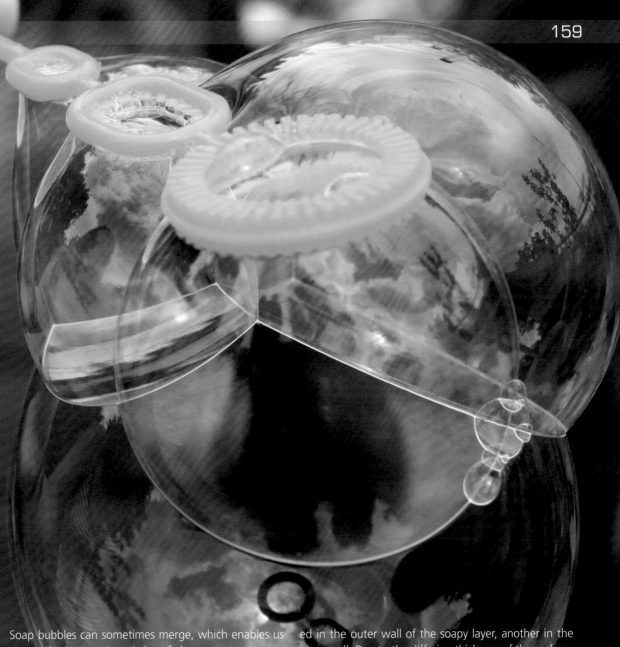

Soap bubbles can sometimes merge, which enables us to see the intersecting circles of the separate spheres. The reflection on the inner wall of the lowest sphere is especially notable, as is the iridescence (or the formation of rainbow-coloured streaks). The latter is merely an interference phenomenon: Part of the light is reflect-ed in the outer wall of the soapy layer, another in the inner wall. Due to the differing thickness of the surface, the individual spectral colours, with all their different wave lengths, are refracted and amplified to different degrees.

WIKIPEDIA **Soap bubble** http://en.wikipedia.org/wiki/Soap_bubble

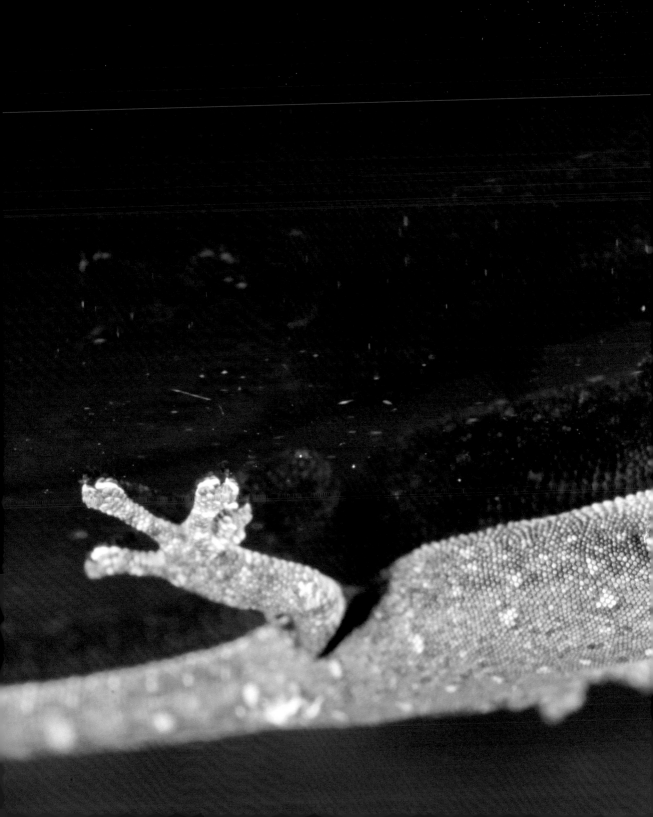

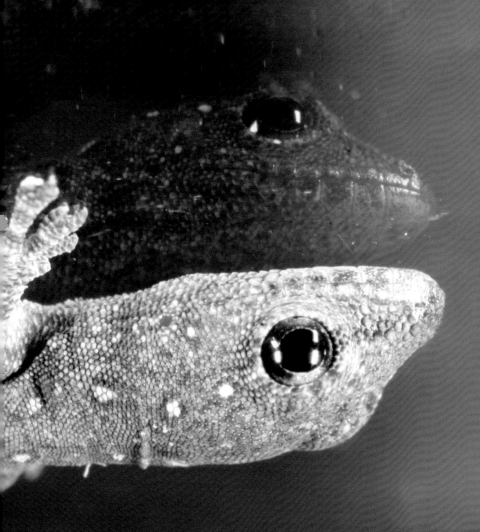

8 Reflection and refraction

The spherical reflection

The reflection in a sphere is reminiscent of photography with a fish-eye-lens. The entire surrounding space becomes visible, except for the points which are obscured by the sphere itself. Thus, the half-space in which the observer resides becomes especially noticeable in the reflection. The telescopic photo shows that it is sufficient to focus on the sphere in order to capture the whole room with adequate sharpness.

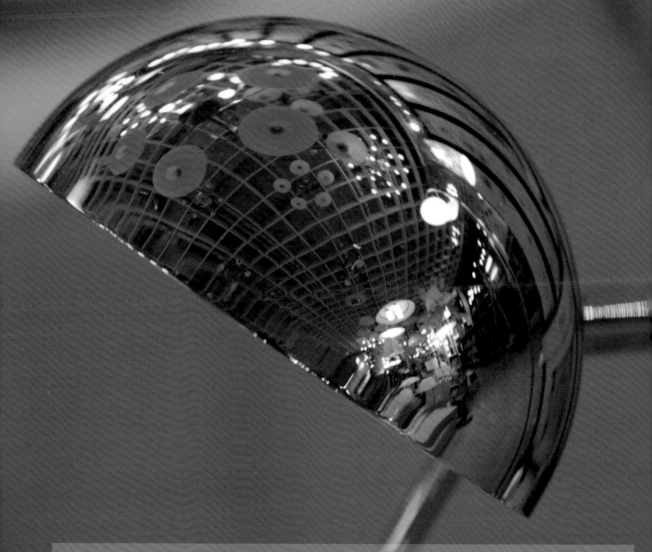

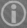 G. GLAESER **Reflections on Spheres and Cylinders of Revolution** www.heldermann-verlag.de/jgg/jgg01_05/jgg0312.pdf

Let Z be the projection centre (lens centre) and M the centre of the reflecting sphere (see the computer graphic on the right). Straight lines PQ appear as fourth-order curves. Thus, the calculation of the reflection point makes it necessary to solve a fourth-order equation. According to the law of reflection, the spatial point P and the reflected point $P*$ lie in the plane PMZ. If PQ is parallel to MZ, then its image on the sphere is a great-circle, and its appearance in the picture resembles an ellipse.

The photo below shows a room reflected in a pitcher, whose shape approximates an ellipsoid of revolution. Despite its different form, the reflection is not all that different from the one in a sphere.

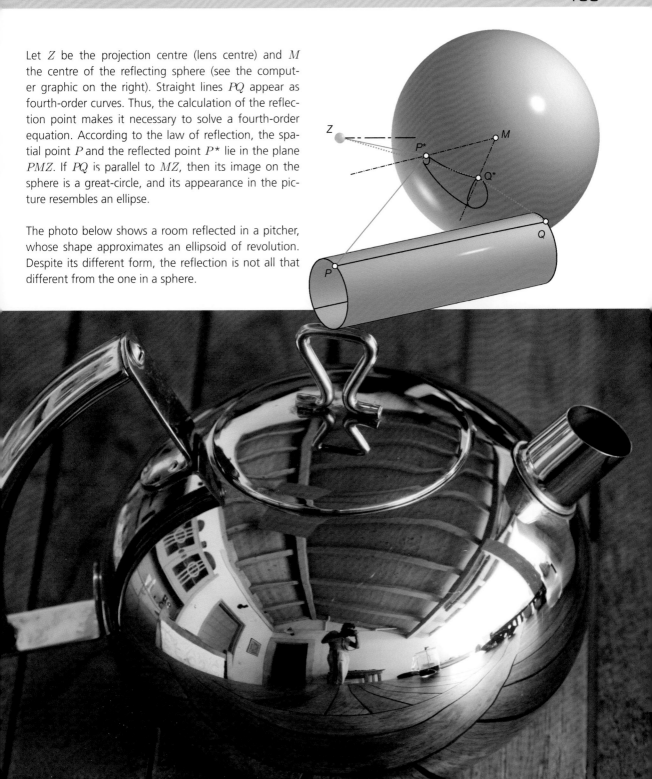

A masked person is holding what looks to be a close approximation of a helispiral (see page 117). For three full revolutions, the curve seems to lie on a cone of revolution, with corresponding points on the conic generatrix being approximately equidistant.

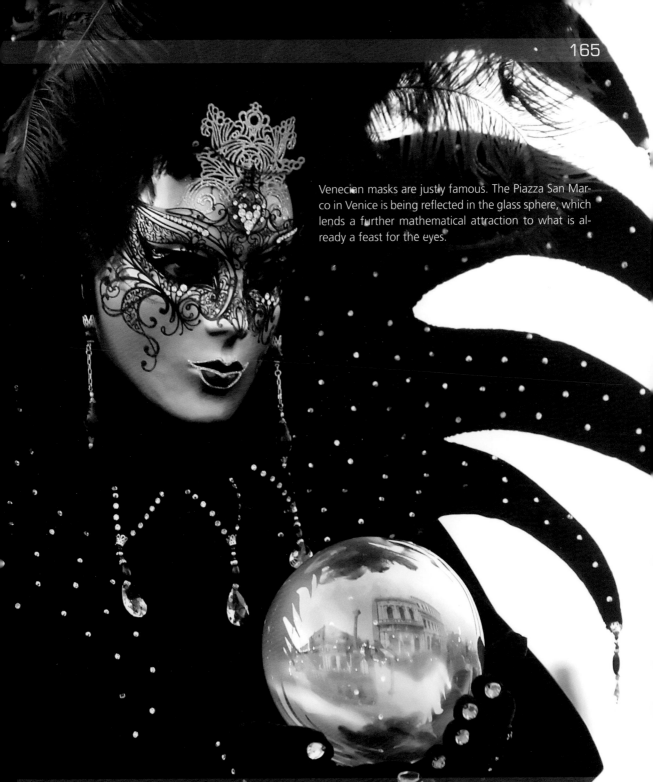

Venecian masks are justly famous. The Piazza San Marco in Venice is being reflected in the glass sphere, which lends a further mathematical attraction to what is already a feast for the eyes.

Mirror symmetry

Symmetry plays an important part in nature, in technology and in aesthetics itself. At times, a highly elaborate but non-trivial symmetry can truly catch the attention of our eyes, such as the photograph of the attic designed by the architect Anton Falkeis. The photo was taken at 2:00 PM of real sun time, when the sun was situated at the centre of the structure, producing roughly symmetrical shadows through the glass roof. This building is not oriented with regard to the sun's path on the firmament – otherwise, it would have been 12:00 AM at the time of the photo. The special case in the picture does not reoccur at the same time, due to the different culmination heights of the sun throughout the year. In most cases, too much symmetry tends to be perceived as dull, which may be the reason for the famously asymmetrical beauty spots on models' faces. The reflection in an irregular water surface thus brings life to the right picture.

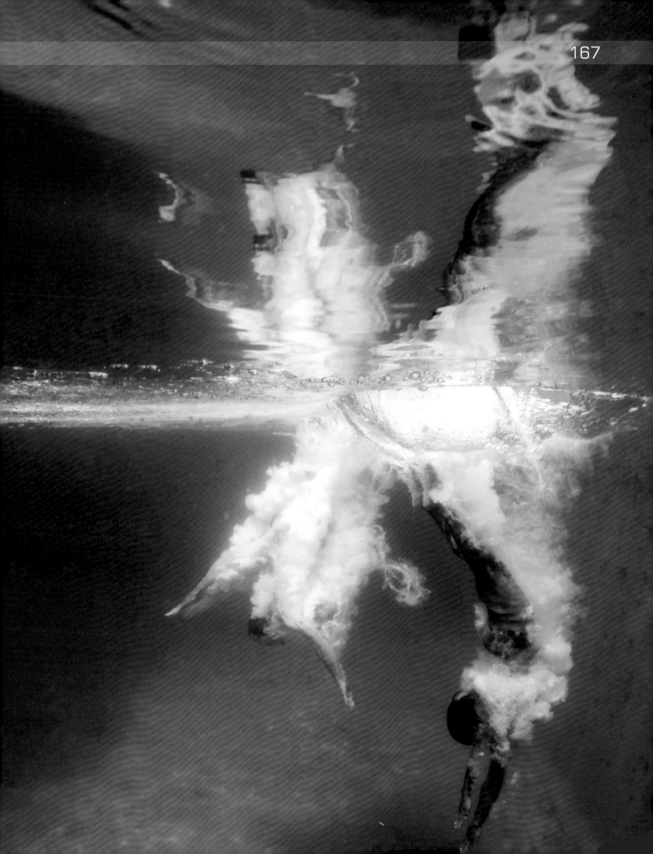

The planar reflection

Each reflection in a plane creates a "virtual mirror world", where the same rules of perspective apply. A point P corresponds to its virtual mirror point $P*$ (image below). The spatial half-point $P'*$ lies in the mirror plane. In the photo below, $P'*$ is situated at the centre of the picture only when the optical axis of the lens is parallel to the mirror.

Due to the glass surface with a reflecting back side, this grasshopper possesses two mirror points each ($P*$ and $P°$). The corresponding half-points $P'*$ and $P'°$ lie above each other, with their spatial distance corresponding to the thickness of the glass surface ($P*P°$ are therefore twice as large). Simple reflections are a popular technique of achieving aesthetics in landscape photography (see small image on the right).

Adding another mirror, however, makes the situation significantly more complicated. A new "virtual mirror world" emerges and causes two mirror worlds to appear in each reflecting surface. This copying process occurs at the speed of light and is consequently not completely instantaneous. The "infinite loop" that is caused by two facing mirrors is really only broken by a slight loss in luminance during each reflection, and by a loss of image fidelity (in other words, a blur) which continues to grow due to the imperfection of the reflective surface. It may also occur that the circular loop of light closes in on itself, due to special angles being at play.

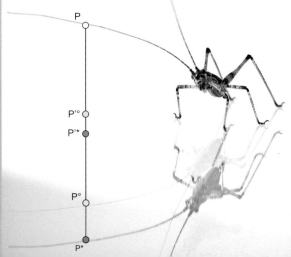

P

P'°

P'*

P°

P*

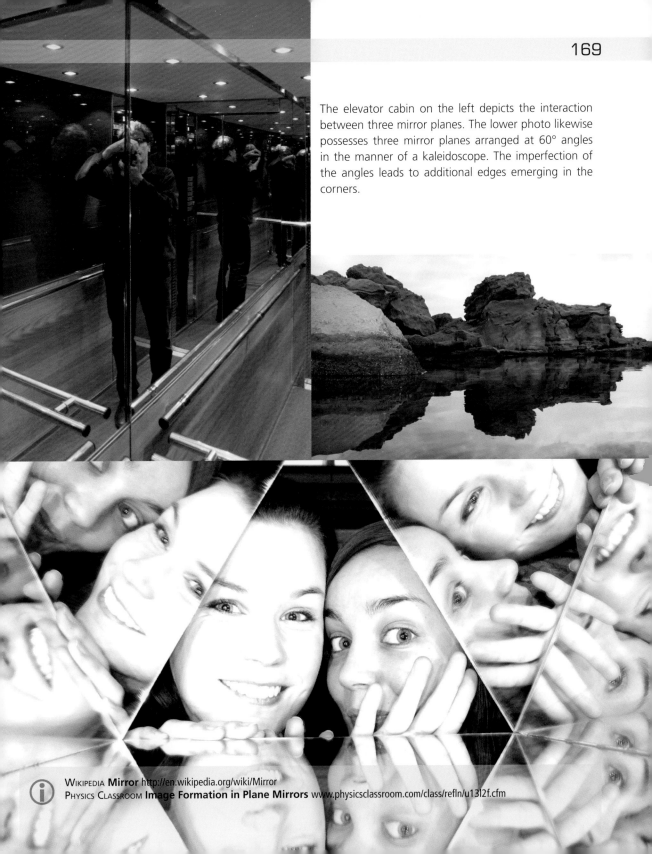

The elevator cabin on the left depicts the interaction between three mirror planes. The lower photo likewise possesses three mirror planes arranged at 60° angles in the manner of a kaleidoscope. The imperfection of the angles leads to additional edges emerging in the corners.

WIKIPEDIA **Mirror** http://en.wikipedia.org/wiki/Mirror
PHYSICS CLASSROOM **Image Formation in Plane Mirrors** www.physicsclassroom.com/class/refln/u13l2f.cfm

Many species of sea stars have 5 arms -- however, there can be many more, as three of the specimen on this spread demonstrate. The surface structures can likewise vary quite substantially. Their bright colours only show up under flashlight. In absence of artificial illumination, their (often red) colour works as a camouflage (see also p. 227).

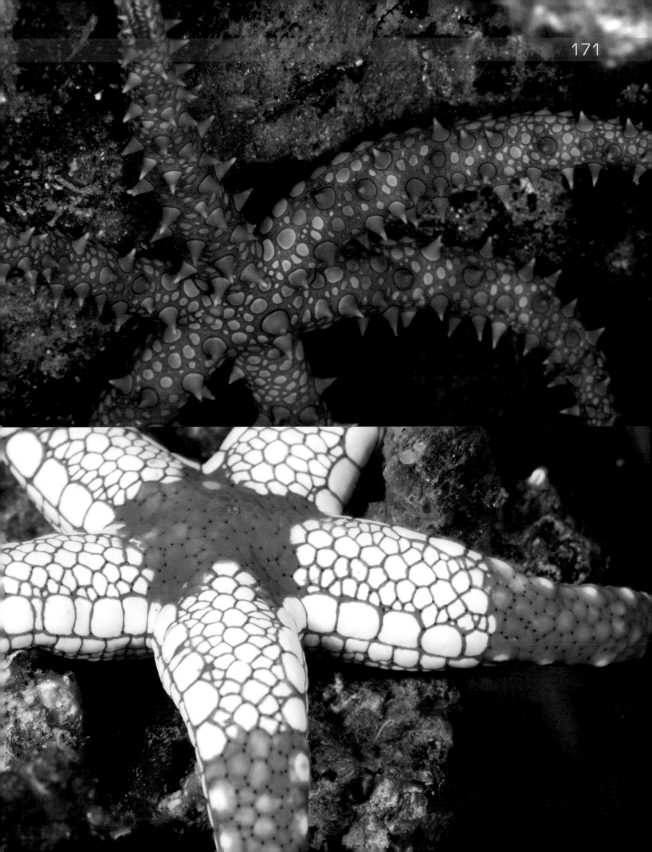

The pentaprism

We shall now undertake to solve the following problem: An inverted picture taken by a system of lenses is to be sent through a series of mirrors and ultimately displayed in a viewfinder. Naturally, this particular challenge occupies the manufacturers of DSLR cameras. After all, it is the purpose of a good viewfinder to display the precise image that is ultimately captured by the imaging sensor. Back in the days of analogue photography, cheaper cameras were distinguished by showing a slightly different perspective through the viewfinder.

Let us imagine a five-sided prism as in the right image. An image appears right above the adjustable mirror, orthogonally to the lower boundary surface (1). It has to be ensured that the light rays stay parallel. At first, this is not the case, since the system of lenses focuses the incident rays through the lens centre. Thus, a diffuser lens is necessary between the mirror and the prism.

The orthogonally incident rays, instead of being refracted, reach the mirrored upper surface of the prism (2), are reflected onto another oblique surface (3) and are then transported horizontally (orthogonally to the vertical side surface) towards the viewfinder (5). Another lens is present to focus the light rays.

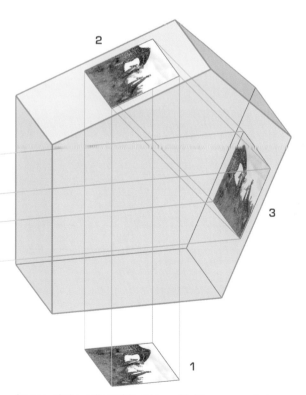

The image in the viewfinder 4

As if this wasn't complicated enough, it is important to recognize that the image stays inverted throughout the whole process. For practical applications in viewfinders, this is extremely confusing and unworkable.

Image of the adjustable mirror. Light rays are being "bent into a parallel shape" via the diffuser lens.

3a

3b

With some ingenuity, the picture can be mirrored in two steps. First, the side surface (3) needs to be replaced by a pair of orthogonal side surfaces (3a and 3b). This is called a "roof pentaprism". Let us first focus on the left side of the image. The rays that incide onto 3a are being reflected towards 3b and leave the prism in an inverted form.

Unbeknownst to the observer, an equivalent but inverted process happens on the right side of the image. It is remarkable to consider that the rays collide with each other between 3a and 3b without any apparent interferences. The left side shows an important geometrical feature of the pentaprism: In order for the light rays to leave the object horizontally, the planes 2 and 3 must satisfy the condition

$$\beta = \alpha - 45°$$

(α and β denote the incidence angles of the planes). In the case of the roof pentaprism, this condition holds true for the inclination of 2 and the inclination of the intersecting edge of 3a and 3b. If the side surfaces are not employed, then the majority of light exits the object, which causes the image to be less exposed. Such a device can be used to observe the sun safely.

WIKIPEDIA **Pentaprism** http://en.wikipedia.org/wiki/Pentaprism

The billiard effect

Under ideal conditions, a billiard ball bounces off the edge of the game table in such a way that the angle of incidence is identical to the angle of reflection. The multiple-exposure photograph on the left suggests that the ball's velocity stays relatively constant while it is still rolling, but that it loses a significant amount of energy upon impact. The edges of a perfect billiard table form precise right angles, and thus, after bouncing off of two adjacent edges, a ball's direction is reversed.

In order to evaluate the relationships of velocity more closely, one would either have to photograph the table from straight above, or conduct a rectification as in the image on the right. In other words, one might project the photo onto an oblique wall so that the four holes marked by the dashed lines align to form a perfect square.

This is always possible in theory, but in practice, the pincushion distortion exhibited by cheaper lenses may preclude any accurate analysis. Rectification can also be accomplished in software by applying an appropriate linear (line-preserving) transformation.

The planar case can be spatially generalized as such: Imagine the corner of a cube, or three pairwise orthogonal planar surfaces. If several parallel light or radar rays are projected into such a corner, the reflected result will not be a random entanglement of rays. In fact, the rays (following three reflection events) will be projected back in the opposite direction so that they become parallel to the original rays. A classical "billiard situation" is given, due to the fact that each of the three normal projections proceeds in the direction of a cube edge. Thus, the parallel relationships of the planar situation also apply to the spatial situation.

This fact has numerous practical applications. The right photo shows a radar reflector on a seafront, which is used by ships for distance determination. Reflex reflectors on cars and bicycles are composed of many tiny and reflecting cube corners (see image below) and are therefore able to shine back the incoming headlights towards their source.

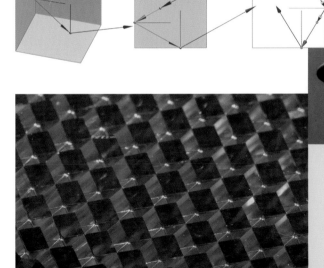

(i) H. Havlicek **Theory of Linear Mappings** www.geometrie.tuwien.ac.at/fg3/linearmap.html
G. Glaeser **Geometry and its Applications in Arts, Nature and Technology** Springer Wien New York 2012

Sound absorption

The right page shows a sound-absorbing wallpaper composed of strung together quadratic pyramids whose side surfaces are inclined at 45°. Many different variations can be found in the picture. The pyramids themselves are made from sound-absorbing Styrofoam and are glued together by a substance that never fully hardens, which further increases the sound-absorbing effect.

Geometrically speaking, it is challenging to determine the various directions in which the sound waves are reflected before being absorbed. In the simulation (general perspective below, with a top and front view directly above), the inciding rays are marked yellow. A majority of the waves are reflected whenever the angle of incidence is relatively large. Small angles of incidence, however, lead to more subsequent reflections, with incremental absorption occurring every time.

Amateur recording engineers may sometimes employ egg cartons in their makeshift studios, due to their sound-scattering and sound-absorbing characteristics. They are, however, justly avoided by professionals for being easily flammable.

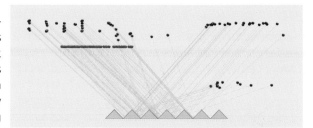

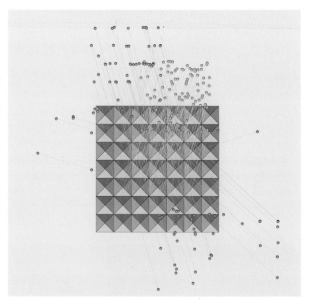

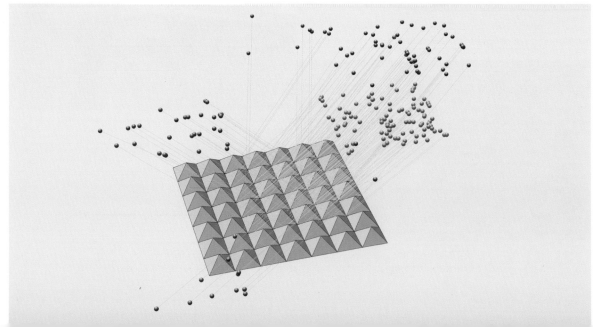

The optical prism

The refraction of light and its unfolding into spectral colours can be beautifully demonstrated by using a threesided glass prism (or another transparent material). According to quantum physics, light has a "dual nature" and acts simultaneously as a photon particle and as a wave.

Sunlight contains waves of different lengths. The shorter the wavelength, the stronger its refraction. This means that the longer-wavelength red light rays are less susceptible to refraction when passing through the transition between air and glass.

What is the reason behind the three spectrums? At first, the white sunray that incides on the right at a parallel angle (1) is being unfolded as on the left page in the computer graphic. Due to refraction, it does not appear at the location where we might expect it (2). The further unfolded light ray eventually exits the object (3).

This spectrum is refracted in the left side surface (4), but also reaches the eye through the right surface (5) after multiple refraction events. Due to the varying angles of incidence, the spectrum appears as a curved rainbow, and unlike a common rainbow in the sky, the red colour appears inside.

The deeper one understands the circumstances that lead to the formation of a rainbow, the better one is able to draw conclusions about the various effects that occur alongside it. After rainfall, the atmosphere tends to be replete with tiny drops of water, through which the white rays of the sun have to pass to reach an observer. We have to differentiate between three types of rays (see sketch). Firstly, the ones that hit the water drops towards their centre. While their direction is shifted slightly towards the vertical, very little actual unfolding occurs. If, however, the rays hit the back side of the droplet at a very inclined angle, then their direction is shifted away from the vertical before they exit the droplet as near-white light at an angle of 0° to 20°. These rays illuminate the inside of the rainbow. Secondly, we shall take a look at the rays that hit the spherical droplets at a point about 65-75% away from their central line. They also exit the droplet largely towards the rear, but at that moment they are already much more unfolded and shifted away at an angle of 20 to 30°. These rays can produce rainbows on the clouds directly behind. The third case concerns the rays that hit the droplets at their edge. Part of the light is then reflected in the sphere and illuminates the background. The rest is

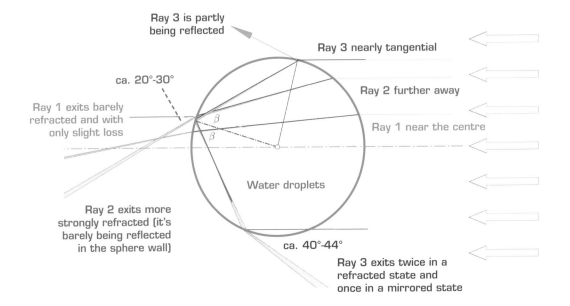

shifted so far towards the vertical and unfolded to such a degree, that on the back side of the droplet, an angle β is reached, producing a total reflection. This causes an inversion of the colour spectrum, and another incidence onto the droplet surface, which may come close to yet another total reflection. The light that is ultimately able to exit the droplet does so at around 40° to 44°, causing the common (primary) rainbow. The rest of the light undergoes additional total reflection and may appear as a secondary rainbow, though much fainter and with inverted colours. Occasionally, a tertiary rainbow might appear, having undergone a third total reflection. So far, our theoretical deliberations have only concerned angles but not distances. As shown on page 183, the water droplets, through which rainbow light passes towards the observer, reside on cones of revolution whose axis passes through the sun. If the sun is behind one's back, it only takes a garden hose to produce a rainbow (or two).

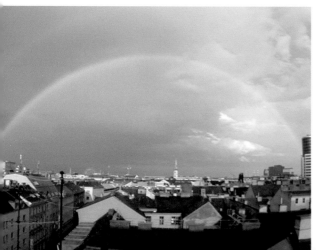

The larger photo on this page was taken with a 30 mm wide angle lens. No rainbow was present in the sky – rather, a jet of water was shooting closely past the camera in the shape of a parabolic trajectory, producing two clearly visible rainbows. The secondary (outer) rainbow with an inverted spectrum is due to light rays that, prior to exiting towards the observer, underwent two total reflections inside the water droplets.

As a point of comparison, two "real" rainbows were captured from the same terrace – though this time, with a fish-eye lens during a low sun position. These shimmering water droplets are many kilometres away!

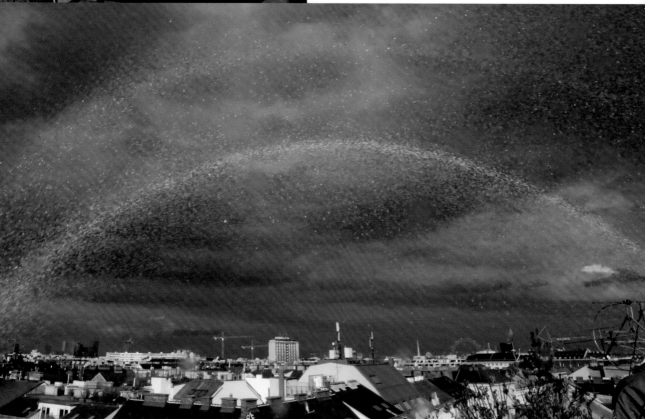

L. Cowley **Through a drop brightly - light rays** www.atoptics.co.uk/rainbows/primrays.htm
J. A. Adam **Like a Bridge over Colored Water: A Mathematical Review of The Rainbow Bridge: Rainbows in Art, Myth, and Science** www.ams.org/notices/200211/fea-adam.pdf

At the foot of the rainbow

As the saying goes, one should look for the treasure at the end of the rainbow! But what is the meaning of this poetic phrase? From the regular vantage point, a rainbow looks like the towering arch of a fixed bridge. If, however, we attempt to approach it, we quickly realize that no matter how long we keep marching, we come no closer to reaching our goal. What's more, if we change our direction to march sideways, the rainbow will follow suit and appear to be marching alongside us. It seems that at some point, we have to admit defeat and lose interest in the treasure.

In reality, we do not perceive a physical arch, but thousands upon thousands of shimmering water droplets that are distributed on a cone of revolution whose tip is located at the position of our eye (or the lens centre). Its axis passes through the sun, and its opening angle varies (depending on the colour) between 44° (for red components) and 41° (for blue components). The distance of the water droplets may vary almost arbitrarily – from mere centimetres (as in the case of the water hose) to many kilometres (see computer graphic on the right side).

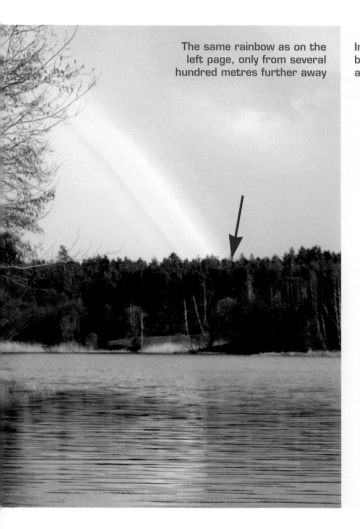

The same rainbow as on the left page, only from several hundred metres further away

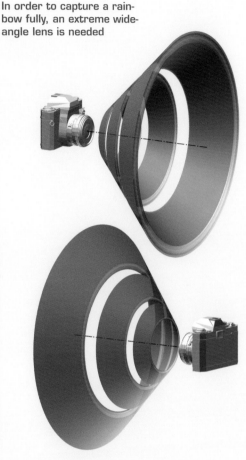

In order to capture a rainbow fully, an extreme wide-angle lens is needed

The computer illustrations demonstrate that a wide-angle lens is required to capture a rainbow fully. During sunrise and sunset, the conic axis is nearly horizontal, which makes it possible to capture the entire upper semicircle (and thus the full diameter of the rainbow) with an opening angle of nearly 90°, spanning the whole width of the image. This is equivalent to an opening angle of 108° across the diagonal of a 3:2 format picture, and thus, of a focal length of only 17mm (ultra-wide-angle-lens). If the sun is higher, regular wide-angle lenses may be sufficient, due to only the upper rainbow segments being visible. Both pictures on this spread are telescopic and thus show only a fragment of the whole rainbow.

B. Casselman **Bill Casselman** www.ams.org/samplings/feature-column/fcarc-rainbows
H. M. Nussenzveig **The Theory of the Rainbow** www.phys.uwosh.edu/rioux/genphysii/pdf/rainbows.pdf

Above the clouds

From the window of an airplane, one can sometimes see quite astonishing optical phenomena. The depicted ring is a so-called "glory". It is no rainbow, but is instead believed to happen due to resonance effects when light is emitted backwards.

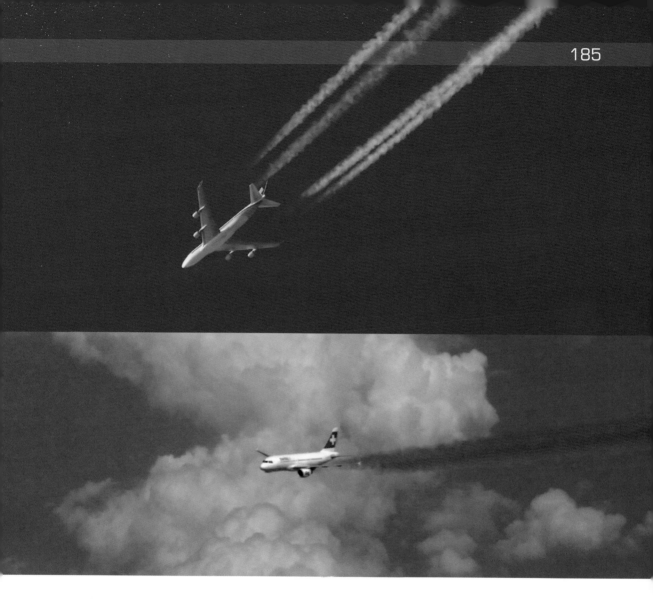

Why is the sky blue? Sunlight contains all the components of the rainbow – from blue to red. Blue light possesses a shorter wavelength and is thus more strongly refracted (and scattered) in the atmosphere. One might say that blue light "loses itself" more easily in the sky, causing red components to predominate. On tall mountains, where the blue components are stronger, photos tend to exhibit a bluish cast!

Why are contrails white? At 10 km, air is cold as ice (significantly below freezing level). Due to freezing delay, it can still contain water droplets in a liquid state. A passing plane expels soot particles from its engines into the atmosphere, on which such water tends to crystallize. The bottom picture shows, however, that these gaseous formations are not as clean as they look from below.

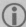
WIKIPEDIA **Glory** http://en.wikipedia.org/wiki/Glory_(optical_phenomenon)
WIKIPEDIA **Contrail** http://en.wikipedia.org/wiki/Contrail
P. GIBBS MAY **Why is the sky blue?** http://math.ucr.edu/home/baez/physics/General/BlueSky/blue_sky.html
J. A. ADAM **A Mathematical Nature Walk** Princeton University Press, 2009

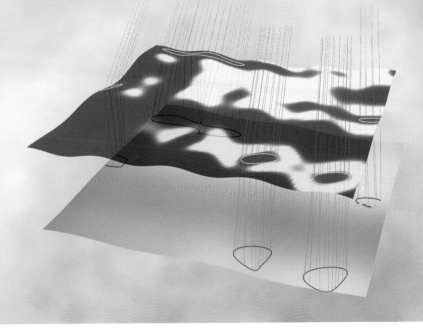

The photo on the right side shows a phenomenon that is well known to shallow water snorkelling enthusiasts. Whenever the sun is at a low position, one gets the impression of seeing rainbow colours underwater. The rainbow lines are far from stationary – in fact, they change their form extremely quickly!

Let us consider the computer simulation above: A slowly moving water surface is being simulated, and an attempt is made to look for points on its surface where the angle between the surface normal and the (orange) sunrays is constant. In general, these points are distributed on closed spatial curves (yellow). The respective refracted light rays (green) incide on the sandy bottom surface as distorted curves (red). From our observations about classical rainbows (page 180) we know that a relevant unfolding into spectral colours occurs mainly during incidence at very flat angles (nearly 90°). Thus, this special effect requires flatly inciding sunrays.

Let k be an intersection curve between a vertical plane through the sun and the wave surface (it may be a superimposed sine curve). Let us now permit the generalization that all normals also lie in a vertical plane. Ideal unfoldings into spectral colours may occur at points, where k's tangents are parallel to the sunrays (small illustration above). If the relevant candidates are points of inflection (small illustrations below), then the unfolding effect will also occur for adjacent points, and the optical effect is significantly magnified.

(i) G. GLAESER **Regenbögen unter der geometrischen Lupe** Proceedings 6. Tagung der DGfGG, 2010

Hermit crab before sunrise, close to
the water surface: The whole scene
is lit by rainbow colours!

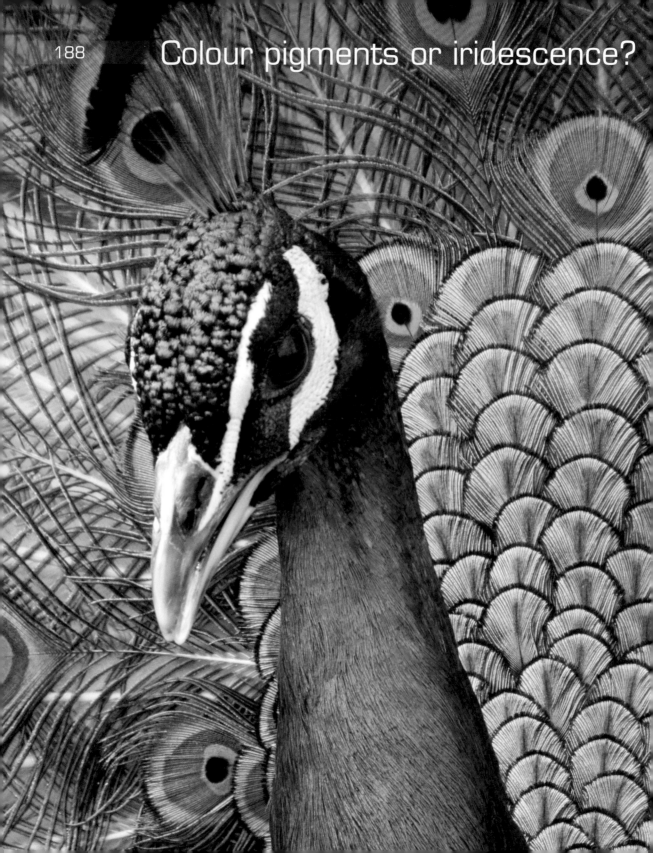

Colour pigments or iridescence?

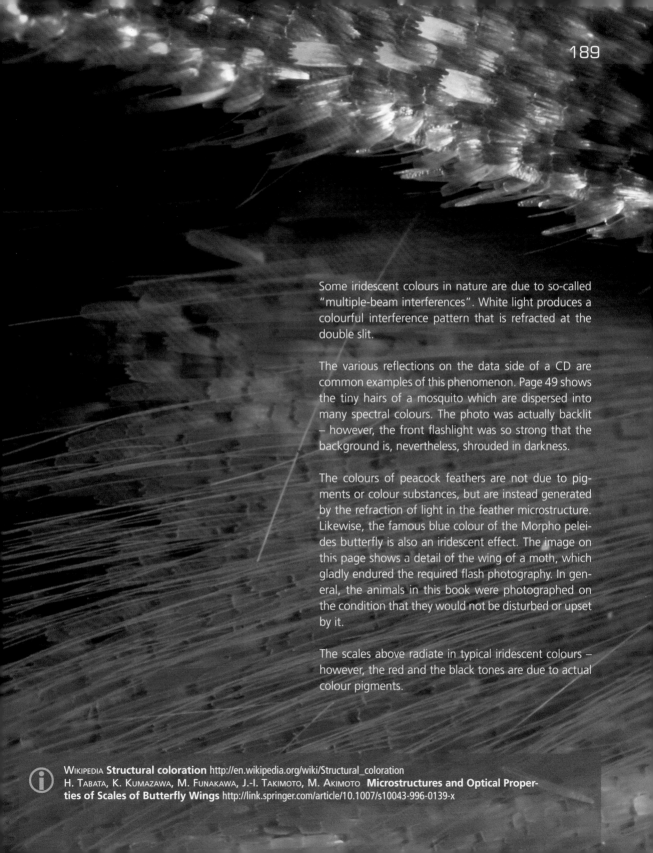

Some iridescent colours in nature are due to so-called "multiple-beam interferences". White light produces a colourful interference pattern that is refracted at the double slit.

The various reflections on the data side of a CD are common examples of this phenomenon. Page 49 shows the tiny hairs of a mosquito which are dispersed into many spectral colours. The photo was actually backlit – however, the front flashlight was so strong that the background is, nevertheless, shrouded in darkness.

The colours of peacock feathers are not due to pigments or colour substances, but are instead generated by the refraction of light in the feather microstructure. Likewise, the famous blue colour of the Morpho peleides butterfly is also an iridescent effect. The image on this page shows a detail of the wing of a moth, which gladly endured the required flash photography. In general, the animals in this book were photographed on the condition that they would not be disturbed or upset by it.

The scales above radiate in typical iridescent colours – however, the red and the black tones are due to actual colour pigments.

WIKIPEDIA **Structural coloration** http://en.wikipedia.org/wiki/Structural_coloration
H. TABATA, K. KUMAZAWA, M. FUNAKAWA, J.-I. TAKIMOTO, M. AKIMOTO **Microstructures and Optical Properties of Scales of Butterfly Wings** http://link.springer.com/article/10.1007/s10043-996-0139-x

Fish-eye perspective

An ultra-wide-angle-lens produces extreme perspectivic distortions, which may either be deliberate or inconvenient. The fish-eye-lens provides an alternative for the creation of wide-angle images. Its considerable angle of view approaches 180°, which is only possible with a substantial distortion of the pictured space (the photo on the right page shows a spiral staircase). But why is the fish-eye-lens named that way? Does it really represent the way in which a fish sees the world? Face to face, fish see approximately as we do, although they are mostly a bit short-sighted. The picture shows a porcupine fish, with a relatively large remora attached to it lower side. This question becomes more interesting whenever fish attempt to observe the goings-on above the water at moments when the water surface is completely still. In fact, the animal actually sees a circle, in which the world above the water is contained in a highly distorted manner (with an angle of view of 180°). This optical phenomenon is so remarkable that it deserves another spread of its own (p. 192).

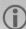 WIKIPEDIA **Fisheye lens** http://en.wikipedia.org/wiki/Fisheye_lens

The helical staircase in a different light: Fish-eye-lenses depict the outside world as it would approximately be seen from below through a completely still water surface. Deliberate use of projective properties can be made to accomplish interesting optical effects.

The circular distorted picture looks like "Snell's window" (p. 192).

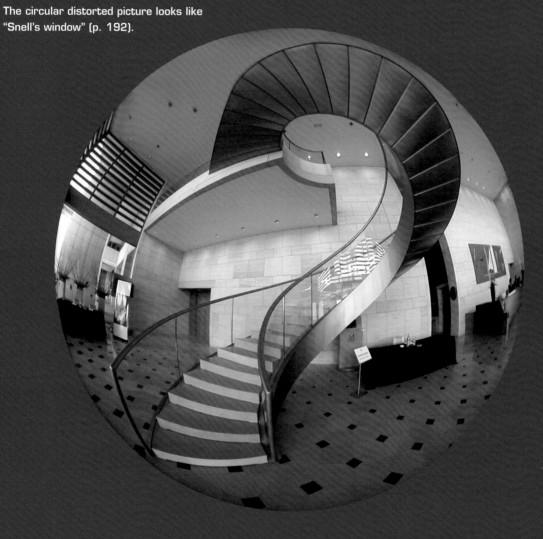

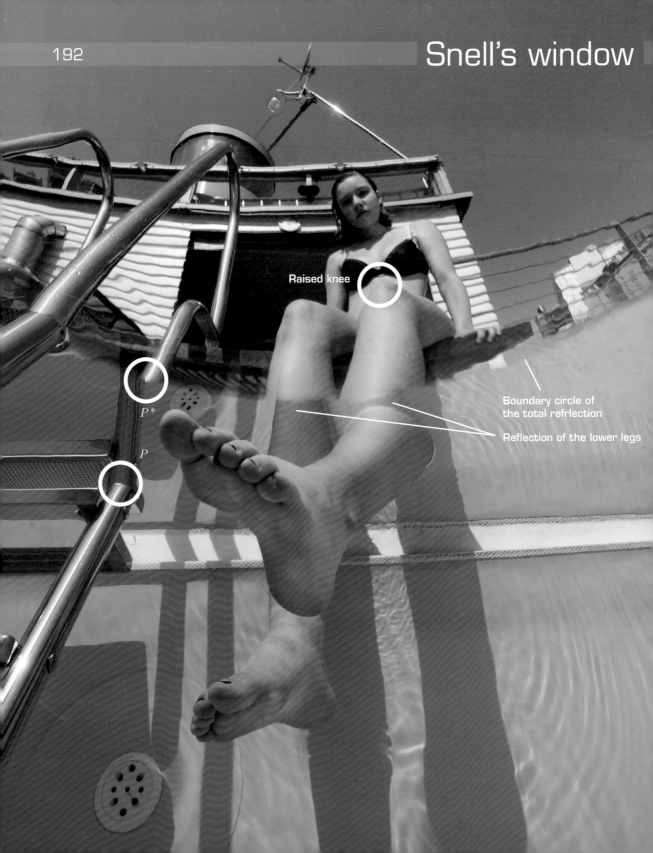

Snell's window

Raised knee

Boundary circle of
the total refrlection

Reflection of the lower legs

$P*$

P

If one attempts to look out of a water basin with an absolutely still surface, one will experience the outside world in a highly distorted state, delimited by an exact circle that, in perspectivic depictions, often resembles the branch of a hyperbola. Let α and β denote the angles of a light ray in relation to the vertical, before and after the refraction. According to Snell's law of refraction, $\sin\alpha : \sin\beta = \mathrm{const}$ will be true (the ratio of water to air is 4/3), and thus, $\sin\beta = 3/4\sin\alpha$. Therefore, $0 \leq \alpha \leq 90°$, while $0° \leq \beta \leq \arcsin 3/4\ (48{,}6°)$ holds true. All light rays that reach the visual centre from outside proceed underwater within a vertical cone of revolution with half an opening angle of 48,6°.

The intersection of the cone with the surface is called the boundary circle of Snell's window. Outside of it, total reflection occurs – that is, the surface acts essentially as a mirror. The "image raising" is equally notable: Because we do not take into account the refraction of light rays while looking outside from below, points close to the water surface will appear to be raised very significantly (see the left page and the next spread). The above image of a dive also exhibits a hyperbola as the boundary line to the outside world. This time, however, it is not represented as a boundary circle but by the intersection circle of the spherical glass panel in front of the lens (dome port) with the water surface. The camera was positioned in such a way, that part of the dome port was protruding outside of the water.

B. Casselman **The Law of Refraction**
www.math.ubc.ca/~cass/courses/m309-01a/chu/Fundamentals/snell.htm
D. Read **Snell's window** www.daveread.com/uw-photo/comp101/snells_window.html

Total reflection and image raising

Raised dorsal fin

Boundary circle

Total reflection of the back

Base of the fin under-going total reflection

Base of the fin under water

This wide-angle picture of a great white shark, whose dorsal fin intersected the surface, was the starting point of this study. Red and brown tones are visible above the shark, with further white patches (encircled red) above its dorsal fin. These patterns were consistently visible throughout a series of three subsequent photographs. The real-life scene was then recreated in a bathtub, in order to prove, that the brownish spots are indeed due to the total reflection of the shark's back, and that the white spots belong to the dorsal fin which protrudes outside of the water surface (large image on the right page). The total reflection is beautifully captured and ends very closely to the boundary circle (resembling a white hyperbola in the picture). The dorsal fin above the water surface (encircled red) is also clearly visible next to the boundary circle.

L. S. PEDROTTI **Basic Geometrical Optics** http://spie.org/Documents/Publications/00%20STEP%20Module%2003.pdf

Snell's window

Raised dorsal fin

Boundary circle

Total reflection of the back

Base of the fin undergoing total reflection

Base of the fin under water

Raised dorsal fin

Boundary cone

Elongated light ray

P*

Reflected shark

Image raising

Light ray under water, passing through P und P*

Boundary circle

R S

Q*

P*

Total reflection

Tip of the fin above water

Light ray refracted from the perpendicular

Q

β=48,5°

Z

The sketch illustrates the mechanism behind this illusion: Each point Q under water (in this case, at the tip of the dorsal fin) possesses a mirror point $Q*$ which causes the same impression at the lens centre Z as the reflection point S. However, this total reflection only occurs outside a vertical cone of revolution with half an opening angle of β (the angle of total reflection). Light rays from the tip of the dorsal fin P reach the lens centre Z only after a refraction at the surface (refraction point R). A sufficiently raised point $P*$ would, without refraction, cause the same impression in the image as point R.

A fish-eye roundtrip

Is it possible to convert a fish-eye photo (below) into a wide-angle photo (lower image on the right page), and vice versa? The answer is yes, albeit with a certain loss in image quality. All lenses are rotationally symmetrical. A spatial point P is to be photographed twice – both times with a fixed lens centre and a fixed optical axis a, but firstly with a fish-eye lens (image point P_1) and secondly with a wide-angle lens (image point P_2). P_1 and P_2 lie in a meridian plane through a and in the sensor plane on a radial ray through the main point (sensor-midpoint). Their radial distances r_1 and r_2 fulfil the reversible function $r_2 = r_2(r_1)$ due to the fact that each value r_1 unambiguously corresponds to its r_2-value, and vice versa. For two primary lenses, it is possible to derive a workable approximation using a polynomial function,

which enables us to convert the images "to and fro" – the only disadvantage being that if the images are later saved as pixels, some of their resolution is necessarily lost, because not every pixel of the original image corresponds to exactly one pixel of the converted image. Straight lines in physical space give a good indication of how accurate the conversion process actually is. In the fish-eye image, they should in general appear to be curved, while the wide-angle image should depict them more realistically as actual straight lines. The top right image shows that this "rectification" can be relatively accurate, if not perfect. A word of consolation for the fastidious eye: Even very good extremely wide-angle lenses produce pincushion distortion.

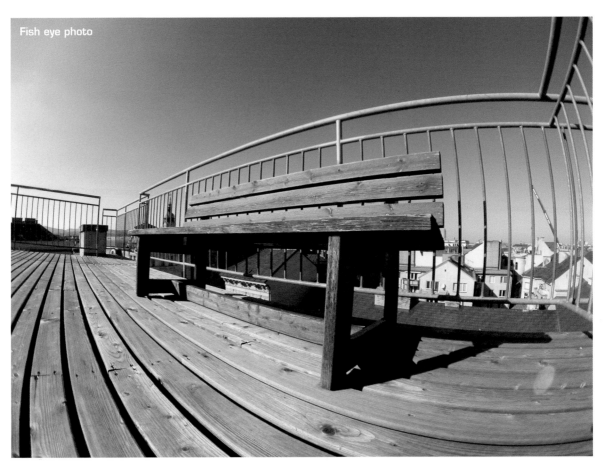

Fish eye photo

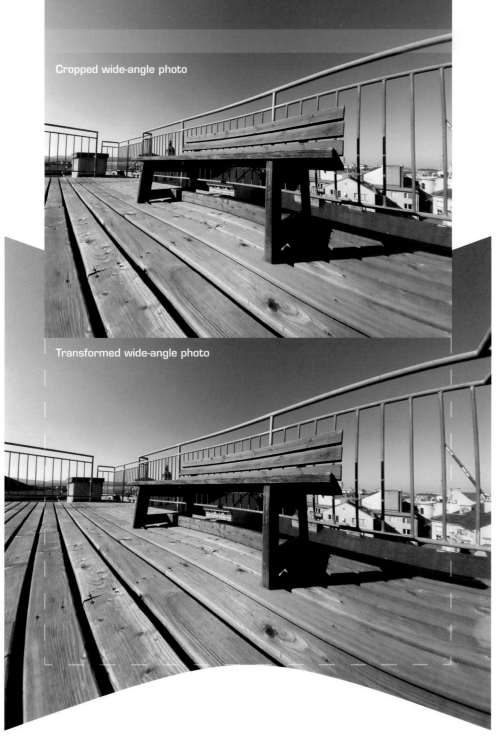

Cropped wide-angle photo

Transformed wide-angle photo

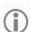

G. GLAESER (AUTHOR), L. NEUMANN, M. SBERT, B. GOOCH, W. PURGATHOFER (EDITORS)
Nonlinear Perspectives in Science, Arts and Nature
Computational Aesthetics 2005 - Eurographics Workshop on Computational Aesthetics in Graphics (PP. 123-132)

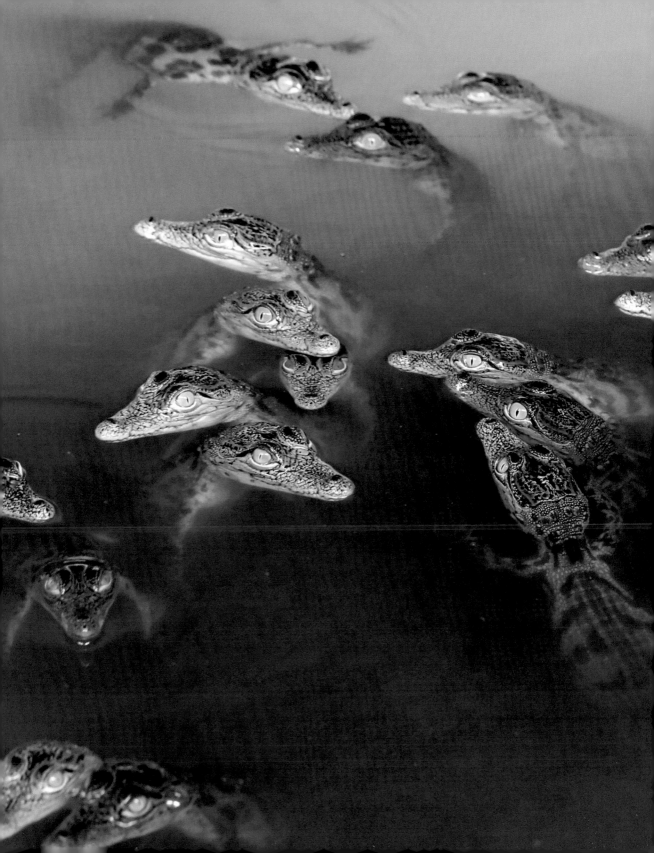

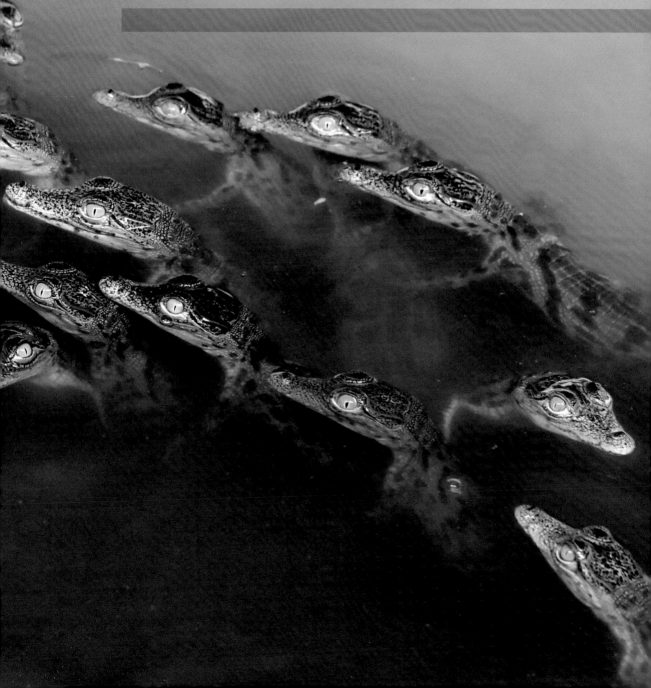

9 Distribution problems

Even distribution on surfaces

The venomous hair of some caterpillars provide adequate protection against predators. Humans exposed to the venom can be stricken by symptoms ranging from itching eczemas to nettle rash to asthma attacks and even anaphylactic shock. The following principle is essential from the perspective of the caterpillar: How should the hair on its body be distributed to provide optimal protection? Let us approximate the caterpillar's body using a cylinder of revolution (images on the bottom left), and that of the rolled-up caterpillar with a torus (centre right image). We shall now look for a distribution of points on these surfaces such that the distances between a given set of points are minimized. The computer algorithm that executes the calculation

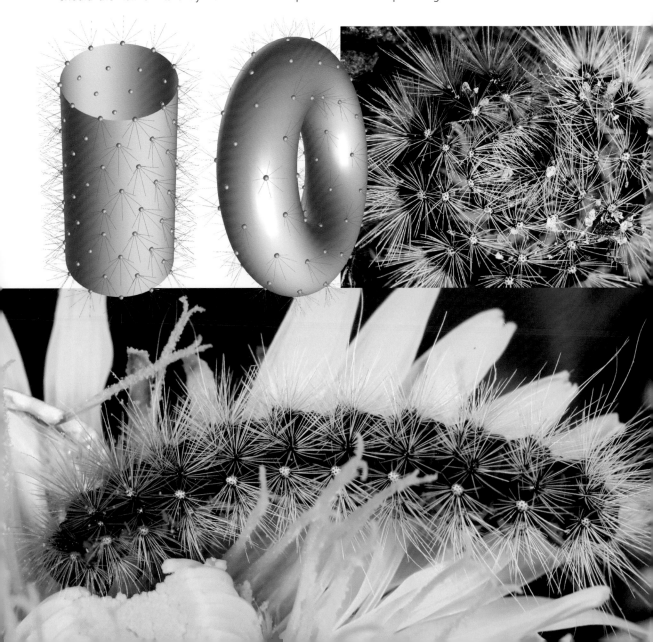

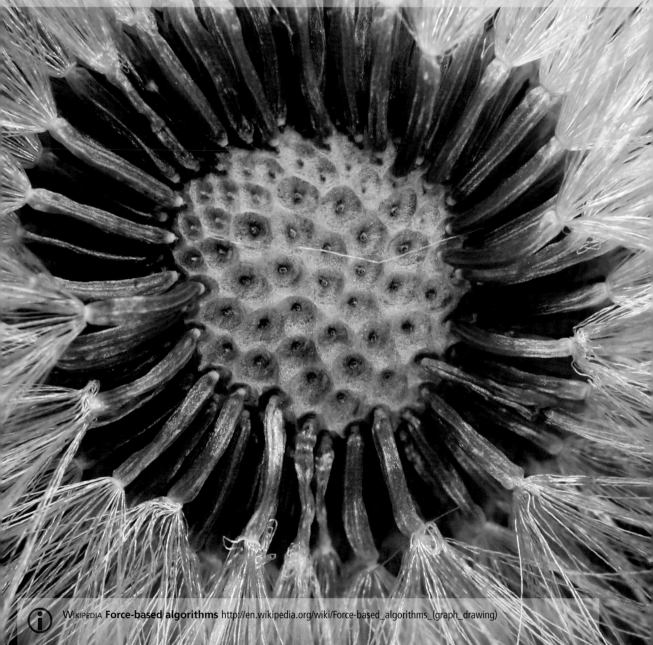

actually simulates spring-like entities between points that each exhibit a repulsive force. It approximates the optimal solution through many minute steps – almost like the caterpillar's own life cycle as it slowly but surely turns into a butterfly! The large image shows a dandeli-on blossom which has lost some of its seeds to the wind (see also page 238). Evolutionary deliberations apply here as well: The more seeds can be carried by a single flower, the greater the average reproductive success of the species, all other things being equal!

WIKIPEDIA **Force-based algorithms** http://en.wikipedia.org/wiki/Force-based_algorithms_(graph_drawing)

Distribution of dew

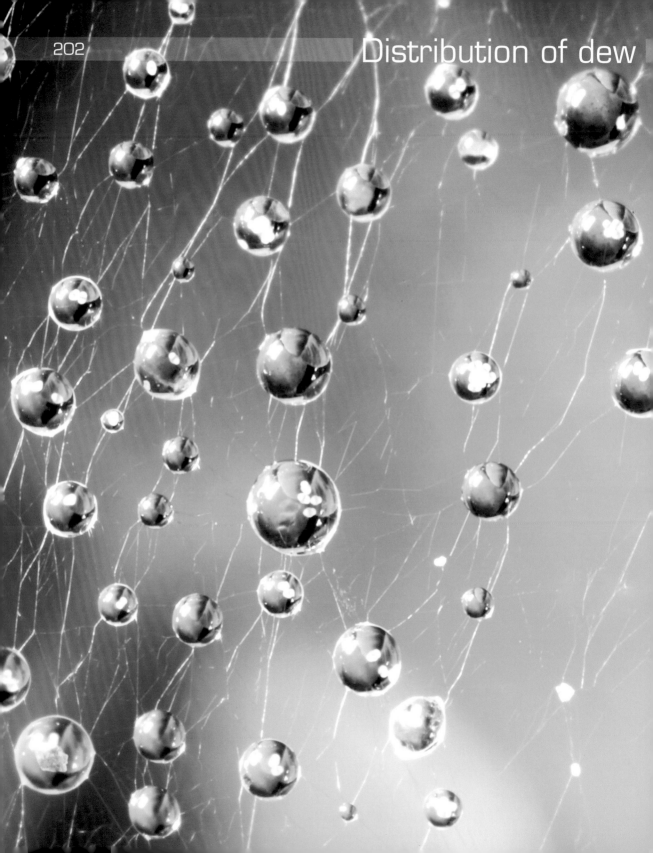

If left to cool and condense, the morning dew that attaches itself to leaves (right) and cobwebs (left) produces wonderful constellations of approximately equal water droplets. These droplets are spherical due to surface tension, which aims to enclose the highest possible volume. Their individual sizes are so similar because of cohesiveness, which causes molecules to be attracted towards "strategic centres" such as equidistant points. The droplets on the cobweb have a radius of about 1-2 mm, just like the smallest droplets on the leaf. If 64 droplets join together, they produce a larger drop of fourfold diameter (see page 280).

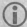 WIKIPEDIA **Hydrophobe** http://en.wikipedia.org/wiki/Hydrophobe
B. KRUMMHEUER, J. VOLLMER **Small droplets grow differently** www.ds.mpg.de/33681/news_publication_6328138

Contact problems

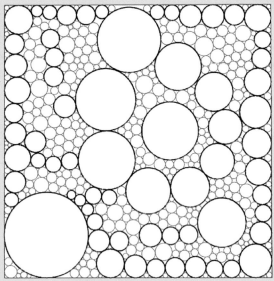

The large photo on the right page depicts an entrance gate composed of many mutually touching circles. The question arises of whether it is possible to add so many circles as to eventually produce a "closed manifold", with each circle touching exactly three others. Astoundingly, this can actually be accomplished. It is merely necessary to keep adding circles until only "triangles" remain (delimited by circular arcs), into which a single circle can be unambiguously inscribed.

This iterative process of adding circles is especially quick and elegant if the boundary is not a rectangle, but one of three touching circular arcs of equal size (as in the large computer graphic on this page).

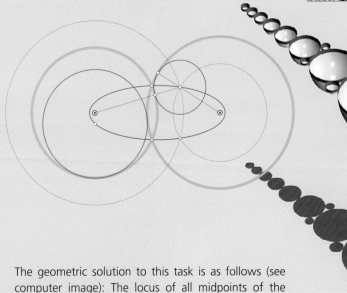

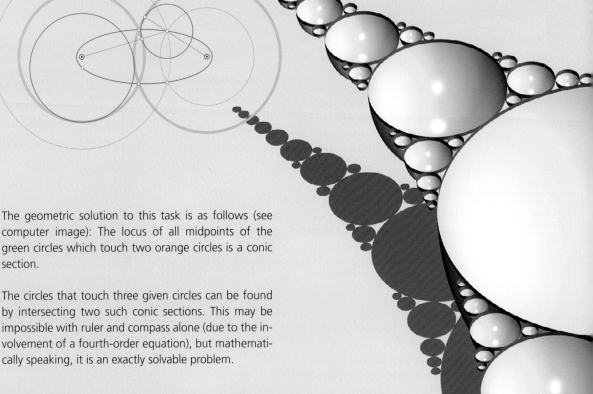

The geometric solution to this task is as follows (see computer image): The locus of all midpoints of the green circles which touch two orange circles is a conic section.

The circles that touch three given circles can be found by intersecting two such conic sections. This may be impossible with ruler and compass alone (due to the involvement of a fourth-order equation), but mathematically speaking, it is an exactly solvable problem.

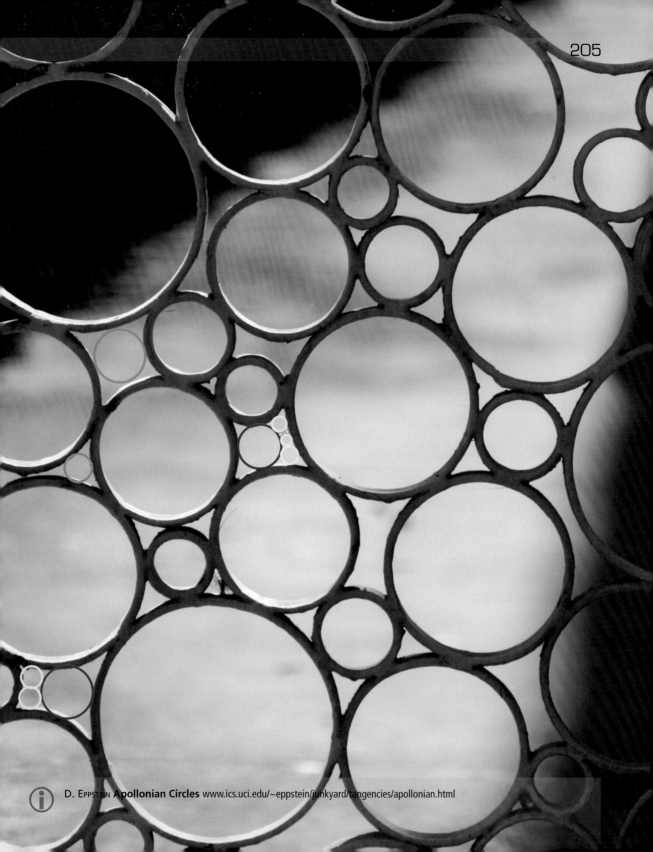

D. EPPSTEIN **Apollonian Circles** www.ics.uci.edu/~eppstein/junkyard/tangencies/apollonian.html

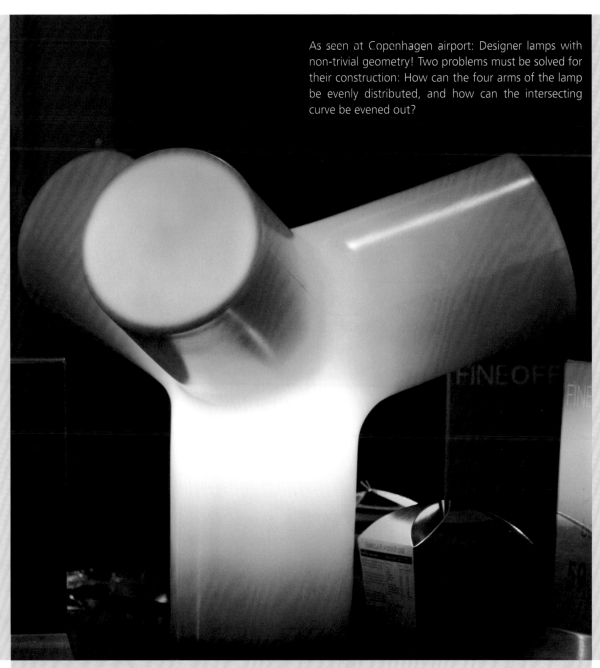

As seen at Copenhagen airport: Designer lamps with non-trivial geometry! Two problems must be solved for their construction: How can the four arms of the lamp be evenly distributed, and how can the intersecting curve be evened out?

D. EPPSTEIN **How Many Tetrahedra?** www.ics.uci.edu/~eppstein/projects/tetra
M. ARISTIDOU **www.math.lsu.edu/~aristido/Webpage/Phys2/chap42/p42_037.pdf**
www.math.lsu.edu/~aristido/Webpage/Phys2/chap42/p42_037.pdf

The answer to the first question is relatively simple: The altitudes in the regular tetrahedron (one of five platonic solids) intersect each other at the same angle due to considerations of symmetry. In order to calculate the angle, we take advantage of the fact that a tetrahedron can easily be cut out of a cube as in the right image (the cube centre also serves as the centre of the tetrahedron). In cases where the cube possesses an edge length of 2, we get

$$\vec{MA} = \begin{pmatrix} -1 \\ -1 \\ -1 \end{pmatrix}, \ \vec{MB} = \begin{pmatrix} 1 \\ 1 \\ -1 \end{pmatrix}$$

In order to determine the cosine of the enclosed angle, the vectors are to be normalized and multiplied as scalars:

$$\cos \varphi = \frac{1}{\sqrt{3}} \begin{pmatrix} -1 \\ -1 \\ -1 \end{pmatrix} \cdot \frac{1}{\sqrt{3}} \begin{pmatrix} 1 \\ 1 \\ -1 \end{pmatrix}$$

$$= -\frac{1}{3} \Rightarrow \varphi \approx 109{,}5°$$

As for the round surface parts along the intersection ellipse of both cylinders, it is merely necessary to lead a sphere of constant radius such that it constantly touches both cylinders. For reasons of symmetry, the locus of the sphere's midpoints lies in the same plane as the intersecting ellipse.

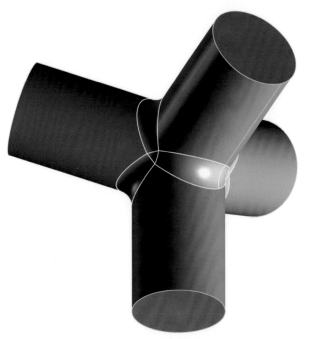

When projecting in axis direction, the midline appears circular and is thus, spatially speaking, an ellipse. This makes the round surface a so-called pipe surface with an ellipse as its midline (comparable to a torus whose midline is a circle).

Spiky equal distribution

The pictured Christmas star resembles a sea urchin. Both the urchin and the star are faced with the challenge of evenly distributing a certain number of spikes on a spherical shell (in the sea urchin's case, the upper half is an ellipsoid of revolution). The Christmas star probably has 24 such spikes, and the sea urchin many many more. On a sphere's surface, it is not possible to distribute any number of points evenly, but some quantities work especially well – such as 12 and 20, since these can be interpreted as the corners of two regular polyhedrons (icosahedron and dodecahedron). In the general case, the problem can be simulated by letting the points "swim" on the surface with the intent of creating an energy minimum or an equilibrium of forces. The optimal solution tends to be approximated after many iterations and may turn out to be quite comparable to the magnification of the sea urchin's shell (large photo on the right). The size of the spherically bounded starting points would be a measure of the forces at play. The pores, through which an exchange of liquids and gas can occur, are especially notable features of the shell.

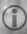

Soft corals are colonies composed of single polyps (see image on the right page). They can stretch and stabilize by pumping water in and out of their bodies. Their "basic shape" is given further stability by tiny needles of limestone. We have attempted to approximate its basic shape (bottom right) before subjecting the thus emerging – and rather plump – geometric form to some transformations so as to maximize the visual degree to which it matches the template. Upon achieving success, it is even conceivable to formulate a hypothesis on whether these lifeforms are exposed to comparable physical influences.

Due to the inherent complexity, the following simulation must be done by a computer: The basic geometrical shape is to be wrapped in a polygon net. The points of

this net are now to serve as magnets that exert slight attraction upon each other. After an initial step, the points will reposition themselves on the basal surface, resulting in slightly decreased attractive forces. A repetition of this procedure for the newly adjusted surface will produce an even more optimal distribution. After only a few dozen iterative steps, the surface will recompose itself into a more natural and organic form – thinner in some places and thicker in others (green shape below).

The surfaces of elastic and natural formations indeed seem to desire a reduction of surface tension. If the object in question is flexible (as soft corals are), it will continuously morph into new optimal trees depending on the current direction of the water current. The bottom left picture shows a soft coral in its natural environment.

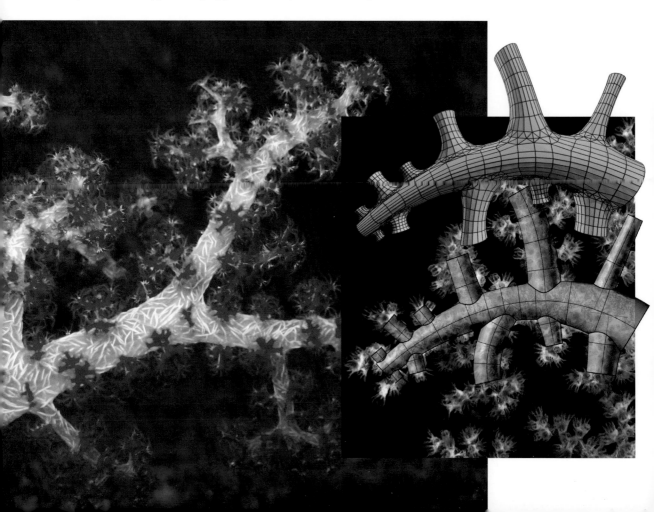

F. Gruber, G. Glaeser **Magnetism and minimal surfaces**
Computational Aesthetics 2007 — Eurographics Workshop on Computational Aesthetics in Graphics, Visualization and Imaging

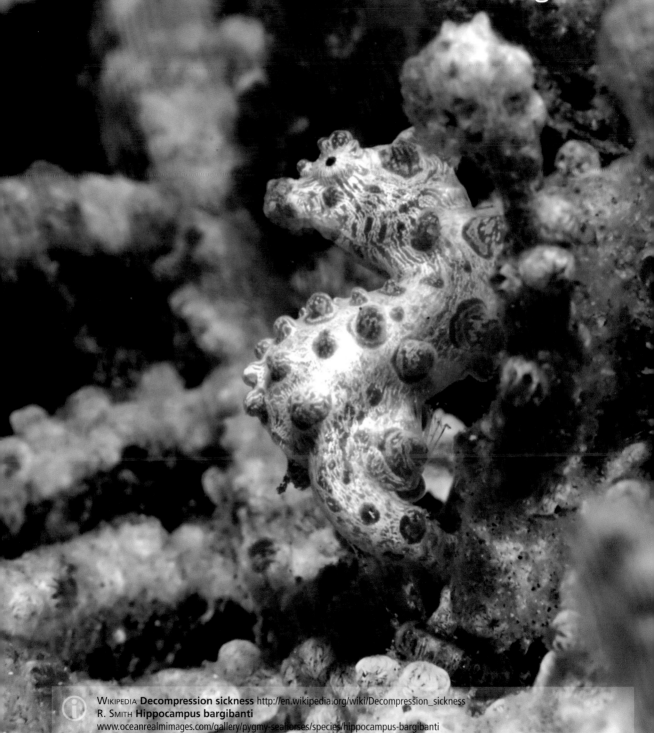

In the left image, among the many coral branches, sits a member of a species that was not discovered until the year 1969, and then only by accident! No wonder, as they live at depths of 35 m and below, where red is the colour of camouflage (see p. 227). Stretched out, this tiny sea horse is not even 2 cm long (the photo probably depicts a pregnant male).

But what could be so dangerous about it? Naturally, given its obscurity, many divers are keen to search for it and take its picture – an endeavour that takes at least several minutes, even under fortunate conditions. At such depths and pressures, however, similar to the case of the champagne bottle, the diver's bloodstream becomes increasingly replete with nitrogen (4,5 bar pressure = 1 bar of air pressure plus 1 bar per 10 meters of water depth). The diver would be well advised to begin immediately with a slow and careful ascent!

The only alternative is to carry even more bottles of compressed oxygen and to plan for several decompression stops (see photo below).

Pressure distribution

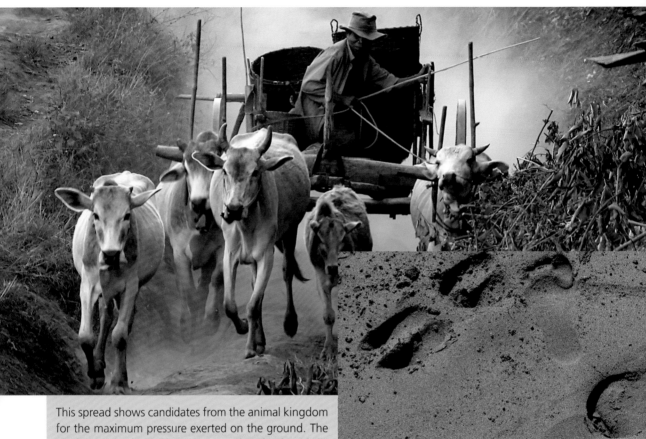

This spread shows candidates from the animal kingdom for the maximum pressure exerted on the ground. The elephant is by far the heaviest animal on land, with its enormously thick legs, of which only one at a time is usually in the air (Elephants are the only mammals unable to jump). Pressure is defined as force per unit of surface. When the animal is resting, 6000 kg of its mass exert a pressure of 6000 kp upon the ground.

If this mass is distributed among four circles of 3 dm diameter each, then the pressure exerted roughly equals 850 kp / dm². Giraffes, which weigh about 1000 kg, are quite good at kicking and galloping, during which a single hoof may occasionally bear the entire organism's mass (exceeding 1000 kp / dm²). Cattle may also weigh close to 1000 kg. Its smaller hooves would therefore be more forceful, having – after all – stamped out the familiar alpine pastures over the course of centuries.

In animals of similar bodily proportions (such as young and old specimen of the same species), the ground pressure grows linearly with the representative length scale (such as the shoulder height). This can be explained by the observation that mass grows in a cubical relationship, unlike the standing surface area, which grows only in a square relationship.

The above photo shows very different impressions in the sand. The human footprint is only relatively weakly indented, as is – amazingly – the horse's hoof. The bicycle, which not only touches the ground with a much smaller surface area but is also usually burdened with a human on top, sinks in a little bit more, but is far exceeded by the ox hoof.

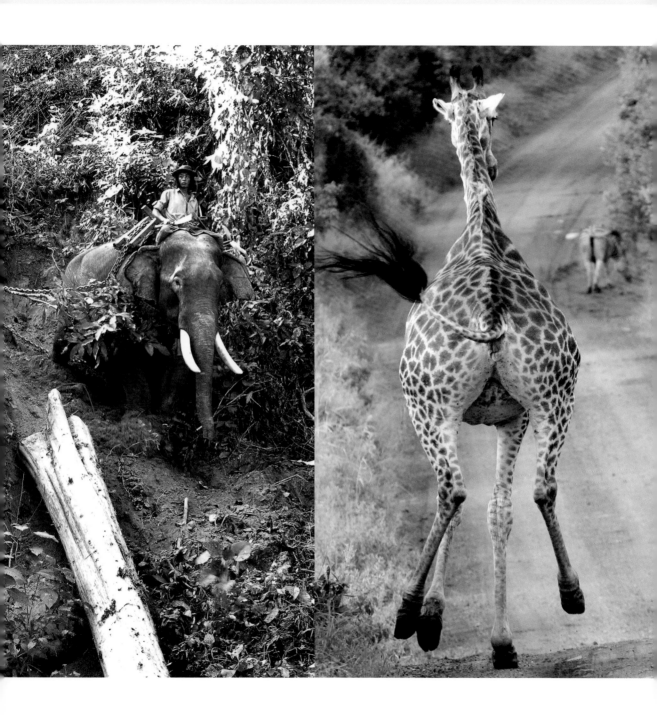

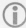 G. Glaeser **Der mathematische Werkzeugkasten (4th edition)** Springer Spektrum, 2014

Fluctuations of weight

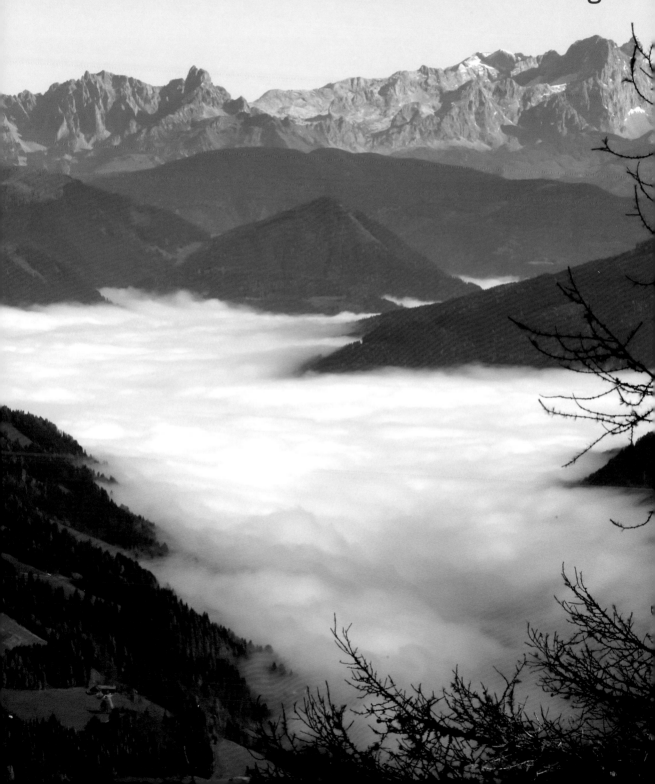

Minute differences in density may sometimes have very noticeable effects. The left photo shows the way in which fog can be neatly and calmly contained within a mountain valley. The fog's upper boundary almost resembles the surface of a liquid. The principle is actually the same: Both some liquid in a cup and fog in a valley are heavier than air and thus align themselves along the bottom of the container. The description "soupy fog" may in fact be a better analogy than one might think!

The image on the right depicts a Galilean thermometer: Glass vessels filled by air and liquid are submerged in a clear substance. Their densities are precisely calibrated and differ only marginally from the density of the surrounding liquid. The relative difference in densities may not even exceed 0,002 grams!

Depending on the temperature of the surrounding liquid (= room temperature), a tiny glass vessel will either float, sink completely to the ground or rise to the surface. The lowest still floating vessel suggests the room temperature, which in the photo measured 22°C.

WIKIPEDIA **Galileo thermometer** http://en.wikipedia.org/wiki/Galileo_thermometer

Kissing numbers

How many identical spheres can touch one another while surrounding an identical sphere at their center? Newton conjectured correctly that the maximum was 12, since a 13th sphere would no longer fit, despite there being some space left (see the computer rendering on the right).

The two-dimensional case is much easier to solve, since a circle is surrounded by exactly 6 congruent circles (middle graphic).

Although these types of packing problems occur frequently in nature, the various spheres produced by biology are usually flexible, and there is always a good solution to be found by means of pushing and pressing.

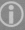

E. W. Weisstein **Kissing Number** http://mathworld.wolfram.com/KissingNumber.html

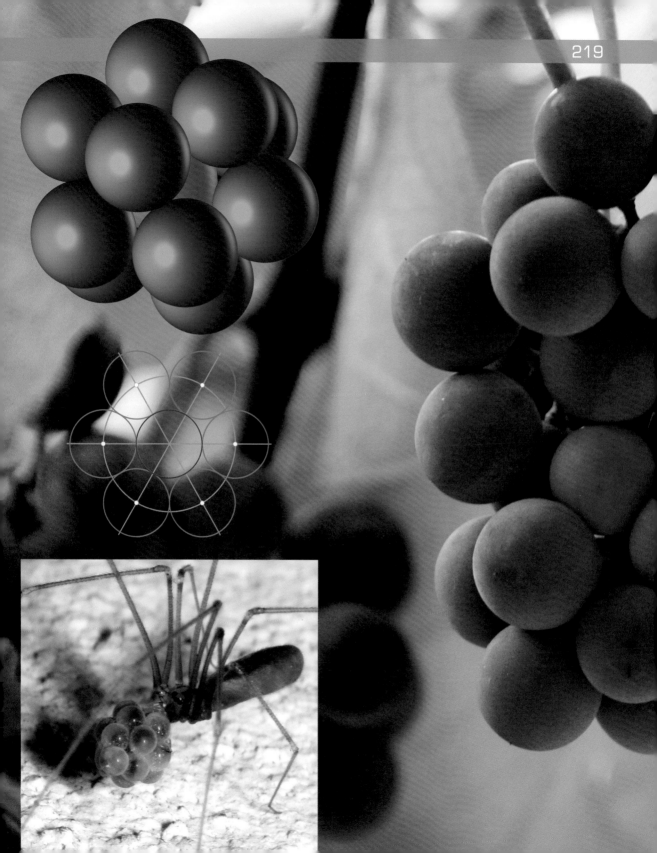

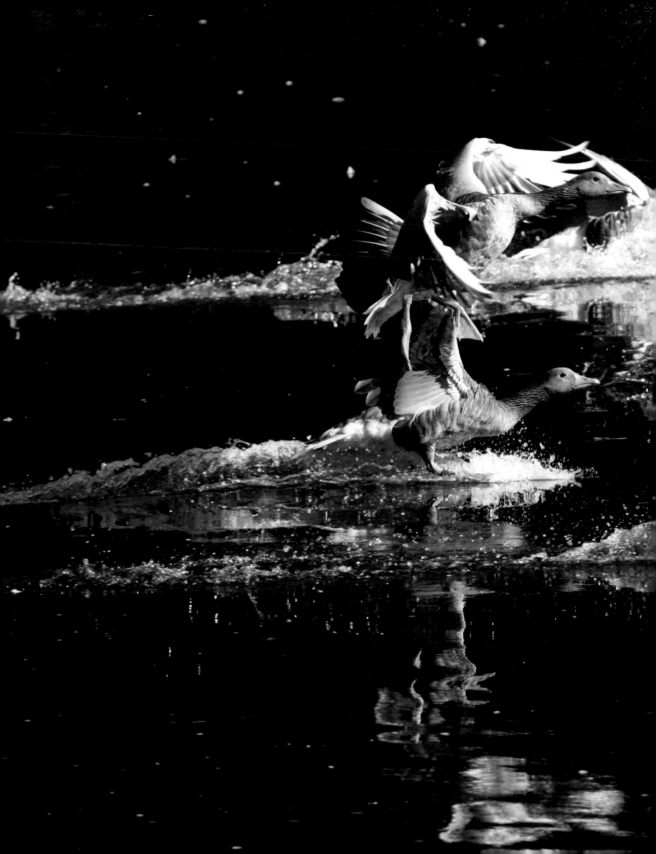

10 Simple physical phenomena

Isaac Newton's laws are part of the canon taught in every high school physics class and are still indispensable for the understanding of mechanics. They can be summarized as follows:

1. Principle of inertia: A body remains at rest or in a uniform straight motion as long as no outside forces exert any influence upon it.

2. Principle of acceleration: When influenced by a force, a body will accelerate in proportion to the force's strength in the direction in which the force acts.

3. Principle of interaction: If a first body exerts a force upon a second, then the second body also exerts an equal but opposite force upon the first.

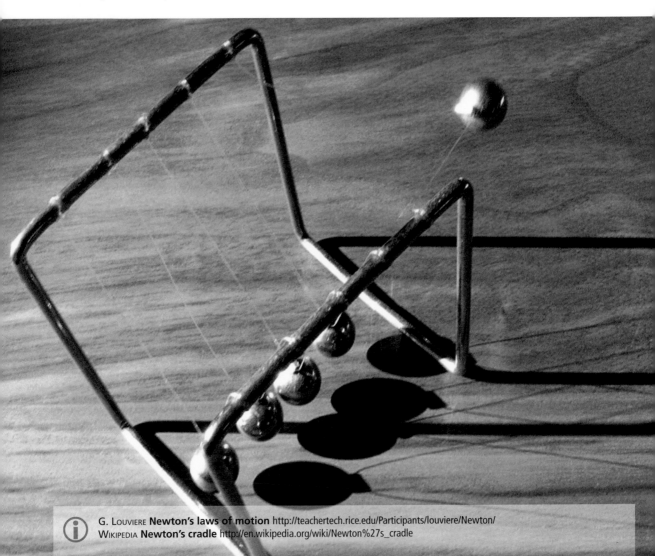

G. Louviere **Newton's laws of motion** http://teachertech.rice.edu/Participants/louviere/Newton/
Wikipedia **Newton's cradle** http://en.wikipedia.org/wiki/Newton%27s_cradle

The principles of acceleration and interaction are often demonstrated using a special pendulum known as Newton's cradle:

If one of the spheres on the side is pulled upward and dropped against the rest, then the elastic impulse will be transferred from sphere to sphere until the sphere on the opposite end is ejected with approximately the same force as the initial impact. If two spheres are raised and dropped on the same side, then the impulse is twice as strong, leading to two spheres being propelled away at the opposite side. This behaviour follows directly from the law of energy (or momentum) conservation.

The small tigers at the Viennese Schönbrunn zoo attempt to explore the principle of interaction in their own terms. They may also be interested to learn how to use the equal size of the opponent to one's advantage: Small deviations from the "ideal impulse" can have great effects, such as the sudden rotation about a shared axis.

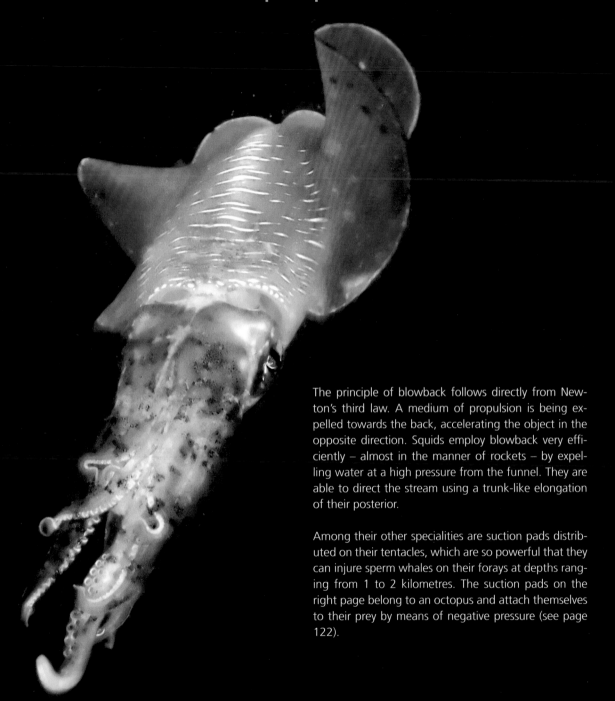

The principle of blowback follows directly from Newton's third law. A medium of propulsion is being expelled towards the back, accelerating the object in the opposite direction. Squids employ blowback very efficiently – almost in the manner of rockets – by expelling water at a high pressure from the funnel. They are able to direct the stream using a trunk-like elongation of their posterior.

Among their other specialities are suction pads distributed on their tentacles, which are so powerful that they can injure sperm whales on their forays at depths ranging from 1 to 2 kilometres. The suction pads on the right page belong to an octopus and attach themselves to their prey by means of negative pressure (see page 122).

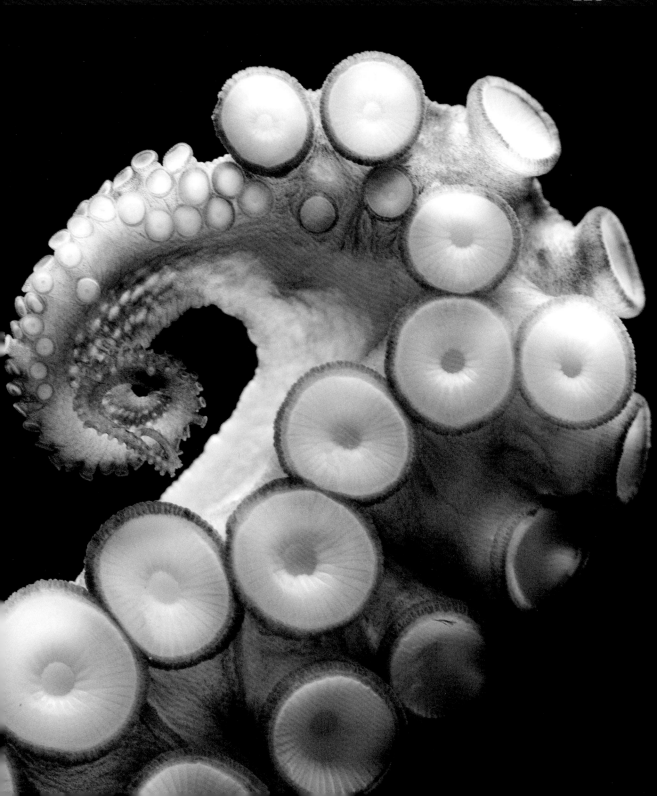

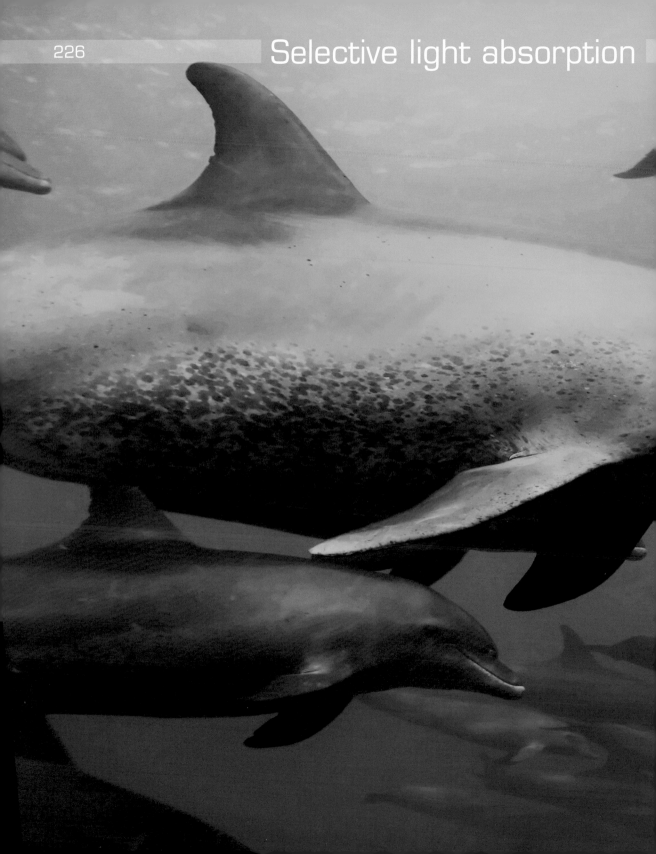

Assuming that the amount of a spectral colour decreases per metre by 10%, when exactly is half of its intensity lost? This problem leads to the exponential equation $0.9^x = 0.5$, which can be solved logarithmically as follows:

$$x \log 0.9 = \log 0.5 \quad (x = 6.6\text{m}).$$

The pictured dolphins were captured at a depth of about 15m, with the foremost animal being merely 1m away from the camera. The surface light, in which all spectral colours were once contained, has thus travelled 16m underwater before reaching the sensor.

Red tones decrease at a greater rate than blue tones, which explains the bluish tint visible in most underwater photographs. This makes it very difficult to deduct the actual colour of underwater objects, especially at great distances from the camera. Deep water appears to us as blue for the same reason – and not just because the sky is being reflected in it!

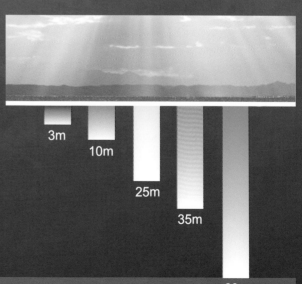

3m

10m

25m

35m

60m

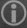 J. Rander **Understanding color loss underwater** http://johnrander.chez-alice.fr/absorption_en.html

Relative velocities

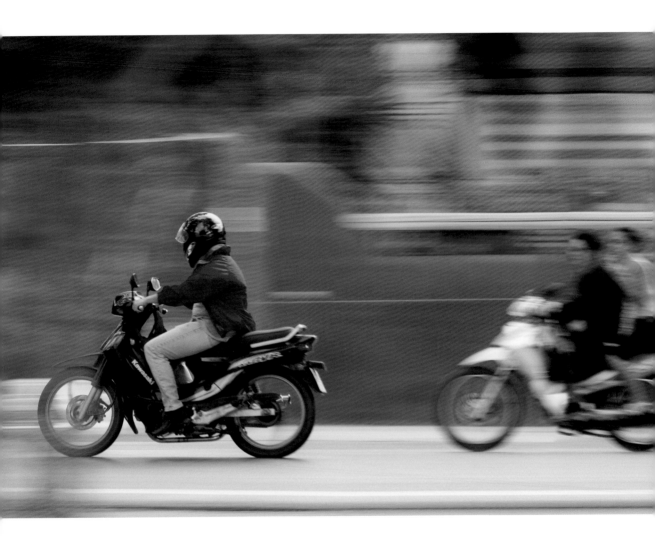

In the above image, the camera is being moved (or rather, panned) along with the motorcycle moving at a velocity v. Despite the relatively long exposure time (1/40 s), neither the vehicle nor its passenger appear to be out of focus. The movement of the camera produces a "negative velocity" $-v$ in the background, which becomes blurred beyond recognition. Now for the interesting question: Was the left motorcyclist just about to overtake the blurry pair on the right, or was it the other way around? From a purely photographical standpoint, it is impossible to make this distinction. However, knowing that the picture was taken in a country with right-hand driving, and assuming that all participants were adhering to the law, one would have to conclude that the left motorcycle was moving faster.

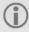 WIKIPEDIA **Relative velocity** http://en.wikipedia.org/wiki/Relative_velocity

What exactly happened in the photo of this very regular forest that almost resembles a painting? The trees in the background are much sharper than the ones in the foreground – which, however, are blurry in a most usual way! The photo was taken from within a fast moving car, and without this movement (about 110 km/h, or 30 m/s), it would have been perfectly sharp. At 1/1000 s, the exposure time was comparatively short, and assuming a relative sideways velocity of -30 m/s, the forest moved 3 cm against the driving direction during exposure. For distant trees, this movement is almost unnoticeable. The frontmost row of trees exhibits a so-called "motion blur".

The aerodynamical paradox

What happens if a table tennis ball gets into the air stream of a hair dryer? One would intuitively think that it would be blown far away before falling to the ground. In fact, if the ball reaches a particular position, it might find itself in an almost magical state: It will be kept at a distance by the stream of air while simultaneously being sucked sideways towards it. It will thus hover in mid-air without ever falling to the ground.

The secret behind this phenomenon is explained by negative pressure created by a stream of air that moves faster than its surroundings. In fact, despite being described mathematically by Johann Bernoulli in the year 1738, this behaviour is so unintuitive that it is often called a paradox.

Three forces act upon the ball: One in the direction of the air current, one perpendicular towards it and a third towards the centre of the earth. If the three forces cancel each other out, the ball will appear to stay suspended in mid-air.

This seeming paradox is the basis for the mechanics behind airplane travel. If one can produce a larger velocity above an aerofoil than underneath it, then the whole mighty airplane can be carried by nothing but air. This difference in velocity can be accomplished by a precise induction of turbulence: The sharp edge at the rear of an airplane's wing produces a first vortex.

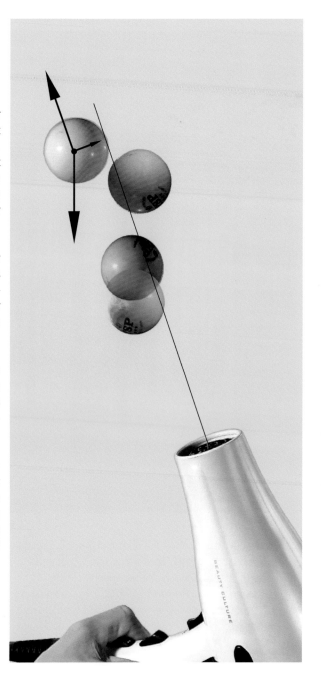

ⓘ ALLSTAR NETWORK **How Airplanes Fly: A Physical Description of Lift** www.allstar.fiu.edu/aero/airflylvl3.htm
FORMULA1-DICTIONARY **Coanda Effect** www.formula1-dictionary.net/coanda_effect.html

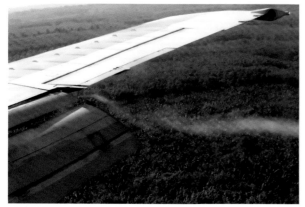

Given an adequate aerofoil profile, another vortex is produced above the front as a reaction to the posterior vortex. Its function is to decrease air velocity at the lower part of the wing, which simultaneously lifts it upwards. At the upper part, the velocities are added, producing a suction (see computer graphic). The second vortex acts according to the Coanda effect along the convex upper side. The photo on the upper left even shows a vortex at the posterior edge, which appears stretched due to the velocity of the airplane.

The photographs below depict various positions of the wing flaps: The left image shows an intermediate position immediately before takeoff. The highest flight position is visible at the centre (the wing would otherwise act as an air break). On the right, the flaps are fully extended for breaking and landing.

Countervortices

Increases air velocity

Decreases air velocity

Vortices around the edge

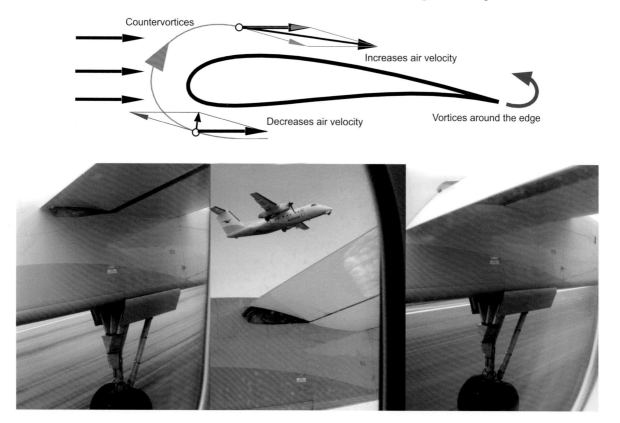

Flying in formation

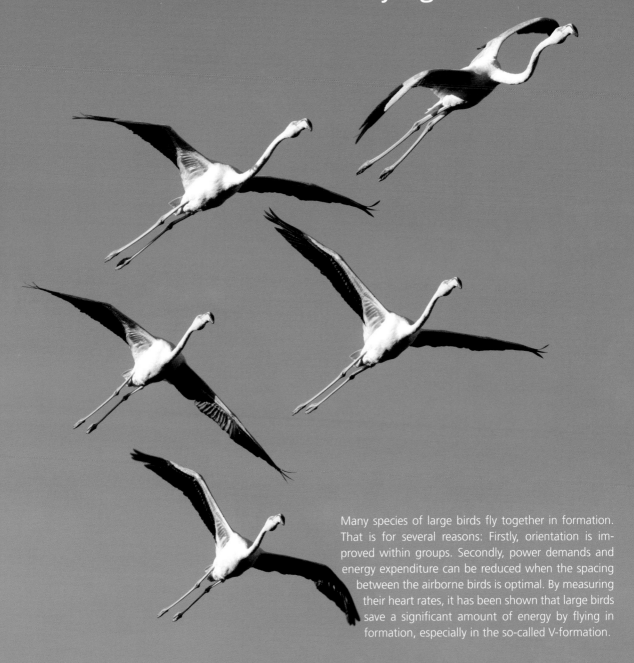

Many species of large birds fly together in formation. That is for several reasons: Firstly, orientation is improved within groups. Secondly, power demands and energy expenditure can be reduced when the spacing between the airborne birds is optimal. By measuring their heart rates, it has been shown that large birds save a significant amount of energy by flying in formation, especially in the so-called V-formation.

H. Weimerskirch, J. Martin, Y. Clerquin, P. Alexandre, S. Jiraskova **Energy saving in flight formation** Nature, 2001
Wikipedia Commons **Airplane Vortex** http://commons.wikimedia.org/wiki/File:Airplane_vortex_edit.jpg

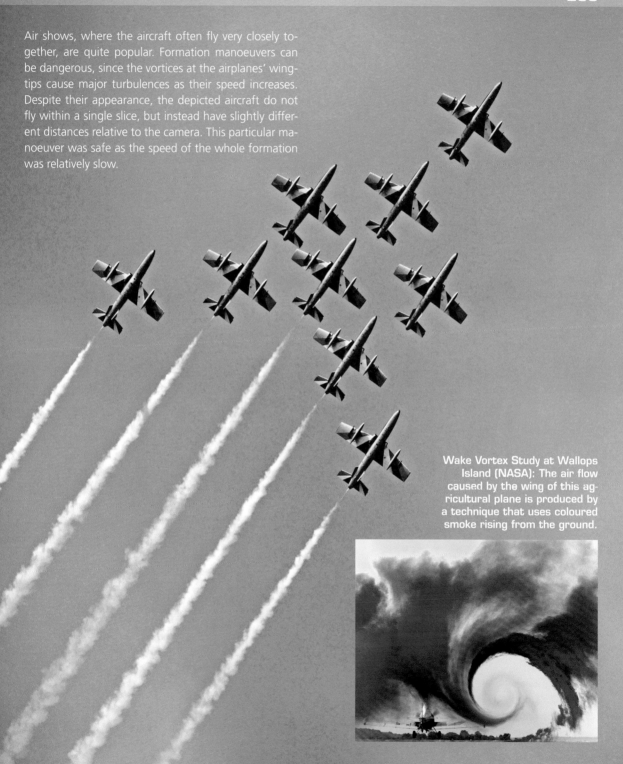

Air shows, where the aircraft often fly very closely together, are quite popular. Formation manoeuvers can be dangerous, since the vortices at the airplanes' wingtips cause major turbulences as their speed increases. Despite their appearance, the depicted aircraft do not fly within a single slice, but instead have slightly different distances relative to the camera. This particular manoeuver was safe as the speed of the whole formation was relatively slow.

Wake Vortex Study at Wallops Island (NASA): The air flow caused by the wing of this agricultural plane is produced by a technique that uses coloured smoke rising from the ground.

Bird or insect?

Like all birds, hummingbirds are warm-blooded, but this particular family of animals can only be found in the New World (most species occupy South and Central America).

As its name already suggests, the Hummingbird Hawk-moth (Macroglossum stellatarum) can easily be mistaken for an actual hummingbird. With 85 wing beats a second, it produces sounds that are similar to those of hummingbirds. Again, form follows function: The two species have almost nothing in common except for their appearance. Being insects, moths are cold-blooded and have six legs (their wings did not evolve from former legs).

Hummingbird Hawk-moths never come into natural contact with hummingbirds, since they live in Eurasia.

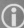

M. Levin, G. Elert **Frequency of Hummingbird Wings** http://hypertextbook.com/facts/2000/MarkLevin.shtml

Form follows function

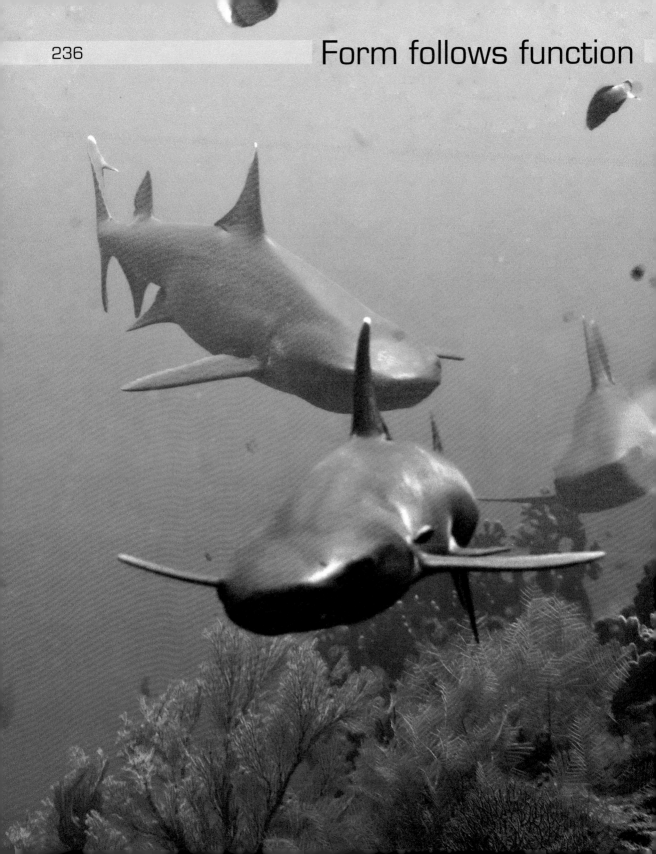

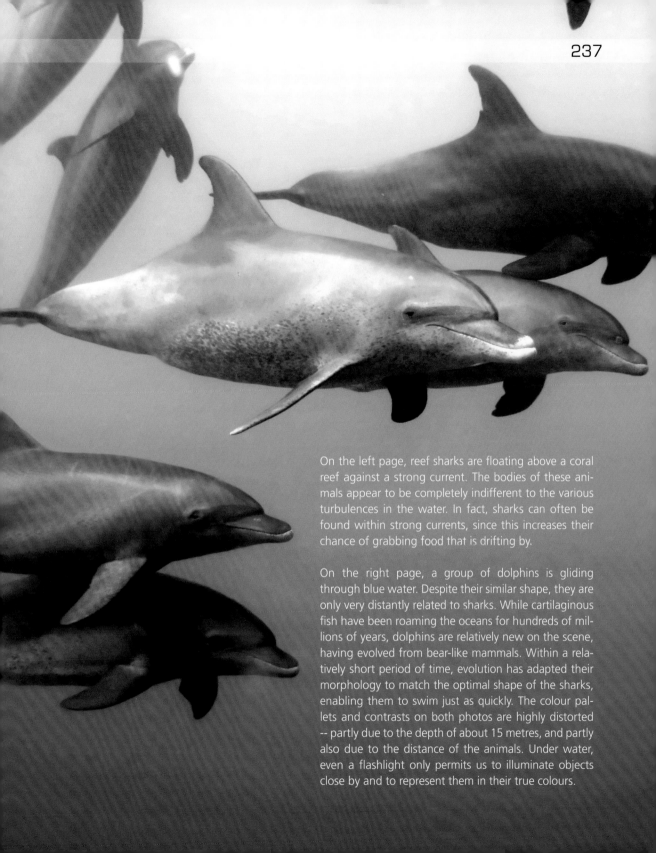

On the left page, reef sharks are floating above a coral reef against a strong current. The bodies of these animals appear to be completely indifferent to the various turbulences in the water. In fact, sharks can often be found within strong currents, since this increases their chance of grabbing food that is drifting by.

On the right page, a group of dolphins is gliding through blue water. Despite their similar shape, they are only very distantly related to sharks. While cartilaginous fish have been roaming the oceans for hundreds of millions of years, dolphins are relatively new on the scene, having evolved from bear-like mammals. Within a relatively short period of time, evolution has adapted their morphology to match the optimal shape of the sharks, enabling them to swim just as quickly. The colour pallets and contrasts on both photos are highly distorted -- partly due to the depth of about 15 metres, and partly also due to the distance of the animals. Under water, even a flashlight only permits us to illuminate objects close by and to represent them in their true colours.

Offspring on parachutes

A dandelion (Taraxacum) has very small flowers (florets) which together make up a composite flower head. Many species of Taraxacum are seed dispersed ruderals that rapidly colonize disturbed soil.

The seeds fall down on quasi-parachutes at a speed of approximately three seconds per metre. This makes it possible for wind to pick it up and spread it even further.

In the left image, a dandelion seed got attached to a spinning thread and accumulated dew droplets of less than 1 mm size over the course of the night.

The fastest track

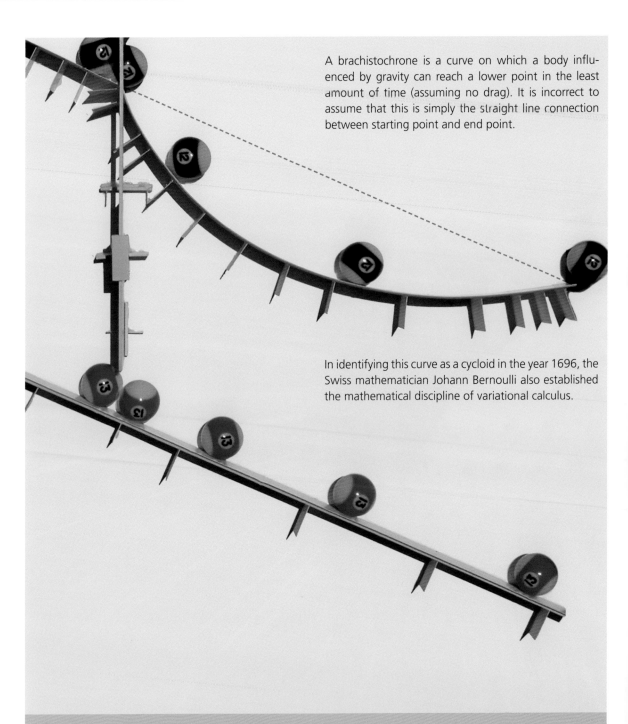

A brachistochrone is a curve on which a body influenced by gravity can reach a lower point in the least amount of time (assuming no drag). It is incorrect to assume that this is simply the straight line connection between starting point and end point.

In identifying this curve as a cycloid in the year 1696, the Swiss mathematician Johann Bernoulli also established the mathematical discipline of variational calculus.

WIKIPEDIA **Brachistochrone curve** http://en.wikipedia.org/wiki/Brachistochrone_curve

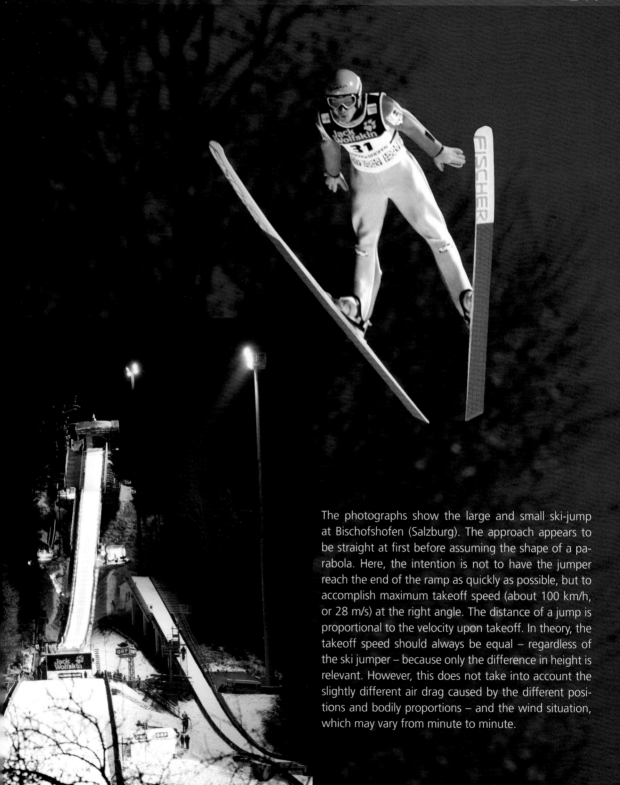

The photographs show the large and small ski-jump at Bischofshofen (Salzburg). The approach appears to be straight at first before assuming the shape of a parabola. Here, the intention is not to have the jumper reach the end of the ramp as quickly as possible, but to accomplish maximum takeoff speed (about 100 km/h, or 28 m/s) at the right angle. The distance of a jump is proportional to the velocity upon takeoff. In theory, the takeoff speed should always be equal – regardless of the ski jumper – because only the difference in height is relevant. However, this does not take into account the slightly different air drag caused by the different positions and bodily proportions – and the wind situation, which may vary from minute to minute.

What do high-speed trains, motorcycles, airplanes, birds, skiers and snowboarders have in common? Whenever they have to turn a corner, they have to assume a well-defined "cornering" position. In the case of trains, the rail cross-sections are inclined at precise angles and are thus best suited for particular velocities.

Curve inclinations α, momentary velocities v and curve radii r can easily be brought into mutual context by considering the parallelogram of forces, which results from the mass vector G with a length of mg and the centrifugal force vector F with a length of mv^2/r. Regardless of the mass m, it follows that:

$$\tan \alpha = \frac{F}{G} = \frac{v^2}{gr}$$

It would seem that velocity has a squared effect on the formula. Let us consider a concrete example: The pictured extreme carver tacks a curve with a radius of $r = 5$ at a speed of $v = 12$ m/s. This results in $\tan \alpha = 2{,}88$, which means, that the board has to be inclined at an angle of 71° in order to keep the carver at a balance. More than three times the earth's gravity is exerted on the carver.

"Touching the snow" as in the photo is a physical necessity, given a standard slope inclination of 20°. The athlete is forced to literally drag himself across the snow if he is to master the curve.

The right photo shows how the snowboard supports the carver as he navigates an extremely tight corner. This is only possible with a load of 200 kPa and above.

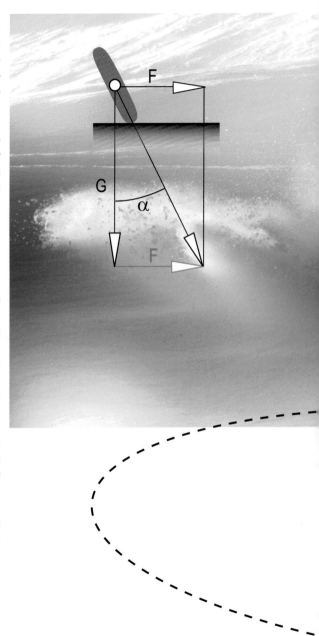

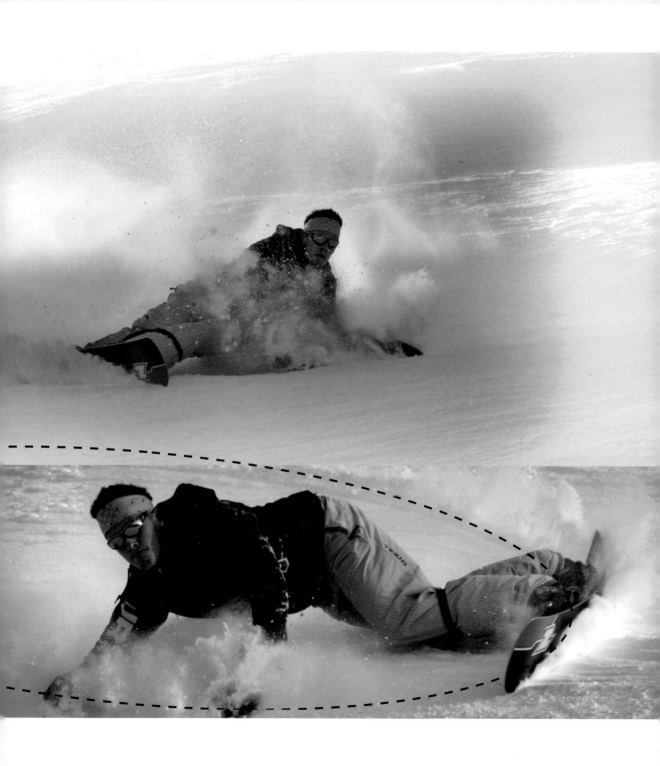

Mathematics and bees

There exist roughly 20 000 species of bees in the world, of which the honey bee is the best known. All species are highly important for the pollination of plants (right photo), and for fruit-bearing trees in particular. The services of honey bees have been calculated to be worth up to 150 billion Euros per year. This makes the honey bee the third most important domesticated animal, following the cow and the pig. Lately, concern has been raised over a phenomenon known as the "colony collapse disorder", which poses a great danger to the survival of the species. Many potential causes have been put forward – from viruses to mites to environmental factors.

If a bee wishes to alert its sisters to the location of a food source, it proceeds with a so-called "tail wagging dance", which can be noticed even at distances exceeding 100 m. The main direction of the dance suggests the location's angle towards the sun, and the length of the dance suggests its distance. Bees flap their wings at a rate of roughly 240 times per second. If the animal is unburdened, the wings themselves span an angle of roughly 90° as they flap up and down. This angle increases if the bee is weighed down, turning the animal into a quasi-transport-helicopter.

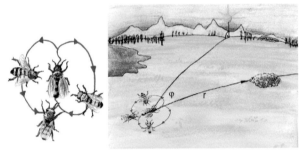

This assassin bug may be a natural predator of the bee, but is not connected to the widespread deaths that are endangering the species.

A bee's wing measures roughly 1cm. Assuming an angular span of 90°, the lift a of the wing measures about $\pm 7\,\mathrm{mm} = 0{,}007\,\mathrm{m}$. If combined with the frequency $n = 240$, the oscillation (as a function of the time t) can be stated in the following form:

$$s = a \sin(2\pi nt)$$

As Newton himself has noted, a single differentiation of this equation yields the momentary velocity, and a double differentiation yields the momentary acceleration.

$$\dot{s} = 2\pi n\, a \cos(2\pi nt), \quad \ddot{s} = -(2\pi n)^2 a \sin(2\pi nt)$$

Sine and cosine have a maximum value of 1, which leads to momentary velocities of up to 10 m/s. At those velocities, due to the small size of the wings, air resistance becomes so large that the bee is able to "push" itself off the air (see also page 302).

Within a mere millisecond, the wing experiences accelerations far exceeding the force of gravity by a factor of a thousand. It follows from the equation that the bee would be well advised to increase the amplitude a instead of the frequency n, as the latter has a square effect upon the acceleration formula.

W. Shyy, H. Aono, C.-K. Kang **An Introduction to Flapping Wing Aerodynamics** Cambridge Aerospace Series, 2013
Wikipedia **Colony collapse disorder** http://en.wikipedia.org/wiki/Colony_collapse_disorder
NC State University **The honey bee dancing language** www.cals.ncsu.edu/entomology/apiculture/pdfs/1.11%20copy.pdf

Interferences

The propagation of waves surrounds us at all times. Movement is induced within a medium, be it air or water. This impulse is then carried forth by means of a wavefront, which, on the water surface, grows in the manner of a circle and, in the air, grows in the manner of a sphere. During this process, the separate particles of the medium barely move but rather oscillate harmonically. Wavefronts are composed of particles at the same "state of oscillation". A raindrop that hits a pond produces typically circular wavefronts.

Superpositions (or interferences) are created when different wavefronts encounter each other (such as when two adjacent raindrops hit a pond's surface at slightly different times). The intersection points of the wave peaks lie on pencils of curves, which are conic sections only if both wavefronts expand at the same speed (see the computer simulation above and on the right page). Otherwise, they are pencils of so-called angularly distorted conic sections. The simulations on the right page depict relative wavefront velocities of 75% and 50%.

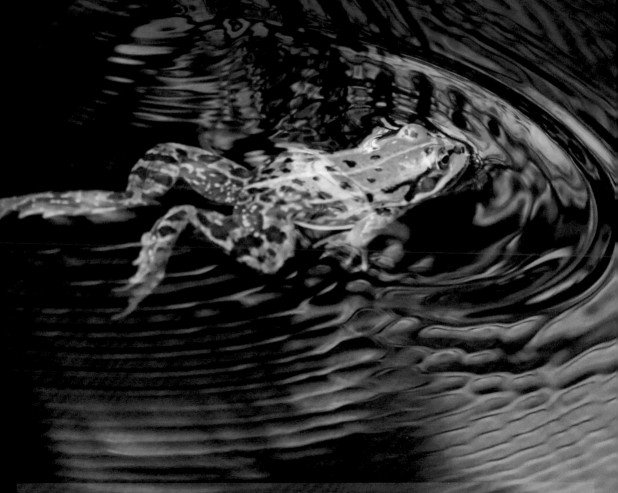

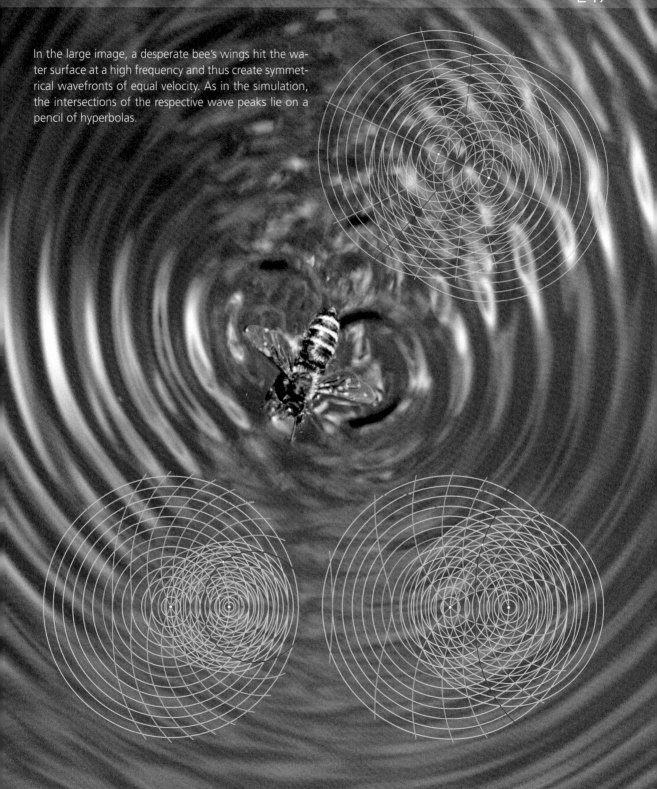

In the large image, a desperate bee's wings hit the water surface at a high frequency and thus create symmetrical wavefronts of equal velocity. As in the simulation, the intersections of the respective wave peaks lie on a pencil of hyperbolas.

Doppler effect and the Mach cone

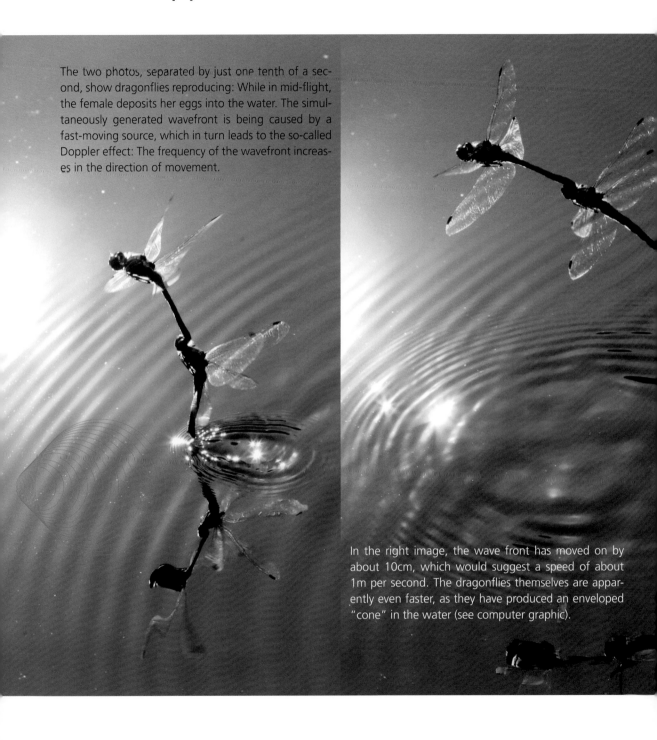

The two photos, separated by just one tenth of a second, show dragonflies reproducing: While in mid-flight, the female deposits her eggs into the water. The simultaneously generated wavefront is being caused by a fast-moving source, which in turn leads to the so-called Doppler effect: The frequency of the wavefront increases in the direction of movement.

In the right image, the wave front has moved on by about 10cm, which would suggest a speed of about 1m per second. The dragonflies themselves are apparently even faster, as they have produced an enveloped "cone" in the water (see computer graphic).

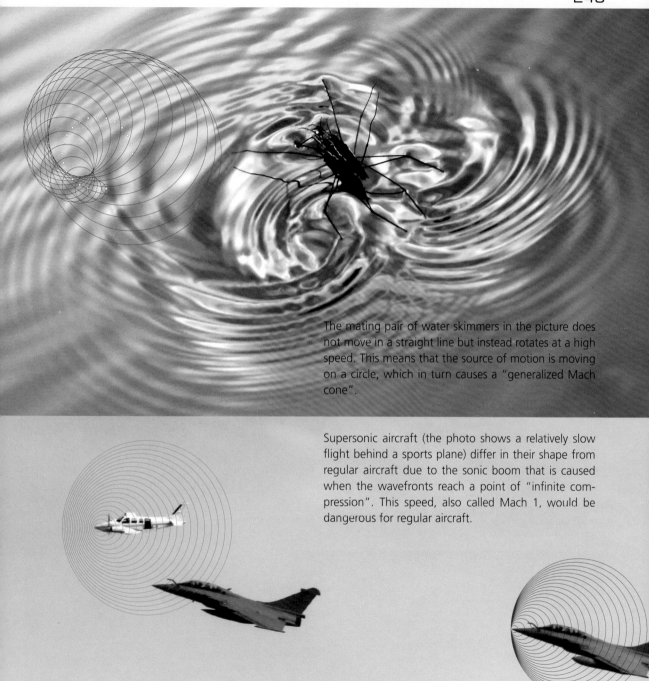

The mating pair of water skimmers in the picture does not move in a straight line but instead rotates at a high speed. This means that the source of motion is moving on a circle, which in turn causes a "generalized Mach cone".

Supersonic aircraft (the photo shows a relatively slow flight behind a sports plane) differ in their shape from regular aircraft due to the sonic boom that is caused when the wavefronts reach a point of "infinite compression". This speed, also called Mach 1, would be dangerous for regular aircraft.

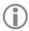

M. FOLWER **The Doppler Effect** http://galileo.phys.virginia.edu/classes/152.mf1i.spring02/DopplerEffect.pdf
C. WASSGREN **The Mach Cone** https://engineering.purdue.edu/~wassgren/applet/java/machcone/

Besides a few exceptions (such as whales), most mammals have intricate outer ears, whose indentations and elevations serve to distinguish back from front and up from down (the distinction between left and right is due to other mechanisms).

Consider the photo on the lower left side, which shows the sometimes strange paths taken by sonic waves in the many folds of the human ear. High frequencies of about 10 000 Hertz deserve our particular attention, as they proceed along the curved walls, which leads to two pieces of sonic information reaching the ear at slightly different times. This difference helps us to distinguish between sounds coming from above and those from below.

To quantify this phenomenon, Rudolf Waltl has experimented with different frequencies and sound waves (bottom right).

In contrast to humans, many other mammals are able to pivot their ears independently. The caracal also has hair on the tips of its ears, which – almost like antennae – help to pin down the location of incoming sounds. The same is true for rhinos (right page), which can hear much better than see.

Sound waves travelling through the human ear

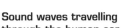

Cheetahs are said to be the fastest animals on land, being able to run as fast as 30 m/s. Their prey (gazelles, for instance), may not be able to reach these velocities, but they can run longer at high speeds and also change directions very quickly. The predator has to approach its target as closely as possible and then accelerate as quickly as possible. Cheetahs only need about three seconds to reach a speed of 30 m/s, which corresponds to an average acceleration of 10 m/s^2 = 1g. On the right page, a deer jumps around in a meadow. Each leap propels the animal forward several meters at a time.

10 pictures were taken per second, and the best ones were stitched together as described on page 72. Higher jumps somewhat decrease the deer's speed, as can be seen from the comparison of both series. The deer moves at a little less than 2 meters per frame (10 frames per second), which corresponds to a speed of about 18 m/s (65 km/h). It is able undertake such sprints for some time. Even a fast predator would have a hard time trying to catch it from a distance. The wolf is the natural predator of the deer. It may not be as fast as its prey (approx. 55 km/h) but it does not tire very easily either.

(i) G. MILLS **Cheetah** http://animals.nationalgeographic.com/animals/mammals/cheetah
 A. REISNER **Speed of Animals** www.speedofanimals.com

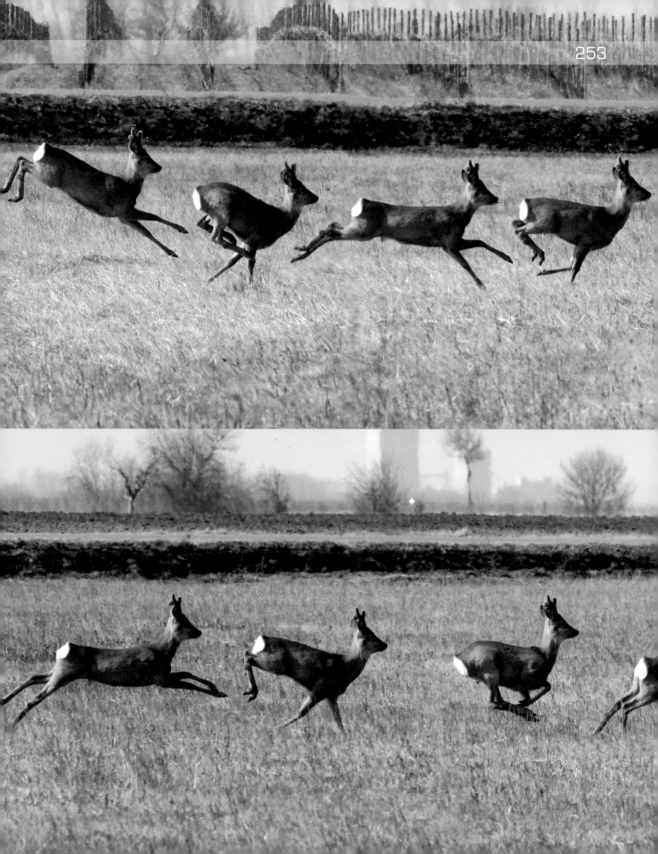

Stroboscopic effect

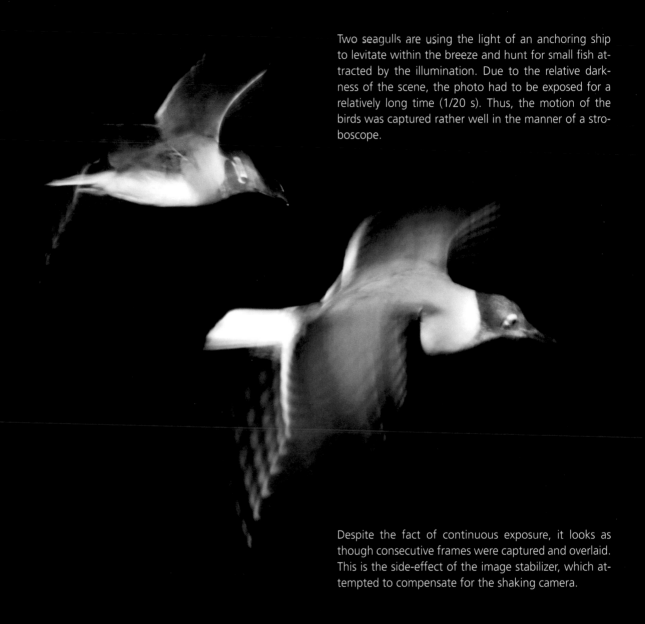

Two seagulls are using the light of an anchoring ship to levitate within the breeze and hunt for small fish attracted by the illumination. Due to the relative darkness of the scene, the photo had to be exposed for a relatively long time (1/20 s). Thus, the motion of the birds was captured rather well in the manner of a stroboscope.

Despite the fact of continuous exposure, it looks as though consecutive frames were captured and overlaid. This is the side-effect of the image stabilizer, which attempted to compensate for the shaking camera.

R. Nave **Precession Torque** http://hyperphysics.phy-astr.gsu.edu/hbase/rotv2.html

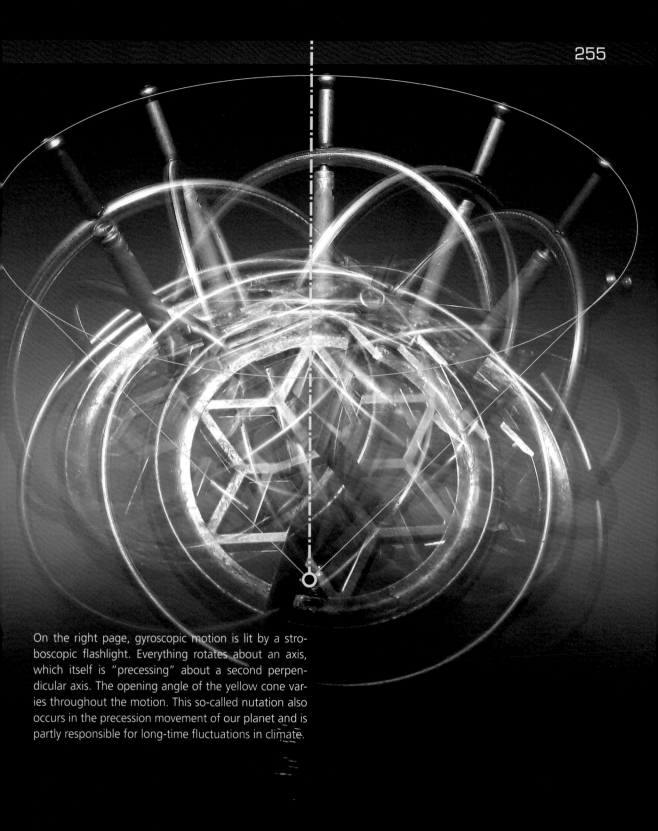

On the right page, gyroscopic motion is lit by a stroboscopic flashlight. Everything rotates about an axis, which itself is "precessing" about a second perpendicular axis. The opening angle of the yellow cone varies throughout the motion. This so-called nutation also occurs in the precession movement of our planet and is partly responsible for long-time fluctuations in climate.

11 Cell arrangements

When looking at sunflowers, daisies, and many other blossoms (such as those of the genus Echinacea), the human eye often detects spirals – sometimes turning towards the left and sometimes towards the right. There are even cases when the spiral direction is difficult or unambiguous to tell (see the computer graphic). The spirals are approximately logarithmic (see page 110) and even share some features with Fibonacci numbers (see page 44). The reasoning behind this phenomenon is always the same: The plant aims to distribute the high-

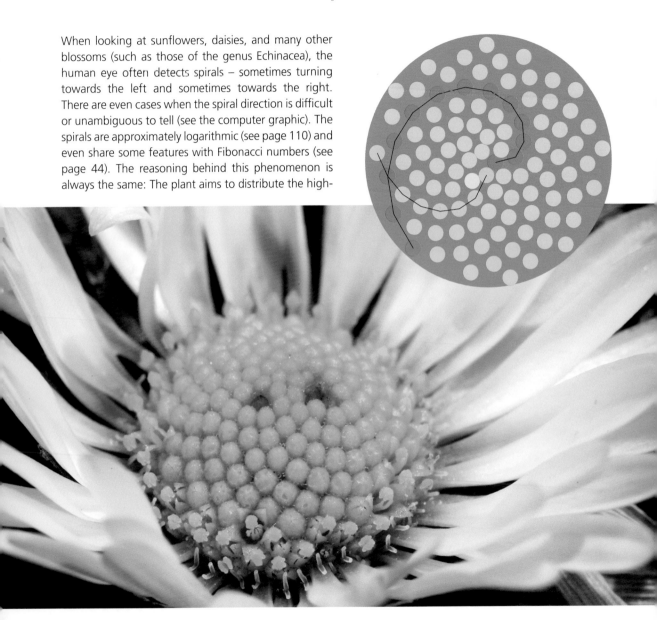

est number of seeds on the smallest surface. It turns out that during growth, an optimal strategy is found in determining the position of the next seed by inducing a rotation at a golden angle and by exponentially increasing the distance from the centre at the same time. Each plant inherits this strategy from its parents, with

tiny mutations along the way, which cause the angles to vary slightly from flower to flower. Plants that have chosen the optimal golden angle are, statistically speaking, most successful at reproduction, all other parameters being equal. By this simple rule, the optimal angle comes out on top, time and again.

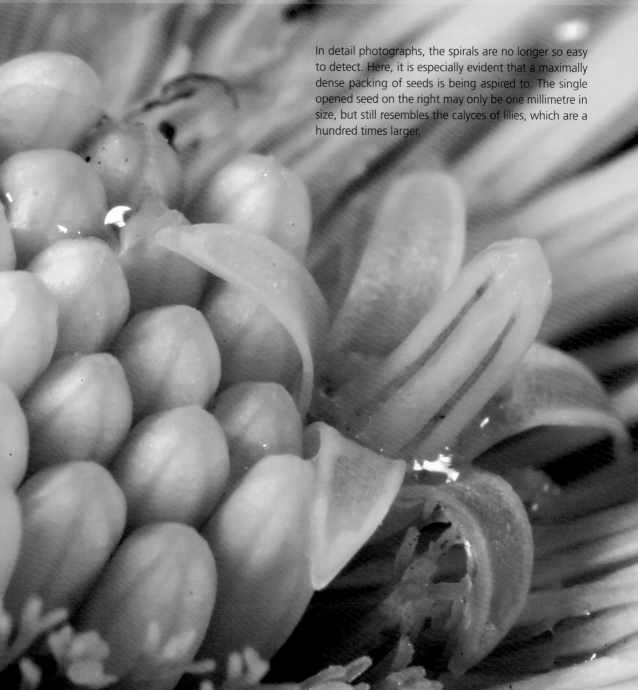

In detail photographs, the spirals are no longer so easy to detect. Here, it is especially evident that a maximally dense packing of seeds is being aspired to. The single opened seed on the right may only be one millimetre in size, but still resembles the calyces of lilies, which are a hundred times larger.

 H. Vogel **A Better Way to Construct the Sunflower Head** Math. Biosci. 44, 179-189, 1979

D. R. Fowler, P. Prusinkiewicz, J. Battjes **A Collision-based Model of Spiral Phyllotaxis**

http://algorithmicbotany.org/papers/phyllo.sig92.pdf

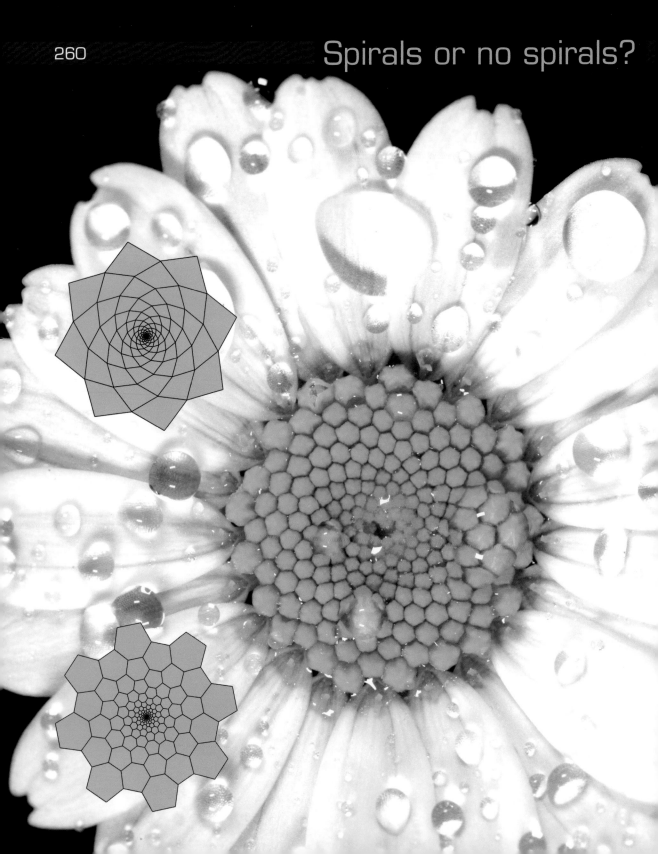

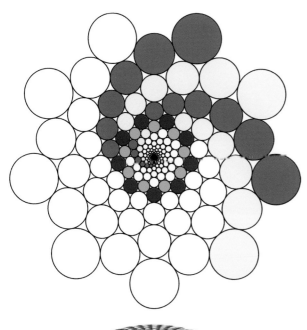

The large image on the left shows the original picture on which the adjacent computer simulations are based. The spirals are more visible to some than to others. The buds in the original are mostly hexagonal like the cells of a honeycomb. However, the hexagons actually get larger as they get further away from the centre. The bottom left corner shows a computer simulation – clearly, there are no spirals in the picture! Above it, the buds are shown as deltoids, and the spirals become instantly visible.

Both simulations use the circular model on the right side as a starting point. Circles that exponentially increase in size are strung together to achieve a perfect fit (exponential functions and Fibonacci numbers are closely related, as seen on page 44). Mathematicians solve this problem by using so-called "conformal mappings" which convert simple patterns of identical circles into the more interesting structures visible in the images. Projecting the exponential circle pattern from the north pole of a sphere around its centre leads to circle patterns on a sphere (image below). These patterns also occur in nature, if only rudimentarily. Whether or not one is able to detect spirals is partly dependent on one's imagination.

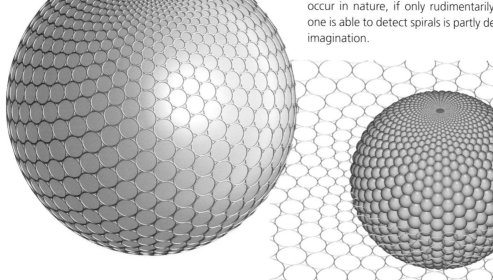

R. V. JEAN **Phyllotaxis: A Systemic Study in Plant Morphogenesis** Cambridge University Press, 2009
S. WOLFRAM **Phyllotaxis Spirals in 3D** http://demonstrations.wolfram.com/PhyllotaxisSpiralsIn3D
J. M. SULLIVAN **Stereographic Projection Demo** http://torus.math.uiuc.edu/jms/java/stereop

Spiralling arrangements are not limited to seeds. It seems that the leaves of some plants also apply the same mechanism, starting with small leaves and growing each new leaf by rotating the current position by a well-defined obtuse angle while increasing the size at the same time. The upper photo shows a rosette plant, and the lower photo an agave. If we divide the full circle revolution of 360° by a proportion of 1:Φ ($\Phi = 1{,}618...$ being the golden ratio), then the smaller of both angles roughly equals 137,5°.

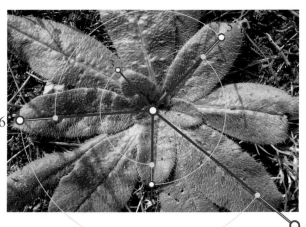

Due to the structure of its formula ...

$$\Phi = 1 + \frac{1}{\Phi} = 1 + \frac{1}{1 + \frac{1}{\Phi}} = 1 + \frac{1}{1 + \frac{1}{1 + \frac{1}{1 + \cdots}}}$$

one could conceivably describe Φ as being "maximally irrational" (a rational number being a fraction). But what does this have to do with the plant?

Well, if the growth angle of every new leaf is increased by steps of 180° (one half of a full revolution), then by the third step, new leaves will be forced to grow underneath the old and bigger ones, which obscures them from the sunlight that is necessary for photosynthesis. If the growth angle is instead changed to 1/n of 360°, then the obscuring situation occurs after n steps. Even if we select 2/7 of 360° (or something to that effect) as our growth angle, the total number of healthy leaves is still limited. This leads us to the conclusion that the optimal growth angle is an irrational fraction of 360° – in other words, it is an angle that cannot be represented as a fraction. Plants whose growth angle comes close to the golden angle may, in certain cases, be more efficient at photosynthesis and would thus be better capable of reproduction. As their genes are passed on, slight mutations in the offspring may alter the angle, causing some of the next generation of specimen to come closer to the desired golden angle, which may in turn be advantageous for reproduction. And so it goes on ...

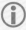 WIKIPEDIA **Golden angle** http://en.wikipedia.org/wiki/Golden_angle

One might rightfully ask why the golden growth angle is not present in all plants of the world. It would seem that after countless millions of evolutionary generations, the golden angle would be well-established in the gene pool. The situation is not so simple, which is why the prior description carefully employed the subjunctive form.

It is possible, after all, that an entirely different mutation (which also affects the growth angle) offers a greater advantage for the plant than the mere fact of conducting photosynthesis on the largest surface area. If that is so, then these more optimal mutations will assert themselves over the course of the generations, at the expense of the irrational growth angle.

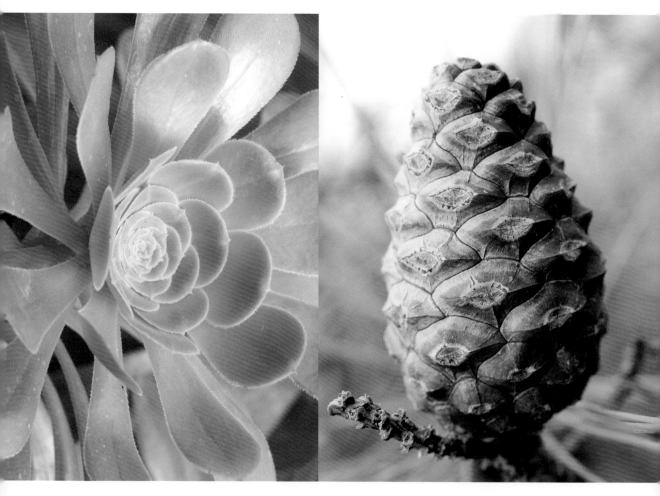

Both examples on this page show that the growth angles of leaves and seeds do not have to be planar. If the third dimension is considered, then different meridian angles may come into play, leading to additional degrees of freedom.

The cone in the right photo shares certain features with the Canarian aeonium on the left: After springing open to release its seeds, it looks rather similar to the thick-leaved aeonium (before it springs open).

Voronoi diagrams

The tiny veins on a dragonfly's wing, the cracks in dried mud and the structure of a fig leaf all seem to share common geometric principles. Essentially, the planar surface is being subdivided into convex polygons. This may either be advantageous for elasticity or the distribution of nutrients – it may also be the result of tensions within the surface. Let us assume a plane on which a set of points has been scattered. Our task is to subdivide the plane into convex regions (whose centres are defined by the given points) such that the closest point of any location within a convex region is always the centre of the same region. This can be accomplished by calculating the perpendicular bisectors of all possible pairs of points. For each point, the perpendicular bisectors to all adjacent points produce a convex region. If all convex regions are combined, a so-called Voronoi diagram is produced (see the computer graphic on the right).

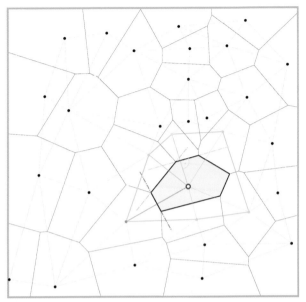

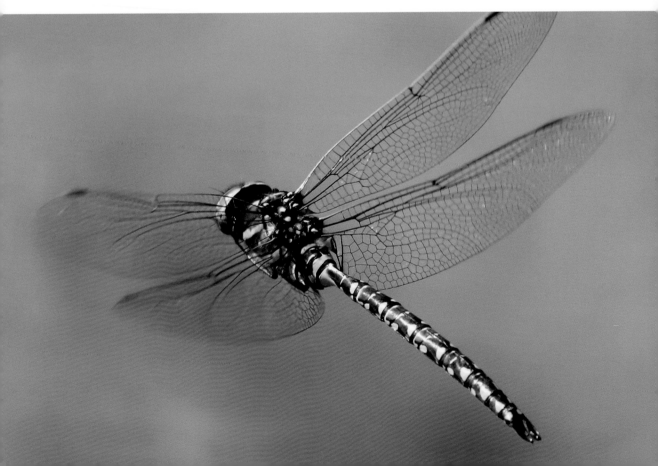

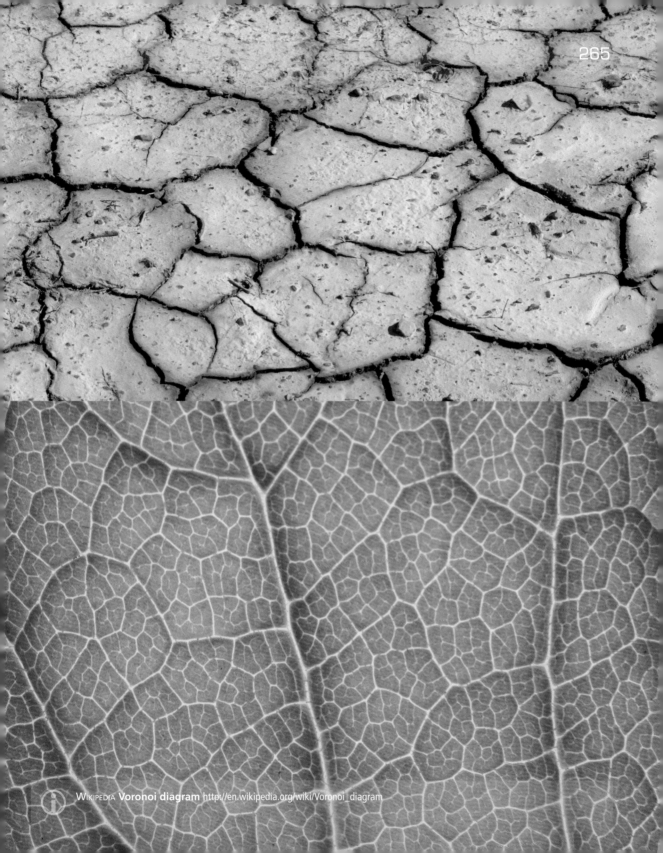

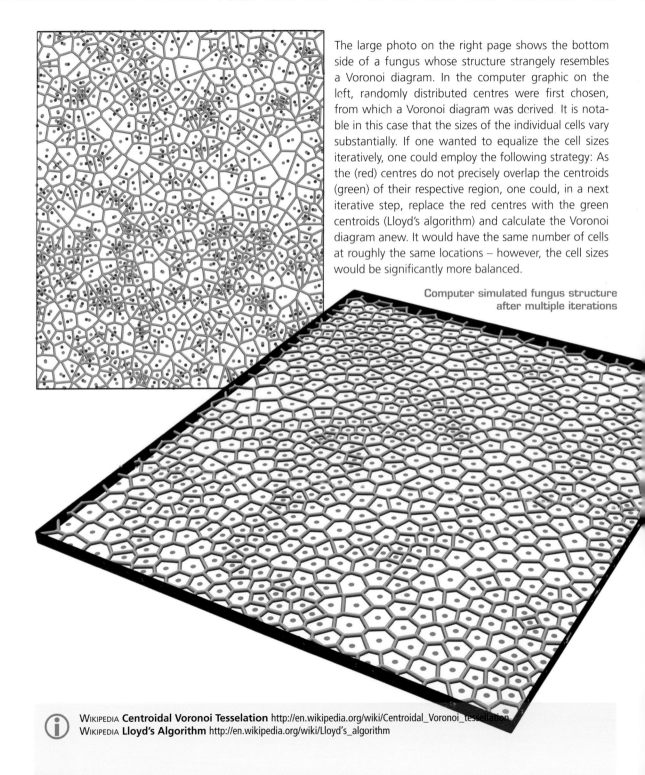

The large photo on the right page shows the bottom side of a fungus whose structure strangely resembles a Voronoi diagram. In the computer graphic on the left, randomly distributed centres were first chosen, from which a Voronoi diagram was derived. It is notable in this case that the sizes of the individual cells vary substantially. If one wanted to equalize the cell sizes iteratively, one could employ the following strategy: As the (red) centres do not precisely overlap the centroids (green) of their respective region, one could, in a next iterative step, replace the red centres with the green centroids (Lloyd's algorithm) and calculate the Voronoi diagram anew. It would have the same number of cells at roughly the same locations – however, the cell sizes would be significantly more balanced.

Computer simulated fungus structure after multiple iterations

WIKIPEDIA **Centroidal Voronoi Tesselation** http://en.wikipedia.org/wiki/Centroidal_Voronoi_tessellation
WIKIPEDIA **Lloyd's Algorithm** http://en.wikipedia.org/wiki/Lloyd's_algorithm

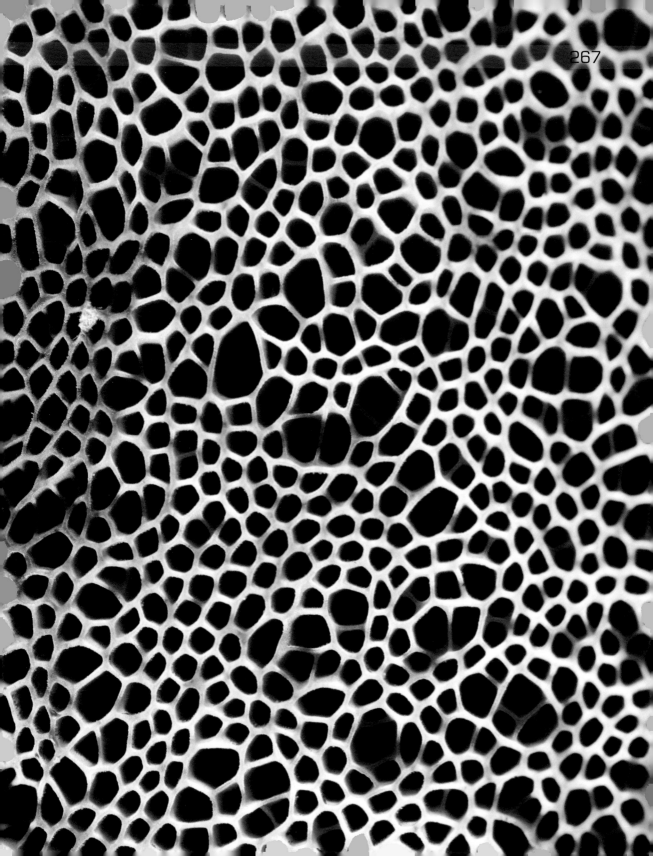

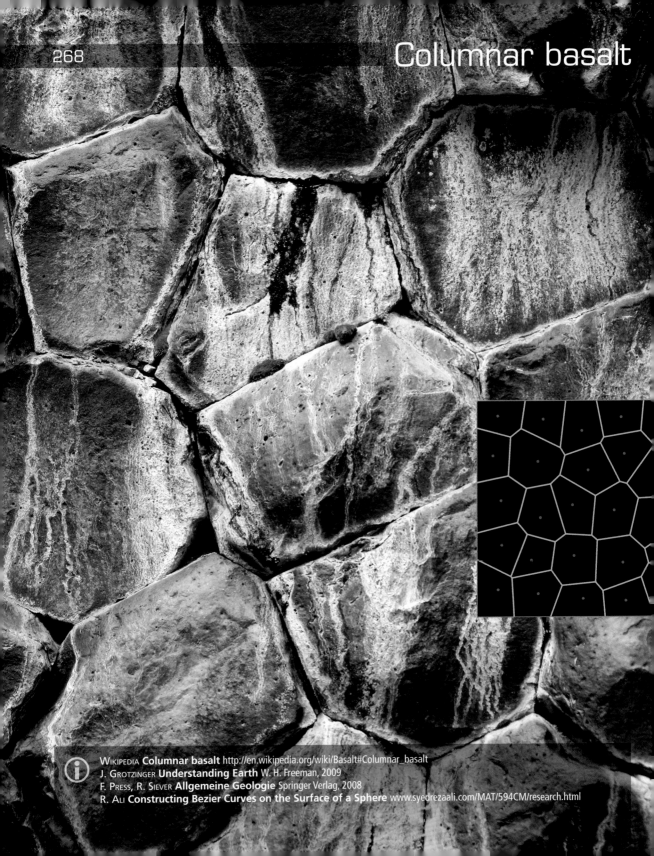

Columnar basalt

WIKIPEDIA **Columnar basalt** http://en.wikipedia.org/wiki/Basalt#Columnar_basalt
J. GROTZINGER **Understanding Earth** W. H. Freeman, 2009
F. PRESS, R. SIEVER **Allgemeine Geologie** Springer Verlag, 2008
R. ALI **Constructing Bezier Curves on the Surface of a Sphere** www.syedrezaali.com/MAT/594CM/research.html

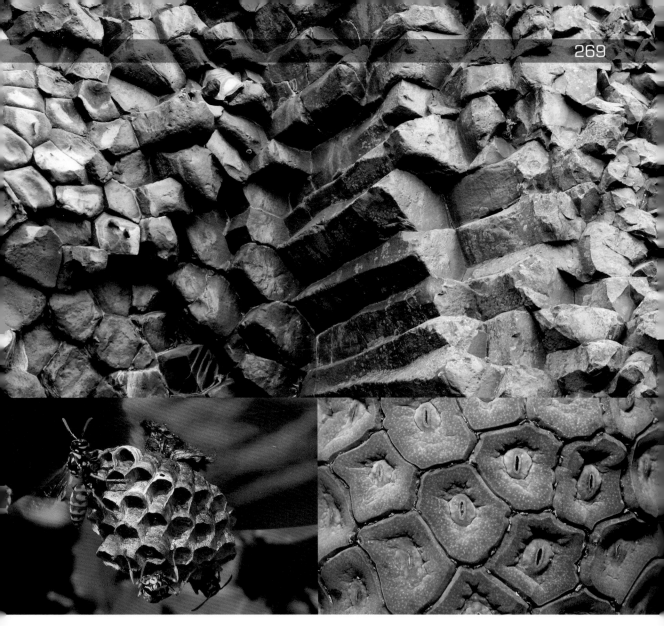

The large photos, showing intriguing basalt formations, were taken at the famous echo cliffs (Hljóðaklettar) in Iceland. Basalt in its extrusive form is a volcanic rock formed by the cooling of extrusive basaltic lava at or very near the surface. The contractional fractures form during the cooling of thick lava flow. The topology of these columns' lateral shapes form a random cellular network closely resembling a Voronoi diagram. Hexagons appear to be dominant in the cross-section. However, one also frequently encounters pentagons, heptagons, and other polygons. The slower the cooling process, the larger these polygons are. For some reason, the photo above -- with its three-dimensional structure -- recalls a cross-section through an insect eye or through the combs that wasps build for their larvae (photo below). Of course, Voronoi diagrams can also be generalized for arbitrary surfaces, and especially for spheres. If the centres are equally distributed (which is only approximately the case in the photos), the result will resemble the pictured insect combs or the tube-like spadices of a philodendron.

3D cells

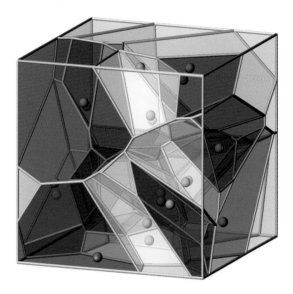 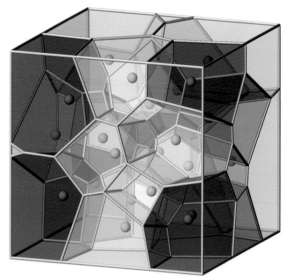

The concept of Voronoi diagrams can be extended to 3-dimensional space: We choose a number of cell kernels (this may, for instance, happen by random chance) and let the faces of each cell (which are always convex) lie in the symmetry planes to the neighbouring kernels (upper left image).

Again, we can improve the "evenness" or "balance" of the diagram by replacing the originally chosen kernels with the barycentres of the generated cells. If we repeat this procedure a few times, the diagram converges on an optimal result (upper right image).

These diagrams, which are purely mathematically defined, come close to "real foam" -- their structure merely depends on the first set of kernels that are selected.

As part of an experiment, foam was generated within a plastic cube, producing a structure reminiscent of a Voronoi diagram. At first, the cell kernels were distributed unhomogeneously (upper image), and after longer periods of time, the foam slowly reorganized itself into a larger and more stable mesh (lower image).

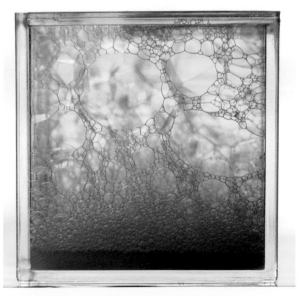

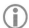 D.-M. YAN, W. WANG, B. LÉVY, Y. LIU **Efficient Computation of 3D Clipped Voronoi Diagram**
http://alice.loria.fr/publications/papers/2010/CLIPPEDVD/ClippedVD.pdf

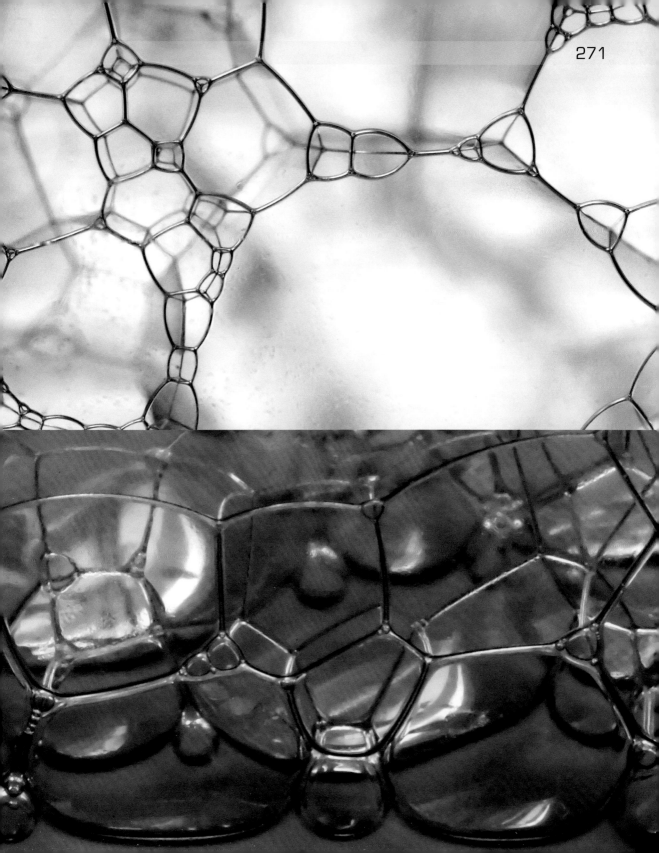

Random paths

Seemingly random paths through Voronoi diagrams, which may be called „Voronoi paths", sometimes occur in nature -- both in two dimensions (in a plane) and in three. The photo on the right shows the tissue of a cactus. The image on the left is a 3D-print of a sculpture that was created by a special architectural software. Such shapes are interesting to architects not only due to their fascinating, organic appearance but also due to their stability, which has implications for structural engineering.

F. GRUBER, G. WALLNER **Algorithms for Generation of Irregular Space Frame Structures** Journal for Geometry and Graphics, 15(2), pp. 169-179, 2011

F. GRUBER, G. WALLNER **Polygonization of line skeletons by using equipotential surfaces - a practical description** Proc. of the 15th International Conference on Geometry and Graphics, 2012, Montreal, Canada

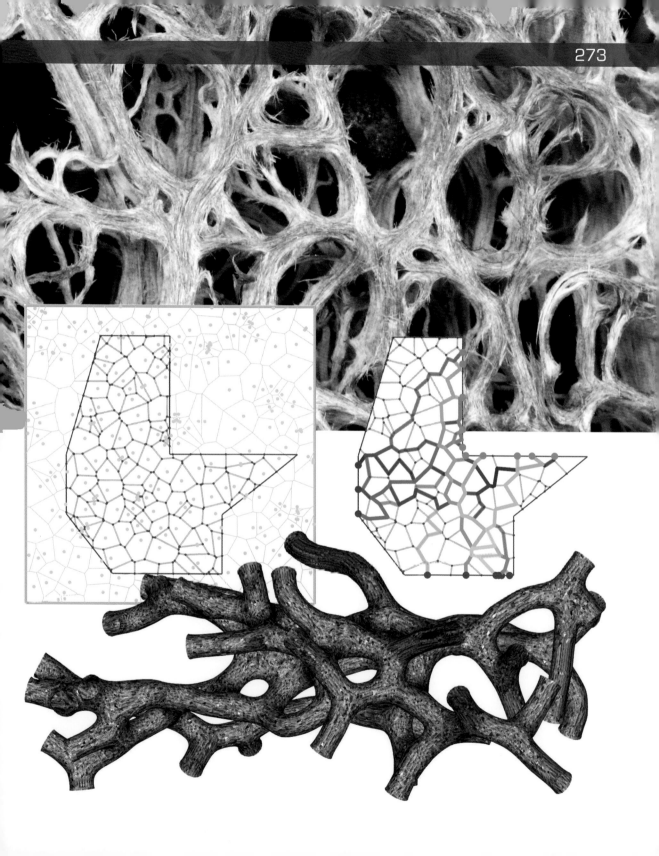

Winding curves

If a car drives straight ahead and encounters an increasingly tight curve, it might attempt to manoeuvre through the bend by slowly but constantly turning the steering wheel in the appropriate direction. This leads to a relationship between the driven distance (mathematically speaking, the arc length) and the course angle. The resulting curve is called a Cornu spiral after its discoverer and is also known to road construction engineers as a clothoid.

Let us analyse the sprout of a fern that is still rolled up (large image). Upon first sight, a mathematician may be excused in mistaking it for a logarithmic spiral. In fact, the curvature is much closer to a clothoid, as a logarithmic spiral never stretches out into a straight line.

Let a fern be composed of 50 segments which, in their initial state, are stretched out into a straight line. The spiral shape can be created as follows:

The last 48 segments should then be rotated about the second segment by the same angle, and the last 47 segments should be rotated about the third segment again by the same angle. This procedure is repeated until no segment is left to be rotated. Unrolling can be simulated quite realistically by reversing the procedure (see computer graphic).

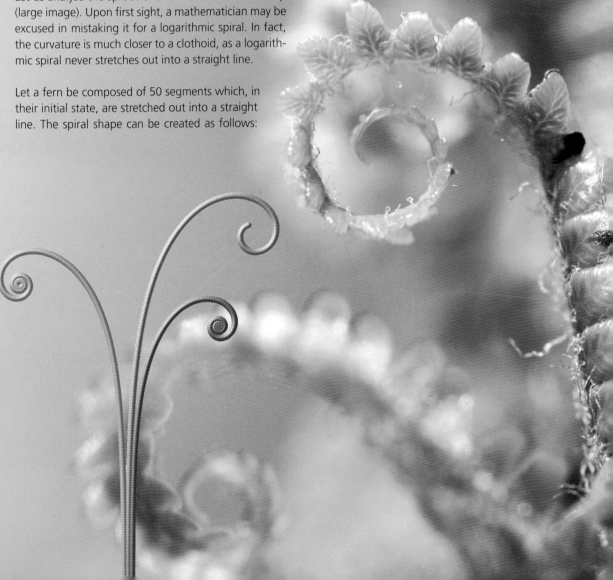

Similar rolling and unrolling happens in the animal kingdom, both above and below the water (Top: Chameleon, Bottom: Feather star).

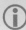

WIKIPEDIA **Euler spiral** http://en.wikipedia.org/wiki/Euler_spiral

Fractal sphere packing

The large image on the left side shows the formation of foam in a mixed drink with a large amount of lime juice (which makes it relatively stable). The right image depicts foam in a brook located in a snowfield next to a small waterfall. Both images are inverted false-color photographs. The volumes of the spheres are constantly changing – however, the right image shows the emergence of "islands" that keep changing their sizes and shapes due to the flowing water.

In the lower sequence of computer graphics, a set of randomly positioned, randomly sized, and mutually repulsive spheres was generated above a hemispherical bowl. During each iterative step, the spheres were moved in the direction of the bowl while the sum of all repulsive force was lowered. Simultaneously, their size was changed to achieve a better packing of the available space. The leftmost image depicts the initial situation, while the subsequent images show the scene after 10, 100, and 1 000 iterative steps.

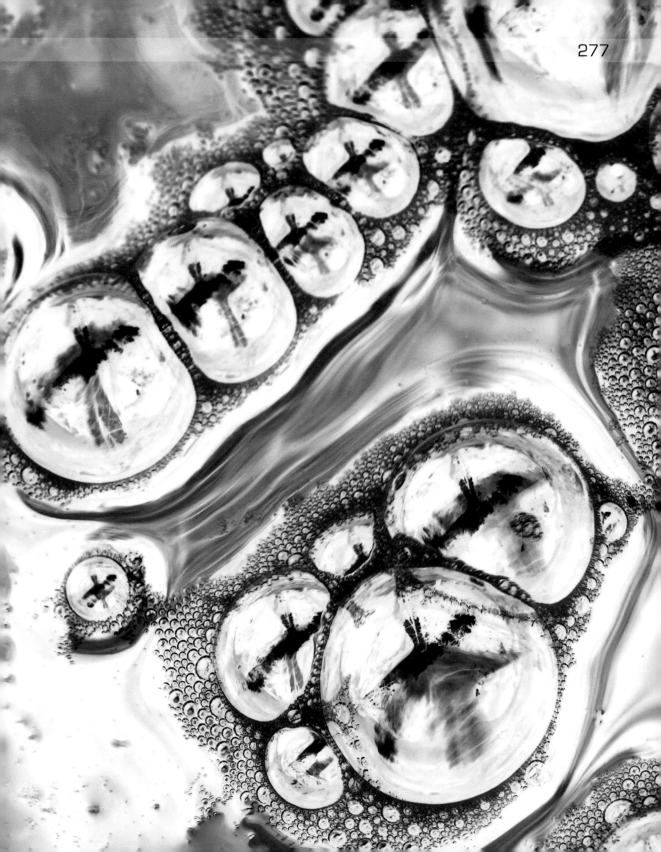

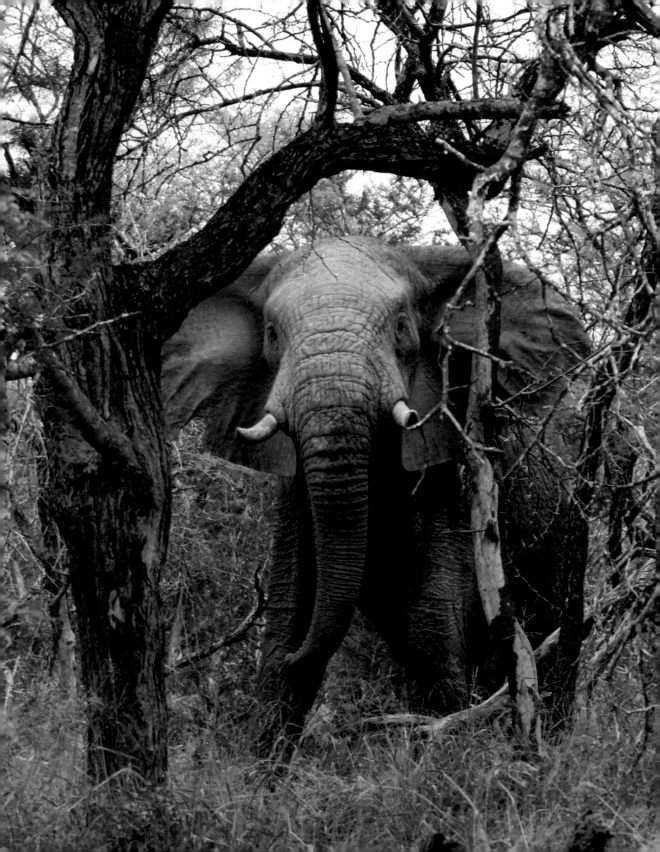

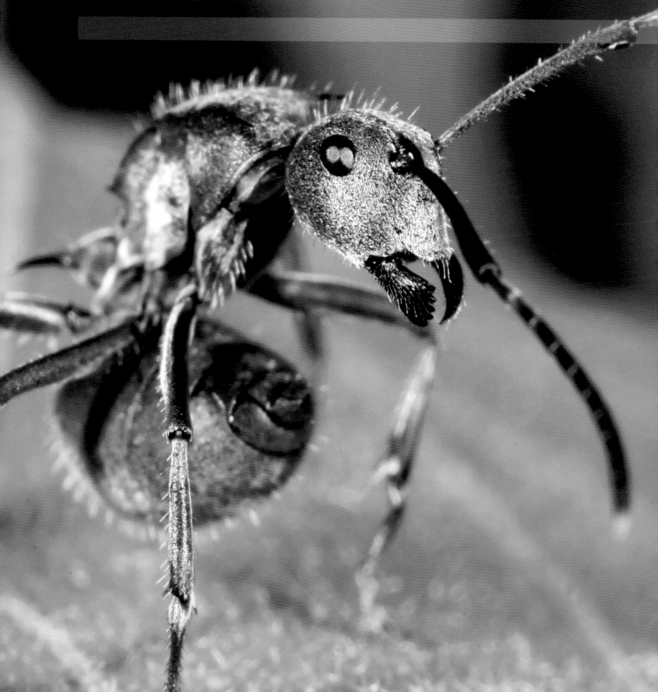

12 The difference between big and small

Decimal powers among animals

How is it possible to roughly estimate the weight of animals? The animal kingdom is known for its vast differences in scale – from enormous whales 30 m in length and 150 tons in weight to perhaps dozens of mammal species weighing more than 500 kg, over smaller mammals, birds and reptiles to the vast diversity of articulate animals with a body length that, for the most part, does not exceed a single centimetre. In general, due to the large proportion of water in the bodies of all animal species, we can assume a density of about 1000 kg per cubic metre (or 1 mg per cubic mm). The question of mass is essentially reduced to one of volume.

The volume of a body increases or decreases cubically with its scale. The size of the body is thus largely responsible for its volume. The four young giraffes together weigh about half as much as their mother or aunt.

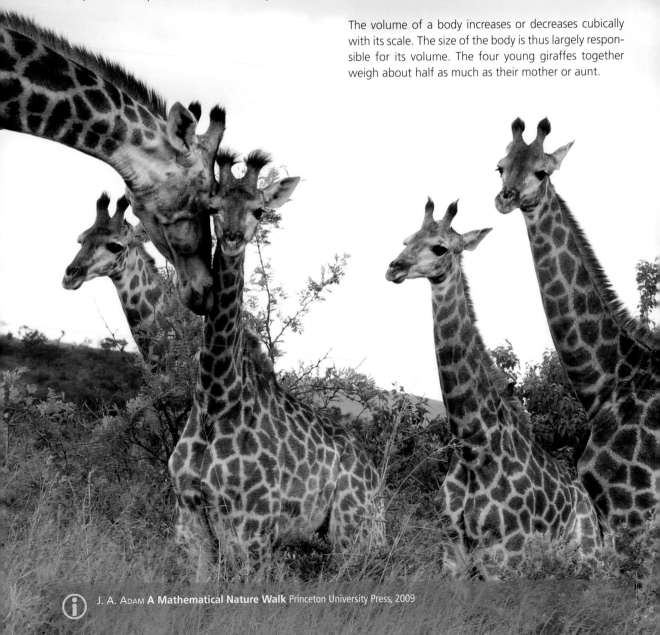

ⓘ J. A. ADAM **A Mathematical Nature Walk** Princeton University Press, 2009

You are invited to try the following approximate formula which uses the terms "relevant torso length" T (in metres) or t (in centimetres) and the "pyknic factor" p (slim or pyknic). Both terms were chosen by the author. The mass of the animal in question is roughly equal to

$$M = 40 \text{ kg} \cdot p \cdot T^3 \text{ and } M = 40 \text{ mg} \cdot p \cdot t^3$$

The p-value may fluctuate between 0,2 (snake) and 3 (fat toad). A human with a relevant torso length of $T = 1,20$ m and $p = 1$ would have a mass of about 70 kg. An elephant with $T = 4$ m and $p = 2,5$ would, therefore, weigh about 6 tons, while a blue whale with $T = 20$ m and $p = 0,4$ would clock in at a massive 130 tons. Our giraffe mother with $T = 2,6$ m and $p =$ 1,3 (excluding the long neck, and compensating by increasing the p-value) would be estimated at about 900 kg. An everyday insect like the honey bee ($t = 1,4$ cm, $p = 0,8$) would weigh about 90 mg. The large and pyknical goliath beetle ($t = 12$ cm, $p = 2$) reaches a mighty 140 g, while a forest ant ($t = 0,8$ cm, p = 0,4) would weigh only 8 mg. The photo depicts an apparent colossus – a crane fly with $t = 2$ cm of relevant length would, according to our formula, weigh about 640 mg (its slender posterior and its tiny head, composed mainly of eyes and a proboscis, can be excluded while increasing p to 2). The green shimmering fly, being only one quarter as long, would weigh only 1 / 64th of the crane fly (assuming an equal p value) – or 10 mg.

150 million years without change

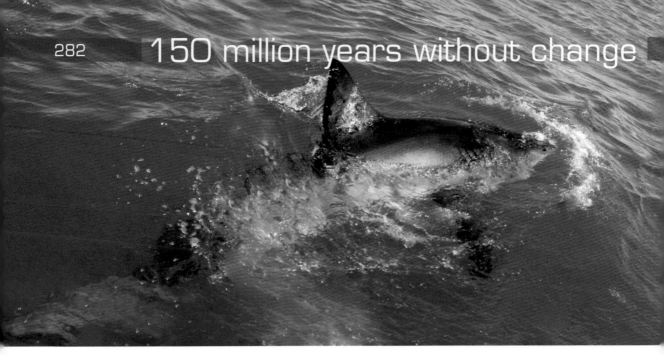

Under water, and in the absence of objects of reference, it is practically impossible to estimate the length of a fish. The young blacktip reef sharks below are, from the tip of their snouts to their posterior fins, only about a metre long. Through diving goggles, however, they appear to be larger by about $1/3$. This significant distortion would lead an observer to mistake their mass by a factor of $(4/3)^3 = 2,37$! The great white shark above (captured from the deck of a ship) has an estimated length of 3,5 metres. Its similarity of form indicates that a single specimen weighs as much as $3,5^3 = 43$ young

reef sharks put together! The largest great white sharks that have ever been observed were twice as long and thus eight times as heavy. Sharks are essential for the marine ecosystems that they inhabit. They are perfectly adapted to water and excel at both sight and smell. Their sideways profiles suggest minute pressure differences which assist the animals during manoeuvring. Their "ampullae of Lorenzini", which can be seen as black dots in the portrait photograph on the top right, are especially notable. They are symmetrical and roughly equally distributed clusters of pores between nose and

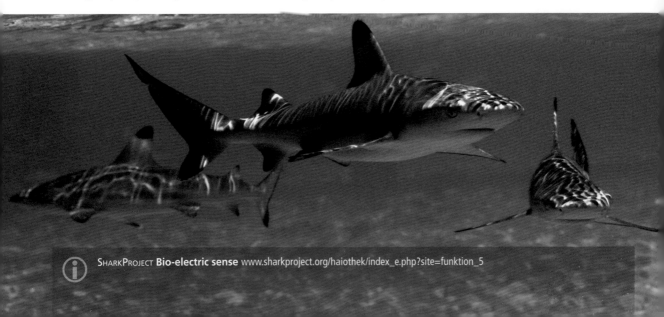

SHARKPROJECT **Bio-electric sense** www.sharkproject.org/haiothek/index_e.php?site=funktion_5

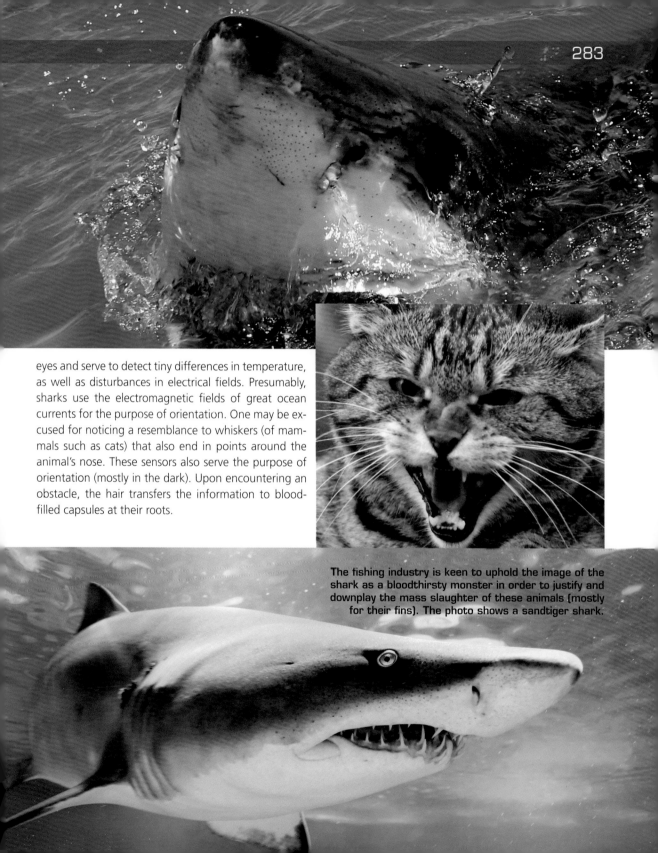

eyes and serve to detect tiny differences in temperature, as well as disturbances in electrical fields. Presumably, sharks use the electromagnetic fields of great ocean currents for the purpose of orientation. One may be excused for noticing a resemblance to whiskers (of mammals such as cats) that also end in points around the animal's nose. These sensors also serve the purpose of orientation (mostly in the dark). Upon encountering an obstacle, the hair transfers the information to blood-filled capsules at their roots.

The fishing industry is keen to uphold the image of the shark as a bloodthirsty monster in order to justify and downplay the mass slaughter of these animals (mostly for their fins). The photo shows a sandtiger shark.

Legendary strength

The strength of ants is so legendary as to be proverbial. Despite their delicate legs, these animals are able to carry weights which exceed their own by a factor of up to 50. What would happen, if an ant that measures 10 mm was enlarged to 1m, as in a horror movie? All length scales would be increased by a hundredfold, which would make the animal $100^3 = 1\,000\,000$ times heavier. However, its muscular strength, which depends on the cross-section of its muscles, would only increase by a factor of $100^2 = 10000$. In relation to its own body weight, the ant would command forces one hundredth smaller than before. Therefore, it could only carry objects half as heavy as itself.

We can draw the conclusion that the relative strength of ants is mostly due to their tiny size. Many animals of the insect world are as strong as ants. The photo below shows that it takes almost 20 ants to overwhelm a single millipede.

At the macro scale, different laws apply from those in the realm of large animals. The tiny claws of insects produce forces of adhesion as they penetrate the leaf's structure. In relation to the very small body volumes (and masses), the thin muscular cross-sections are enough to carry the animal's weight. The same rules apply to all lifeforms at these scales.

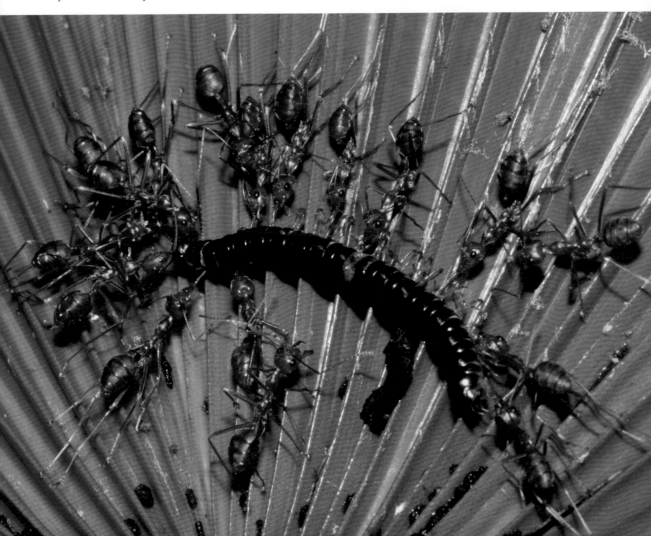

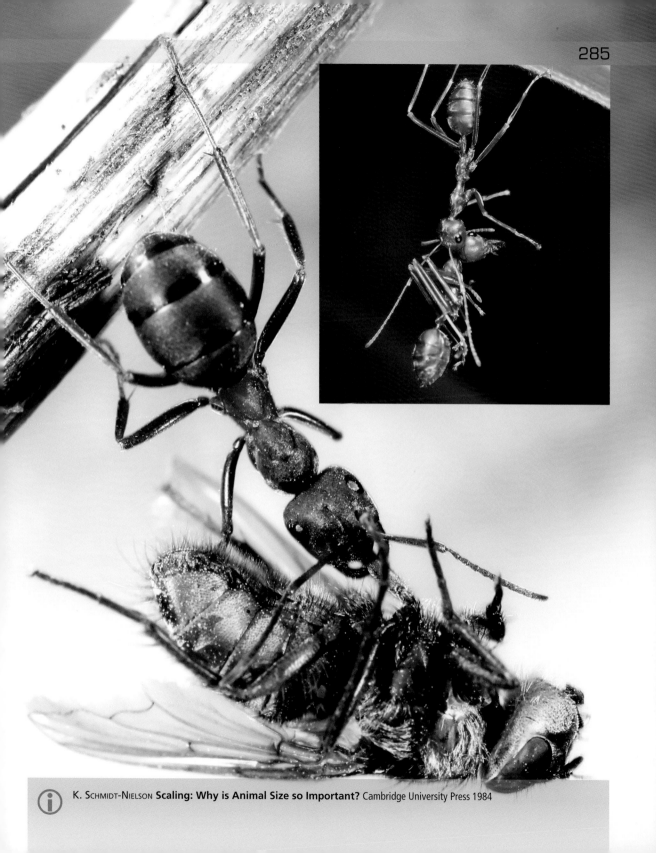

K. Schmidt-Nielson **Scaling: Why is Animal Size so Important?** Cambridge University Press 1984

Our ant from page 285 literally hangs by a thread (one of its leg hooks, to be exact) and is trying not to drop the fly that it is carrying. After about 15 seconds, it decides to undertake a "controlled plunge" into the abyss, and after landing relatively gently, it proceeds with its transport. Physically speaking, an object's weight equals its mass multiplied by earth's gravitational acceleration. The latter is a constant that is independent of the size or weight of the animal or object in question. The mass, on the other hand, shrinks cubically if the object is made smaller (one tenth of the size equals one thousandth of the mass). It thus appears that insects are disproportionately lighter in proportion to the size of their bodies. We also know that if an animal is shrunk, its muscle strength only shrinks by a square of the shrinking factor, as this depends on the muscular cross-section (see page 284). The surface of the animal also shrinks in a square relationship, while air resistance grows or shrinks in an inversely linear fashion: Animals ten times smaller have an air resistance that is (in proportion) ten times larger. The ant-fly-pair will, thus, reach its (rather low) terminal velocity rather quickly during free fall.

ⓘ **C. R. KNOSPE Insect Flight Mechanisms: Anatomy and Kinematics** http://people.virginia.edu/~crk4y/research/flight.PDF

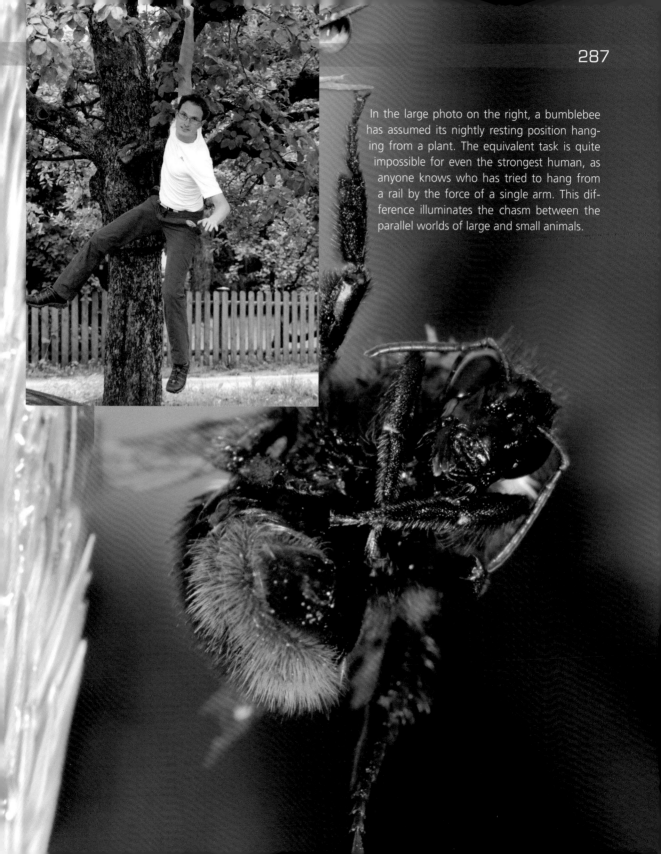

In the large photo on the right, a bumblebee has assumed its nightly resting position hanging from a plant. The equivalent task is quite impossible for even the strongest human, as anyone knows who has tried to hang from a rail by the force of a single arm. This difference illuminates the chasm between the parallel worlds of large and small animals.

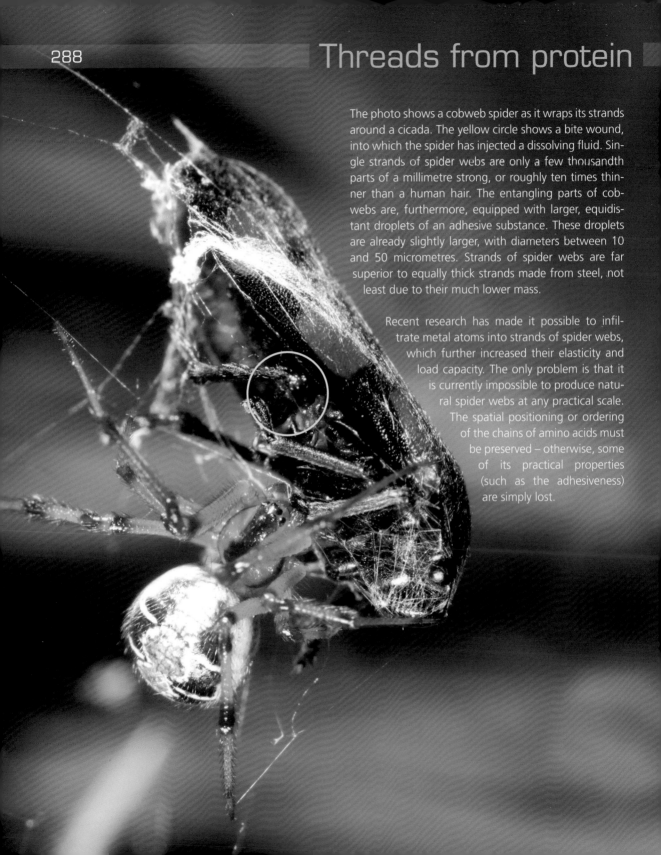

Threads from protein

The photo shows a cobweb spider as it wraps its strands around a cicada. The yellow circle shows a bite wound, into which the spider has injected a dissolving fluid. Single strands of spider webs are only a few thousandth parts of a millimetre strong, or roughly ten times thinner than a human hair. The entangling parts of cobwebs are, furthermore, equipped with larger, equidistant droplets of an adhesive substance. These droplets are already slightly larger, with diameters between 10 and 50 micrometres. Strands of spider webs are far superior to equally thick strands made from steel, not least due to their much lower mass.

Recent research has made it possible to infiltrate metal atoms into strands of spider webs, which further increased their elasticity and load capacity. The only problem is that it is currently impossible to produce natural spider webs at any practical scale. The spatial positioning or ordering of the chains of amino acids must be preserved – otherwise, some of its practical properties (such as the adhesiveness) are simply lost.

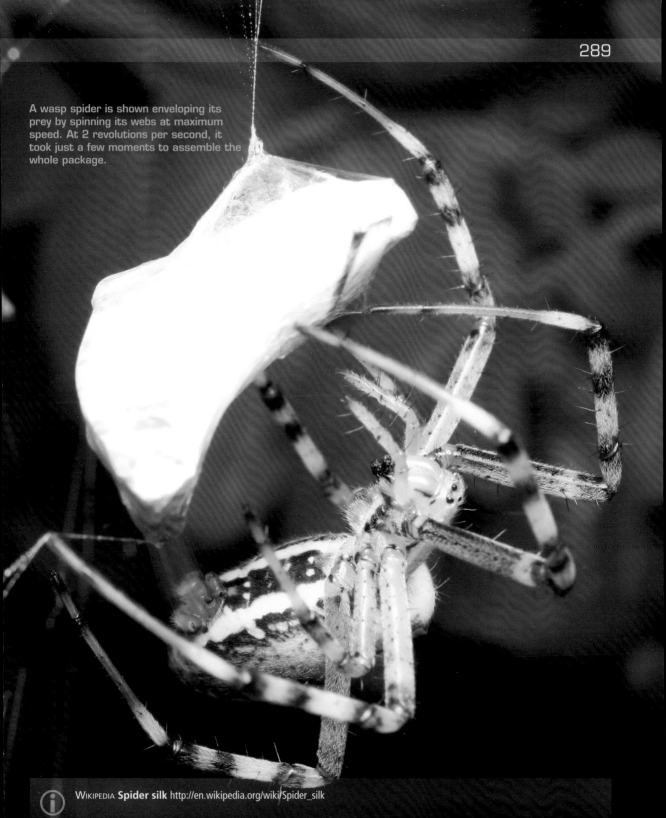

A wasp spider is shown enveloping its prey by spinning its webs at maximum speed. At 2 revolutions per second, it took just a few moments to assemble the whole package.

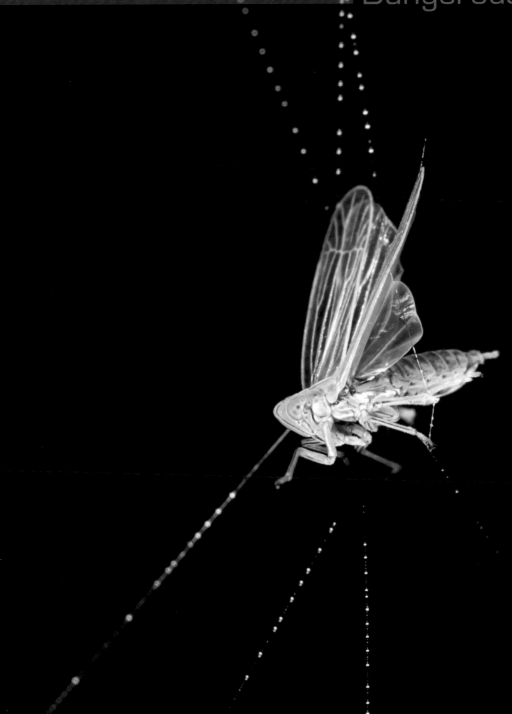

Tiny insects live extremely dangerous lives. A skilful flying technique may be good when escaping predators, but makes the insect more likely to end up in the omnipresent traps of spiders. Spinning threads have an extremely small diameter, ranging from 10 to 7000 nanometres (=1/140 of a millimetre). The left image shows tiny, more or less equally distributed glue droplets that are especially difficult to escape. On the right, the much larger droplets are actually dew and make the threads visible until the water evaporates again.

Both types of droplets are spherical due to surface tension and pose different but deadly dangers to insects: The picture below shows a tiny tropic bark beetle that got stuck in a water droplet. Scientists have discovered that the difference in roughness of the fibres, from which the threads are composed, helps water droplets in sliding towards the spindle knots, making them stick when they finally arrive.

(i) Y. ZHENG, ET AL **Why spider webs glisten with dew** Nature 463, 640-643 (2010)

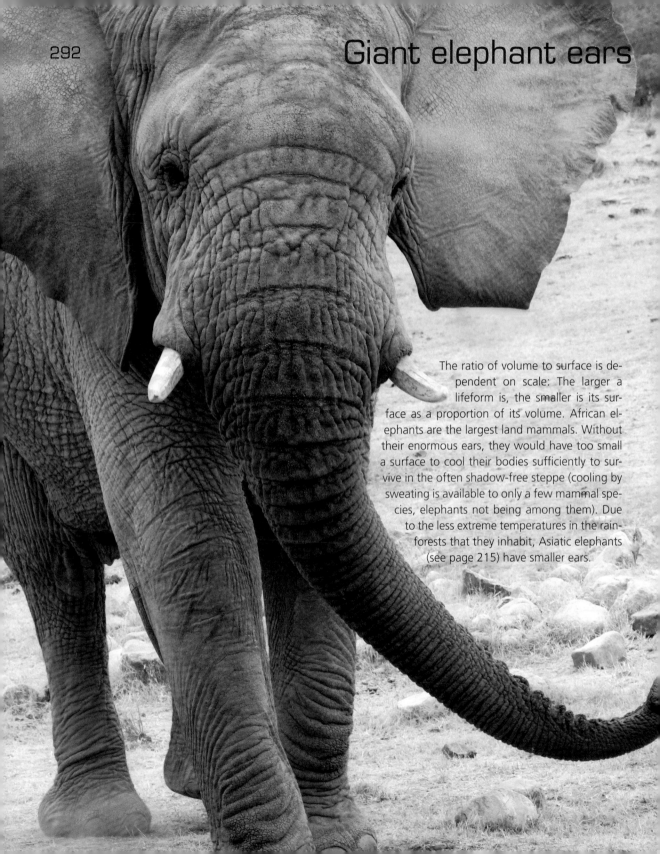

Giant elephant ears

The ratio of volume to surface is dependent on scale: The larger a lifeform is, the smaller is its surface as a proportion of its volume. African elephants are the largest land mammals. Without their enormous ears, they would have too small a surface to cool their bodies sufficiently to survive in the often shadow-free steppe (cooling by sweating is available to only a few mammal species, elephants not being among them). Due to the less extreme temperatures in the rainforests that they inhabit, Asiatic elephants (see page 215) have smaller ears.

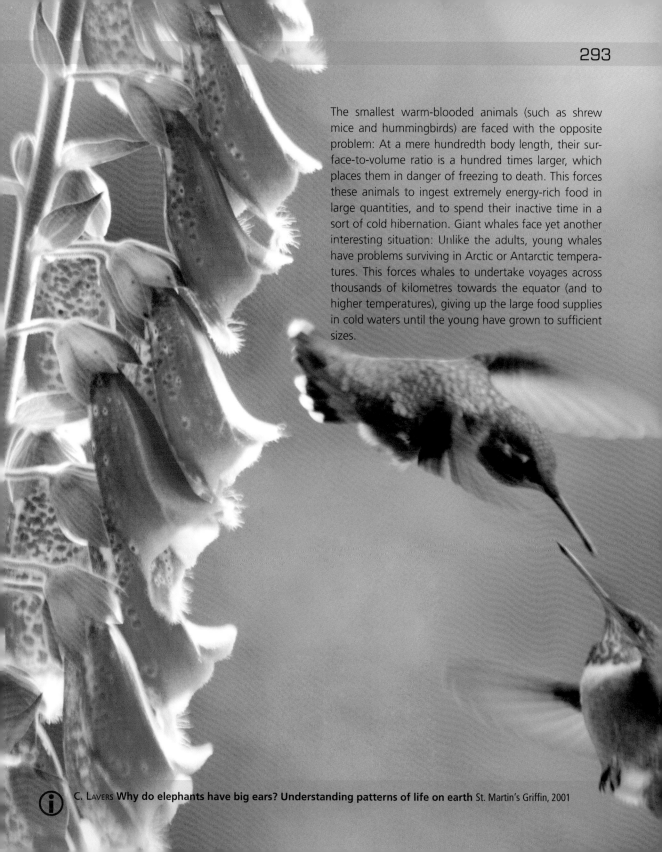

The smallest warm-blooded animals (such as shrew mice and hummingbirds) are faced with the opposite problem: At a mere hundredth body length, their surface-to-volume ratio is a hundred times larger, which places them in danger of freezing to death. This forces these animals to ingest extremely energy-rich food in large quantities, and to spend their inactive time in a sort of cold hibernation. Giant whales face yet another interesting situation: Unlike the adults, young whales have problems surviving in Arctic or Antarctic temperatures. This forces whales to undertake voyages across thousands of kilometres towards the equator (and to higher temperatures), giving up the large food supplies in cold waters until the young have grown to sufficient sizes.

C. LAVERS **Why do elephants have big ears? Understanding patterns of life on earth** St. Martin's Griffin, 2001

Making a piece of change float on top of water requires patience – apart from a suitable coin. This trick is easier to accomplish by placing the metal flatly on the water on a floating piece of paper and by waiting until the soaked paper drifts to the bottom. In theory, any metal (including gold) can float, but only if the hypothetical coin is small enough. If a coin is scaled down by a factor of 10, then its weight is reduced by a factor of 1000, and its surface only by a factor of 100. Thus, the surface of the downscaled coin has increased tenfold in relation to its mass. This makes it possible for the water's surface tension to do its job more effectively. The above image begs the question of how exactly the surface is distorted by the metal object.

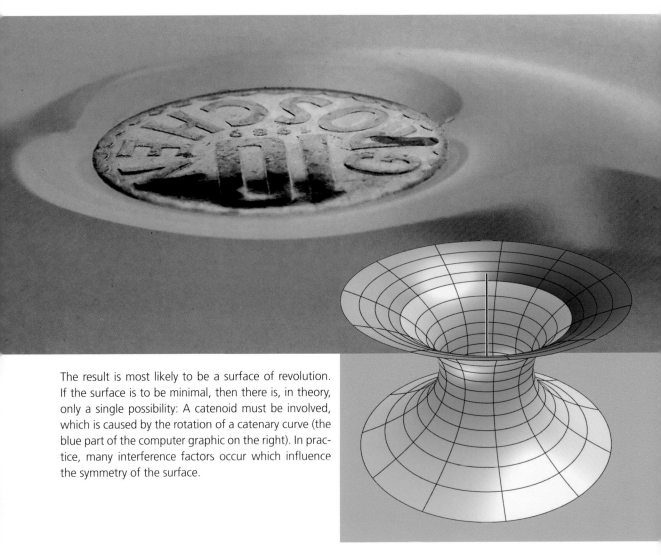

The result is most likely to be a surface of revolution. If the surface is to be minimal, then there is, in theory, only a single possibility: A catenoid must be involved, which is caused by the rotation of a catenary curve (the blue part of the computer graphic on the right). In practice, many interference factors occur which influence the symmetry of the surface.

The second photo from the series of floating coins deserves closer analysis: It was taken during very flatly inciding sunlight. The rays which pass through the edge of the coin keep producing an oblique circular cylinder prior to refraction. During their entry into the water, these rays are then strongly refracted towards the perpendicular. However, they stay parallel and keep form- ing an oblique circular cylinder. This cylinder strikes the cylinder-of-revolution-shaped wall of the container and intersects it along a fourth-order spatial curve (see the computer graphic on the lower left). Due to the different indices of refraction of the spectral colours, and due to the light's flat angle of incidence, we can observe a splitting up of sunlight into rainbow colours.

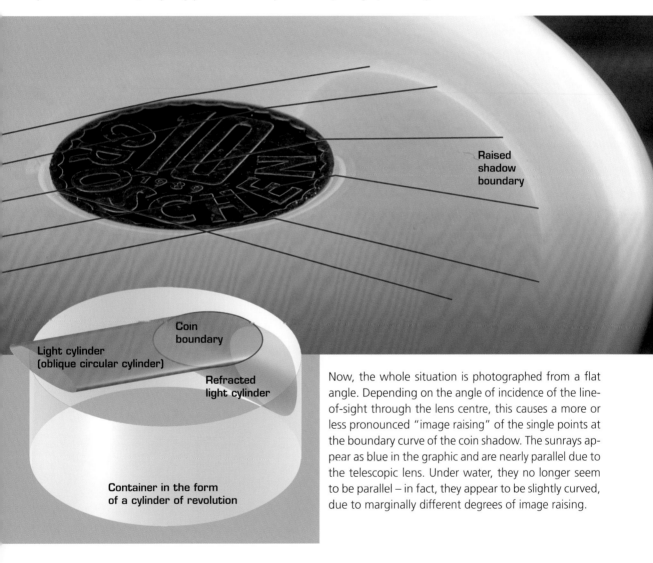

Raised shadow boundary

Coin boundary

Light cylinder (oblique circular cylinder)

Refracted light cylinder

Container in the form of a cylinder of revolution

Now, the whole situation is photographed from a flat angle. Depending on the angle of incidence of the line-of-sight through the lens centre, this causes a more or less pronounced "image raising" of the single points at the boundary curve of the coin shadow. The sunrays appear as blue in the graphic and are nearly parallel due to the telescopic lens. Under water, they no longer seem to be parallel – in fact, they appear to be slightly curved, due to marginally different degrees of image raising.

Model and reality

Even as we pass through an increasingly complex age of computer animation, physical models still aid us tremendously in understanding large objects. However, their physical properties are usually very different: A model of a bridge or a ship may sink or break under a heavy load, but it takes great experience (and great care) to apply these conclusions to bridges or ships of a regular size.

The minimal property of a surface (see page 155) is a geometrical characteristic (an average curvature of zero) which has physical consequences (minimal surface tension). Thus, it is sometimes right to assume that the large final product may inherit some properties of the much smaller model. The left image shows a model of a pavilion roof by C. Rushitzka. The right image shows very similar structures at the Olympia Park in Munich.

ⓘ G. Glaeser **Der mathematische Werkzeugkasten (4th edition)** Springer Spektrum, 2014

The smaller objects are, the more difficult it is for a photographer to capture them in perfect focus. At first glance, this observation seems to contradict the fact that photography, as the projection of a space into the sensor plane, is a purely geometrical procedure and should, therefore, be independent of scale. This seeming problem can be explained by the introduction of a scale-dependent physical property – the focal length. In fact, the system of lenses in a photo camera does not create a two-dimensional image, but a three-dimensional one. If an object is far away from the lens centre (many times the focal length of the respective lens system), then its three-dimensional image becomes highly flattened. From a distance of a hundredfold focal length

onward, the virtual image behind the camera is nearly completely flattened. It thus becomes easy to keep it in focus on the imaging sensor. Given a typical lens with a focal length of 50 mm, this might happen from a distance of about 5 metres, and given a telescopic lens of 300 mm, from a distance of about 30 m. Let us consider both computer graphics: On average, the dragonfly is about twice as far away from the lens centre Z as the focal length. As the light passes through the lens centre, it becomes a "virtual dragonfly" that is, in spatial terms, highly distorted. Only the points P, which are located exactly in the sensor plane, appear in focus. Points Q, which extrude from the focal plane, produce so-called "circles of blur" (also known as "Bokeh").

Both in absolute terms and in factors of the focal plane, the biplane below is very far away from the lens centre. Its virtual image is completely flat, which means that even its frontmost and rearmost points Q appear in focus. The size of the circles of blur is proportional to the camera's aperture diameter, which should not be smaller than about 1mm, as this would diffract the light rays, producing a phenomenon known as "diffraction

blur". Paradoxically, it is, therefore, easier to capture a large room photographically in great detail than to achieve an equivalent level of detail in a photo of an object the size of a postage stamp. At scales of one order of magnitude below, conventional spatial photography becomes practically impossible, even with the best photographic equipment. Electron rays are, thus, employed instead of light rays, as they are subject to substantially

lower diffraction. The photo shows the extent of what is possible: The fly's eyes measure just a single millimetre in diameter and are barely adequately in focus. The water droplets on the eyes are so tiny, that they are nearly impossible to detect with the naked eye. The magnification of spherical lenses is beautifully on display.

Stopping down (e.g. shrinking the aperture) would have made the blurry posterior legs slightly sharper, but would have robbed the interesting parts in focus of their details due to diffraction blur, which would have been noticeably higher.

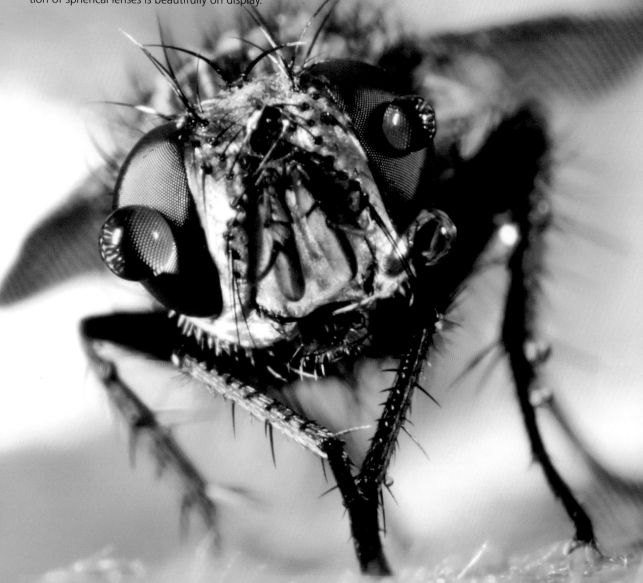

 G. Glaeser **3D-Images in Photography?** Journal for Geometry and Graphics (JGG), Volume 13 (2009), No. 1, pp.113-120 (http://www1.uni-ak.ac.at/geom/files/3d-images-in-photography.pdf)

Blurry decisions ...

This page shows two photographs created during equal conditions with a 50 mm prime lens. The depth of field in the left photo is significantly lower than in the right. Both effects may be desirable, depending on the visual effect that the photographer wants to accomplish. The focal length is proportional to the focal ratio (f-number). A smaller focal ratio causes a lower depth of field.

The task was to produce equal exposure on the imaging sensor in both cases. With an "open aperture" (small focal ratio), exposure takes a shorter amount of time. If the f-ratio is 10 times larger, however, then only one hundredth of the light reaches the sensor during the same interval of time. It is, thus, necessary to increase the sensor's light sensitivity to achieve equal exposure.

The processed quantity of light is proportional both to the exposure time and to the light sensitivity, but indirectly proportional to the square of the aperture diameter (double diameter = quadruple surface). For the sake of verification, the value $t \cdot i / b^2$ has to be roughly equal. Incidentally: In the usual case, a higher f-ratio is only advisable if the background of what is being pictured is relatively neutral – otherwise, background and foreground – both being in focus – would become hard to distinguish, which may upset some aesthetic sensibilities.

	left	right	right vs. left
Exposure time t (s)	1/1600	1/50	32
Focal ratio b	2,8	28	10 Exposure intensity: $(1/10)^2 = 0,01$
Light sensitivity i (ISO)	160	640	4
$t \cdot i / b^2$	0,0128	0,0163	roughly equal

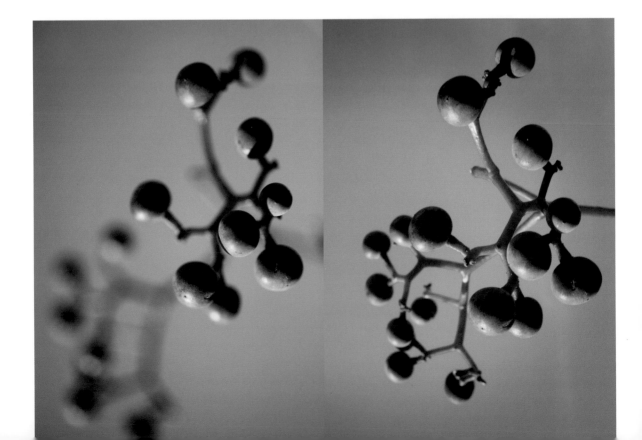

The tiny toad baby was photographed using the same 50 mm lens used for the photos on the left page. Despite a focal ratio of 16, the background is pleasantly neutralised. In such cases, it is advisable that essential body parts (such as the nostrils, eyes and the front paw) are as focused as possible.

However, it is impossible for this particular lens to focus on all body parts of the small animal at the same scale and from the same perspective. If the aperture diameter falls below a certain minimum (about 1mm), then the whole image becomes significantly (and negatively) affected by diffraction blur.

Fluids

A fluid is a substance that does not pose any resistance if exposed to an arbitrarily slow shear (gases or liquids). But what if the shear is too fast? Insects such as the beautiful ladybird flap their wings up and down (but also forwards and backwards) at a rate of several hundred times a second. This rapid interaction causes air to behave as a liquid, on which the insect may thus support itself. The stork, which is 200 times larger (and thus millions of times heavier) is unable to achieve such frequencies, as its muscular strength increases as a square of its size, while its weight increases cubically with its size. The bird is, thus, forced to employ different tricks to become airborne, such as special turbulences like those caused by airplanes, or by spreading apart its wingtips. The latter peculiar feature is especially appreciated by bionic scientists, and it is being applied to the construction of airplane wings in order to improve their in-flight behaviour.

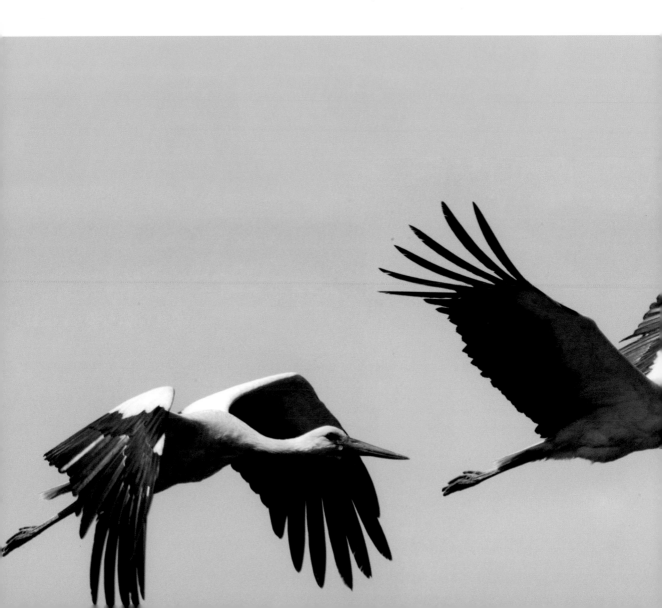

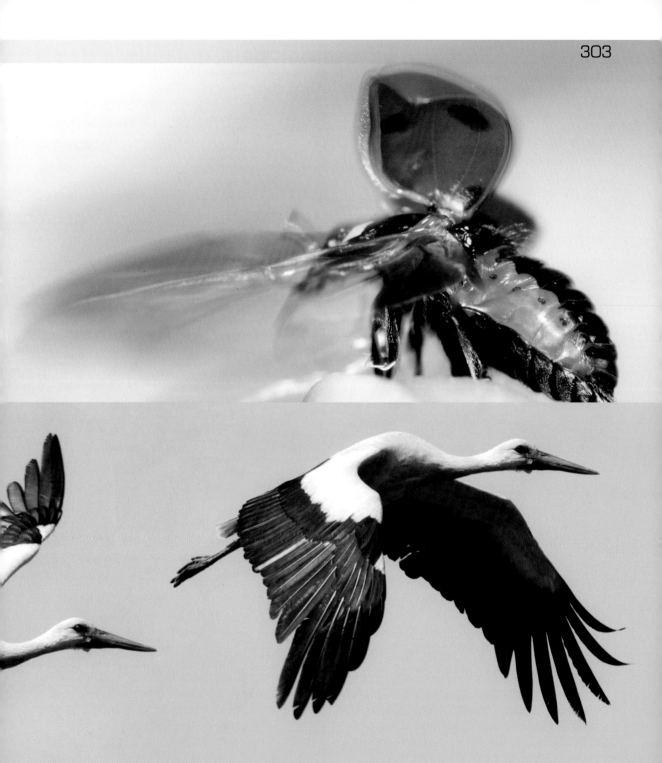

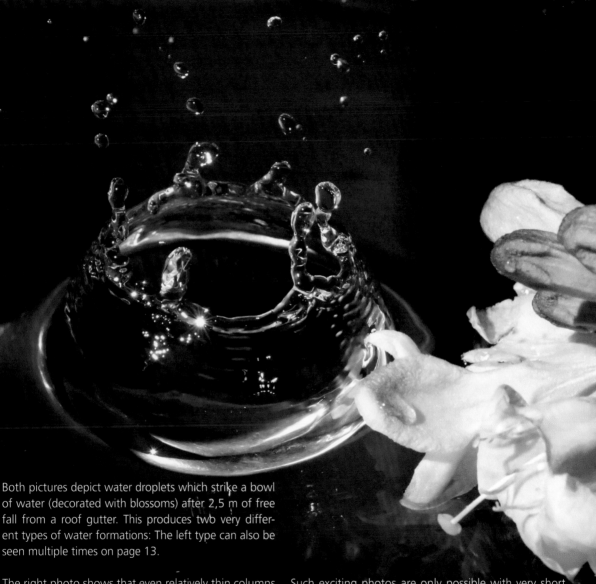

Both pictures depict water droplets which strike a bowl of water (decorated with blossoms) after 2,5 m of free fall from a roof gutter. This produces two very different types of water formations: The left type can also be seen multiple times on page 13.

The right photo shows that even relatively thin columns of water may be pushed upwards in a "whip-like" reaction. However, such columns collapse very quickly, and as they do so, they resemble a falling droplet that has been turned on its head.

Such exciting photos are only possible with very short exposure times, as the motion blur would otherwise render the droplets visually incomprehensible. The pictures on this spread were exposed within 1/8000 of a second. Due to the law of free-fall $s = g/2 t^2$, a water

column with a height of 2 cm collapses within ...

$$t = \sqrt{\frac{2s}{g}} = \sqrt{\frac{2 \cdot 0{,}02\,\mathrm{m}}{10\mathrm{m/s}^2}} = 0{,}02\,\mathrm{s}$$

... and during this very short period of time, it takes on thousands of different forms. In the world of the very small, which is not so familiar to us, events take place much more quickly than at our human scales (see also page 346).

YouTube **Drop of water in slow motion** www.youtube.com/watch?v=CJ-AX1G0SmY

Flexible straws

The proboscis of a butterfly is obviously a type of winding curve (see page 274) which is able to roll itself out and to curl itself back up within one hundredth of a second. This spread shows three of its positions for the Cleopatra butterfly. In the case of the privet hawkmoth (upper images on the right side), the proboscis is more than twice as long as its body. This helps the insect to reach within the long blossoms of the evening star flowers.

 WIKIPEDIA **Proboscis** http://en.wikipedia.org/wiki/Proboscis

The photos show that the proboscis is bent at its first third, which means that the insect primarily rolls in the first part. The speed with which the proboscis can be manipulated is all due to its small size (see page 305). The torque that is needed to accomplish the quick movement is reduced dramatically! It is no wonder that, by comparison, the elephant moves its trunk in "super slow motion".

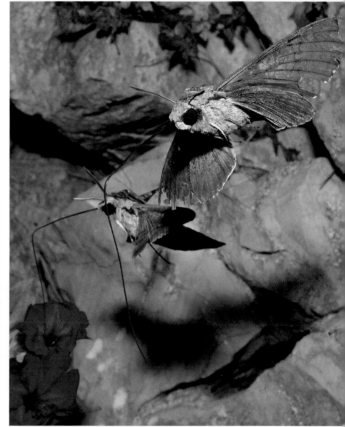

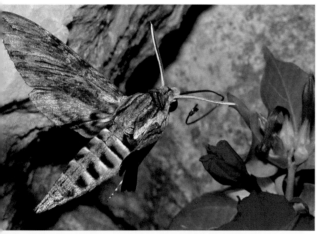

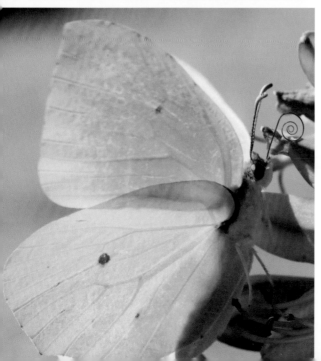

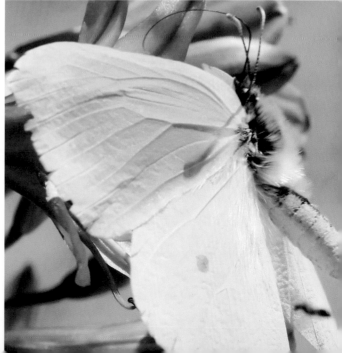

Biomass

Biomass can be measured in different ways, but in strict scientific applications, it is defined as the mass of organically bound carbon (C) that is present in a given environment. The total live biomass of bacteria probably exceeds that of plants and animals. As one travels up the food chain, the total biomass of the respective animal groups tends to decrease. In oceans, biomass usually follows the food chain "phytoplankton » zooplankton » predatory zooplankton » filter feeders » predatory fish".

PRINCETON UNIVERSITY **Biomass** www.princeton.edu/~achaney/tmve/wiki100k/docs/Biomass_%28ecology%29.html

Terrestrial biomass generally decreases significantly at each higher level (plants » herbivores » carnivores). Trees, for instance, possess a vastly larger amount of biomass than all animals put together.

The picture on the left shows trees that are 15 metres tall. The right photo depicts bushes with a height of 30 cm. One can thus conclude that, since the trees are 50 times taller, they should have roughly 100 000 times more biomass ($50^3=125\,000$).

Like an oil bath

The animals depicted on this spread are extremely small – as tiny as two millimeters in diameter and barely visible to the naked eye – and are, thus, very hard to depict photographically (see p. 298 concerning macro photography). Due to their size (see also pages 286 and 347), their relative water resistance is extremely high, which forces them not to move smoothly but rather to pulsate by using their legs (left) or squeezing their body.

Left: Daphnia pulex is the most common species of water flea, having a cosmopolitan distribution and being part of typical zooplankton. It was the first crustacean to have its genome sequenced. Like all crustaceans, it originally had two eyes. Over millions of years, these compound eyes fused together into one.

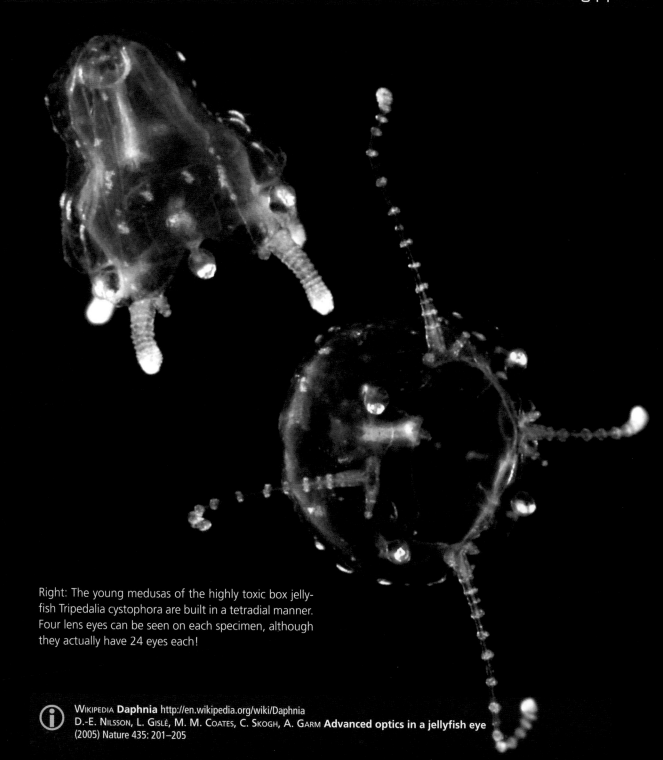

Right: The young medusas of the highly toxic box jelly-fish Tripedalia cystophora are built in a tetradial manner. Four lens eyes can be seen on each specimen, although they actually have 24 eyes each!

ⓘ WIKIPEDIA **Daphnia** http://en.wikipedia.org/wiki/Daphnia
D.-E. NILSSON, L. GISLÉ, M. M. COATES, C. SKOGH, A. GARM **Advanced optics in a jellyfish eye**
(2005) Nature 435: 201–205

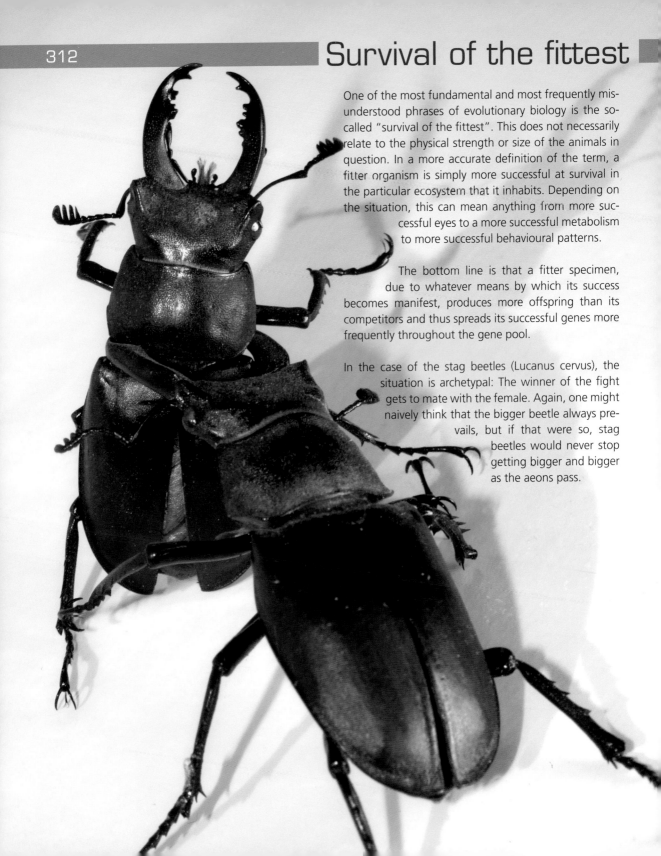

Survival of the fittest

One of the most fundamental and most frequently misunderstood phrases of evolutionary biology is the so-called "survival of the fittest". This does not necessarily relate to the physical strength or size of the animals in question. In a more accurate definition of the term, a fitter organism is simply more successful at survival in the particular ecosystem that it inhabits. Depending on the situation, this can mean anything from more successful eyes to a more successful metabolism to more successful behavioural patterns.

The bottom line is that a fitter specimen, due to whatever means by which its success becomes manifest, produces more offspring than its competitors and thus spreads its successful genes more frequently throughout the gene pool.

In the case of the stag beetles (Lucanus cervus), the situation is archetypal: The winner of the fight gets to mate with the female. Again, one might naively think that the bigger beetle always prevails, but if that were so, stag beetles would never stop getting bigger and bigger as the aeons pass.

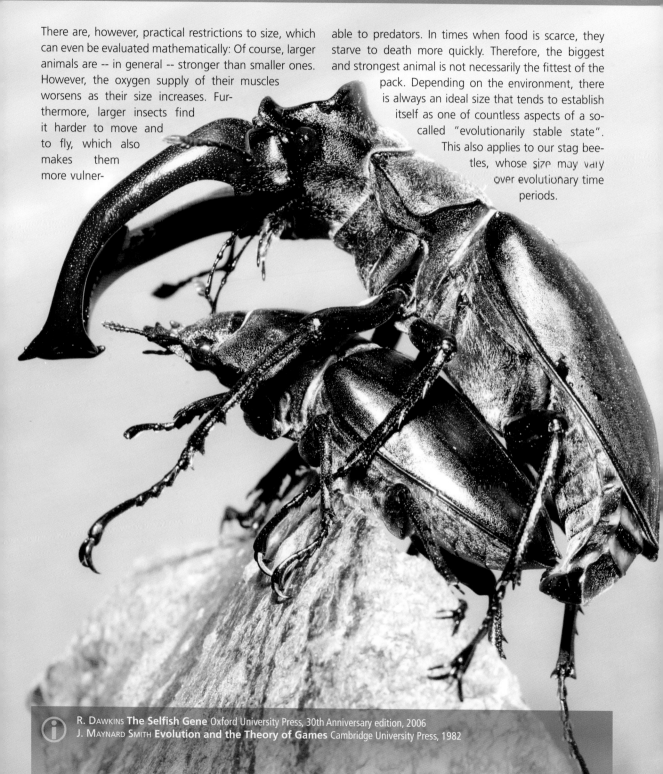

There are, however, practical restrictions to size, which can even be evaluated mathematically: Of course, larger animals are -- in general -- stronger than smaller ones. However, the oxygen supply of their muscles worsens as their size increases. Furthermore, larger insects find it harder to move and to fly, which also makes them more vulner-able to predators. In times when food is scarce, they starve to death more quickly. Therefore, the biggest and strongest animal is not necessarily the fittest of the pack. Depending on the environment, there is always an ideal size that tends to establish itself as one of countless aspects of a so-called "evolutionarily stable state". This also applies to our stag beetles, whose size may vary over evolutionary time periods.

R. DAWKINS **The Selfish Gene** Oxford University Press, 30th Anniversary edition, 2006
J. MAYNARD SMITH **Evolution and the Theory of Games** Cambridge University Press, 1982

13 Tree structures and fractals

Thinkers as far back as Leonardo da Vinci have suspected that, as trees branch out into ever more intricate formations, their total cross-section, nevertheless, stays roughly the same (see image on the right). This apparent rule has been explored and refined by computer graphics engineers.

Let us attempt an analysis based on the African Aloe tree on the right page. It may not be exact, but it is sufficiently approximate to imagine the branches as having a locally circular cross-section. If this is true, then the following reasoning works relatively well: Wherever a first branching occurs, we select the midpoint M of a sphere, which then includes the cross-section circles of the branches as small-circles. The circles then appear as line segments which can be measured.

If the largest (lower) circle has a diameter of 1 unit (= 100%), then the smaller circles have the radii 0,57

(57%), 0,38 (38%), and 0,7 (70%). We know that the circle area increases as a square of the diameter. In fact, our result of $0{,}57^2 + 0{,}38^2 + 0{,}7^2 = 0{,}96$ is not far removed from our expectations of $1^2 = 1$. It would seem that Leonardo's rule works well in the case of the smallest sphere.

We now increase the sphere radius. The number of branches has now grown to 25, which would suggest an average cross-section surface of $1 / 25$, or $1 / 25 = 1 / 5$ (20%) of the maximum diameter. Leonardo's rule does not seem to apply this time, as the total cross-section seems to have grown smaller. This irregularity is even more pronounced when considering the third sphere, where the total cross-section is even smaller.

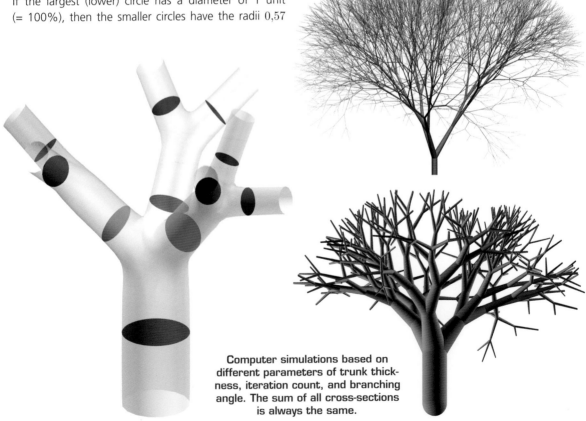

Computer simulations based on different parameters of trunk thickness, iteration count, and branching angle. The sum of all cross-sections is always the same.

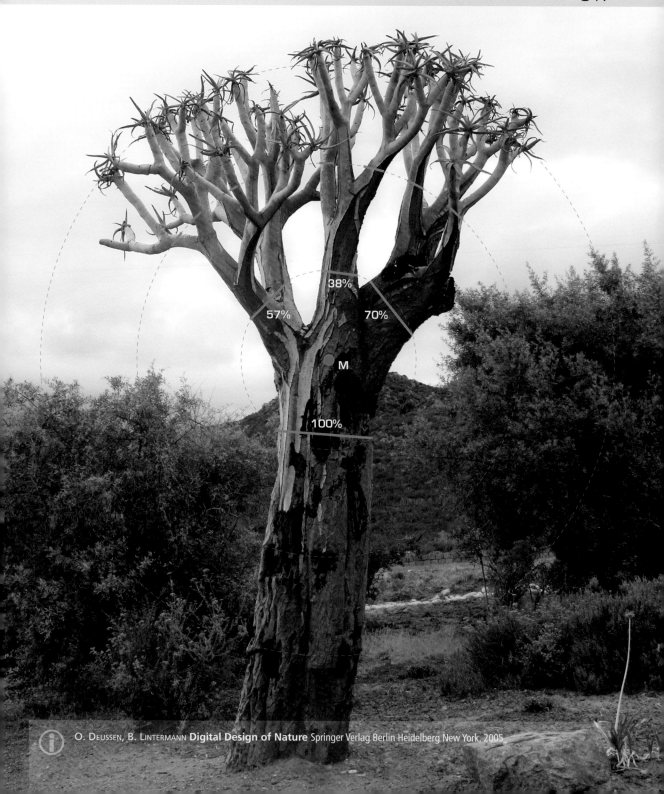

Systematic chaos

Nature often produces shapes which, at first glance, do not seem to have anything in common, but which are, nevertheless, based on similar principles. The coral branches may appear to be completely chaotic, but their purpose is to cover the whole area in order to best filter the incoming water. But what might be the purpose of the rather similar surface-covering lines on the humphead wrasse? Well, as this fish is active by day and as it often hides within corals, the most probable explanation is camouflage.

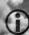
E. W. Weisstein **Peano Curve** http://mathworld.wolfram.com/PeanoCurve.html
Wikipedia **Humphead wrassle** en.wikipedia.org/wiki/Humphead_wrasse

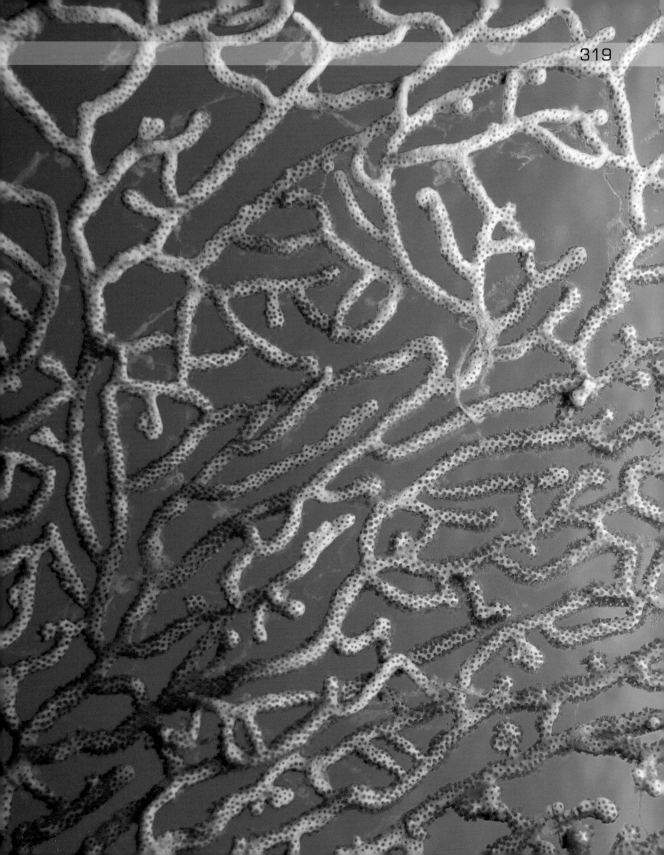

Branching

By branching out into hugely complicated shapes, plants seek to increase the fineness of their structure. By these means, they maximize their surface area, which leads to the actual goal of optimal interchange of liquids and nutrients (the image shows a corkscrew hazel).

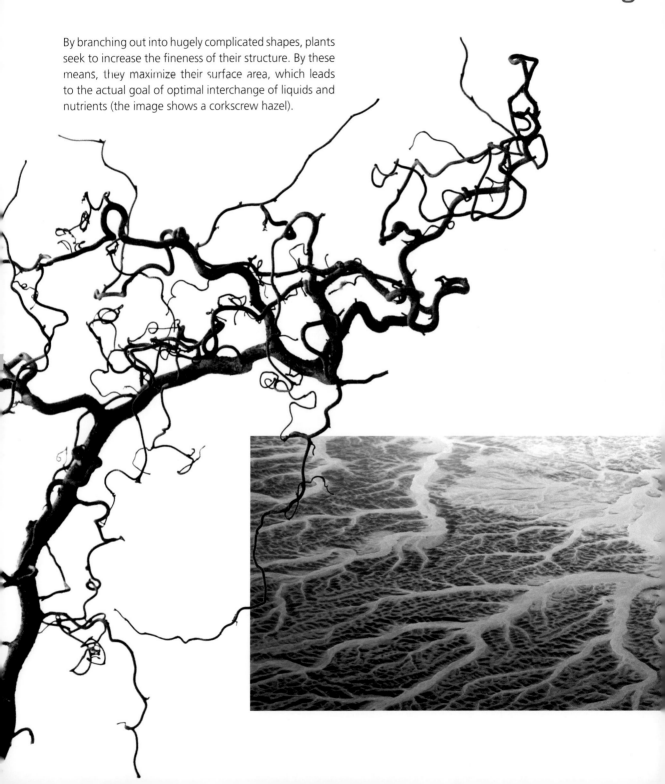

The lower pair of photos may look like a root system, but is, in fact, a photo taken from an airplane of the Egyptian desert near Luxor. The right version was colour-corrected in a computer to suggest the branches of a river. These branching structures are so-called wadis, which only carry water every few years, and when they do, a veritable avalanche of water and mud – unhindered by any vegetation – sweeps across the valleys. This remarkable phenomenon can at once be deadly and life-giving. In a completely opposite way, the river on the far right (near Thessaloniki) diverges into a delta as it enters the sea.

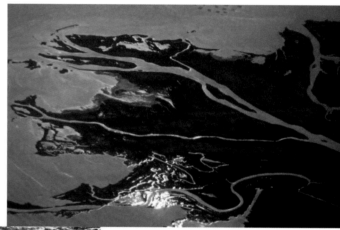

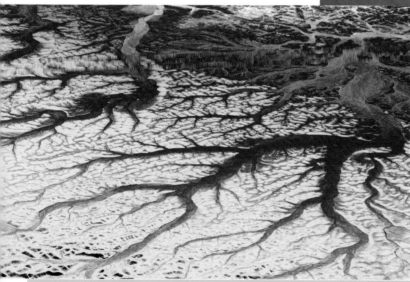

Wonderful coincidences

Plants, such as the pictured Euphorbia tirucalli, grow as it most suits them from moment to moment, depending on the conditions of light, wind and obstacles. This principle produces a variety of forms.

The lower computer graphic attempted to simulate such plant-like growth. A boundary surface was specified to limit the extent of the virtual growth.

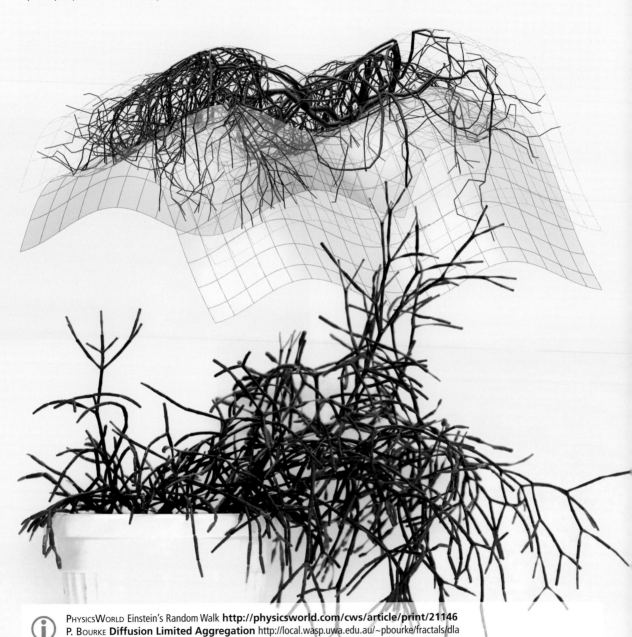

The "geodesic robot" of Peter Hausegger may be seen as a "random walker". The wire frame sphere is being propelled by a battery operated fan, which is mounted on a swing that moves around by means of strategically placed weights. This element of chaos makes it virtually impossible to predict the path of the robot.

In Latin, "fractus" means "broken" or "fractured". The term "fractal" was introduced in 1975 by Benoît Mandelbrot and describes natural or artificial patterns that exhibit certain properties which can, for instance, be detected in clouds: At first, a certain independence of scale can be noticed, as large clouds look very similar to small ones. Furthermore, patterns within a fractal seem to repeat themselves at different scales (self-similarity). All fractals possess an indistinct contour, which, in theory, is of infinite length. Koch's snowflake (pictured three times) is a classic example.

Due to the physical limitations of matter, objects in nature can never fulfil the mathematical criteria of a fractal, which does not, however, hinder their very close resemblance – such as the real snowflake in the smaller photo.

(i) D. White **Mandelbulb** http://www.skytopia.com/project/fractal/mandelbulb.html#rendersl
 E. W. Weisstein **Koch Snowflake** http://mathworld.wolfram.com/KochSnowflake.html

Fractal pyramids

Building three-dimensional fractals can be very challenging. The pictured "Sierpinski pyramid" is 40 cm tall, weighs 25 kg, and was built by Christoph Pöppe from metal spheres with help from the IWR (Heidelberg University). Another smaller pyramid is pictured behind it. Four strung-together spheres produce a tetrahedron. This procedure must be carefully expanded by replacing each sphere with groups of four spheres at half the original diameter. Thus, every stage of expansion requires four times the effort of the previous one!

A model is beautifully suited to imagine a really complicated structure such as this. In a computer model, it is useful to calculate special shadows that show the pyramid's holes from multiple perspectives.

C. Pöppe **Kartonbausätze für geometrische Körper** www.poeppe-online.de/12.html
C. Pöppe **Fraktale Weihnachtskugeln** www.spektrum.de/sixcms/detail.php?id=1017912&_druckversion=1
Universität Heidelberg **Sierpinski Tetrahedron** http://www.iwr.uni-heidelberg.de/groups/ngg/Sierpinski/
P. Bertok **Computer rendering of a Sierpinski pyramid**
http://upload.wikimedia.org/wikipedia/commons/b/b4/Sierpinski_pyramid.png

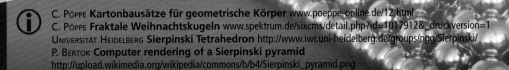

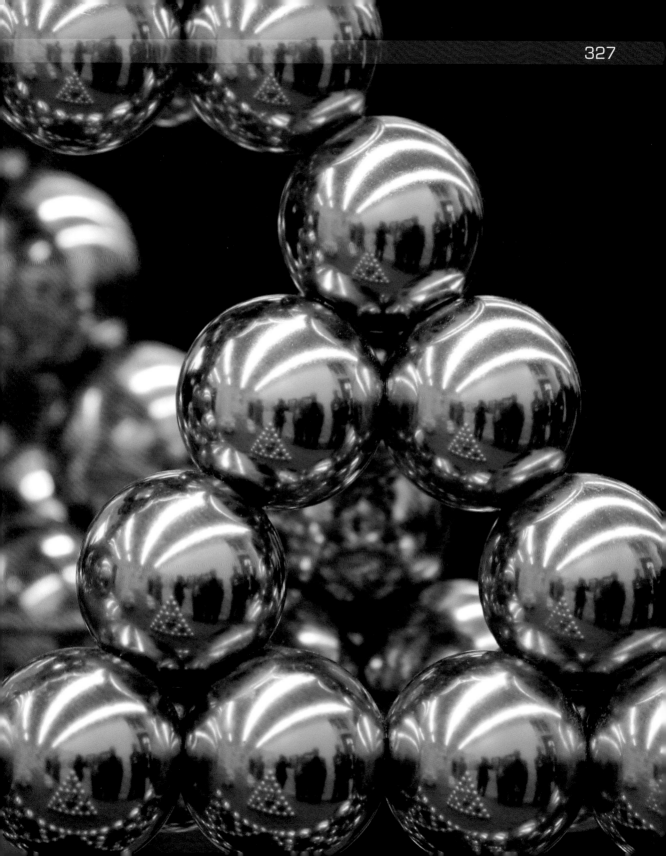

Animals or plants?

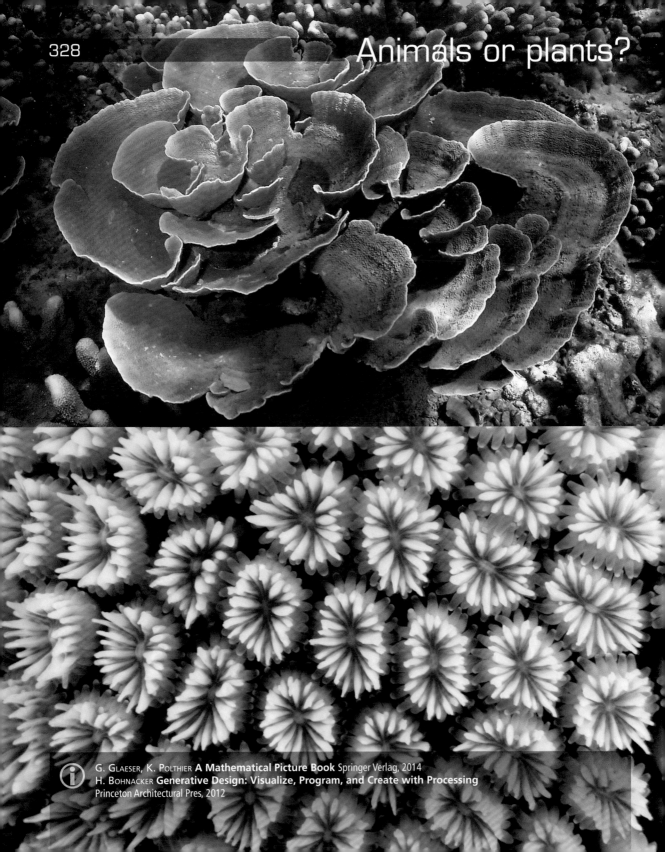

G. GLAESER, K. POLTHIER **A Mathematical Picture Book** Springer Verlag, 2014
H. BOHNACKER **Generative Design: Visualize, Program, and Create with Processing**
Princeton Architectural Pres, 2012

So far, we have discussed corals several times (p. xxx, p. xxx). A coral is a sessile animal that consists of multiple polyps and relies on a symbiosis with the plantlike algae. Over countless generations, hard corals are able to build huge structures of wholly biological origin. Generations of polyps grow and die, slowly laying the limestone foundation for coral reefs.

From a geometrical point of view, the forms of hard corals can be quite diverse and always highly interesting. The pictures on the right show a so-called brain coral that "winds" its way along a sphere. This process is somewhat reminiscent of a computer graphic by Franz Gruber, where he drew a "Hilbert curve" (a type of fractal) on a sphere.

Mathematical ferns

A fern is a good example of a fractal-like structure in nature. Take a look at the computer-generated shape on the right: Most botanically knowledgeable observers will rightfully identify it as a fern and agree with its fractal designation, as the basic structure repeats itself over and over again at different scales.

Let us now consider the photograph of an actual fern on page 46. Here, the fractal nature is not as clear as in the computer simulation. After the second iterative step, the self-similarity is all but over. If the reverse of the fern leaf is magnified many times over, it becomes clear that the fanning out of the fractal-like leaf structure serves the purpose of covering the maximum possible area with sporangia (small images). It is also a good strategy for optimizing photosynthesis.

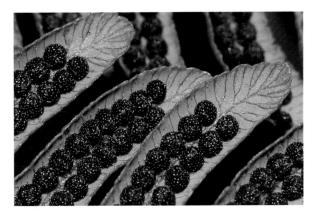

The right page shows a basket starfish. This mobile brittle star is active by night and very sensitive to light: One of its 13 arms must have been hit by a diver's torchlight, which caused it to curl up (including its many branches). As in the case of the fern, the reason for its complex and area-covering branching structure is also obvious: Its main objective is to filter as much plankton from the water as possible.

The computer graphic is based on an idea by Michael Barnsley, whereby the algorithm repeatedly applies one of four (exactly defined) affine transformations to a single point. This iterative procedure moves the point continuously, producing a fractal of this kind.

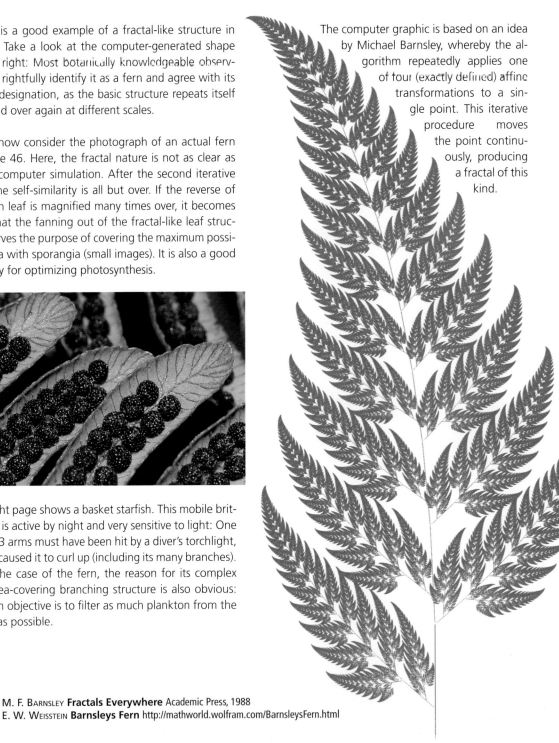

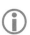
M. F. BARNSLEY **Fractals Everywhere** Academic Press, 1988
E. W. WEISSTEIN **Barnsleys Fern** http://mathworld.wolfram.com/BarnsleysFern.html

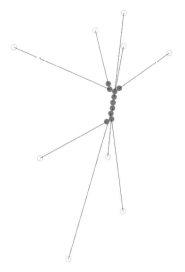

Let us consider the following algorithm: A circle is given at the start. We now create a second circle within a given rectangular boundary and keep moving the new circle towards the old one until they touch each other. Now, a third circle is introduced at a random location. If it is closer to the first circle, it is moved towards it by the same procedure as before. Otherwise, it is moved likewise towards the second circle. After many circle gen-erations of this kind, a tattered sort of "string of pearls" is produced, with many branches of its own. This algo-rithm tends to fill the plane in a fractal manner. How-ever, nature probably does not follow this exact recipe. The problem of filling areas in a non-regular manner is often encountered in the natural world – for instance, in the growth of lichen or in camouflage effects. The right page shows the magnified eye of a sandperch.

ⓘ H. Bohnacker, et al. **Wachstumsstruktur aus Agenten** Verlag Hermann Schmidt Mainz, 2009 (S. 228)
 H. Bohnacker, et al. **Generative Gestaltung** www.generative-gestaltung.de

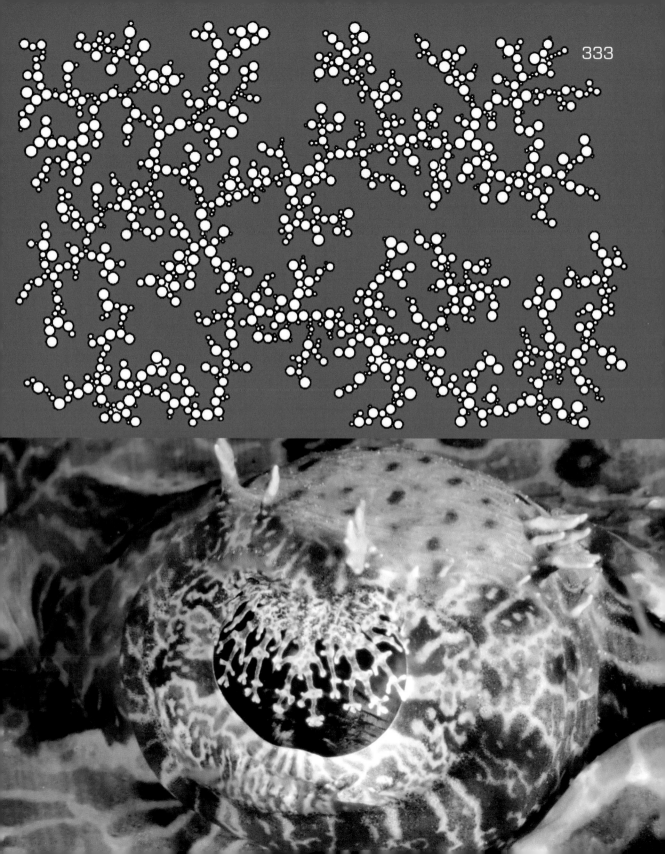

Level curves

The boundary between fog and land is a level curve of the landscape. The more jagged the landscape, the more the level curve resembles a fractal. The computer simulation below shows how the landscape appears to change as the water level rises or sinks. These principles are especially relevant in our age of global climate change.

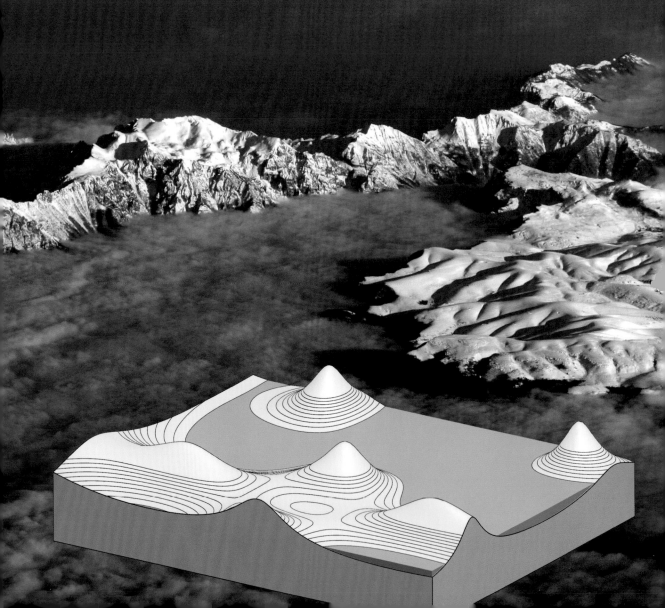

The top right photo shows a dried-out hollow on a sea-shore. Several layers of salt, which also function as level curves, are visible. Its overall appearance resembles the steps of a stone quarry (centre right). The bottom photo shows the terraces of Pamukkale (Turkey). The calciferous spring water accumulates in the basins whose boundaries are level curves of the terrain.

From octahedrons to snowflakes

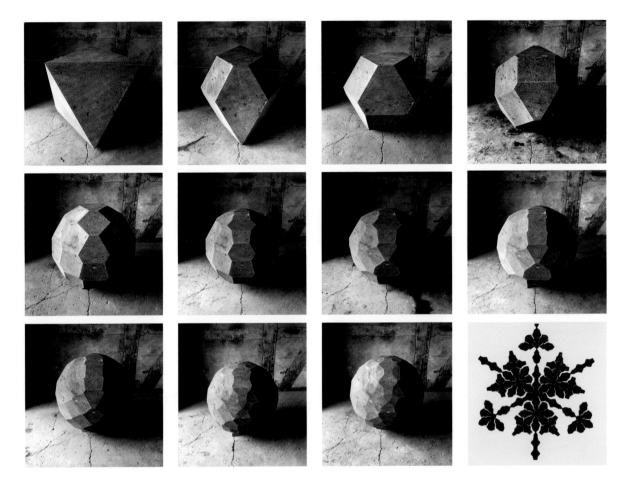

Klaus Becker is a sculptor with a background in architecture and mathematics. One of his ideas, as presented on this spread, was to chisel out a stone sphere with a considerable 80cm diameter from an octahedron based on a strict procedure. The series of photos above was created in 1994. For the mathematically curious, the "octahedron sphere" offers one further charm: Its development (determined empirically) is reminiscent of a snow flake, and thus contains fractal characteristics. Franz Gruber implemented the algorithm of the computer simulation, not only enabling interesting insights, but also the production of images with an arbitrary de-

gree of accuracy. Let us start with an octahedron, into which we inscribe a virtual sphere (first image on the right page). We first cut off square pyramids from the edges of the octahedron in such a way that their basal planes touch the sphere. The remaining manifold is now composed of six squares and eight half-regular hexahedrons. Some elements at the centre remain from the 12 edges of the octahedron (coloured green). In a next step (second image on the right page), we keep chiselling away at the structure, in parallel to the green edges, so that the inner sphere is once again touched.

ⓘ K. BECKER **Algorithmen in Stein – Algorithms in stone** Klaus Becker, Hrsg., 1998 (www.klausbecker.org)

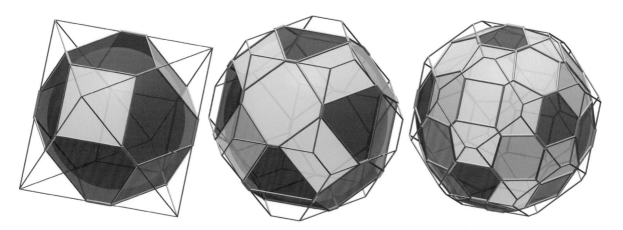

The squares now become half-regular octahedrons. The half-regular hexahedrons shrink together, adding 12 further rectangles. Once again, the trimmed polygons share green edges.

How do we continue from here? We keep chiselling away in parallel to the green edges until the inner sphere is touched. Octahedrons become squares, and the rectangles become half-regular hexahedrons. Non-regular hexahedrons, which no longer have a circumcircle, are introduced for the first time. We keep colouring the shared edges of the trimmed polygons green (or, all that was left of the old "scaffolding" edge) and keep chiselling away in parallel …

This algorithm enables us to keep track of which facets belong to which "generation", which lets us systematically develop the polyhedron, in order to produce a fractal snowflake-like shape as Becker imagined it.

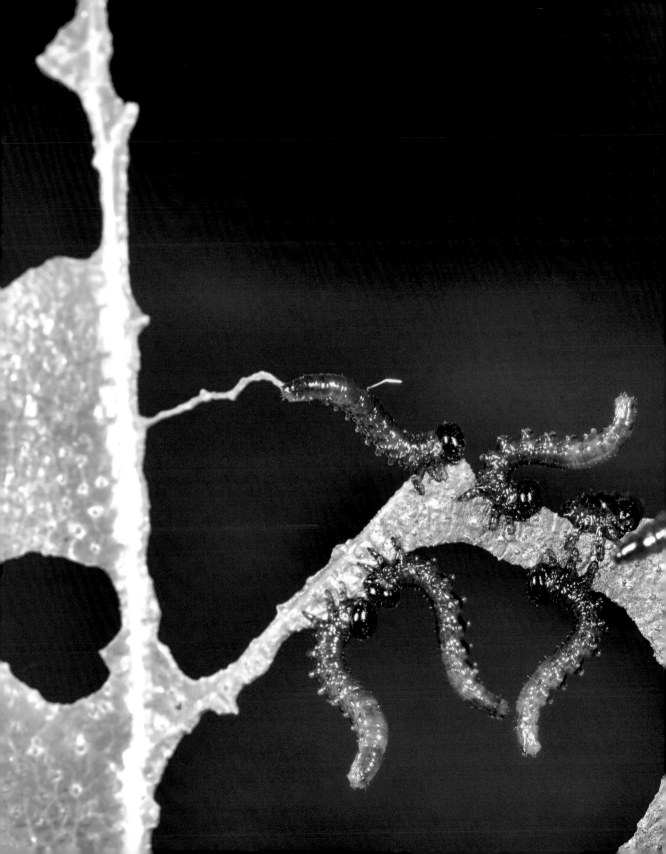

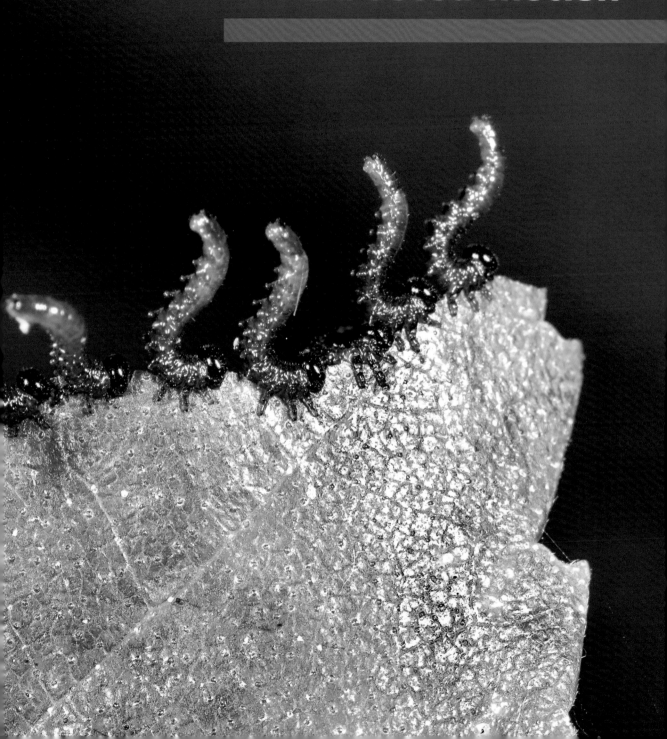

Wilhelm Blaschke is said to have stated that kinematics is the "paradise of the geometricians". In any case, the pictured gears allow our geometric imagination to truly "run wild": These elliptical gears force us to differentiate between three systems: the first gear (red), the second congruent one (green), and finally the rod LA. Depending on which of the three systems is held constant, we perceive the motion of the whole in different ways.

If the red ellipse is held constant, then its focal points L and M are likewise fixed. The green ellipse now rolls along the red one – without gliding, which is ensured by the gear teeth. The associated ellipse tangent is a symmetry axis, which means, that $LA = MB$ holds true (and, by definition, $LM = AB$). The four-rod gear system $LMAB$ is, thus, called the anti-parallelogram and produces the same rolling movement. The centre of the green ellipse possesses a path curve that is reminiscent of a bicycle chain. The computer graphic is a quasi-stroboscopic representation of the situation, and it shows where the centre moves more quickly and where it

moves more slowly. We can see that the mechanism is downright pulsating. We now assume LA to be fixed (photos below). Both ellipses now move, even if at different speeds. In the right photo below, a longer exposure time was deliberately chosen, allowing motion blur to indicate the high angular velocity of the left ellipse. The path curve of the left ellipse's centre is also visible in the familiar stroboscopic manner (a figure-eight loop).

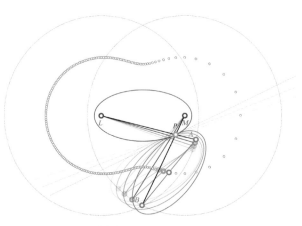

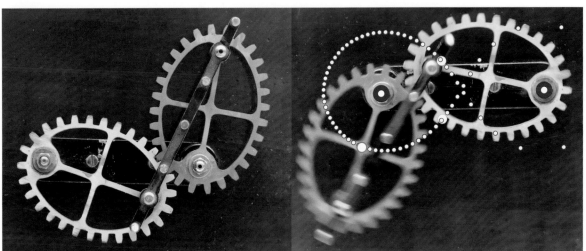

F. L. Litvin, A. Fuentes-Aznar, I. Gonzalez-Perez, K. Hayasaka
Introduction to Theory of Gearing, Design, and Generation of Noncircular Gears
http://assets.cambridge.org/97805217/61703/excerpt/9780521761703_excerpt.pdf
W. Wunderlich **Ebene Kinematik** B. I. Hochschultaschenbücher 447/447a, Mannheim 1970
C. J. Scriba, P. Schreiber **5000 Jahre Geometrie: Geschichte, Kulturen, Menschen** Springer Verlag Berlin-Heidelberg, New York, 3. Auflage, 2009

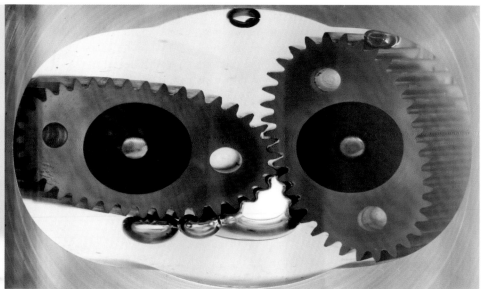

The motion with the fixed rod LA was brilliantly implemented by Bopp & Reuther / Mannheim: Two gears in the form of interlocking, congruent elliptical cylinders slowly sink due to gravity in a glass cylinder full of oil. In due course, they roll upon each other – one might rightly think of an "elliptical hourglass" (the model itself is called an "oval wheel counter").

One slight blemish precludes its perfection: The glass cylinder might have needed one or two further teaspoons of oil to avoid the air bubbles. A photographer may find them especially interesting (see photos above). It is further remarkable that the cylinders appear strangely distorted due to refraction.

Christian Perelli and Georg Hierzinger have used a similar idea in their own particular artistic ways, thereby creating an installation in a Viennese shopping mall (photos below).

Let us consider the inside of an electrical screwdriver. An unprepossessing 3,6 volt battery (see the left photo) provides the necessary electricity to turn the small electric motor with a speed of about 3500 revolutions per minute. The motor shaft propels a small gear with only six teeth (large photo). This so-called sun gear transfers its rotational momentum to three equilaterally positioned planetary gears, whose number of teeth results from the remaining construction. The planetary gears are positioned such that they are connected to a fixed outer gear with 48 teeth. This causes the centres of the planetary gears to rotate with one eighth $6:48$ of the drive shaft's angular velocity. The centres of the planetary gears form a fixed equilateral triangle. On its reverse, in a second step, a further 6-tooth sun gear propels three other planetary gears with the same

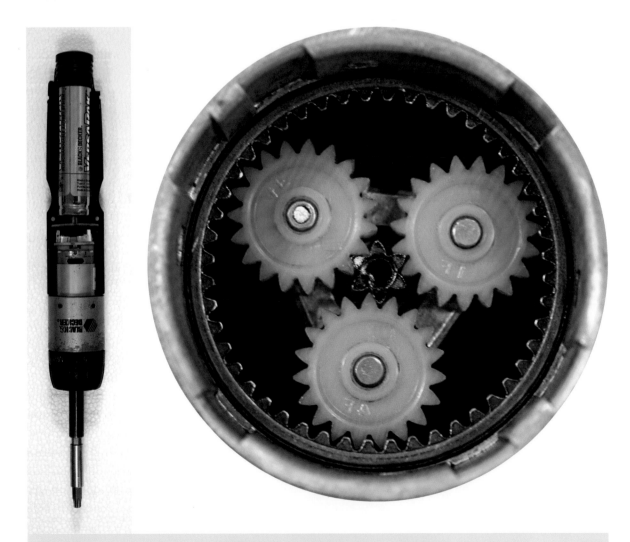

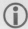 WIKIPEDIA **Epicyclic gearing** http://en.wikipedia.org/wiki/Epicyclic_gearing
MATHWORKS **Planetary Gear** www.mathworks.de/de/help/physmod/sdl/ref/planetarygear.html

translational ratio as before. The connecting triangle between the planetary gears at the second layer is finally connected to the axis of the screwdriver. The $8 \cdot 8 = 64$ revolutions of the electromotor, thus, cause a single turning of the screw (roughly $3500 / 64 = 55$ revolutions per minute). This explains the large angular momentum M. Assuming the motor's constant power P, we can apply the equation $P = M \cdot w$, where w is the angular velocity. Planetary gears have many applications in technology, such as in gearboxes, cable winches, and bicycle hub gears. Another variation on the same principle is also notable: If the axes of the planetary gears are fixed, and the outer gear is allowed to rotate, then it rotates significantly slower than the drive shaft (the photo was taken at the German Museum in Munich).

Robust and efficient

A four-bar transmission is a system of rotating, interconnected bars of predefined length. The joint positions shall be termed L, A, B, and M. Normally, the points L and M are fixed (producing the bar LM). This means that LA rotates about L and MB about M (the crank). The remaining bar AB moves as well, but in a non-trivial manner. Each point C connected to this coupling describes a so-called coupler curve. The diversity of such curves is virtually endless, enabling it to serve a variety of functions.

Let us consider the crane in the large photo (its miniature model is shown on the right page). The bars are dimensioned such that the coupler curve of C describes a very long and nearly straight part that can be used to move heavy loads. In designing the transmission such that only the near-straight part is used, its clever engineers built in a further crank about the fixed point N (red part of the rightmost computer graphic). This also solved the problem of propulsion.

Something similar must have occurred to the designers of the mechanical linkage in the top right corner of this page, where the approximately straight-line component of a completely different coupler curve is used (usually for oil pumps). The series at the bottom shows an alternative implementation of such a pump. The advantage lies in the great stability of such mechanisms, which last forever by all reasonable standards.

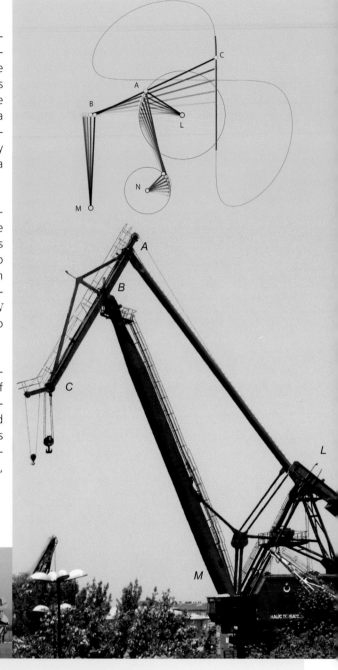

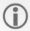 W. WUNDERLICH **Ebene Kinematik** B. I. Hochschultaschenbücher 447/447a, Mannheim, 1970
H. LAZAR **Analyse ebener Getriebe** www.geometrie.tuwien.ac.at/theses/lazar

The smaller animals are, the quicker they are able to move their limbs, since, according to the equation $s = a/2 \; t^2$, time shrinks in square proportion to s.

The monkey above seems to positively fly across the rope at a speed of roughly 3 m per second. The smaller photo of the fleeing gecko shows the movement that the animal must execute in order to detach itself from the surface. Despite the fact that thousands of its tiny hairs stick to the wall through adhesion, the reptile zips across it at 1 m/s. If the situation was scaled up to our own body size, this would result in a speed of about 15 m/s (or more than 50 km/h).

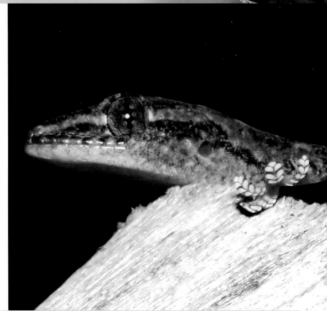

Wikipedia **Gecko** http://en.wikipedia.org/wiki/Gecko

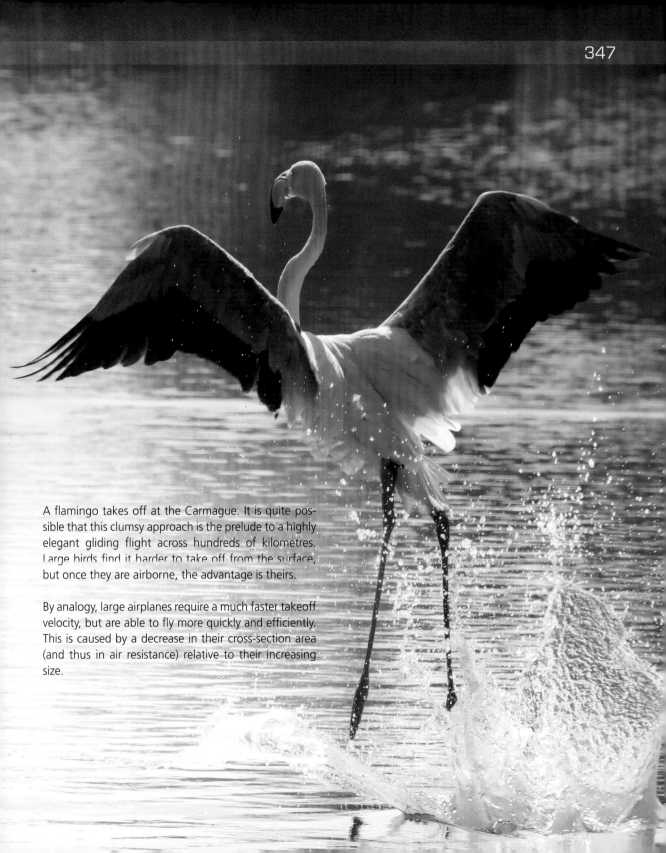

A flamingo takes off at the Carmague. It is quite possible that this clumsy approach is the prelude to a highly elegant gliding flight across hundreds of kilometres. Large birds find it harder to take off from the surface, but once they are airborne, the advantage is theirs.

By analogy, large airplanes require a much faster takeoff velocity, but are able to fly more quickly and efficiently. This is caused by a decrease in their cross-section area (and thus in air resistance) relative to their increasing size.

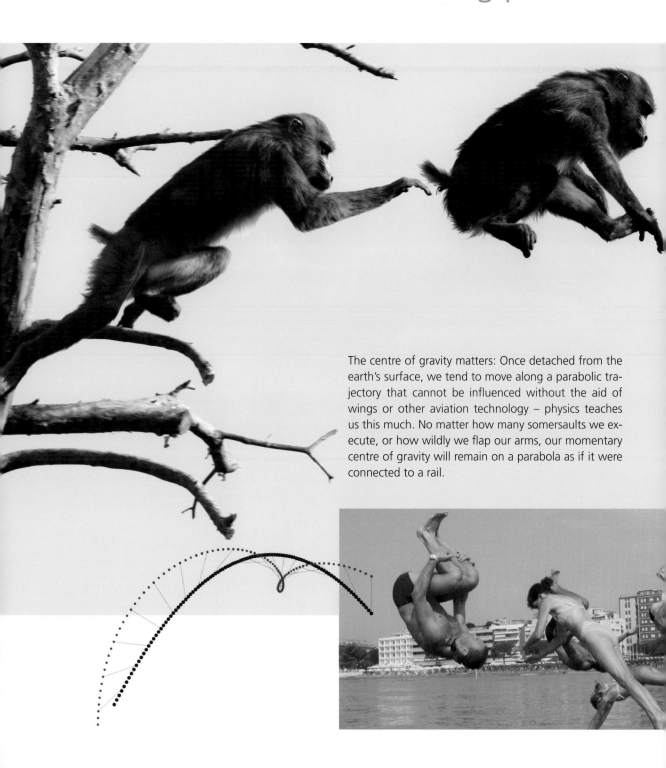

Throwing parabola

The centre of gravity matters: Once detached from the earth's surface, we tend to move along a parabolic trajectory that cannot be influenced without the aid of wings or other aviation technology – physics teaches us this much. No matter how many somersaults we execute, or how wildly we flap our arms, our momentary centre of gravity will remain on a parabola as if it were connected to a rail.

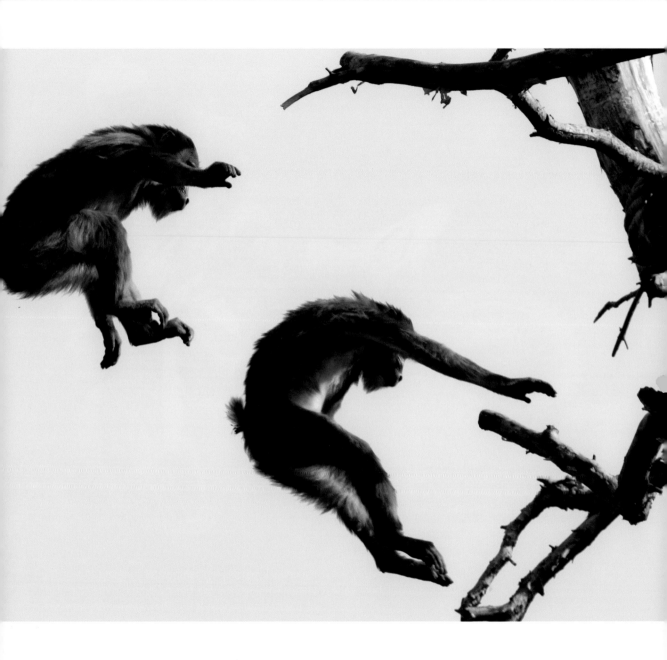

Jumping up high

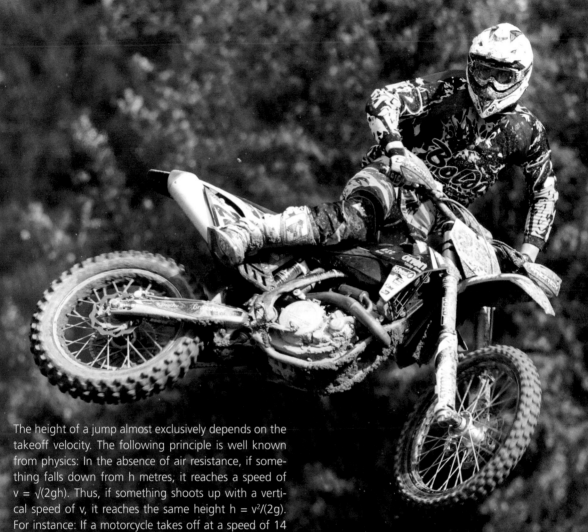

The height of a jump almost exclusively depends on the takeoff velocity. The following principle is well known from physics: In the absence of air resistance, if something falls down from h metres, it reaches a speed of $v = \sqrt{(2gh)}$. Thus, if something shoots up with a vertical speed of v, it reaches the same height $h = v^2/(2g)$. For instance: If a motorcycle takes off at a speed of 14 m/s and at an angle of 30°, the "vertical velocity" is $14 \cdot \sin 30°$ m/s = 7 m/s. The motorcycle will then reach a height of $h = 49/20$ m (= 2.45 m).

2.45 m is the current world record for high jumping. However, due to the jumping technique that is employed, the jumper has to lift his barycenter by about 1.50 m, which leads to a vertical speed of approx. 5.5 m/s. He must, therefore, initiate the jump at a velocity that allows him to reach the necessary vertical speed.

Humpback whales are famous for jumping out of the water. They usually get out by a little more than half of their length (about 8 m). Their barycenter, however, does not need to be lifted quite as much. If the whale were to speed up to 10 m/s and hit the surface in a perpendicular manner, it could theoretically lift its barycenter by 5 m. However, this is not enough to lift its entire body out of the water. The lower images show the proportion of the whale and its enormous fluke, which exerts tremendous forces to speed up the giant.

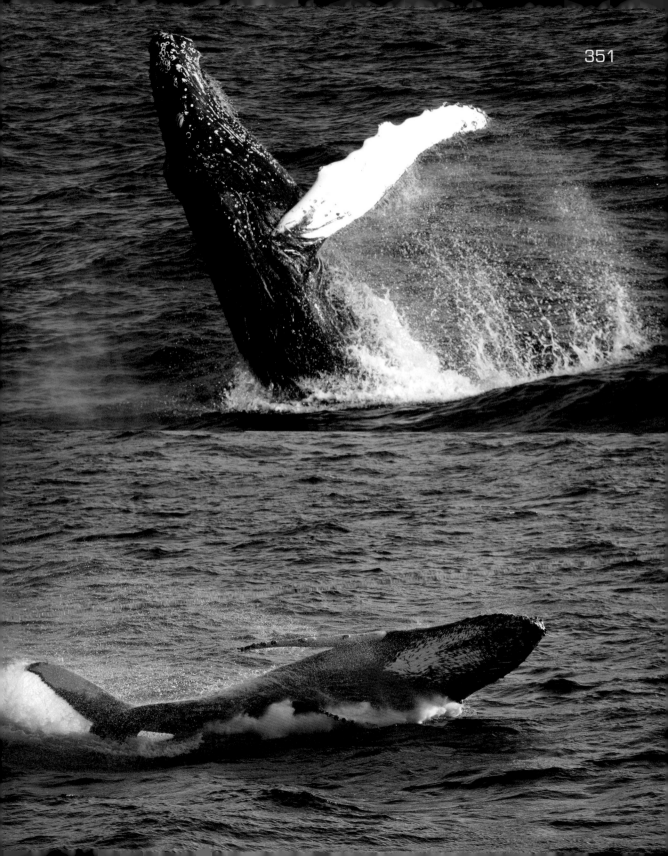

With a club and cavitation

The appropriately named peacock mantis shrimp (Odontodactylus scyllarus) is a remarkable animal for a variety of reasons. Aside from its impressive appearance – no less than a warning signal – it is justly famous for its weapons, which appear within white circles in the picture. Its mighty leg muscles are tightened in the manner of a spring. Once the locking device on the exoskeleton is released, the lower part of its legs rockets forth – a manoeuvre which, on average, takes about $t = 3$ milliseconds. If a distance of $s = 3$ cm is being travelled during the attack, then the acceleration thus accomplished measures $a > 600$ g (according to the equation $s = a/2$ t^2)! This means that the final velocity exceeds 20 m/s due to $v = at$. This extreme acceleration causes gas bubbles which evaporate instantly – a phenomenon called cavitation. The gaseous pressure tends to stun its prey (usually shellfish) even before the actual impact.

The animal's telescopic eyes, which can be moved independently, are equally remarkable: The crustacean possesses excellent sight due to 10 000 ommatea per eye and 10 different colour pigments. The longitudinal stripes at the centre of its eyes allow trifocal imaging of the environment.

WIKIMEDIA **Odontodactylus Scyllarus** http://upload.wikimedia.org/wikipedia/commons/b/b2/OdontodactylusScyllarus.jpg
S. N. PATEK, W. L. KORFF, R. L. CALDWELL **Biomechanics: deadly strike mechanism of a mantis shrimp**
Nature (2004 Apr 22) ; 428(6985) : 819-20

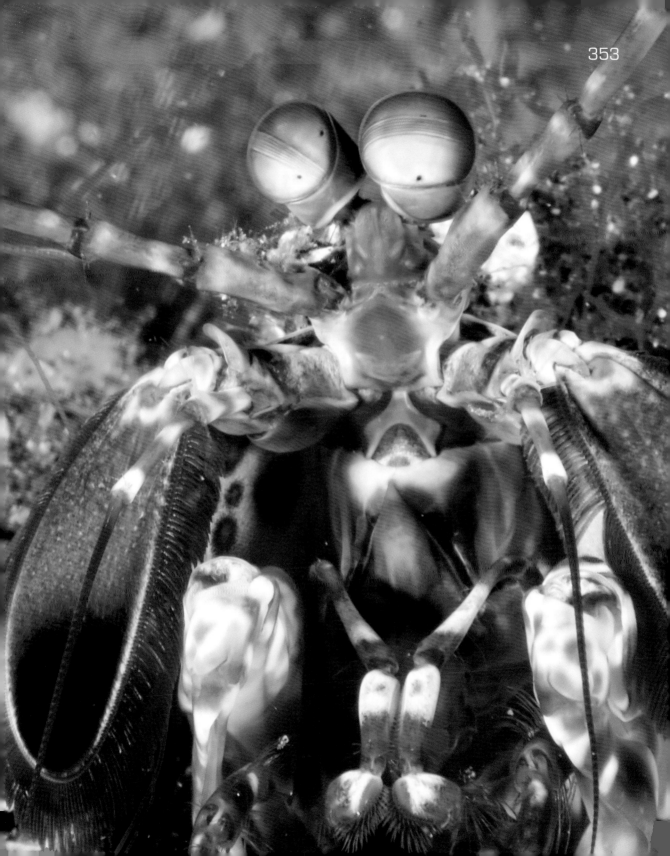

Toys of changing colour

The mechanisms behind many popular toys are based on geometrical and highly theoretical principles. With the theory of computer graphics in mind, for example, one can build a mechanism with eight "buttons" (four green and four orange ones), which are at any time distributed on two regular tetrahedra of variable size.

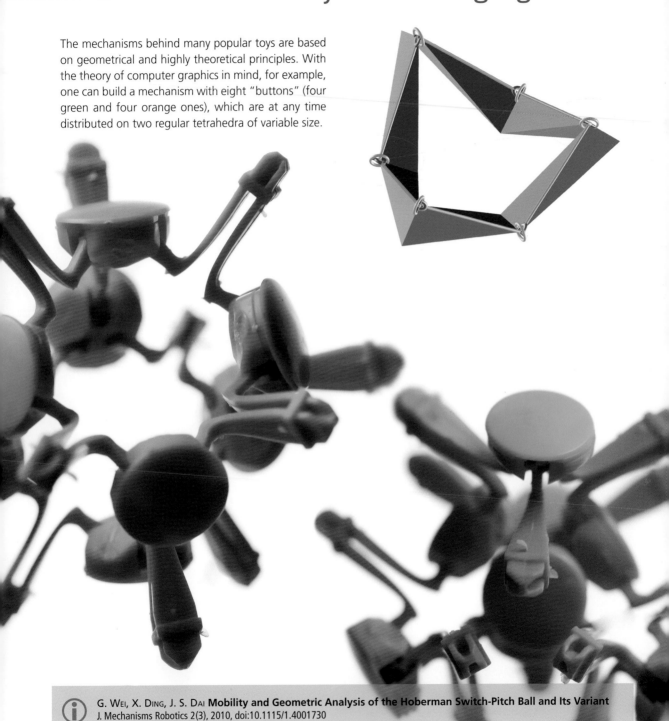

G. Wei, X. Ding, J. S. Dai **Mobility and Geometric Analysis of the Hoberman Switch-Pitch Ball and Its Variant**
J. Mechanisms Robotics 2(3), 2010, doi:10.1115/1.4001730
P. Schatz **Die Welt ist umstülpbar. Rhythmusforschung und Technik.** Niggli, Zürich, 2008

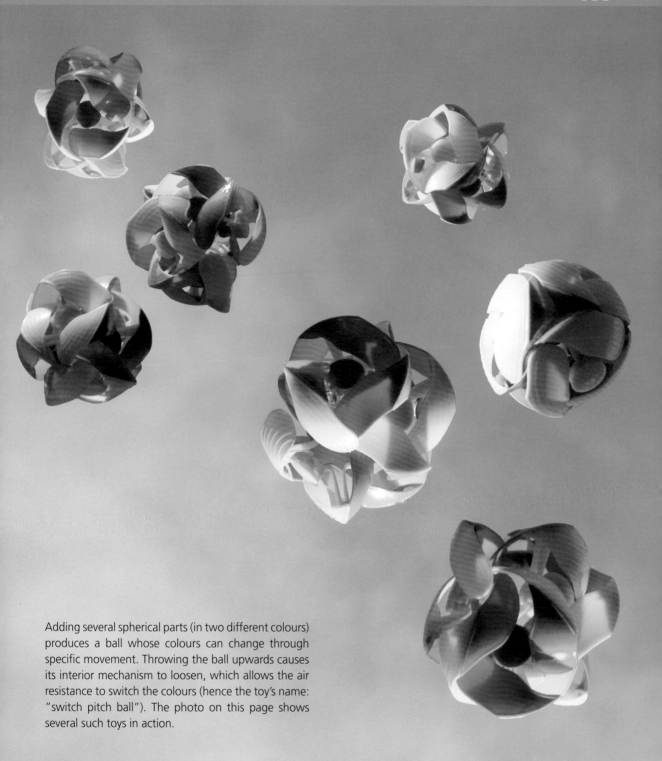

Adding several spherical parts (in two different colours) produces a ball whose colours can change through specific movement. Throwing the ball upwards causes its interior mechanism to loosen, which allows the air resistance to switch the colours (hence the toy's name: "switch pitch ball"). The photo on this page shows several such toys in action.

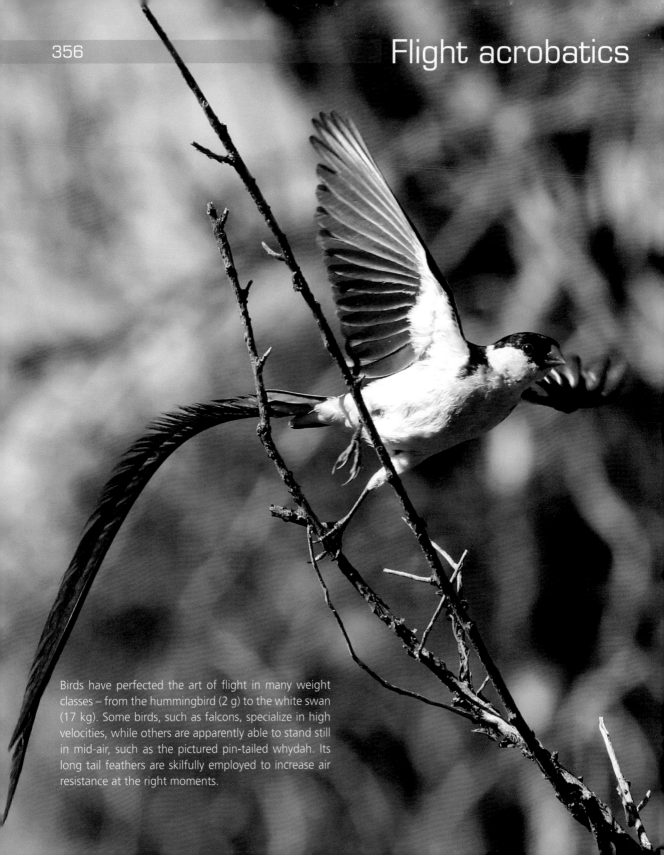

Flight acrobatics

Birds have perfected the art of flight in many weight classes – from the hummingbird (2 g) to the white swan (17 kg). Some birds, such as falcons, specialize in high velocities, while others are apparently able to stand still in mid-air, such as the pictured pin-tailed whydah. Its long tail feathers are skilfully employed to increase air resistance at the right moments.

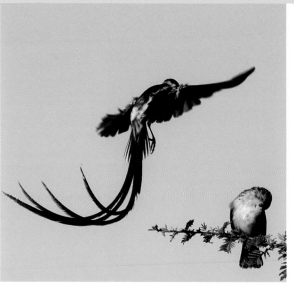

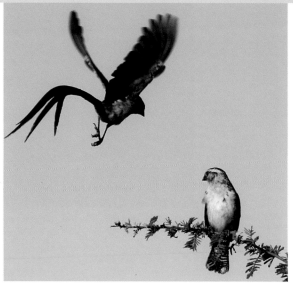

Through masterful movements, the bird is able to hover in the same spot. At 10 wing beats per second, its flapping frequency is relatively small, but that is still enough to ward off swarms of mosquitoes or to impress a female as in the series of pictures.

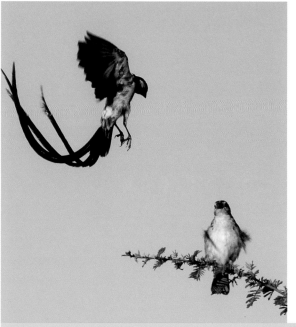

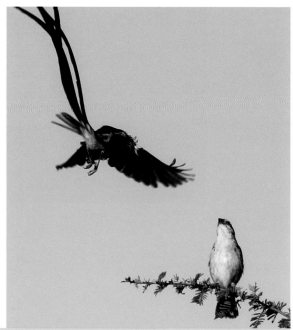

Index

This book contains about 750 photos and illustrations, the vast majority of which were created by **Georg Glaeser** (including most computer graphics). All other contributions are listed here.

Franz Gruber
created a substantial part of the computer graphics:

p. 4 top right	p. 204 top right
p. 5 bottom left	p. 207 bottom right
p. 10 bottom right	p. 210 bottom left
p. 30 right	p. 260 left
p. 33 top right	p. 261
p. 34 top	p. 264 top left
p. 35 top	p. 266
p. 36	p. 270 top
p. 37	p. 273 bottom
p. 40 bottom	p. 276 bottom
p. 45 top right	p. 311 top
p. 77 bottom	p. 316
p. 137	p. 329
p. 172 bottom	p. 330 right
p. 173	p. 332
p. 176	p. 333 top
p. 178 bottom	p. 337
p. 197	p. 344 top
p. 200 top right	p. 345 bottom

Rudolf Waltl
took the following photos:

p. 106 right	p. 240
p. 177	p. 250 bottom
p. 230	p. 344

Heinz Adamek
took the photo on the right on p. 83.

Klaus Becker
took the photos on p. 336 (Right: VG-image art).

Udo Beyer
created the computer graphic on p. 136
and took the photos on p. 136 and 137.

Othmar Glaeser
took the photo on p. 233.

Harald Andreas Korvas
created the hand-drawn illustrations on p. 62.

Hartmut Luecke
created the computer graphics on p. 20 and 21.

Christian Perrelli and **Georg Hirzinger**
took the three photos on p. 341 bottom.

Hans-Peter Schröcker
created the computer graphic on p. 74.

Peter Waltl
took the two photos on p. 351.

Sophie Zahalka
created the illustration on p. 244.

Updated internet links can be found at
www.uni-ak.ac.at/nature-and-numbers